REMARKABLE
BOOKS

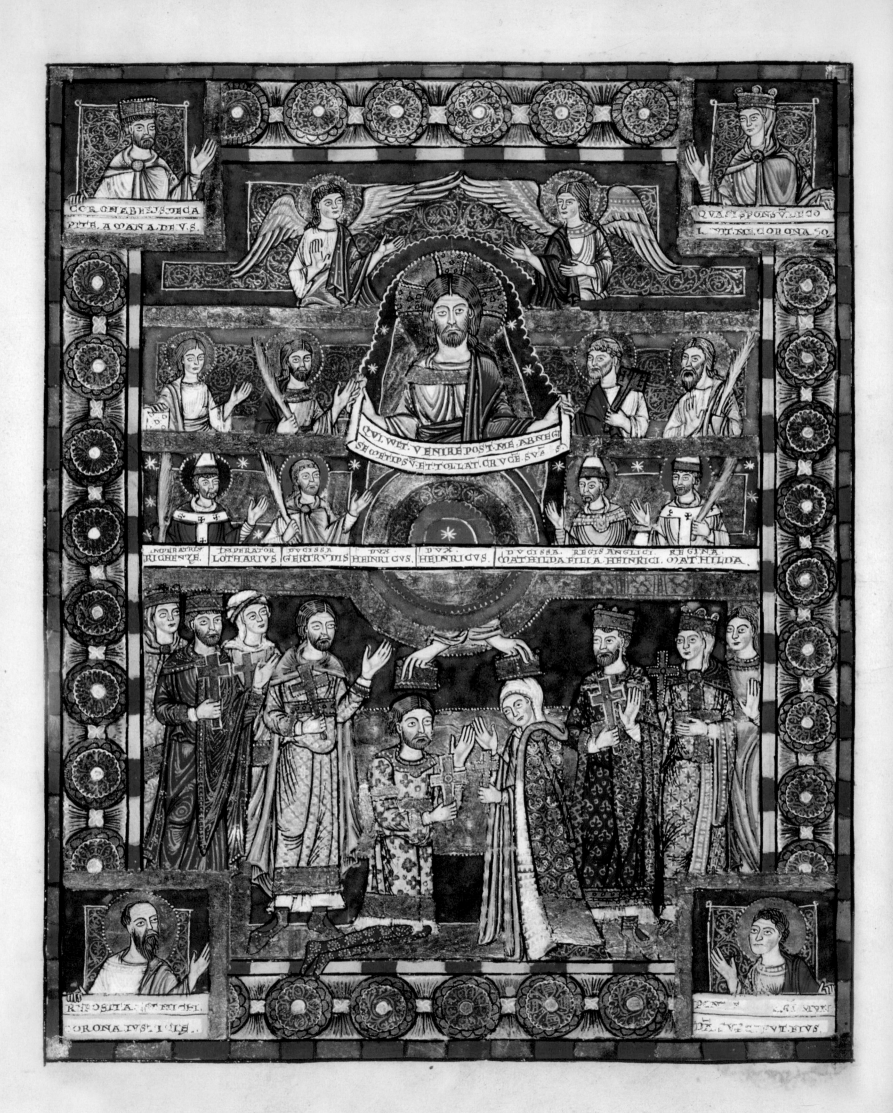

REMARKABLE BOOKS

A Celebration of the World's Most Beautiful and Historic Works

Contributors
Father Michael Collins
with Alexandra Black, Thomas Cussans, John Farndon, and Philip Parker

DK

Senior Editor Kathryn Hennessy
Senior Art Editor Jane Ewart
Editors Jemima Dunne, Natasha Khan,
Joanna Micklem, Ruth O'Rourke-
Jones, Helen Ridge, Zoë Rutland,
Alison Sturgeon, Debra Wolter
Designers Stephen Bere, Katie Cavanagh,
Phil Gamble
US Editor Kayla Dugger
Managing Editor Gareth Jones
Senior Managing Editor Lee Griffiths
Picture Researchers Roland Smithies, Sarah Smithies
Senior Jacket Designer Mark Cavanagh
Jacket Design Manager Sophia MTT
Jacket Editor Claire Gell
Pre-production Producer Gillian Reid
Producer Mandy Inness
Publisher Liz Wheeler
Art Director Karen Self
Publishing Director Jonathan Metcalf

DK INDIA

Senior Managing Art Editor Arunesh Talapatra
Senior Art Editor Chhaya Sajwan, Devika Khosla
Art Editor Meenal Goel
Assistant Art Edtior Anukriti Arora
Editor Nishtha Kapil
Pre-production Manager Balwant Singh
Production Manager Pankaj Sharma
DTP Designers Jaypal Chauhan, Nityanand
Kumar, Mohammad Rizwan

First American Edition, 2017
Published in the United States by DK Publishing
345 Hudson Street, New York, New York 10014

Copyright © 2017 Dorling Kindersley Limited
DK, a Division of Penguin Random House LLC
17 18 19 20 21 10 9 8 7 6 5 4 3 2 1
001-300185-Sep/2017

A catalog record for this book is available from the
Library of Congress.

ISBN 978-1-4654-6362-3

DK books are available at special discounts when
purchased in bulk for sales promotions, premiums,
fund-raising, or educational use.
For details, contact: DK Publishing Special Markets,345
Hudson Street, New York, New York 10014
SpecialSales@dk.com

Printed and bound in China

All images © Dorling Kindersley Limited
For further information see:
www.dkimages.com

A WORLD OF IDEAS:
SEE ALL THERE IS TO KNOW

www.dk.com

Contents

3000 BCE–999 CE

1000–1449

Contributors

Lead contributor
Father Michael Collins
Michael Collins is a graduate of
the Pontifical Institute of Christian
Archeology in Rome. His initial
passion for books and writing
stemmed from his interest in
calligraphy. It was further fuelled
when he discovered that the
Book of Kells was once owned by
an ancestor, Bishop Henry Jones,
who donated it to Trinity College
Dublin in 1663. Michael has
published books in 12 languages.

Contributors
Alexandra Black
A freelance author, Alexandra
Black's writing career initially took
her to Japan. She later worked
for a publisher in Australia, before
moving to Cambridge, UK. She
writes on a range of subjects, from
history to business and fashion.

Thomas Cussans
A freelance historian and author
based in France, Thomas Cussans
was for many years a publisher
responsible for a series of bestselling
history atlases. He has contributed
to many DK titles, including History:
The Definitive Visual Guide.

John Farndon
A Royal Literary Fellow at Anglia Ruskin
University in Cambridge, John Farndon
is an author, playwright, composer, and
poet. He has written many international
bestsellers and translated into English
verse the plays of Lope de Vega and
the poetry of Alexander Pushkin.

Philip Parker
A historian and former British
diplomat and publisher who studied
History at Trinity College, Cambridge
and International Relations at the
John Hopkins School of Advanced
International Studies, Philip Parker
is a critically acclaimed author and
award-winning editor.

1450–1649

1650–1899

1900 ONWARD

Preface

A book is a remarkable thing. It can represent beauty, knowledge, ideas, freedom, and escapism— and, crucially, what is imparted depends on who is reading it. To one person a book may be a mine of information, which informs, enlightens, and illuminates. To another it may represent a journey into a different life, offering something bigger and more extraordinary than their own world perspective. To others still, a book may be an object of beauty, something to collect, preserve, and treasure. Whatever the motivation for reading, books and the experiences they give us are to be cherished.

In theory, what constitutes a book is easy to define: a set of written or printed pages that are bound together and convey information. Yet the first "books," thousands of years old, were scrolls inscribed with ink, or slabs of bamboo engraved with a script. From these ancient beginnings the handwritten book evolved into a printed artifact, which eventually became mass-produced and available to all.

Today a book is still a set of printed pages; yet it may also be a digital file that a person can pay to access but never physically own.

The historic importance of the book cannot be overstated, as it is through written documentation that human history and development can be accurately traced. For centuries books were our primary means of spreading knowledge—they communicated religious and spiritual rituals and teachings; they enabled scientific theories to be shared across the world; they disseminated political ideas that unified the disenfranchised of society and formed the seeds of revolution. Once the preserve of the elite, books have evolved over time to form a constant and essential part of human life, whether as a school textbook, a travel guide, a sacred text, or a novel for bedtime reading. Through books we educate our children about the world they live in; through books we teach them how to read. The books on our shelves trace a line through our

own lives, each one a memory of a time gone by: a place visited, a person we knew, a story we loved. To know and have access to books is a privilege that is easy to underestimate.

Today an understanding of the role of books is more important than ever. Books represent freedom of expression and of information—subjects once considered controversial, such as political agendas, sexual content, or scientific reasoning, are now firmly within the public domain, largely due to authors who dared to challenge established thought by publishing texts that were deemed contentious, or even heretical. Consequently, throughout history this precious commodity has frequently come under threat. Religious and political censorship have led to the banning, and in extreme cases the destruction, of many great literary works. Even today, the rise of the internet and the development of ebooks has threatened the popularity and perceived usefulness of what was once our most ubiquitous art form.

However, neither the convenience and portability of the ebook, nor the infinite scope of the internet as a source of information, has been able to supersede the vital importance of the book to human society.

Remarkable Books offers a window into some of the most beautiful and important books produced since the origins of the written word. These books are featured as much for their physical beauty—from exquisite illuminated manuscripts to masterpieces in typographic design—as for their historical, cultural, and social significance—such as scientific papers, political treatises, and formative children's literature.

Everybody's list of the most remarkable books in history will be different—the thousands of books that have influenced the world cannot all be included within these pages. What is presented here is a selection of unique and extraordinary books without which the world would be a very different, and infinitely poorer, place.

Scrolls and Codices

Books are almost as old as writing itself, and their coming marks the watershed between prehistory, when mankind's story was passed on only by word of mouth, and history, when it was recorded for future generations to read.

The first books were written on a wide variety of materials, including clay tablets, silk, papyrus (made from reeds), parchment (animal skins), and paper (pulped rags). They were bound together in various ways, although sometimes they were not even bound at all. One of the world's oldest books is the Sumerian story of Gilgamesh, an ancient epic, which was written down on a collection of clay tablets nearly 4,000 years ago.

Until the development of the printed book in the fifteenth century, most books came in the form of scrolls or codices. Scrolls are sheets of papyrus, parchment, or paper stuck together end-to-end then rolled up. The Ancient Egyptians wrote on papyrus scrolls at least 4,600 years ago. Codices (or a codex, singular) are stacked sheets of papyrus, parchment, or paper joined down one side and bound between a stiff cover so they can hinge open—rather like a modern book, only handwritten. Codices date back at least 3,000 years, but are often associated with the spread of Christianity across Europe.

Every copy of a scroll or codex was compiled from manuscripts written out laboriously by hand. This made them extremely rare and precious objects. The investment of time and effort meant that only the most wealthy and powerful people could afford to have them made. But their rarity and the way they carried exact wordings into the future gave the earliest books an authority that seemed almost magical. For example, the Ancient Egyptian Books of the Dead were scrolls buried with a deceased person to enable them to carry words that had the power to guide them even in the afterlife (see pp.18–23).

Books became the foundation stones that the world's great religions were built upon. They were used to record ancient stories and beliefs. Some works even helped local beliefs to develop into major religions by spreading the definitive words of a great sage or prophet far and wide, and through time from generation to generation. Christians spread Christ's words through their Bible, Jews studied the Torah (see p.50), while Muslims followed the Qur'an, Hindus the *Mahābhārata* (see pp.28–29), and Taoists the *I Ching* (see pp.24–25). All of these books still have a profound impact on lives today, thousands of years after they were first written.

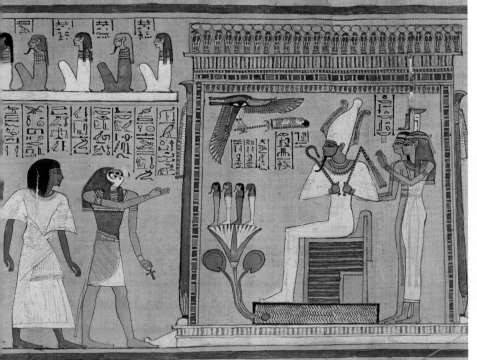

▲ **EGYPTIAN BOOKS OF THE DEAD** No two Books of the Dead are the same; each was tailored to the deceased and their needs in the afterlife. They consist of spells and illustrations on papyrus, and date from around 1991–50 BCE.

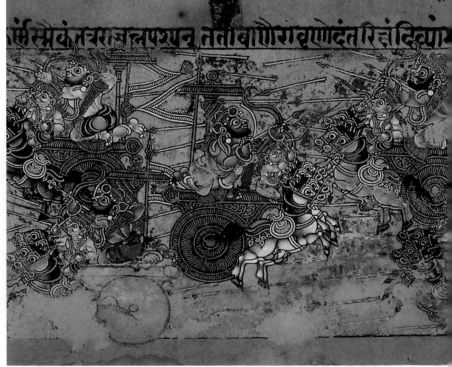

▲ **MAHĀBHĀRATA** Written in Sanskrit, this epic poem recounts tales of ancient India. The text reached its final form in around 400 BCE. The manuscript above depicts a battle between Ghatotkacha and Karna, and dates from around 1670.

> To preserve the memory of the past by putting on record the astonishing achievements of our own and of the Asiatic peoples. 99

HERODOTUS, GREEK HISTORIAN SETS OUT HIS AIM IN WRITING *THE HISTORIES*, C.450 BCE

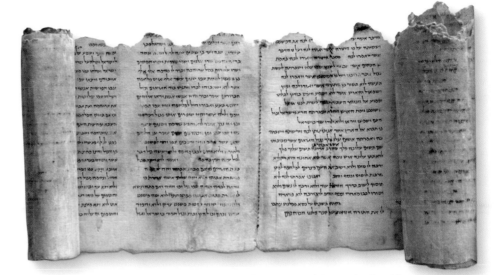

▲ **DEAD SEA SCROLLS** Created between around 250 BCE and 68 CE, the Dead Sea Scrolls are a collection of 981 manuscripts discovered in the Qumran Caves on the shore of the Dead Sea. Most of the manuscripts contain Hebrew scriptures, others are noncanonical texts, while some are in such a poor condition that they cannot be identified.

Indeed, the painstaking process of writing a book out by hand was often an act of religious devotion in itself. Many monks labored long to produce "illuminated manuscripts" of dazzling beauty such as the *Gospels of Henry the Lion* (see pp.60–63) or the *Book of Kells* (see pp.38–43).

However, it wasn't only religions that harnessed the power of books. Books stored ideas and information to be accumulated over time, so that each generation built on the learning of those who had gone before, gradually expanding the stock of human knowledge.

Writers such as Ibn Sīnā (see p.56), for instance, combined his own medical knowledge with that of previous generations to create a definitive textbook for physicians, *The Canon of Medicine* (see pp.56–57). There were very few copies of books, however, so the libraries that collected them, such as the great Greek library at Alexandria in modern-day Egypt, and the libraries of the Muslim world became the great engines of knowledge. During the Middle Ages, scholars would travel thousands of miles simply to read a rare copy of a key book.

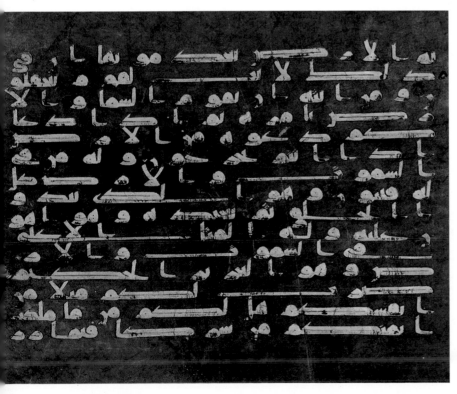

▲ **THE BLUE QUR'AN** Most likely produced in North Africa in around 850–950 CE, it is thought that the *Blue Qur'an* (see p.44–45) was compiled for the Great Mosque of Kairouan in Tunisia. The gold letters are written in Kufic calligraphy.

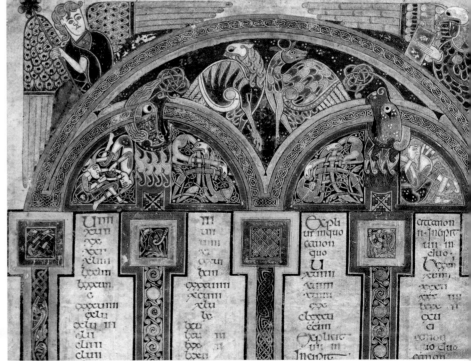

▲ **BOOK OF KELLS** Brilliantly illuminated with rich colors and gold leaf adorning the text, the *Book of Kells* was created in Ireland in around 800 CE. The manuscript contains the Gospels and the tables of the Eusebian Canons, shown above.

The Printed Book

Printing dates back over 1,800 years to carved wood blocks in China and Japan that were used to stamp religious images onto paper, silk, or walls. By the ninth century, the Chinese were printing entire books, including the *Diamond Sutra* (see pp.46–47) of 868 CE, the oldest surviving dated example. The Chinese even invented a form of movable type, which involved building up pages from ready-made collections of letters. But it was in 1455 in Mainz, Germany, when Johann Gutenberg used movable type to print the Bible, that the printed book really arrived.

The Gutenberg Bible (see pp.74-75) was a large luxury item, that only the rich could afford. But printers were soon making smaller, cheaper books. One of the pioneers of mass printing was Aldus Manutius (see pp.86–87), a Venetian scholar who set up the world's first great publishing house, the Aldine Press, in the 1490s. Manutius introduced the elegant, easy-to-read Italic (from Italy) typeface, and the handy octavo-size book–similar to a typical modern hardback. Books were no longer just kept in libraries but could be read anywhere. Within 50 years of the first printing of Gutenberg's Bible, there were 10 million printed books, and the Aldine Press was launching titles with initial print runs of 1,000 books or more.

The impact was both public, as ideas were shared quickly among numerous readers, and private, as books allowed people to explore their imaginations at home. Interestingly, many of the first ideas shared through print were ancient ones. The Aldine Press concentrated on publishing the classics, leading to a revival of interest in Virgil and Homer, Aristotle and Euclid. All the same, newer books such as Dante's *Divine Comedy* (see pp.84–85) and *Hypnerotomachia Poliphili* (see pp.86–87) soon became classics, and print ensured their style influenced writers across Europe, including William Shakespeare in England.

Printed books like Andreas Vesalius's revolutionary work on anatomy (see pp.98–101) and Galileo's watershed tome on the Earth's place in the universe (see pp.130–31) did not only help spread scientific ideas rapidly; they also consolidated knowledge, as many people could turn to exactly the same source. They created a sense that the understanding of the world was gradually increasing.

Also encouraged by the printed book was the expression of individual thought. Before print, a writer was generally an anonymous scribe, merely copying words rather than creating an original work. But printed books prompted individual authorship, and made living authors celebrities,

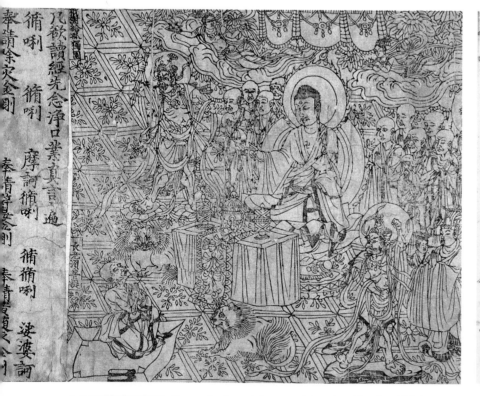

▲ **DIAMOND SUTRA** The earliest surviving complete printed book, which bears an actual date, is the *Diamond Sutra* of 868 from China. It was printed using woodblocks and predates the Gutenberg Bible by almost six centuries.

▲ **GUTENBERG BIBLE** Marking the arrival of the European printed the book in 1455, the Gutenburg Bible was the first printed using movable type. However, its richly illuminated pages were accessible to only an elite few due its high price.

> He who first shortened the **labor of copyists** by the device of **movable types** was … creating a whole new democratic world. **"**

THOMAS CARLYLE, SCOTTISH HISTORIAN, 1795–1881

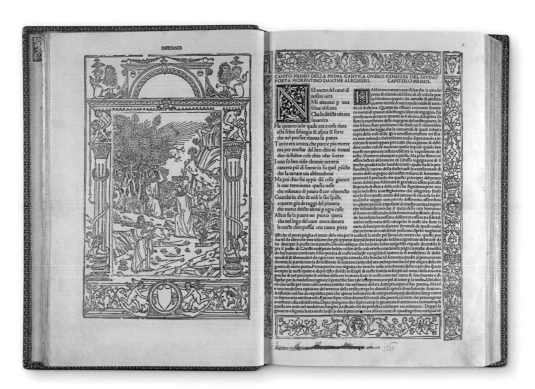

► **DIVINE COMEDY** Dante completed his narrative poem in 1320, but the first printed edition was not published until 1472. Its publication helped to standardize the Italian language and the work has influenced artists and writers across several centuries.

such as Miguel de Cervantes with his epic, *Don Quixote* (see pp.116–17). This elevation of individual expression may have been a factor in the great revolutions in European thought—the Protestant Reformation, the Renaissance, and the Age of Enlightenment.

One of the surprising impacts of printing, however, was the stimulation of a development in national languages, such as English, French, and German. In the Middle Ages people in Western Europe spoke such a mix of dialects that someone from Paris was virtually unintelligible to someone from Marseilles; scholars, however, often conversed in Latin. But printed books helped to standardize national languages. The King James Bible, the first authorized bible in English, played a huge part in setting the form of the English language as its words were read every week in churches across the land.

▲ **THE NUREMBERG CHRONICLE** Printed in 1493, the *Nuremberg Chronicle* (see pp.78–83) is a richly illustrated account of biblical and human history. It is one of the earliest examples of illustrations and text being fully integrated.

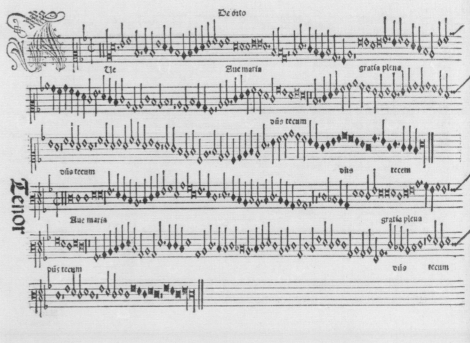

▲ **HARMONICE MUSICES ODHECATON** Published in 1501, Ottaviano Petrucci's *Odhecaton* (see pp.88–89) made sheet music more widely available. Each song has lines for a number of instruments, allowing musicians to read the same page.

Books for All

The eighteenth century saw an explosion of book publishing and printing in Europe. This period was called the Age of Enlightenment, and books helped to spread knowledge on an unprecedented scale. During the Middle Ages, fewer than 1,000 copies of manuscripts were made in an entire year across the whole of Europe; in the eighteenth century, 10 million books were printed every year—a staggering 10,000-fold increase in production.

Books became available everywhere, and at a relatively cheap price, and so increasing numbers of people learned to read. In western Europe fewer than one in four people were literate in the seventeenth century, but by the mid-eighteenth century two thirds of men were literate and more than half of women. A massive new readership was born, which in turn fueled the demand for books.

New kinds of books emerged, too, including popular information titles. Previously, factual books had been created mostly for specialists, but in the eighteenth century learning became more democratic, and books helped to ensure that knowledge wasn't only for the elite. Canny publishers realized that there was a huge market among the public for books that would help them understand what was known about the world around them.

At the same time, many writers earnestly wished to spread knowledge and enlightenment as far as possible. Writing books, in some ways, became a revolutionary act. When Denis Diderot (see pp.146–49) created his great encyclopedia in the middle of the century, he was seeking not just to provide people with information; he was also striking a blow for democracy by showing that the world of knowledge was every man and woman's right, and not just the divine right of kings and aristocrats. Thomas Paine took up the call for the rights of every human being with his *Rights of Man* (see pp.164–65), which was widely read and studied, and underpinned the French and American Revolutions.

Books were also the medium by which scientists and philosophers introduced their ideas to the world. In some ways the Enlightenment had been prompted by Sir Isaac Newton's ground-breaking book *Philosophiae Naturalis Principia Mathematica* (see pp.142–43) in which he introduced his laws of motion. Newton's book showed that the entire universe was not a magical divine mystery, but that it ran on precise mechanical laws, which could be studied and understood by scientists. Meanwhile, Robert Hooke introduced a previously unsuspected microscopic

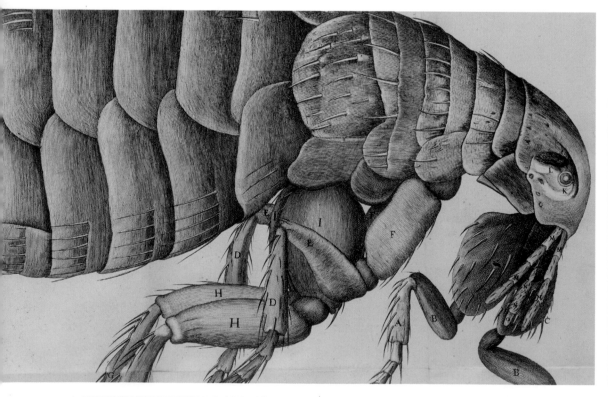

▲ **HOOKE'S MICROGRAPHIA** Published in 1665, Robert Hooke's ground-breaking *Micrographia* revealed a miniscule world that readers had never experienced before. Exquisitely intricate illustrations, such as this large fold-out drawing of a flea, depicted creatures and objects in monstrous yet beautiful detail.

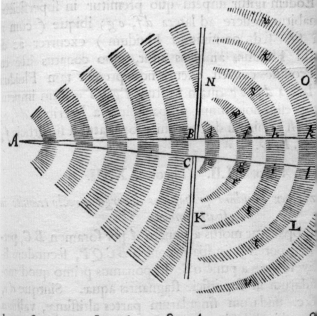

▲ **PRINCIPIA MATHEMATICA** Newton's 1687 work laid out his explanation for the orbit of the spheres. Despite the dense subject matter, it won him instant fame.

> ... bound together solely by their zeal for the best interests of the human race and a feeling of mutual good will. "

DENIS DIDEROT, ON THE WRITERS OF *ENCYCLOPÉDIE*, 1751

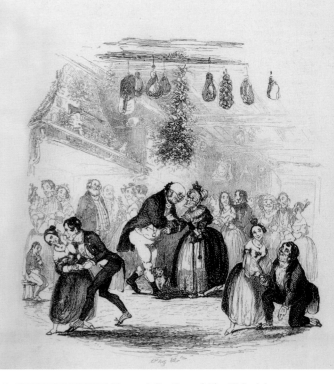

▲ **DAS KAPITAL** Published in 1867 at a time of immense social and industrial change, Marx's polemic was a timely account of the injustices suffered by many under the capitalist system. Though the book had a small readership at the time, Marx's influence lasts to the present day.

world with his *Micrographia* (see pp.138–41); Carolus Linnaeus showed how nature could be pinned down and classified in his *Systema Naturae* (see pp.144–45); and Charles Darwin showed how life evolved in his *On the Origin of Species* (see pp.194–95). By the end of the eighteenth century there were also books showing how even human society could be analyzed and understood. Adam Smith's *Wealth of Nations* (see pp.162–63) provides the theoretical basis for capitalist economic systems, while Karl Marx's *Das Kapital* (see pp.200–201) created a powerful counterargument that started revolutions that are still in progress today.

Besides the great theoretical works, fiction was developing as a genre, and novels such as *Tristram Shandy* (see pp.156–59) responded to the increasing consciousness and imaginative private life of individuals. Initially, novel-reading was the domain of wealthy ladies of leisure. However, Dickens's *The Pickwick Papers* (see pp.178–79) was serialized in cheap weekly installments, each with a cliff-hanger ending to keep the reader hooked. This helped his novel reach vast numbers of ordinary people and, for the first time, the book was entertainment.

▲ **TRISTRAM SHANDY** Laurence Sterne's comic novel was published in 1759. It purports to be the biography of the title character, Tristam Shandy, and is characterized by frequent plot diversions and a playful use of language, drawing heavily on the poets and satirists of the seventeenth century.

▲ **PICKWICK PAPERS** The serialization of *The Pickwick Papers* in a magazine secured its popularity before being published in book form a year later.

The Modern Book

Throughout the twentieth and twenty-first centuries, the book world has grown on a scale unimaginable even in the Victorian Age, when the popular novel first appeared. The figures are extraordinary: more than a million new titles are now published every year in the U.S. alone, and the number of copies printed around the world annually runs into the trillions. The choice for the average reader is immense, with an estimated 13 million previously published books to choose from as well as the year's new titles.

Books are now incredibly cheap to buy, and are no longer thought of as luxury items. Penguin revolutionized the book industry in the 1930s by introducing inexpensive "paperback" books (see pp.230–31), and mass-marketing by giant retailers such as Amazon has pushed the price down even further. Even a new book can often be bought now for little more than the price of a cup of coffee. The coming of electronic e-books has meant that the content of books can also be accessed instantly anywhere.

Yet only a tiny proportion of the millions of published books is ever read by more than a handful of people. Although three-quarters of Americans read more than one book a year, most read no more than six. Very few books are read by a significant number of people.

Nevertheless, some books of the last hundred years have left an indelible mark, not because they were widely read, but because they changed the way people thought. One of these is Einstein's *General Theory of Relativity* (see pp.226–27. In this book Einstein presented theories that overturned the view of the universe dating from the time of Newton, and led to a profound shift in our knowledge of time. Few people have actually read the work, and of those who have, fewer still understand it fully. And yet the impact of its ideas has rippled out far beyond the scientific world.

Throughout history, certain books have sparked controversy, whether for political, moral, or religious reasons. After World War II Hitler's manifesto *Mein Kampf* (see pp.242) was banned as extremist in many European countries—Poland only lifted the ban in 1992 and Germany in 2016. In 1928 D.H. Lawrence published *Lady Chatterley's Lover* (see pp.242) but it was banned in the U.S. and the UK for breaking obscenity laws. The bans were lifted in 1959 and 1960 respectively.

A new kind of book, designed to draw public attention to specific issues, emerged in the twentieth century: books became an effective way of voicing protest. Rachel Carson's *Silent Spring* (see pp.238–39), for

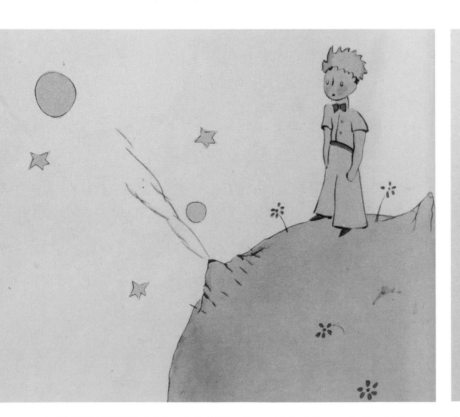

▲ **LE PETIT PRINCE** Antoine de Saint-Exupéry published his novella for children in 1943. Illustrated with exquisite watercolors by the author, it became a classic of children's literature and has been translated into more than 250 languages.

die „Energiekomponenten" des Gravitationsfeldes.

Ich will nun die Gleichungen (47) noch in einer dritten Form angeben, die einer lebendigen Erfassung unseres Gegenstandes besonders dienlich ist. Durch Multiplikation der Feldgleichungen (47) mit $g^{r\sigma}$ ergeben sich diese in der „gemischten" Form. Beachtet man, daß

$$g^{r\sigma}\frac{\partial \Gamma^{\alpha}_{\mu\nu}}{\partial x_{\alpha}} = \frac{\partial}{\partial x_{\alpha}}\left(g^{r\sigma}\Gamma^{\alpha}_{\mu\nu}\right) - \frac{\partial g^{r\sigma}}{\partial x_{\alpha}}\Gamma^{\alpha}_{\mu\nu},$$

welche Größe wegen (34) gleich

$$\frac{\partial}{\partial x_{\alpha}}\left(g^{r\sigma}\Gamma^{\alpha}_{\mu\nu}\right) - g^{r\beta}\Gamma^{\sigma}_{\alpha\beta}\Gamma^{\alpha}_{\mu\nu} - g^{\sigma\beta}\Gamma^{r}_{\beta\alpha}\Gamma^{\alpha}_{\mu\nu},$$

oder (nach geänderter Benennung der Summationsindizes) gleich

$$\frac{\partial}{\partial x_{\alpha}}\left(g^{\sigma\beta}\Gamma^{\alpha}_{\mu\beta}\right) - g^{mn}\Gamma^{\sigma}_{m\beta}\Gamma^{\beta}_{n\mu} - g^{r\sigma}\Gamma^{\alpha}_{\mu\beta}\Gamma^{\beta}_{\nu\alpha}.$$

Das dritte Glied dieses Ausdrucks hebt sich weg gegen das aus dem zweiten Glied der Feldgleichungen (47) entstehende; an Stelle des zweiten Gliedes dieses Ausdruckes läßt sich nach Beziehung (50)

$$\varkappa(t^{\sigma}_{\mu} - \tfrac{1}{2}\delta^{\sigma}_{\mu}t)$$

setzen $(t = t^{\alpha}_{\alpha})$. Man erhält also an Stelle der Gleichungen (47)

▲ **RELATIVITY** In 1916 Albert Einstein published *General Theory of Relativity* with the specific aim of bringing his theories to a wider lay audience, who had no background in theoretical physics.

> … the average book fits into the **human hand** with a seductive nestling, *a kiss of* texture, whether of cover cloth, glazed jacket, or flexible paperback. "

JOHN UPDIKE, *DUE CONSIDERATIONS*, 2008

instance, alerted people to the terrible damage farm pesticides were inflicting on wildlife, and it had a huge impact on the way people think of the environment.

Children's books first appeared in the eighteenth century, with titles like *Fables in Verse* (see pp.160–61), but it was in the twentieth century that books became an integral part of childhood in the developed world, shaping the way readers in their formative years viewed life. Today children's literature is a sophisticated genre, with highlights such as Antoine de Saint-Exupéry's *Le Petite Prince* (see pp.234–35).

Now, 45 trillion pages are printed every day, accessible to billions of people. Books help us to share experiences, stories, and ideas in our hugely populated world in a way that would otherwise be impossible.

▲ **PENGUIN PAPERBACKS** With its simple, and now iconic, cover design, the Penguin paperback changed reading habits in the twentieth century. Mass production made books affordable and opened up a world of literature to a wider readership.

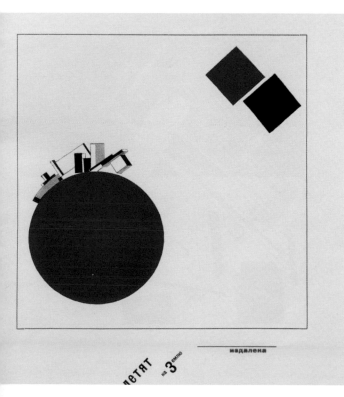

▲ **PRO DVA KVADRATA** El Lissitzky's *About Two Squares* (see pp.228–229) was published in 1922. This children's story acts as an allegory of the superiority of the new Soviet order.

▲ **SILENT SPRING** The book that triggered the start of the environmental movement, *Silent Spring* (see pp.238–39), was published by Rachel Carson in 1962. Her evocative language, accompanied by beautiful illustrations, drew public attention to the dangers of pesticide use.

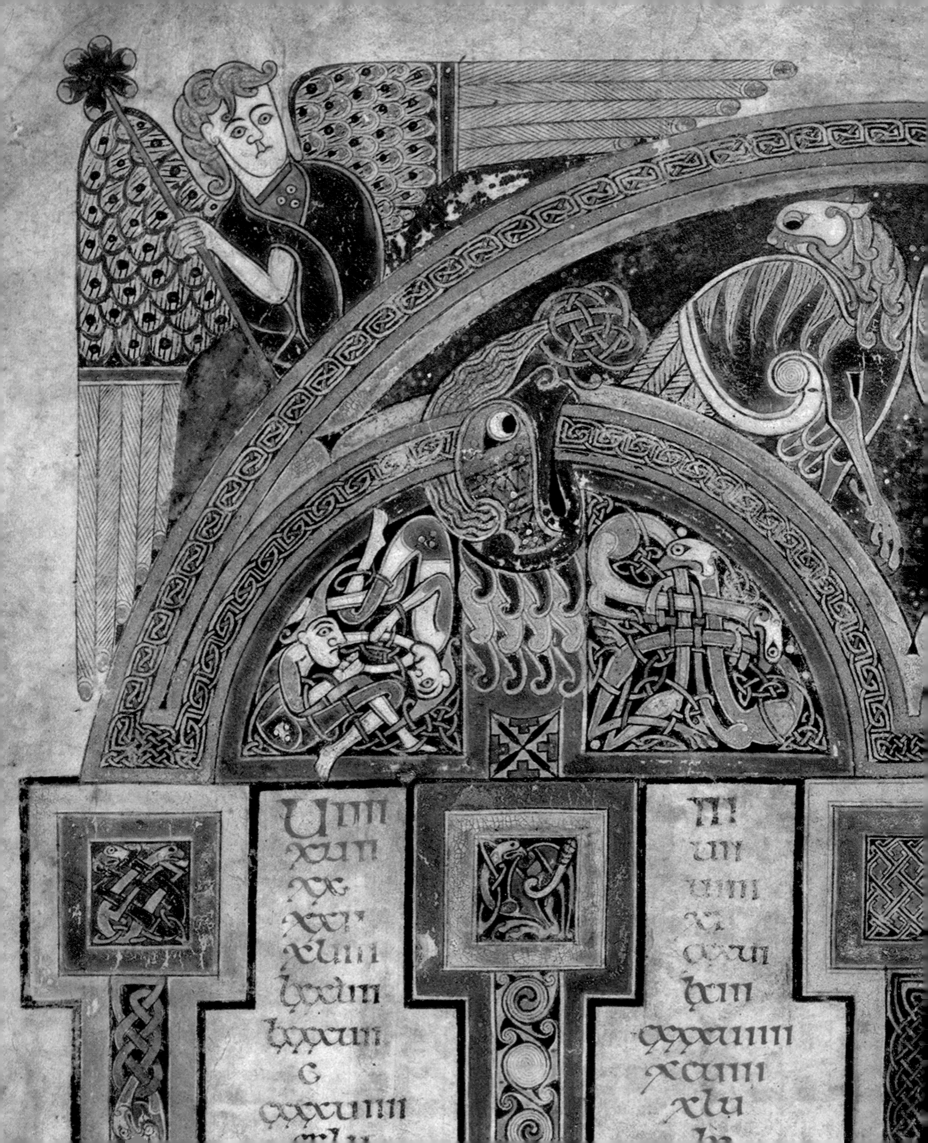

3000 BCE— 999 CE

CHAPTER 1

Ancient Egyptian Books of the Dead

C.1991-50 BCE ■ PAPYRUS SCROLLS ■ C.3-130 ft × 6-18 in (1-40 m × 15-45 cm) ■ EGYPT

VARIOUS AUTHORS

The Ancient Egyptian Books of the Dead were funerary texts that were used for nearly 1,500 years. They took the form of spells (both magical and religious) and illustrations inscribed onto a papyrus scroll that were buried in a tomb with the deceased. It was believed that these spells gave the souls of the dead the knowledge and power they needed to navigate the treacherous netherworld in safety, and to achieve a full afterlife.

Books of the Dead were created by highly skilled scribes and artists. Often more than one scribe would work on a single text, typically writing in cursive hieroglyphics (picture symbols) or hieratic script (a form of hieroglyphics used by priests), in black-and-red ink on papyrus scrolls. Illustrations depicted the journey through the netherworld, with vignettes accompanying the spells. The first Books of the Dead were prepared for elite figures, but by the New Kingdom era (c.1570-1069 BCE), the texts had become available to the wider society—the most elaborate versions date from this time.

The books were organized into chapters, and scribes composed the contents according to the patron's request, incorporating a selection of the 192 prayers available that best reflected how the patron had lived their life. No two books are the same, although most include Spell 125, "Weighing of the Heart," which instructs the soul of the deceased on how to address Osiris, god of the afterlife, following successful judgment of their earthly life.

The term "Book of the Dead" was coined by Prussian Egyptologist Karl Richard Lepsius (1810-84), but a closer translation of its Egyptian name is the "Book of Coming Forth into Day." These pictorial guides for the dead provide vital insight into the Ancient Egyptian beliefs about the afterlife and a tantalizing glimpse into a vanished civilization.

IN CONTEXT

The tradition of providing the deceased with a text to help them on their journey in the afterlife dates back to the Old Kingdom (third millennium BCE), when funerary texts were written on the walls of burial chambers. At the start of the Middle Kingdom (c.2100 BCE), they were mostly written inside coffins. It was these so-called "Pyramid Texts" and "Coffin Texts" that evolved into the Books of the Dead. The papyrus scrolls were rolled up and typically inserted into a statue or encased within the wrappings of the body during mummification. Other objects considered necessary for the journey ahead, such as food and protective amulets, were included in the tomb, and the spells in the book guided the deceased in how to use these items to navigate the netherworld.

◀ **Books of the Dead** were often placed inside containers, such as this case with a painted wooden statuette, to preserve them when buried.

▶ **FINAL TEST** This section of scroll belongs to the Book of the Dead of Maiherpri, who lived during the Eighteenth Dynasty. It illustrates his final test in the netherworld—the weighing of his heart, with Ammut, the winged devourer of souls, looking on. Ancient Egyptians believed that the heart was the seat of human intellect and emotions, and during the mummification process it was not removed.

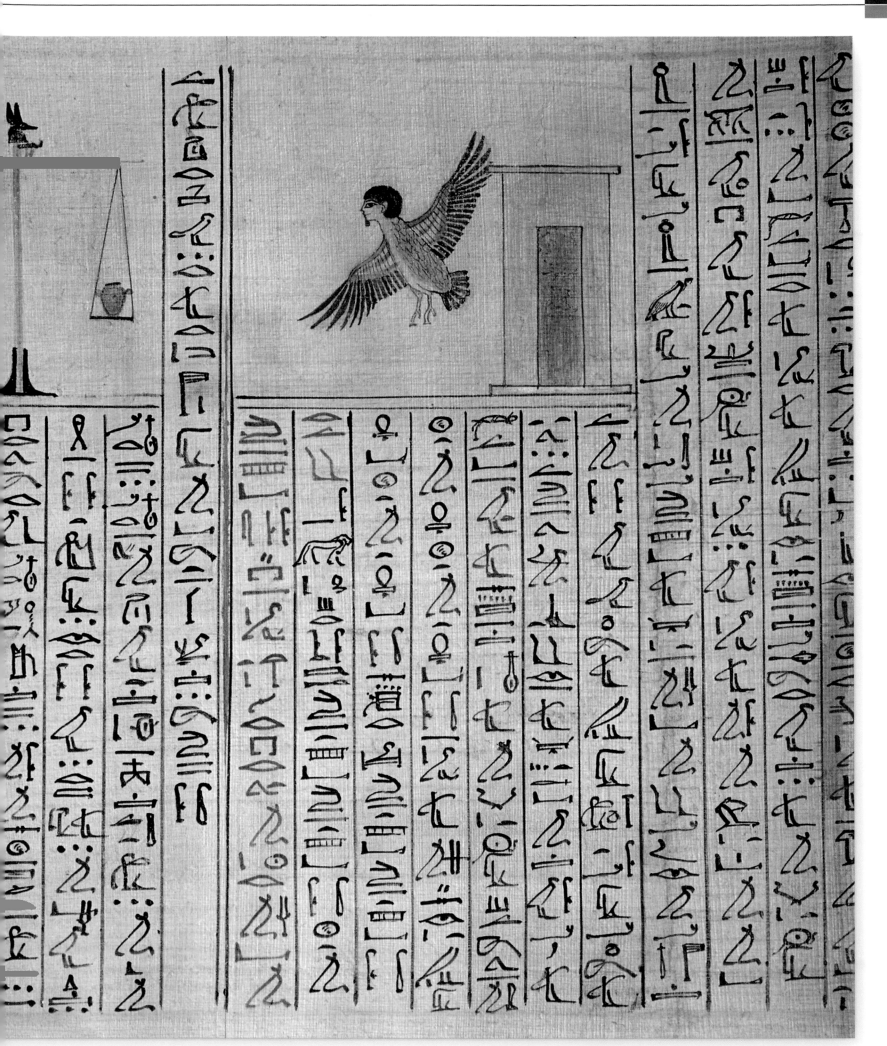

Greenfield Papyrus—In detail

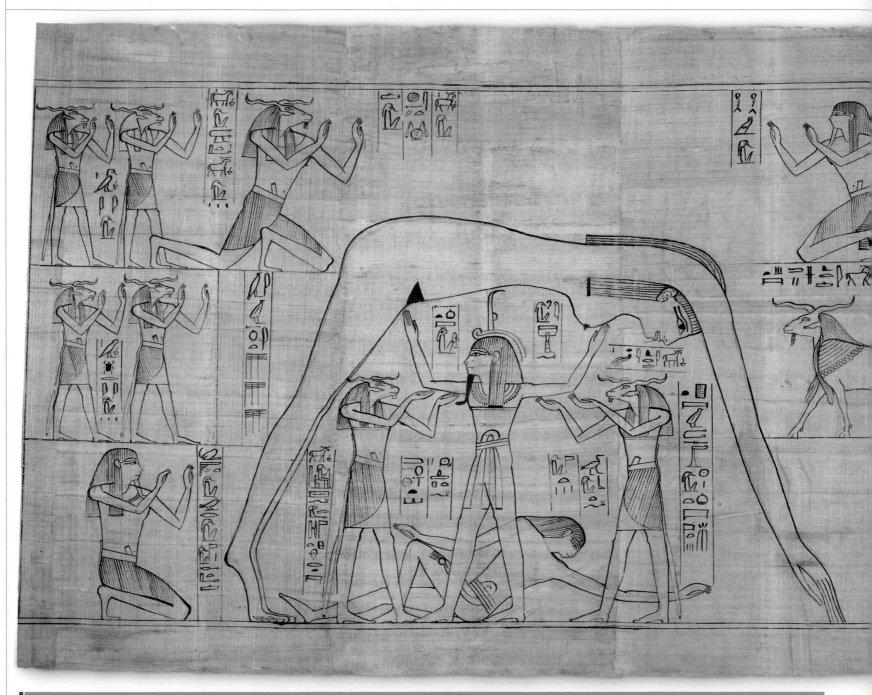

ON **TECHNIQUE**

The scrolls used for Books of the Dead were made from the papyrus plant, a type of reed that grew abundantly in Ancient Egypt, mostly on the banks of the River Nile. Its green bark was peeled back to reveal the white pith beneath, which was cut into long strips. These were then soaked in water for two to three days to release gluelike chemicals. To form the page, the strips were then laid out side by side, slightly overlapping, with a second layer of strips laid on top of them at a 90-degree angle. These were pressed between wooden boards to squeeze out water and bind the layers together. After being dried, the papyrus was polished with a stone to smooth out any ridges and imperfections, providing a better-looking finish. Individual pages were then either cut to measure, or sheets were glued together to the required length of a scroll.

▶ **The first known use** of papyrus, the world's oldest writing surface, dates back to the First Dynasty of Ancient Egypt (c.3150–2890 BCE). Egypt's dry climate is the reason that so many anicent documents have survived.

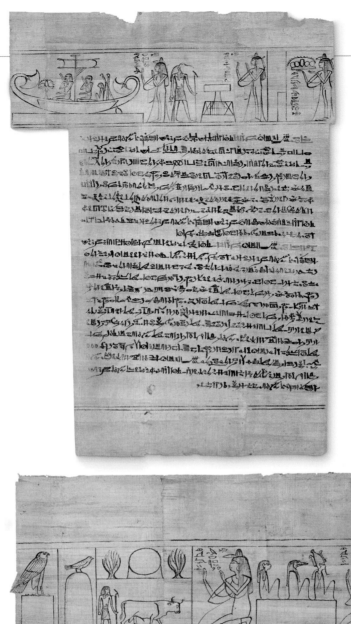

◄ **SEPARATE SHEET**
Measuring almost 121 ft (37 m), Nestanebetisheru's papyrus is the longest known example of an Egyptian Book of the Dead. In the early 1900s this scroll was cut into 96 separate sheets to make it easier to study, display, and store. These are now mounted between protective layers of glass.

◄ **MAGIC SPELLS** The deceased, Nestanebetisheru, is shown twice in this black line vignette. She kneels before three gatekeepers and also before a bull, a sparrow, and a falcon. Accompanying the illustration and written in hieratic text in black-and-red ink is a spell. This Book of the Dead includes a huge number of magical and religious texts, some of which are not found in any other manuscript, suggesting that they were added at Nestanebetisheru's request.

▲ **CREATION OF THE WORLD** Nestanebetisheru was the daughter of a high priest and a member of the ruling elite. Her Book of the Dead, dating from around 950–930 BCE, is one of the most beautiful and complete manuscripts to have survived from Ancient Egypt. It was donated to the British Museum by Edith Mary Greenfield in 1910, and is often known as the Greenfield Papyrus. Here black line drawings depict the creation of the world, with the goddess of the sky, Nut, arching over Geb, the reclining god of the earth.

Book of the Dead of Hunefer—Visual tour

KEY

▶ **ILLUSTRATED HYMN** This detail from Spell 15 of the Book of the Dead of Hunefer, a royal Egyptian scribe (c.1280 BCE) illustrates the opening hymn to the rising sun. Horus, the god of the sky and one of the most significant Ancient Egyptian deities, was often represented as a falcon (as here) or as a falcon–headed man. The solar disc above his head signifies his connection to the sun, while the curved blue line is thought to represent the sky.

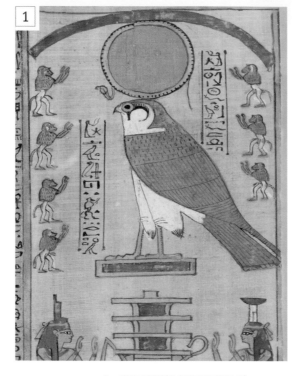

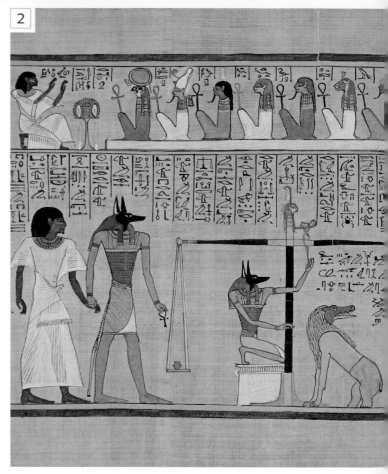

▶ **HUNEFER'S JUDGMENT** The scribe, Hunefer, is shown being led by the jackel-headed Anubis toward the scales of judgment, where his heart is weighed. He passes the test and is then led by Horus to meet Osiris, god of the afterlife, seated on his throne.

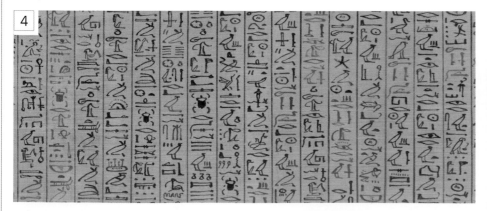

▲ **HIEROGLYPHICS** The Book of the Dead of Hunefer is one of the finest ever discovered, and the handiwork of expert scribes, possibly Hunefer himself. The hieroglyphic text is inscribed in black-and-red ink with black dividing lines in between. Black ink was typically derived from carbon, and red ink from ochre.

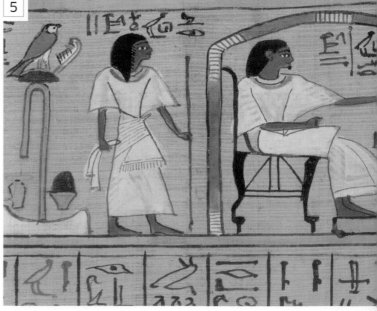

▶ **BOARD GAME** Hunefer is shown here playing a board game. This may have been a favored pastime during his life, but there could be a deeper significance that correlates victory in the board game with victory over obstacles encountered in the netherworld–thereby ensuring Hunefer's successful entry into the afterlife.

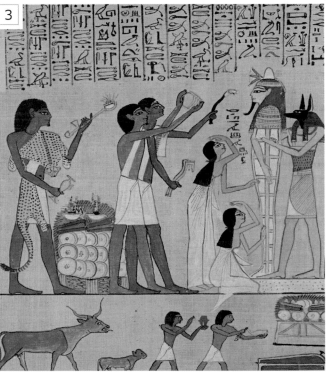

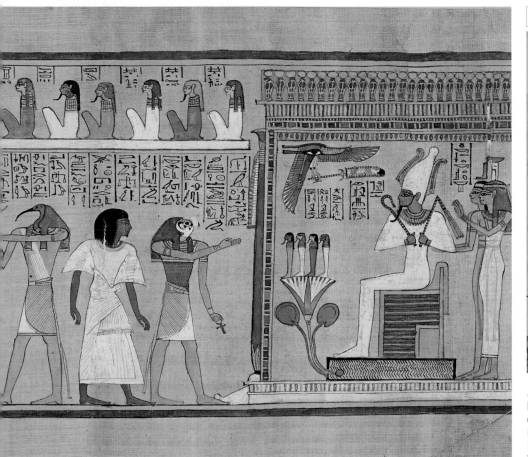

3

▲ **BURIAL CEREMONY** This vignette illustrates the mummified body of Hunefer being symbolically brought to life in the "Opening of the Mouth" ceremony, reuniting Hunefer's spirit with his corpse. His widow is shown in mourning, while a priest in a jackal mask, impersonating Anubis, the god of embalming, supports the mummy. The semicursive hieroglyphs above contain the ritual declarations.

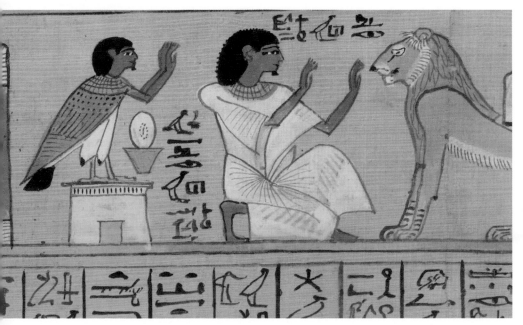

6

▲ **SNAKE BEHEADING** Spell 17 in Hunefer's Book of the Dead includes an illustration of a cat killing a snake. This image comes at the end of a band that runs along the top of the sheet, which also features Hunefer worshipping five seated deities. These are named in the black cursive hieroglyphic captions.

I Ching

C.1050 BCE (WRITTEN) ▪ ORIGINAL MATERIAL AND DIMENSIONS UNKNOWN ▪ CHINA

AUTHOR UNKNOWN

The oldest of the Chinese classic texts, the *I Ching*, or *Book of Changes,* was originally used as a divination guide to help followers interpret the casting of yarrow stems or coins as a means to understand life, make decisions, and predict events. Its origins are obscure, but it evolved over 3,000 years during which "commentaries" were written incorporating Taoist, Confucian, and Buddhist beliefs, such as the seventeenth-century example shown on the far right.

The main body of the *I Ching* is divided into 64 sections, each one corresponding to a named and numbered symbol called a "hexagram." Each hexagram is made up of six horizontal lines, with a broken line denoting yin and a solid one meaning yang. The order in which the stems or coins are cast determines which hexagram is referred to, for which the *I Ching* provides explanatory text, sometimes cryptic, or a "judgment," to interpret its meaning.

Although no parts of the original *I Ching* exist, its ideas are still used by millions of people worldwide to answer fundamental questions about human existence.

IN **CONTEXT**

The *I Ching* developed from the ancient Chinese belief that the world is the product of duality: of yin (negative/dark) and yang (positive/light), and that neither element can exist without the other. Central to the *I Ching*'s purpose as an oracle is the idea that every conceivable situation in human life is the result of yin-yang interplay, and can be encapsulated within and interpreted by its hexagrams.

The earliest known Chinese symbols for yin and yang, along with basic hexagrams, are found in inscriptions made on "oracle bones," the skeletal remains of turtles and oxen used in shamanistic divination practices during the Shang dynasty (1600-1046 BCE). The use of oracle bones in fortune telling declined when the *I Ching* gained popularity during the Zhou dynasty (1046-256 BCE).

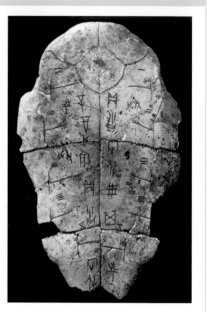

▲ **This turtle shell "oracle"** dates from c.1200 BCE. Fortune tellers burned a shell or bone until it cracked, read the resulting lines, and sometimes carved an "answer."

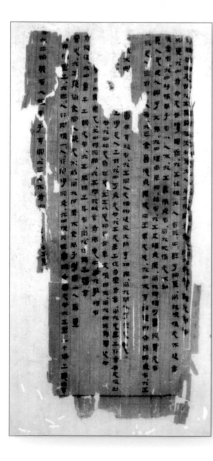

◄ **CONFUCIAN COMMENTARY** Unearthed in 1973 from Han Tomb 3 at the Mawangdui archaeological site, this fragmented length of silk is a Confucian commentary on the *I Ching*'s 64 hexagrams. Dating from early in the reign of Wendi (180-157 BCE), the fourth Han emperor, it is one of the detailed texts and essays made by Confucian scholars following the death of Confucius (551-479 BCE), the great Chinese philosopher (see p.50). Confucius studied the *I Ching* extensively, and viewed it as a manual by which to live in order to attain the highest level of virtue, rather than as a means of divination. The commentaries Confucius wrote were more detailed and extensive than any other at the time.

▲ **COMMENTARIES** In 136 BCE the format of the *I Ching* was standardized, and remains unchanged today. The first part of the work, the hexagrams and their interpretation, are appended by the Ten Wings, or commentaries, as seen on this edition printed during the Southern Song dynasty (1127-1279).

▲ **MING DYNASTY EDITION** Toward the end of the Ming dynasty (1368–1644), printed copies of the *I Ching* were becoming scarce. This edition was published in 1615 by Wu Jishi and features a claim on the title page to be a faithful representation of the original.

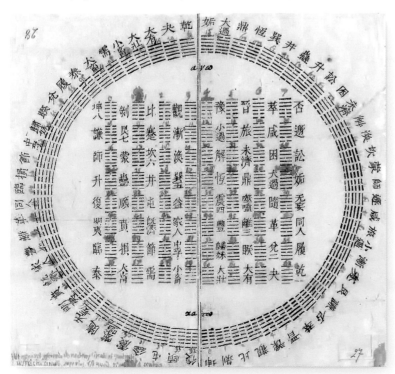

> If some years were added to my life I would devote fifty of them to the study of the Book of Changes and might then avoid committing great errors. **"**

CONFUCIUS, *ANALECTS VII*

◄ **CULTURAL TRANSFER** The *I Ching* was known about in the West in the 1600s, although it was only first studied in detail in 1701 by German mathematician and philosopher Gottfried Wilhelm Leibniz. These pages here show his own handwritten notes on the chart of hexagrams.

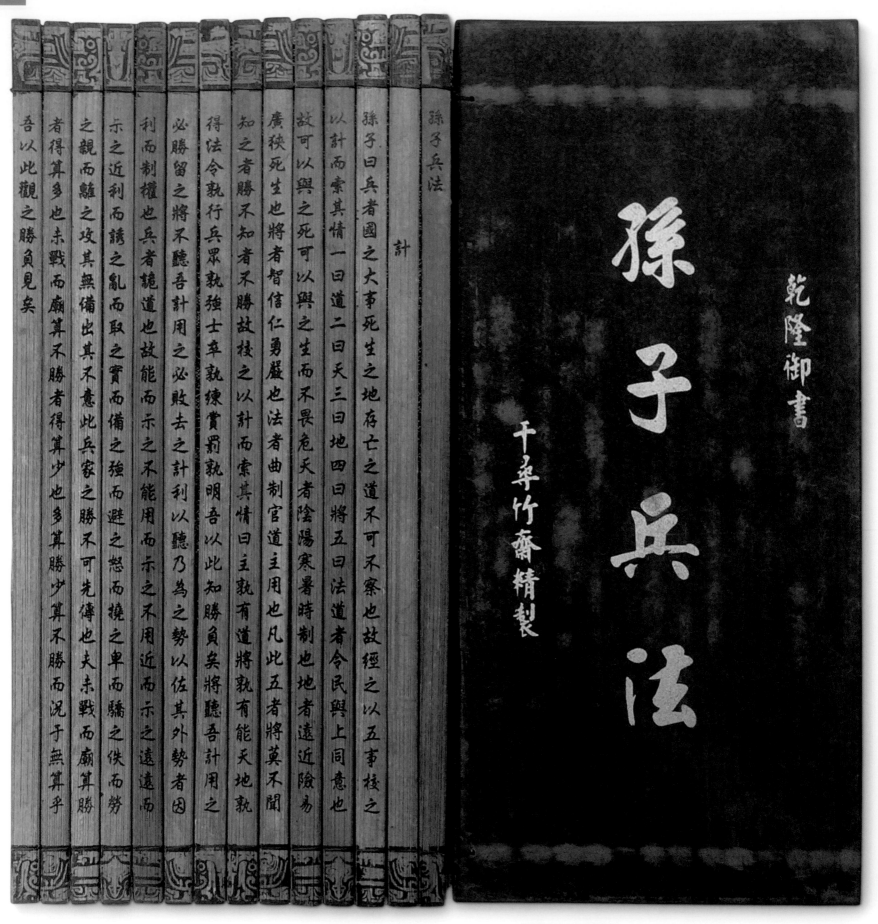

孫子兵法

乾隆御書

千尋竹齋精製

▲ **NATURAL MATERIAL** In China about 2,000 years ago, a variety of materials were written on: shells, bones, occasionally silk, and, more commonly, readily available bamboo slips. Bamboo was cut and then its surface shaved and cured, before being dried and split into strips or "slips," as seen here, which were bound together to form what was, in effect, a book.

The Art of War

C.500 BCE (WRITTEN), C.1750 CE (VERSION SHOWN) ■ BAMBOO ■ 6,000 WORDS, 13 CHAPTERS ■ CHINA

SUN TZU

Whatever the uncertainties of its dating and authorship, *The Art of War* has proved one of the most enduring and influential texts from the ancient world. This military manual is divided into 13 chapters, shown here written on bound bamboo slips–typical of Chinese writings of the time. The book comprehensively covers every aspect of training, organizing, and leading armies. Given the endless conflicts of the times in which the text was written, the Spring and Autumn period (770–476 BCE), its practical application was clear. But it is a mark of its exceptional longevity that when, 1,500 years later, Emperor Shenzong (1048–1085) decreed the creation of the *Seven Military Classics*, a collection of military textbooks, the first work to be cited was *The Art of War*. As such, it was required reading for all officers in the Imperial Chinese Army. Even today, 2,500 years later, it is widely read by military leaders across the world, inspiring those as diverse as Napoleon and Mao Tse-tung. Perhaps more strikingly still, it has also found a ready audience among business leaders.

The Art of War is a supremely practical work. Its prime concerns are preparedness, discipline, strong leadership, and the absolute importance of dictating the terms of battle, rather than responding to those of the enemy.

SUN **TZU**

544–496 BCE

The Art of War is said to have been the work of Sun Tzu, a highly successful military leader during a time of great conflict in China. But his authorship of the influential text is often questioned.

That Sun Tzu was a Chinese general and military strategist is widely agreed. But whether he was the sole author of *The Art of War*, or whether the work was a distillation of existing Chinese military theories brought together under his name remains uncertain. Similarly, there are arguments that the book may have been compiled in the later Warring States period (475–221 BCE). The uncertainty and intrigue surrounding the book's origins only add to its appeal.

In detail

▲ **BAMBOO SLIPS** With only one line of text per slip, the medium of bamboo books encouraged simple, pithy statements. A fine brush rather than a pen was used to paint the intricate ink characters onto the slips.

▲ **BOOK BINDING** The slips were bound together with silk cord or lengths of leather, which meant that they could be rolled up and transported easily. They also proved remarkably durable–much more so than European works on parchment from the same period.

IN **CONTEXT**

The oldest surviving copy of *The Art of War* was one of several works discovered in 1972 in two tombs, dating from the Han dynasty (202 BCE–9 CE). They were unearthed by workmen at the foot of the Yinqueshan, or Silver Sparrow, mountain in Shandong, eastern China, and this location gave the works their name: the Yinqueshan Han Slips. Among the 4,942 bamboo slips found was a copy of a later military manual *Art of War*, by Sun Bin, who is presumed to be a descendant of Sun Tzu. Both texts are believed to have been buried between 140 and 134 BCE. Their discovery was one of the most significant Chinese archeological finds of the twentieth century.

▲ **These bamboo slips** dating from the second century BCE are the oldest copy of *The Art of War*.

> Appear **weak** when you are **strong,** and **strong** when you are **weak.**

SUN TZU, *THE ART OF WAR*

Mahābhārata

400 BCE (WRITTEN), C.1670 (VERSION SHOWN) ▪ PAPER ▪ 7 × 16 in (18 × 41.7 cm) (SHOWN) ▪ INDIA

SCALE

VYĀSA

Said to have been dictated by the sage Vyāsa in a cave in Uttarakhand, northern India, the *Mahābhārata* is the longest epic poem ever created, comprising over 100,000 couplets. According to the text, this epic was extended from a 24,000-couplet version called *Bhārata*. The oldest text fragments date back to 400 BCE, but there is no definitive original written version, and many regional variations have developed over time. The piece of the *Mahābhārata* shown here dates from 1670, and is written in Devanāgarī script–characterized by the horizontal line that runs along the top of the letters.

At its heart is a tale of the struggle between two sets of cousins: the Kauravas and Pandavas. The Pandavas are the five sons of the deceased King Pandu, and by a trick of fate each of them marry the beautiful Princess Draupadi. After a game of dice, the brothers are forced into exile for 12 years and if found by the Kauravas will be forced into exile again. The story culminates in a cataclysmic battle, after which the Pandavas regain their kingdom.

The *Mahābhārata* is a fascinating source on the evolution of Hinduism. Its central story is just one of many folk tales, histories, and philosophical and moral debates within it. The *Mahābhārata* also includes the 700-verse Hindu scripture *Bhagavad Gita*, which presents the concept of *dharma* (or moral law), the bedrock of Hinduism.

VYĀSA

C.1500 BCE

According to Hindu tradition Vyāsa is the legendary Indian sage, said to be the author of the *Mahābhārata*, as well as one of the compilers of the Vedas.

Legend has it that Vyāsa lived around 1500 BCE in Uttarakhand, northern India, and was the son of the Princess Satyavati and the scholar Parashara. His father had been promised by the God Vishnu that his son would be famous in return for the severe penance Parashara had done for Vishnu. Vyāsa grew up in the forests, living by the river Satyavati with hermits who taught him the ancient sacred texts of the Vedas that he developed to create the *Mahābhārata*. Tradition states that he composed his epic over two and a half years, dictating it in a cave to his scribe Ganesha, the elephant god, although the poem is more likely to have been the result of an oral tradition.

▲ **THE FINAL BATTLE** This is a section from a version of the *Mahābhārata*, dating from around 1670. Originating from Mysore or Tanjore in southern India, the text is written in black-and-red ink on paper, and the illustrations are painted with opaque watercolor and gold leaf. The text is taken from the tale of the struggle between the Pandavas and the Kauravas. The central scene depicts the mighty battle between coarse-featured Ghatotkacha (upper right, identified by a label in the margin above) and Karna, the best fighter on the Kaurava side. Karna suceeds in killing Ghatotkacha with a magic weapon given to him by the God Indra.

Whatever is here, is found elsewhere. But what is not here, is nowhere else.

THE BOOK OF THE BEGINNING

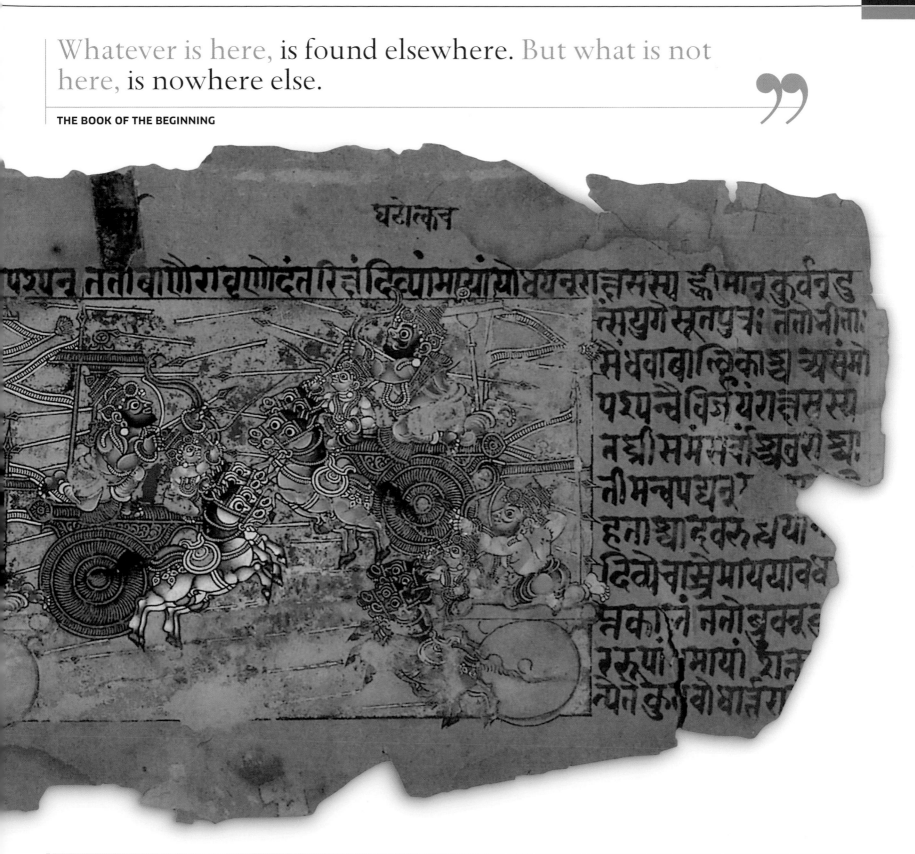

IN **CONTEXT**

The earliest versions of the *Mahābhārata* were written on manuscripts made from dried palm leaves. One of the oldest writing materials, palm leaves were first used in southern Asia. The scribe cut letters into the leaf with a needle, then filled the marks with a soot and oil mixture.

▶ **These nineteenth-century palm-leaf manuscripts** are from Bali. The *Mahābhārata* stories were recounted across Southeast Asia and are found in many forms, from scrolls to paintings and temple decorations.

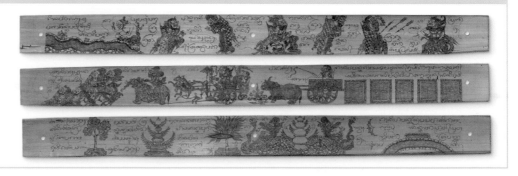

Dead Sea Scrolls

250 BCE–68 CE ▪ VELLUM, PAPYRUS, LEATHER, AND COPPER ▪ VARIOUS SIZES ▪ 981 SCROLLS ▪ ISRAEL

VARIOUS AUTHORS

For more than 18 centuries, a collection of scrolls lay hidden in caves near the ancient settlement site of Qumran, on the northwestern shore of the Dead Sea in Israel. Known as the Dead Sea Scrolls, they are the oldest copies of Jewish texts in existence and have shed light upon Jewish and Christian understandings of the Bible. Their chance discovery in 1947, by a Bedouin boy searching for a lost goat, sparked one of the most exciting archaeological hunts of the twentieth century. In total, 11 caves containing pots with scrolls inside them were discovered and 981 scrolls collected, together with other artifacts, such as coins and inkwells. Only a few complete scrolls were found, but some 25,000 fragments were also unearthed. The majority of the Dead Sea Scrolls are made of animal skin, but others are made of papyrus or leather, and one of copper. While most of the scrolls have Hebrew text, some have text in Aramaic and Greek.

It is not known why the scrolls were hidden or by whom. One theory is that it might have been an act of protection against the Roman occupation of Jerusalem, and the people's property, around 60 CE. Today, the collection is housed in a specially built museum, the Shrine of the Book, on the grounds of the Israel Museum in Jerusalem.

Temple Scroll

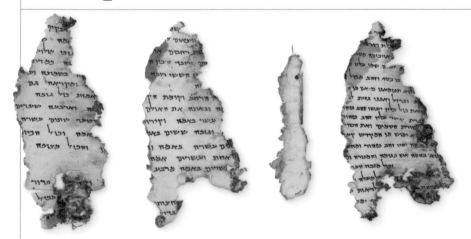

▲ **SCROLL FRAGMENTS** While the main part of the Temple Scroll is the most complete, there are many fragments like these from one end of the scroll. The Hebrew script—which reads from right to left in neat lines—is remarkably clear right up to the damaged edges and so in spite of the damage, scholars have been able to translate the text. The content corresponds closely to the biblical Books of Exodus and Deuteronomy.

▲ **INNER PORTION** Measuring around 25 ft (8.15 m) this scroll, the longest of the Dead Sea Scrolls, was found in Cave 11 in 1956. It is made from 18 pieces of the thinnest vellum found in the caves, and the inner portion is its best-preserved section as it was not as exposed to the elements as the outer sheet was. The Hebrew text is written in the square Herodian script of the late Second Temple Period. As with many Hebrew texts written in this period—and all of the Dead Sea Scrolls—the scroll is read from right to left. This scroll takes its name from the text, which is written in the form of a revelation from God to Moses, and describes the building of a temple similar to those built in the Israelites' camps on their exodus from Egypt. It suggests that Solomon should have followed these guidelines when he built the Temple in Jerusalem.

> ... I was privileged by destiny to gaze upon a Hebrew Scroll which had not been read for more than 2,000 years. "

PROFESSOR ELIEZER LIPA SUKENIK OF HEBREW UNIVERSITY, IN HIS DIARY ENTRY, 1940s

◄ **DAMAGED SHEETS** The three columns shown (columns 42, 43, and 44, from left to right) are from the central section of the scroll. The torn edges are a result of the way the scrolls were rolled tightly in the storage jars (*see image, top left*), and also due to careless handling since their discovery. However, with modern imaging techniques, experts have been able to decipher the writing even on damaged fragments.

The Great Isaiah Scroll

▲ **LAST SECTION** One of the first scrolls found in 1947, this scroll, which features all six chapters of the Book of Isaiah, is the only complete book from the Bible found among the scrolls. It is the best preserved of all the biblical scrolls, and this last section shows the edges of the sheets are only very slightly damaged. Dating from the second century BCE, it is the oldest Old Testament manuscript known by more than 1,000 years.

Habakkuk commentary

◄ **HABAKKUK COMMENTARY, OR HEBREW PESHER** This text, written in the first century BCE, is written on two pieces of leather sewn together with linen thread. It tells how the prophet Habakkuk sees Israel facing danger from a foreign enemy, just as the writer of the scroll sees danger from the Romans. This commentary is considered a crucial source of information regarding the people of Qumran's spiritual life.

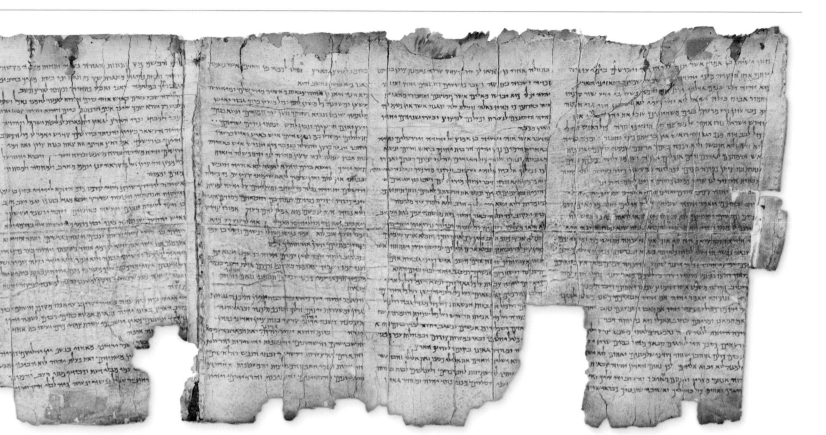

▲ **FIRST SECTION** The Great Isaiah Scroll features 54 columns of text, and the first four are shown above (text was read from right to left). The scroll is written in Hebrew on 17 pieces of parchment (either goat or calf). The black ink used was made from soot from oil lamps, which was mixed into honey, oil, vinegar, and water. As can be seen here, no punctuation was used.

The War Scroll

▲ **THE WAR SCROLL** In contrast to the other scrolls found in 1947, this scroll is a manual for war and military strategy, including some fictional aspects, which is believed to combine the work of many authorities. It contains a prophecy of an apocalyptic war between the "Sons of Light" and the "Sons of Darkness."

IN **CONTEXT**

The first seven of the Dead Sea Scrolls were discovered in 1947, when local Bedouin shepherd Edh-Dhib happened to throw a stone into one of the caves, only to hear something smash—one of the clay pots containing the scrolls. Despite being told that the scrolls were worthless, Edh-Dhib took them to an antiques dealer, and they quickly came to the attention of American scholar John Trever. Two years later, a full-scale archaeological expedition was launched. In 1953 they found a copper scroll, which seemed to be a treasure map. By 1956 11 caves had been excavated and hundreds of scrolls and manuscripts unearthed. In February 2017 another cave was discovered, but while objects of interest have been found, it has yet to yield any manuscripts or scrolls.

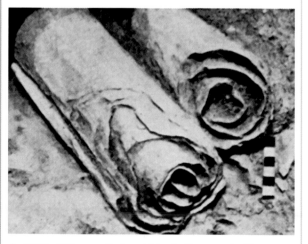

▲ **Many of the scrolls** found lying in the caves had been damaged, some so badly that it has not been possible for archaeologists to identify or translate them.

Vienna Dioscorides

C.512 CE ▪ VELLUM ▪ 14 × 12 in (37 × 30 cm) ▪ 982 FOLIOS ▪ BYZANTINE EMPIRE

PEDANIUS DIOSCORIDES

Also known as the *Juliana Anicia Codex*, the *Vienna Dioscorides*, is the oldest surviving copy of Pedanius Dioscorides' classic work on herbal remedies, *De Materia Medica* (*On Medical Matters*). One of the most important medical works of the Greco-Roman world, the original text was written in about 70 CE by Pedanius Dioscorides. It exhaustively lists the medical properties of 383 herbs and 200 plants.

The *Vienna Dioscorides* is a copy of *De Materia Medica*, produced about 450 years later in Constantinople–then the capital of the Eastern Roman Empire. The work was dedicated to Princess Juliana Anicia, daughter of the Emperor Flavius Anicius Olybrius and a patron of the early Church and healing. In 1569 the Holy Roman Emperor Maximilian II purchased the manuscript for his Imperial Library in Vienna, from where the book takes its name.

The combination of detailed information and visual richness in this codex (an ancient, handwritten text in book form) is unrivaled in early Byzantine art. It is not known if Dioscorides' original manuscript was similarly illustrated, but the *Vienna* copy contains over 479 sumptuous images of plants. Whether these were drawn from nature or from existing depictions is also unclear. The book contains three further works besides Dioscorides' herbal remedies: a medical treatise believed to have been written by the first-century CE Greek physician Rufus of Ephesus; a simplified version of a second-century Greek treatise dealing with snakebites, thought to have been written by Nicander of Colophon; and an illustrated treatise on birds.

PEDANIUS **DIOSCORIDES**

C.40–C.90 CE

Pedanius Dioscorides was a Greek physician, pharmacist, and botanist, whose seminal work *De Materia Medica*, or the *Juliana Anicia Codex*, remains the single most important source of knowledge about Ancient Greek and Roman medical practices.

Dioscorides was born in Anazarbus, Cilicia, although few details of his life are known. He is believed to have practiced medicine in Rome during the reign of Emperor Nero (37–68 CE) before serving as a surgeon with the Roman armies. At this time he traveled widely across the Roman Empire, and was able to study the medicinal properties of many plants and minerals, which he used in the compilation of his major text, *De Materia Medica*. Dioscorides is believed to have taken 20 years to produce this text in which he divided plants according to their medicinal and botanical properties. Originally written in Greek, it was later translated into Latin. The work is a remarkable record of natural history and the enduring influence of ancient learning.

▼ **LIFELIKE ILLUSTRATIONS** Naturalistic images of the plants were intended to help the pharmacist easily identify herbs when making remedies. Full-page images were generally accompanied by descriptions of their properties on the facing page. The illustration here, from folio 174, is typical, with both root and plant shown. The Greek text is written in "uncial" characters (capital letters) which developed, in both Latin and Greek, in the third century.

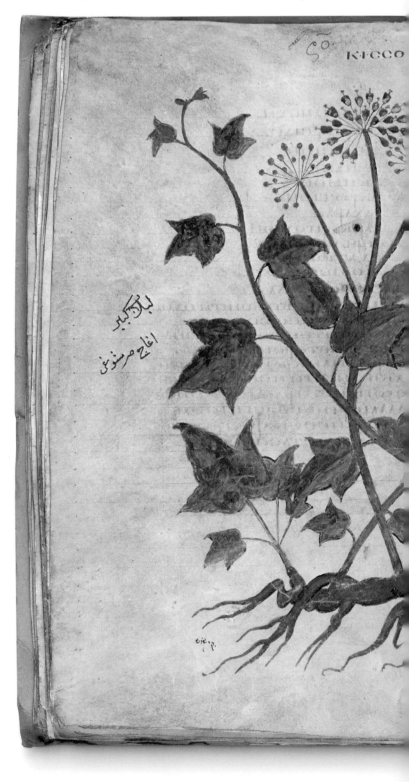

> For almost two millennia Dioscorides was regarded as the ultimate authority on plants and medicine …
>
> **TESS ANNE OSBALDESTON**, ON *DE MATERIA MEDICA*, 2000

▲ **TITLE PAGE** The codex's inscription describes the work's scope of "plants, roots, seeds, juice, leaves and remedies," and explains its alphabetical ordering.

◄ **PORTRAIT OF THE PATRON** The codex features the oldest painting of a patron with its image of Princess Juliana Anicia. She is flanked by the allegorical figures Magnanimity (left) and Wisdom (right). A putto (cherub) offers her the manuscript.

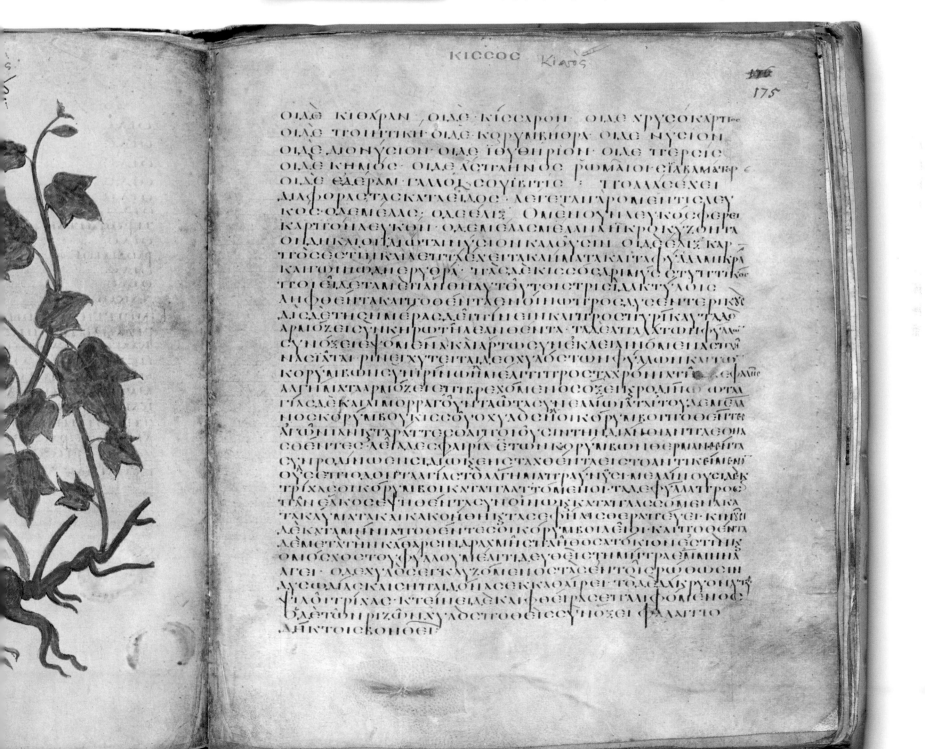

In detail

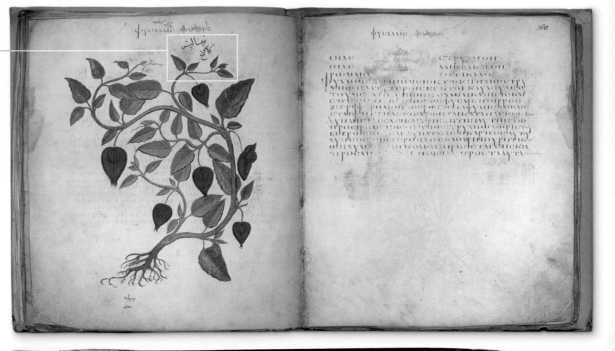

▲ WIDE INFLUENCE Following the fall of Byzantium to the Ottomans in 1453, Arabic plant names were added to the manuscript. The *Vienna Dioscorides* impacted as deeply on Arab learning as it did on later European learning.

▶ SUGGESTED REMEDIES In the text facing this picture of a winter cherry, Dioscorides recommends the plant's stem as a sedative. Mixed with honey, it was claimed to improve vision; and with wine, to ease toothaches.

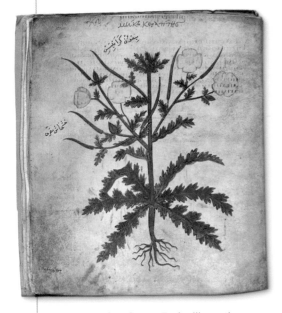

▲ DRAWING FROM LIFE The illustrations in the *Vienna Discorides* were the product of exact observation, as shown in this depiction of a yellow horned poppy. Later Byzantine art would become progressively more religious and restrained by imperial priorities, projecting ever more elaborate visions of grandeur.

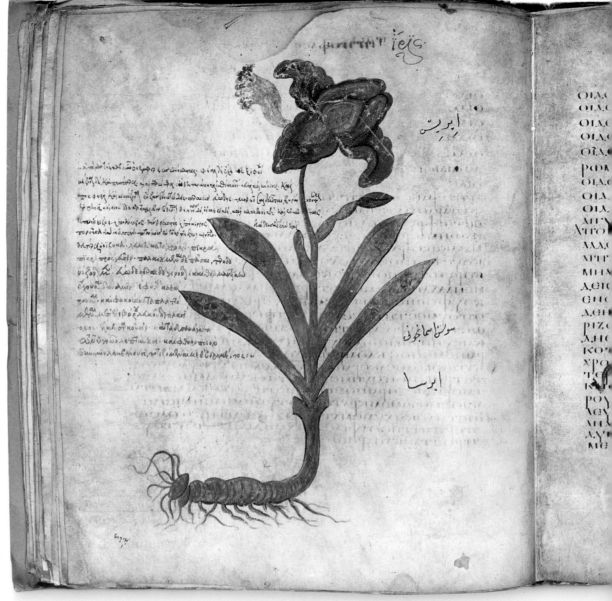

▶ TIP TO ROOT Dioscorides examined every part of the plant. Roots, leaves, flowers, and berries were all included in the drawings so that pharmacists could see all the relevant parts that could be used as ingredients. On this page, the artist decorated the vellum before the scribe added the text.

► **TREATISE ON BIRDS** Forty Mediterranean birds were described and illustrated with delicately painted line drawings. The inclusion of this work, thought to be by Dionysius (first century CE), makes the *Vienna Dioscorides* the oldest known illustrated treatise on birds.

IN **CONTEXT**

De Materia Medica collated the wisdom and practice of generations. As late as the 1930s, an aging Greek monk was observed treating patients according to the remedies laid down by Dioscorides. In fact, for at least 1,500 years after his death, Dioscorides' *De Materia Medica* remained the standard pharmacological work across the West and the Arab world, translated into Arabic and Persian, as well as–in the Middle Ages and the Renaissance–Italian, French, German, and English.

▲ **Swedish botanist Carl Linneaus** was deeply influenced by Dioscorides, and, in his 1749 *Materia Medica*, made the novel division of plants into genus and species, producing the first modern classification of plants. The frontispiece shows a cabinet with plants and herbs.

Book of Kells

C.800 CE ▪ VELLUM ▪ 13 × 10 in (33 × 25.5 cm) ▪ 680 FOLIOS ▪ IRELAND

SCALE

IRISH COLUMBAN MONKS

Dating from around 800 CE the *Book of Kells* is the finest surviving illuminated manuscript from the Celtic medieval period, boasting a design of unsurpassed complexity and extravagance. The sumptuously illustrated text consists primarily of the four Gospels in Latin, based on St. Jerome's fourth-century translation of the Bible. Believed to be the work of three artists and four scribes, it is written in the formal script known as Insular majuscule on vellum (prepared calfskin). Today the manuscript contains 680 folios–around 30 others have been lost over time. With its full-page illustrations, abstract decoration, and colored lettering, it is the most lavishly decorated example of an Insular manuscript–a decorated manuscript produced in the British Isles between the sixth and ninth centuries. The transcription, however, was particularly careless, with letters and entire words missing or repeated, indicating that the book was intended for ceremonial use rather than for daily services.

Also known as the *Book of Columba*, the manuscript was composed by Irish monks, followers of the sixth-century Irish saint, St. Columba. Their order had fled from their abbey on the Scottish island of Iona during Viking raids in the ninth century and taken refuge in the monastery at Kells, north of Dublin. The manuscript may have been produced either wholly in Iona or in Kells, or started in Iona and completed in Kells. A medieval source states that it was stolen in 1006 for its *cumdach*–the ornamental box in which it was stored. Although this was never recovered, most folios of the manuscript were. The current binding by British book-binder, Roger Powell, dates from 1953. Powell divided the manuscript into four volumes to preserve it while on display in the Old Library at Trinity College, Dublin, where it has been kept since the seventeenth century. It remains a central symbol of Irish culture and identity.

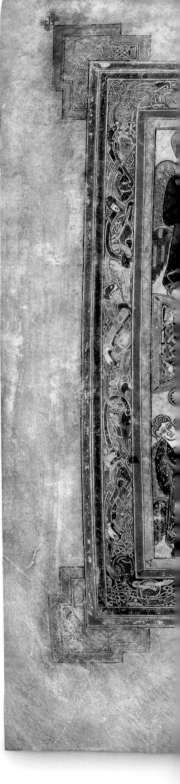

ON **TECHNIQUE**

At least 185 calfskins were used in the production of the *Book of Kells*. The word vellum (prepared calfskin) on which the book was written comes from *vitulum*, the Latin for "calf." All other animal skins are called parchment. Each skin was soaked in lime, dried, and scraped smooth with pumice before being cut into folios. From the Latin for "leaf" (*folium*), a folio is a two-sided page, with "recto" defining the front side, and "verso" the reverse. Before the scribe began to write the page was scored with pinpricks, and horizontal lines were drawn with a blade to guide the scribe. Quills, made from feathers, were trimmed and cut diagonally to form a nib. Ink was made from soot or iron gall mixed with gum arabic, and seven pigments, derived from a wide range of sources, were used for the illustrations in the manuscript.

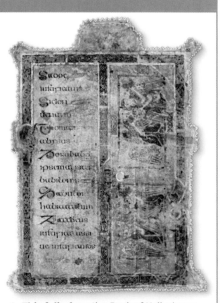

▲ **This folio** from the *Book of Kells* shows the use of red (from lead) and green (from copper sulfide) pigments.

➤ **FACING PAGES** The *Book of Kells* exhibits the oldest existing depiction of the Virgin Mary in a Western manuscript. Wearing Byzantine robes, she sits on a throne with the young Jesus on her lap. The surrounding angels hold stylized fans, possibly inspired by Egyptian Coptic art. Notable features are the unusual representation of the Virgin's breasts, her apparently two right feet, and Jesus's elaborate blond hair. The page is an appropriate accompaniment to the *Breves causae* of Matthew (the summary of the Gospel) that begins on the opposite page. This is the most elaborately decorated page of text in the manuscript, starting with an elegant, elongated letter "N." The Latin reads: "*Nativitas XPI in Bethlem Judeae Magi munera offerunt et infantes interficiuntur Regressio*" ("The birth of Christ in Bethlehem of Judea; the wise men present gifts; the slaying of the children; the return").

> It is widely regarded as Ireland's greatest historical treasure … one of the most spectacular examples of medieval Christian art in the world.
>
> **UNESCO'S MEMORY OF THE WORLD REGISTER**

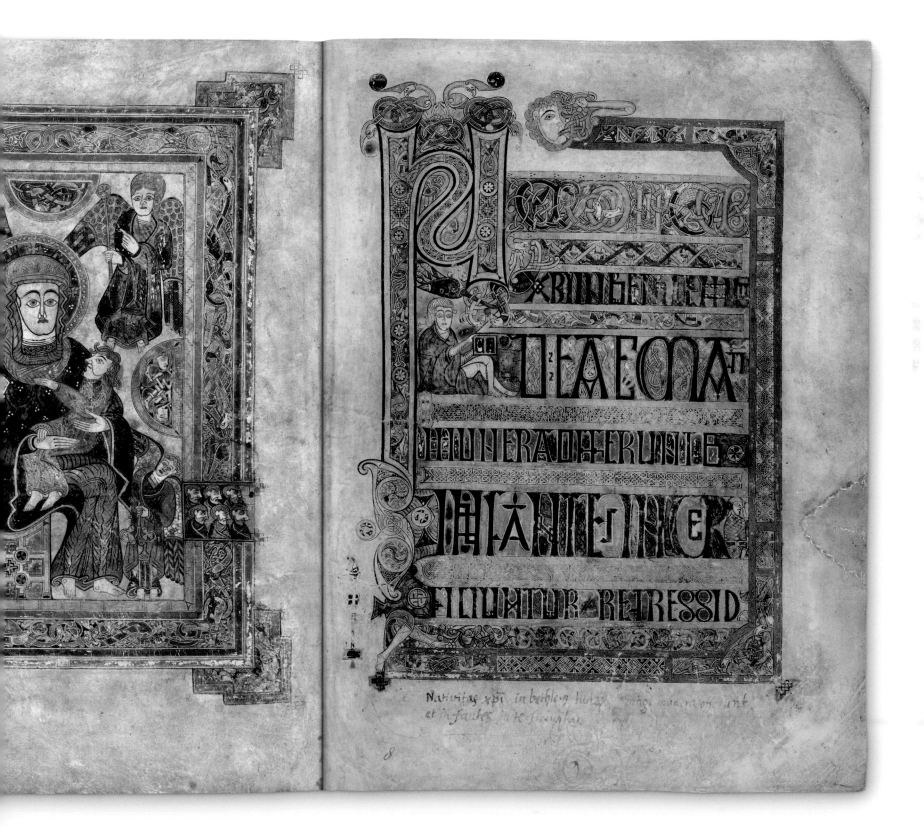

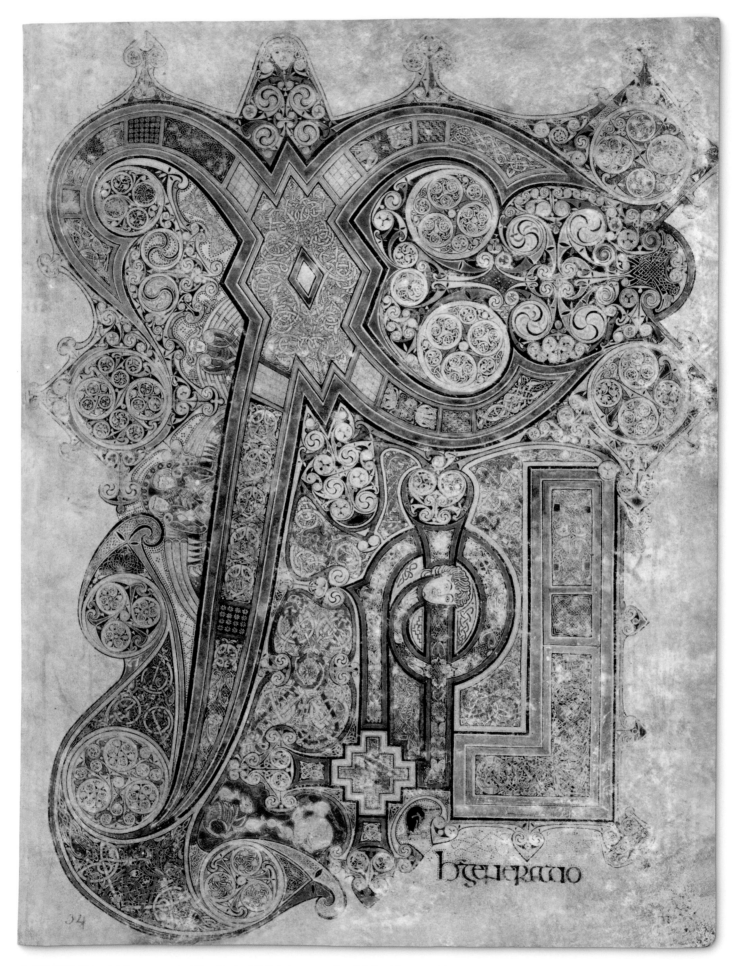

▲ **CHI RHO** The most famous page of the *Book of Kells* is known as the Chi Rho. These are the first two letters of the word "Christ" in Ancient Greek–*Chi* is written as "X" and *Rho* is written as "P." Heavily stylized, they are the focus of this page, which illuminates the Gospel of St. Matthew, relating Christ's birth. The page also features the letter "I," for *Iota*, the third letter in the word Christ, and the word *generatio*. This is the opening of the verse that reads, "This is how Christ came to be born."

Visual tour

KEY

▼ **HIDDEN IMAGES** The Chi Rho page is renowned for its concealed illustrations of animals and people. Here, a blond man's head set on its side finishes the elaborate curve of the *Rho*, resembling the letter "P," while a third Greek letter, *Iota*, an "I," passes through its center. It is thought by some academics that the head represents Christ.

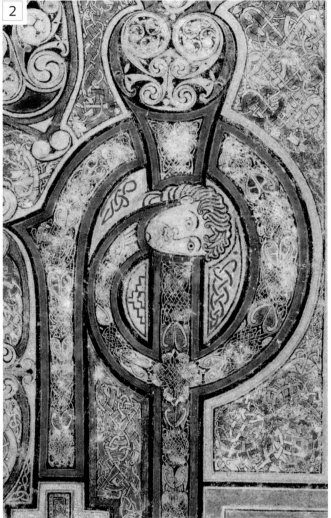

▼ **INTRICATE DESIGN** Squeezed between the right-hand curls of the letter Chi, or "X," is this exquisite swirling motif. The artist's work shows such extraordinary detailing and delicacy that it has been compared to that of a goldsmith.

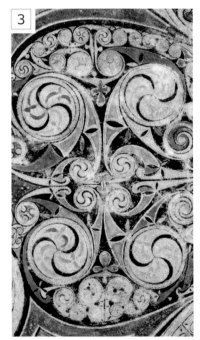

▲ **HEAVENLY ANGELS** Angels, drawn as male figures with wings and blond hair, appear to rise out of one of the cross arms of the Chi, or letter "X." Positioned just above, but not seen here, is a third angel. These divine messengers of God were sent to spread the word of the birth of Christ—the word "angel" comes from the Greek *angelos*, meaning "messenger."

➤ **ANIMAL MOTIFS** Toward the bottom of the page, two cats appear to be watching a pair of large mice holding a white disc in their mouths. The disc may represent a Holy Communion wafer but its precise symbolic significance, and that of the creatures, has been lost over the centuries.

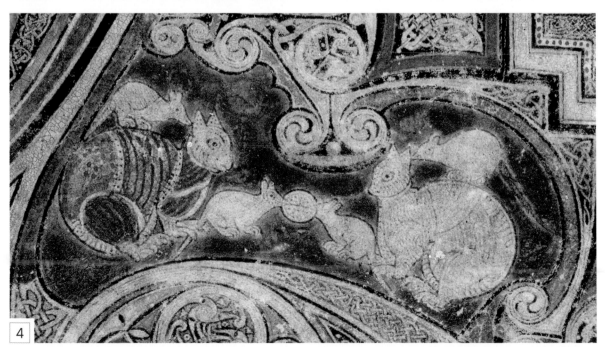

In detail

▼ **GROUP EFFORT** The *Book of Kells* is thought to have been the combined work of three monks writing the Latin text, and four decorating the pages and coloring the initials. It is the first known Irish manuscript in which every single opening letter is illustrated, and the first medieval manuscript with spaces between the words to make reading easier.

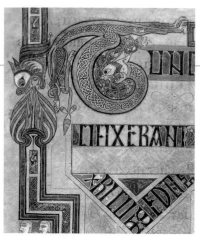

▲ **ILLUSTRATED LETTER** Folio 124r from the Gospel of St. Matthew uses an elaborately illustrated initial letter "T" and a fierce fire-breathing lion to symbolize Christ's crucifixion.

▲ **STYLIZED SCRIPT** This detail from Folio 19v features an ornate letter "Z," followed by *acha*, with the rest of the name *Zachariae* relegated to the next line, prioritizing decoration.

▲ **REPEATED WORDS** Folio 200r illustrates the genealogy of Christ. *Qui* ("Who") is repeated at the start of each line, and illustrations of intertwined serpents link the generations.

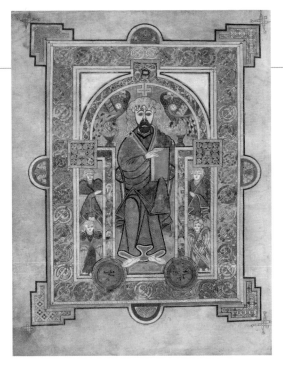

▲ **PORTRAIT PAGE** Among the purely decorative pages are a number of portrait pages. Above, the purple-robed Christ, flanked by four angels, is shown seated and holding a Book of the Gospels in his hands. The two peacocks are symbols of Christ's resurrection.

▶ **CANON TABLES** The eight canon tables at the start of the manuscript are an index to those passages that are shared between the four Gospels. Each table is illustrated. The patterned architectural columns are topped by a half dome enclosing fantastical creatures.

▼ **CARPET PAGE** Even though carpet pages—so named because they resemble oriental rugs—are characteristic of Insular manuscripts, there is only one in the *Book of Kells*. Geometrically precise and highly ornamental, it is dominated by roundels created with a pair of compasses. The circles are filled with over 400 discs and spirals of incredibly detailed workmanship.

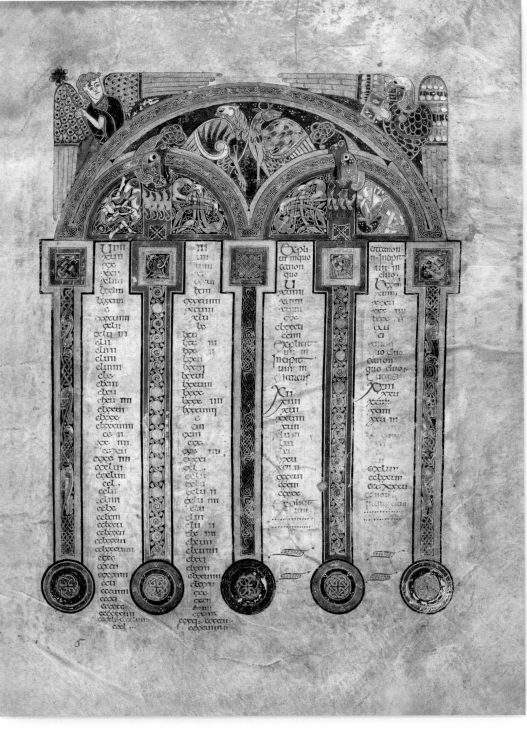

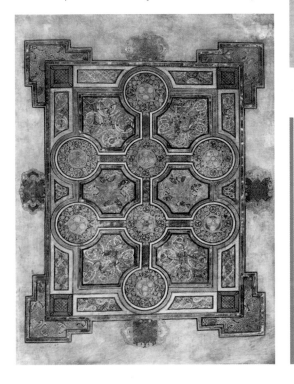

RELATED **TEXTS**

The *Lindisfarne Gospels* is another beautiful example of Insular art, written and decorated in the early eighth century at the abbey of Lindisfarne, an island off the northeast English coast. Although smaller and far less elaborate than the *Book of Kells*, it boasts similar patterns and colors. It also features ornamental carpet pages, like the *Book of Kells* (see left), with one at the beginning of each of the Gospels. The text of the Gospels was translated from Latin into Old English and written between the lines of the manuscript in the tenth century. This makes it the oldest existing translation of the Gospels in the English language.

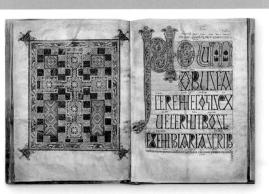

▲ **A cross-carpet page** from the *Lindisfarne Gospels* facing beautifully decorated initials and display capitals.

The Blue Qur'an

C.850–950 CE ▪ GOLD ON DYED VELLUM ▪ C.12 × 16 in (30.4 × 40.2 in) ▪ 600 PAGES ▪ TUNISIA

SCALE

AUTHOR UNKNOWN

The Qur'an is the core Islamic text, which Muslims believe was revealed to Muhammad by God between 609 and 632 CE. This sacred work describes God and humankind's relationship to Him, and gives directives in order for His followers to achieve peace in this life and thereafter—every Muslim is expected to be familiar with its teachings.

Dating from the late ninth to early tenth century, the sumptuous Blue Qur'an is one of the most beautiful copies of the book ever produced, and takes its name from the vivid indigo dye that colors its pages. The visually contrasting gold text is a rare feature in books of this period, although it does follow Islamic tradition, where many religious texts were written in gold or silver on dark surfaces. The scribe who wrote the Blue Qur'an used elongated strokes in order to make the script fill the pages in a manner pleasing to the eye. Clarity has been sacrificed for aesthetics, as there are no diacritical marks (such as accents) above or below letters to indicate vowels, and the calligrapher has also inserted spaces within words simply to make the columns of text align.

Little is known of when, where, and how the Blue Qur'an was produced, although it is speculated that it may have been produced in Baghdad, capital of the Abbasid caliphate, or Cordoba in Spain, capital of the Umayyad caliphate. The most widely accepted theory is that it was commissioned for the Great Mosque in Kairouan, Tunisia. It is possible that the unique coloring may have been used in an attempt to echo the imperial blue or purple used for similarly opulent documents of the contemporary and rival Byzantine empire. Certainly the use of indigo and gold was expensive, suggesting that it was commissioned by a very wealthy patron, possibly the caliph or one of his inner circle. Today, the folios have been divided and are kept in different museums around the world, although most are held at the Bardo National Museum in Tunis.

In detail

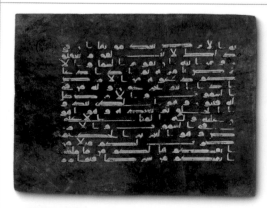

▲ **EVEN LINES** Part of the visual appeal of the pages is due to their 15 lines of equal length. Most contemporary copies contained only three lines per page. To achieve these equal lines, the scribe manipulated letters and omitted important grammatical marks.

▲ **GREATEST TO LEAST** The Qur'an consists of 114 chapters, or *surah*, each consisting of a series of verses, or *ayah*, of varying lengths. Perhaps confusingly, the chapters follow no chronological or thematic structure, but are arranged by length: the longest first, and the shortest last. In the Blue Qur'an, the chapters are separated by silver rosettes, all long since faded as a result of oxidation.

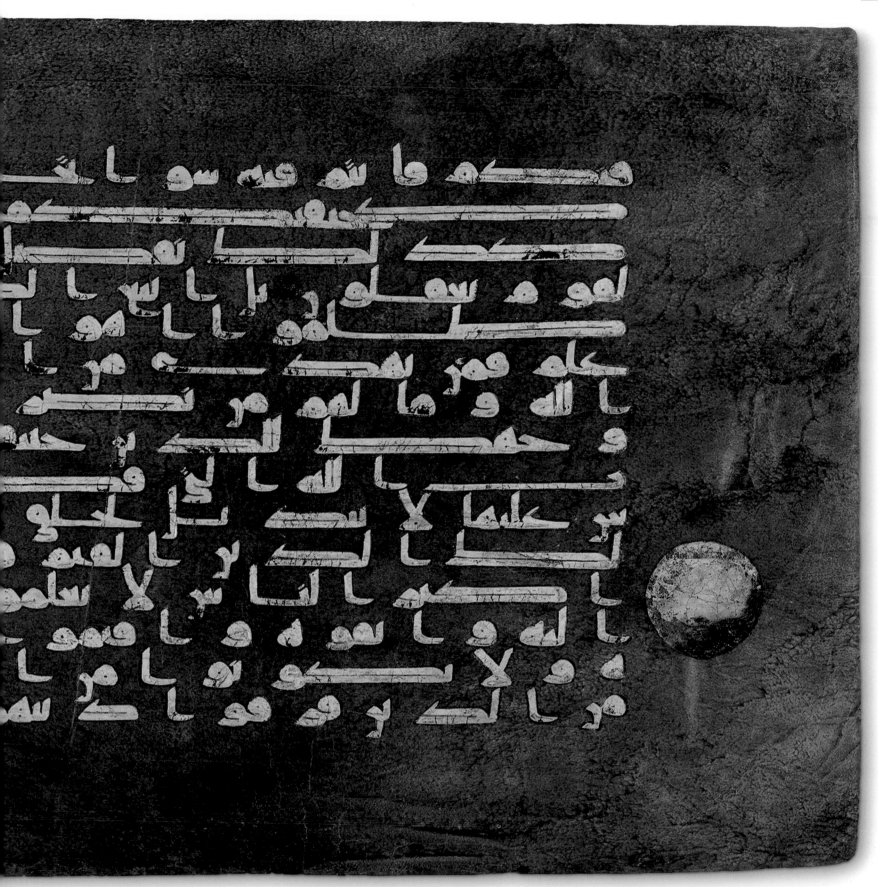

This is the book about
which there is no doubt …

THE QUR'AN, 2:2

▲ **KUFIC SCRIPT** The Blue Qur'an is written in Kufic script. This is the earliest form of Arabic script, named for Kufa in Iraq, where it was developed during the late seventh century. Its horizontal format is typical of tenth–eighth century copies of the Qur'an. As with all Arabic scripts, it is read from right to left.

Diamond Sutra

868 CE ▪ PRINTED ▪ 11 in × 16 ft (27 cm × 5 m) ▪ CHINA

SCALE

AUTHOR UNKNOWN

The *Diamond Sutra* is a key Buddhist text. A "sutra," an Indian Sanskrit word, is the name for the teachings of the founder of Buddhism, Siddhartha Gautama, the Buddha, or "Awakened One," who lived in the sixth century BCE. The title of the sutra is a reference to what the Buddha called "the Diamond of Transcendent Wisdom": the wisdom that can cut through the illusions of wordly concerns to the eternal reality. The text takes the form of a dialogue between an aging disciple, Subhuti, and the Buddha. As with all such Buddhist teachings, it aims to highlight the idea that human existence, like the material world, is illusory.

The added importance of the scroll, now in the British Library, is that it is the oldest complete printed document in the world whose date is exactly known. The scroll was discovered in 1900 by a Chinese Daoist monk, who found it in the Caves of the Thousand Buddhas, a warren of tunnels dug into a cliff outside the Silk Road settlement of Dunhuang, northwest China (see p.51). With it were 60,000 other paintings and documents, all apparently hidden for safe-keeping in around the year 1000 CE. In 1907 the scroll was acquired by a Hungarian-born explorer, Marc Auriel Stein, who sent it to the British Museum.

The *Diamond Sutra* is a precise example of the sophistication of Chinese printing, which developed in the eighth century, and of Chinese paper-making, which developed earlier still, perhaps in the second century BCE. It is also a remarkable testimony to the spread of Buddhism from its Indian heartlands.

▶ **ILLUSTRATION** The opening of the *Diamond Sutra* reveals its only illustration, and the earliest surviving example of a woodcut illustration in a printed book. It shows the Buddha in the center of the scene, clearly a figure of authority, as he dispenses the wisdom of the sutra to the crouching Subhuti at the lower left of the frame. The Buddha's disciples surround him.

◀ **EXACT DATE** At the foot of the scroll is an inscription, or colophon, which reads: "Reverently made for universal free distribution by Wang Jie on behalf of his two parents, 11 May 868." Such precise dating of the time of commission makes this scroll unique.

▼ **LARGE SCALE** Due to the length of the text, it was created in seven sections that were then pasted together. The scroll was designed to be unrolled from a wooden pin, or stave, and to be read, top down, from left to right. Reciting the Sutra was intended to help bring happiness in rebirth.

▲ **EARLY PRINTING** Following the printing methods used in ninth-century Tang China, wood blocks (painstakingly carved from painted originals) were used to print onto a paper dyed with a substance made from the bark of the Amur corktree. Nothing comparable would be produced in Europe for another 600 years until the arrival of Gutenberg's printing press.

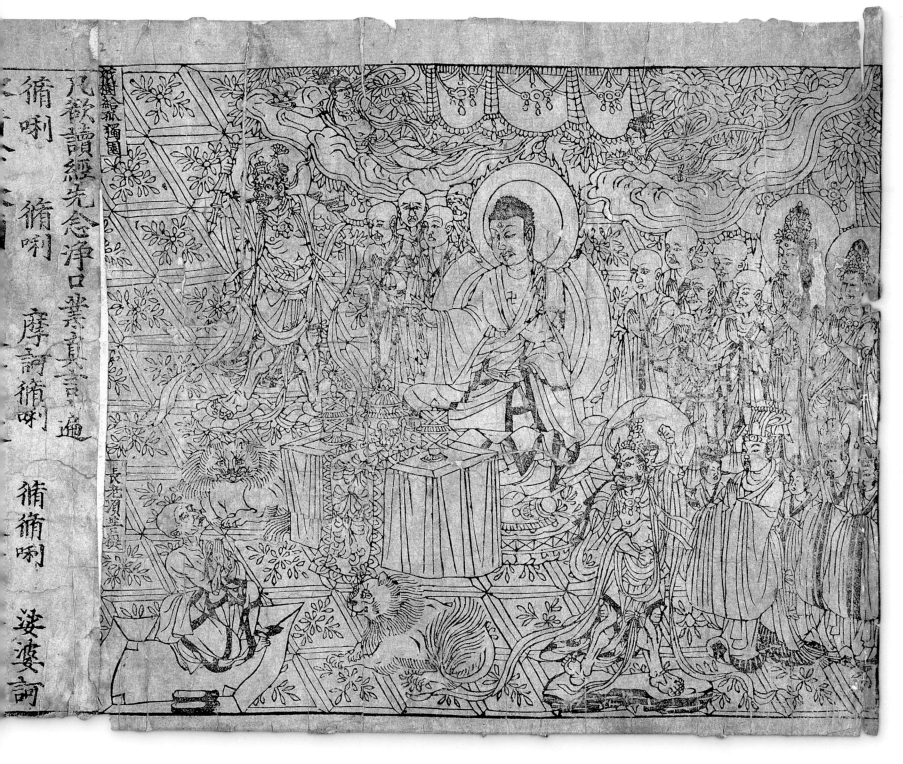

All conditional phenomena are like a dream,
an illusion, a bubble, a shadow.

THE *DIAMOND SUTRA*

The Exeter Book

C.975 CE ■ VELLUM ■ 12 × 9 in (32 × 22 cm) ■ 131 PAGES ■ ENGLAND

AUTHOR UNKNOWN

SCALE

The largest and most varied collection of medieval Anglo-Saxon poetry, *The Exeter Book* is one of only four Anglo-Saxon collections of poetry to survive. Most likely written around the end of the tenth century, it has been described by UNESCO as "the foundation volume of English literature, one of the world's principal cultural artifacts."

The book takes its name from Exeter Cathedral, to whose library Bishop Leofric bequeathed the volume at his death in 1072. It was written in the scriptorium of an English Benedictine monastery and has no single theme, but contains poems and riddles. The poems cover a wide variety of subjects–religion, the natural world, and animals. There are also several "elegies" concerned with themes such as exile, loneliness, fate, the acquisition of wisdom, and loyalty. Famously, the book contains almost 100 riddles, possibly intended to be performed. Some are unclear in their meaning, but a handful are plainly intended as lewd double entendres. Scholars have identified many elements of the book's religious and secular poems as dating from centuries before their written form, some of which may originate in the seventh century CE.

Written on vellum in Old English, the book is testimony to the civilizing influence of the Church, specifically of the oldest monastic order in England, the Benedictines, and to the emerging Anglo-Saxon taste for literature and the power of the written word. As such, it is a glimpse into the Anglo-Saxon culture of post-Roman Britain, and sheds light on the monastic enclosure where it was scribed. As a literary work its impact can be seen in the work of writers, such as J. R. R Tolkien (1892–1973) and W. H. Auden (1907–1973).

▶ **SINGLE SCRIBE** *The Exeter Book* is the work of one scribe. It is penned in a somber brown ink, in what one expert has described as "the noblest of Anglo-Saxon hands." The calligraphy–regular, rhythmic, and rounded–is extraordinarily consistent throughout. While the book contains no illustrations, there are a number of soberly restrained decorated capital letters, as shown here.

In detail

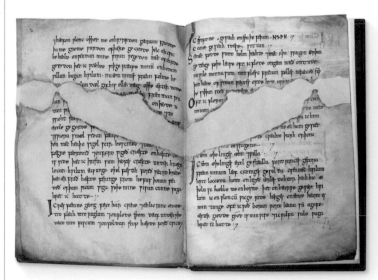

▲ **DAMAGED PAGES** *The Exeter Book* did not always receive the care it deserved. Its first eight pages are missing, while other pages have been damaged. Those shown here, for example, were burned when a firebrand was placed on it. The book has also been marked by spillages of glue and gold leaf, as well as a large gash and a sewn-up tear.

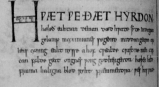

▲ **LATIN ALPHABET** The Old English script uses the Latin alphabet, with a number of letters, such as "G" and "D," written in a form principally found in manuscripts from the British Isles. A large "H" indicates the start of one of the longest poems in the book: an account of St. Juliana of Nicomedia (in modern-day Turkey), an early Christian convert martyred in about 300 CE, having refused to renounce her faith and marry a Roman senator. The poem is characteristic of the medieval world's veneration of early Christian martyrs.

The wonder is that any part of it should have survived.

R. W. CHAMBERS, FRIEND OF J. R. R. TOLKIEN

RELATED **TEXTS**

While *The Exeter Book* contains the largest and most important collection of Anglo-Saxon poetry, the best-known single Anglo-Saxon poem is the 3,000-line epic *Beowulf*. It seems likely that this poem was composed in the eighth century, although it clearly reflects an earlier, possibly sixth-century oral tradition. The single existing original Anglo-Saxon copy seems to have been written in about 1000 CE. This classic story, which tells how the great warrior Beowulf slew the terrible monster Grendel and his equally fearsome mother, accurately reflects the Anglo-Saxons' Germanic origins. It is a compellingly rich picture of honor and heroism poised between a pagan past and a Christian future. Translated into many languages, the story has also been adapted into films, operas, and computer games.

▶ **The sole, fragile copy** of *Beowulf* is held in the British Library. It is the work of two scribes, their handwriting clearly distinguishable. It is unknown where in England the manuscript was originally produced.

Directory: 3000 BCE-999 CE

RIGVEDA

INDIA (C.1500 BCE)

Originally passed down via oral tradition, The *Rigveda* is the oldest of the four ancient Hindu sacred texts, known collectively as the *Vedas*. The *Rigveda* is a collection of hymns dedicated to the Vedic deities. The longest and most important of the *Vedas*, it was probably composed in the northwestern region of the Indian subcontinent, and is written in an ancient form of Sanksrit. It comprises 1,028 hymns and 10,600 verses of varying lengths, which have been divided into 10 books known as *mandalas* (or "circles"). The *Vedas* are the basis of all Hindu sacred writings, and some hymns of the *Rigveda* are still used in Hindu ceremonies today, making it one of the world's oldest religious texts still in current usage.

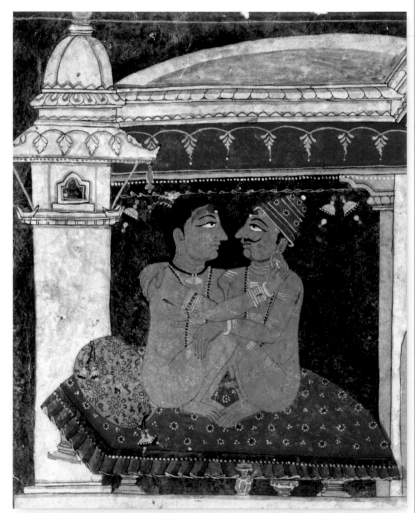

The science of the erotics from a *Kama Sutra* of the Pahari school, Northern India.

THE ILIAD AND THE ODYSSEY
HOMER

GREECE (LATE 8TH-EARLY 7TH CENTURY BCE)

These two ancient Greek epic poems dating from the late eighth to the early seventh century BCE are the oldest known works of Western literature. *The Iliad* is set during the Trojan War, while *The Odyssey* describes Odysseus's journey home following the Fall of Troy. Both poems are attributed to the poet Homer, although some scholars believe they are the work of multiple contributors but ascribed to a single identity: Homer. The poems were written in a dialect known as Homeric Greek, and more copies exist than of any other ancient Western text. The most famous, *Venetus A*, dates to the tenth century and is the oldest complete text of *The Iliad*.

TORAH

ISRAEL (C.LATE 7TH CENTURY BCE)

The most important document of the Jewish faith, the Torah is said to have been dictated by God to Moses while on Mount Sinai. The text on a Torah scroll is taken from the first five books of the Hebrew Bible (the Old Testament) and is handwritten on parchment from a kosher animal. The writing of the scrolls is believed to date to the eighth century BCE but the oldest complete scroll in existence dates to 1155-1225 CE. Parts of the Torah text have also been found on fragments of a Hebrew Bible dating back to the late seventh century BCE.

THE ANALECTS
CONFUCIUS

CHINA (WRITTEN C.475-221 BCE; ADAPTED 206 BCE-220 CE)

This collection of the teachings of the Chinese philosopher Confucius (551-479 BCE) is one of the central texts of Confucianism. Written with brush and ink on strips of bamboo bound together with string, *The Analects* was complied by Confucius's followers after his death. While it is unlikely to be a record of the exact words of Confucius, it is considered to be a representation of his doctrine. *The Analects* is made up of a series of short passages divided into 20 books, and encompasses ethical concepts for the Confucian way of life. During the Song Dynasty (960-1279) *The Analects* was classified as one of the four texts that encapsulate the core beliefs of Confucianism.

THE HISTORIES
HERODOTUS

GREECE (C.440 BCE)

Written by the ancient Greek historian Herodotus (c.484-c.425 BCE), *The Histories* is widely acknowledged to be the earliest existing work of history in the West. It examines the growth of the Persian Empire, the events that lead to the Greco-Persian Wars (499-449 BCE), and the eventual defeat of the Persians. Herodotus also describes the belief systems and spiritual practices of these ancient civilizations. The oldest existing complete manuscript of *The Histories* dates to the tenth century CE, but much older papyri fragments have been found, primarily in Egypt. This text is considered to have established the genre of history writing in Western culture.

TAO TE CHING

CHINA (C.4TH CENTURY BCE)

A classic text of Chinese philosophical literature, the *Tao Te Ching* (or *Dao De Jing*) is the basis for philosophical and religious Taoism. Most scholars attribute it to the Chinese sage and teacher Lao Tzu. However, little is known about him and some argue that he never even existed. The text was originally written in a form of calligraphy known as "zhuanshu," and comprised 81 short, poetic chapters divided into two sections: the *Tao Ching* and the *Te Ching*. Versions of the manuscript have been discovered written on bamboo, silk, and paper. The oldest fragments date to the fourth century BCE, yet some scholars believe the *Tao Te Ching* may have existed as far back as the eighth century BCE. It has been translated into western languages more than 250 times and is considered one of the most profound philosophical texts on the nature of human existence.

THE SYMPOSIUM AND THE REPUBLIC
PLATO

GREECE (C.385-370 BCE)

These are two of the 36 dialogues written by the Classical Greek philosopher Plato (c.428-c.348 BCE). Plato's dialogues were grouped into

early, middle, and late periods, and both of these texts fall into the middle period. It is through his dialogues that Plato gives voice to Socrates, the founding father of Western philosophy and Plato's mentor who was executed for his beliefs. Socrates is given a central role in Plato's philosophical works, and much of what is known about Socrates today comes from these dialogues.

The Symposium is a fundamental philosophical treatise on the nature of love, which it examines through a witty discussion between a group of men at a *symposium* (an ancient Greek "drinking party") with Socrates at the center. This philosophical and literary masterpiece has influenced generations of writers and thinkers, and provides the basis of the concept of "platonic love"–a deep but nonsexual love between two people.

The Republic is by far the most famous and widely read of Plato's dialogues, and is considered to be one of the world's most influential works of philosophy. This dialogue discusses the meaning of justice–asking what it is and considering whether the just or the unjust man is happiest. Again Socrates is the central character. *The Republic* is a key document in the history of Western political philosophy.

◀ KAMA SUTRA
MALLANAGA VĀTSYĀYANA

INDIA (200–400 CE)

This ancient Sanskrit text was compiled by Hindu philosopher and sage Mallanaga Vātsyāyana and is considered the first comprehensive work on human sexuality. It comprises 36 chapters of 1,250 verses, which are then separated into seven parts. The text acts as a guide to good and fulfilled living, the nature of love, and how to create a happy marriage through a combination of physical and emotional love. In Western society, *The Kama Sutra* has come to be a byword for a sex manual, but in reality the original manuscript, written in a complex form of Sanskrit, was a treatise on love in which the 64 sexual positions described form only a part. It was published with an English translation in 1883 by the British explorer Sir Richard Burton.

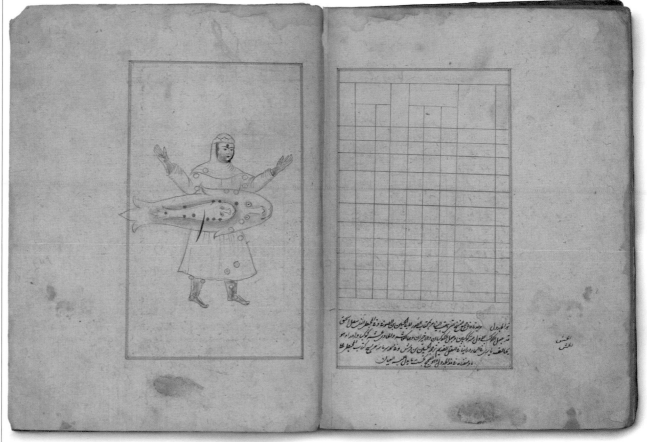

Andromeda with a fish across her waist representing the Andromeda Galaxy, from the *Book of the Constellations of Fixed Stars.*

DUNHUANG MANUSCRIPTS

CHINA (5TH–11TH CENTURIES CE)

An important collection of around 60,000 sacred and secular documents, the *Dunhuang Manuscripts* were discovered in 1900 by the Chinese monk Wang Yuanlu in a cave in the town of Dunhuang, China. Believed to have been sealed up for 900 years, the manuscripts date to between the fifth and eleventh centuries. They were primarily written in Chinese and Tibetan, but examples of 17 different languages are represented, some now extinct, such as Old Uyghur and Old Turkic. The sacred texts include Buddhist scriptures, as well as Taoist, Nestorian Christian, and Manichean writings. The secular manuscripts cover a wide range of academic disciplines, such as mathematics, astronomy, history, and literature, as well as wills, divorce papers, and census registers, so they provide scholars with invaluable insight into the period. Perhaps the most important discovery was the world's earliest example of a printed book– the *Diamond Sutra* (see pp.46–47), a Buddhist text written in 868 CE.

THE KOJIKI
O NO YASUMARO

JAPAN (C.712 CE)

The oldest existing written record of Japanese history, *The Kojiki* (or *Record of Ancient Matters*) was compiled from an oral tradition. The author, O no Yasumaro, was commissioned to write it by the Empress Genmei. *The Kojiki* begins with the mythology of Japan's creation (supposedly from foam) and goes on to discuss gods and goddesses, historical legends, poems, and songs, it also provides a chronology of the Imperial line from its beginning up to the reign of Empress Suiko (628 CE). The book divides into three parts: the *Kamitsumaki* (the age of the gods), the *Nakatsumaki* (from Emperors Jimmu to Ojin, the 15th) and the *Shimotsumaki* (continuing story up to Suioko, the 33rd Emperor). Shinto, the national religion of Japan, is believed to be largely based on the mythology outlined in *The Kojiki*. When the book was compiled there was no written Japanese language, so the text uses Chinese characters to interpret the Japanese sounds, a writing system known as *Man'yōgana*. *The Kojiki* was first translated into English in 1882.

▲ BOOK OF THE CONSTELLATIONS OF FIXED STARS
ABD AL-RAHMAN AL-SUFI

IRAN (964 CE)

This treatise, known in Arabic as *Kitāb suwar al-kawākib al-thābita*, was composed by Persian astronomer Abd al-Rahman al-Sufi (903–986). Earlier, the Greek astronomer Ptolemy (100–168 CE) had constructed an elegant mathematical model of the movement of the heavens as spheres rotating around the unmoving Earth. Al-Sufi's book was a brilliant attempt to combine the theories proposed in Ptolemy's *Almagest*, (one of the sources of al-Sufi's text), with his own astronomical observations. The book presents tables listing the names of hundreds of stars, as well as descriptions of the 48 constellations –known as Fixed Stars–which, according to the medieval conception of the universe, inhabited the eighth of the nine spheres around the Earth. Each description is accompanied by two illustrations in mirror image, showing how the constellation appears in the sky and through astronomical instruments.

1000—1449

- The Tale of Genji
- Canon of Medicine
- The Domesday Book
- The Gospels of Henry the Lion
- Les Très Riches Heures du Duc de Berry

CHAPTER 2

The Tale of Genji

1021 CE (WRITTEN) 1554 CE (VERSION SHOWN) ▪ SIX PAPER SCROLLS ▪ DIMENSIONS UNKNOWN,
ORIGINAL SCROLL c.450 ft (137 m) LONG ▪ JAPAN

MURASAKI SHIKIBU

The crowning glory of Japanese literature, *The Tale of Genji* (*Genji monogatari*) by noblewoman Murasaki Shikibu is often considered to be the world's first full novel. Although the original manuscript has been lost, fragments of the text are preserved on a twelfth-century illustrated hand scroll. Later depictions of the story such as the scrolls shown here, created in the sixteenth century by female *Genji* artist and scholar Keifukuin Gyokuei (1526–after 1602)—were based on edited versions of the manuscripts made by two Japanese poets in the thirteenth century.

The long and complex, two-part narrative is largely set in the imperial court of early eleventh-century Heian-Kyō (now Kyōto), and features over 400 characters. However, 41 of the 54 chapters tell the adventures and romantic liaisons of Genji, the emperor's son. Murasaki wrote *Genji* while serving as an attendant at the Japanese court, and part of its appeal lies in her vivid portrayal of the rivalries and intrigues of this rarefied world; Heian courtiers were obsessed with rank and breeding, and were acutely attuned to the beauty

MURASAKI **SHIKIBU**

c.978–1014

Murasaki Shikibu was a high-born Japanese writer, poet, and lady-in-waiting, best known as the author of *The Tale of Genji*, one of the greatest works of Japanese literature.

Murasaki Shikibu, a descriptive name, was born in Kyōto into one of Japan's leading families (the Fujiwara clan) – her real name is not known. She received a good education before marrying one of her cousins, with whom she had a daughter. In 1001 Murasaki's husband died, and four years later she was summoned to serve at the court of the empress. Although the precise dates when she wrote her epic novel are not known, it is most likely that it was during her service at the imperial court. The first 33 chapters of *Genji* are written with extreme consistency, yet discrepancies in later chapters suggest that the latter half was written by another author.

of nature and the pleasures of music, poetry, and calligraphy. The book is also revered for its great psychological insights. The suffering endured by its major female characters—Genji's myriad lovers—is described with great sympathy; none more so than that of Murasaki, Genji's favourite wife, who dies of a broken heart. But the novel's main theme is the impermanence of life, its fleeting pleasures, and the inevitability of grief. Even in modern Japan, *Genji* remains a cultural icon.

In detail

▲ *HAKUBYO GENJI MONOGATARI EMAKI* The hand scroll shown here, created in 1554 by aristocratic painter Keifukuin Gyokuei, is thought to be the first version and commentary of the *Genji* prepared by a woman for female readers. Knowledge of the *Genji* was considered to be a sign of status in sixteenth-century Japan, and for women, it could help them to secure a favorable marriage.

▲ SCROLL ENDS A hand scroll is held in a reader's hands and read from right to left, as Japanese is written. The reader unfurls the left-hand portion of the scroll, which is bound around a dowel, while rolling up the right-hand portion. Typically, only an arms-length of the narrative is visible at a time. There are six scrolls in the *Hakubyo Genji Monogatari Emaki*; the ends of scroll two are shown above and left.

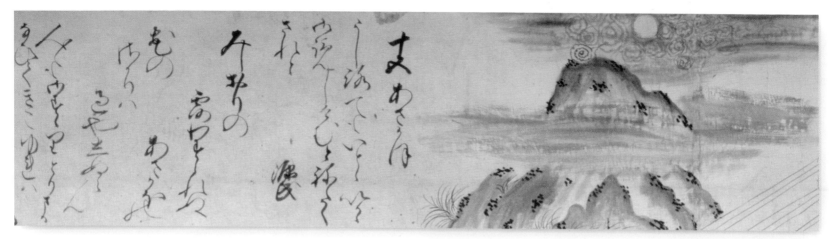

▲ **VISUAL NARRATIVE** The *Hakubyo Genji Monogatari Emaki* features a number of different, highly stylized forms of calligraphy that have long held a cult following in Japan. Designed for visual appeal rather than legibility, it renders the text almost impossible to read.

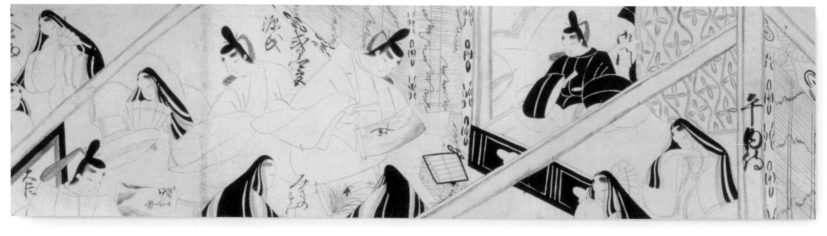

▲ **SCENE WITH COURTIERS** Many illustrations in the *Genji* depict scenes occurring inside buildings at the Heian court, seen from above, as if the roof has been removed (as shown here). It gives the reader a sense of watching events unfold as they happen, as described in the accompanying text.

▼ **WHOLE OF SCROLL TWO** Illustrated hand scrolls play an important role in the tradition of Japanese story telling. From the twelfth century wealthy patrons commissioned them for their own pleasure, and *The Tale of Genji* was one of the most popular narratives.

▲ *HIRAGANA* **SCRIPT** The phonetic script in which *Genji* was written, seen here on the scroll, was known as "women's hand." Almost colloquial, *hiragana* became the language of poetry. Highly nuanced and rarely direct, it used imagery, such as the blooming of a flower, shown above, to convey emotions.

IN **CONTEXT**

The Tale of Genji is enduringly popular in Japan; over the past 1,000 years it has been presented with text and illustrations in various mediums, including scrolls, albums, books, fans, screens, and woodbock prints. The novel was revered during the Edo period (1615–1868), which saw a revival of classical Heian culture, particularly among Kyoto courtiers and merchants. More recently it has been the subject of paintings, films, operas, and animé, and modern translations have been published in Chinese, German, French, Italian, and English.

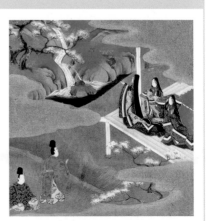

▶ **This vividly colored** seventeenth-century painting depicts a scene in chapter five, "Young Murasaki."

Canon of Medicine

1025 CE (WRITTEN), 1600s (VERSION SHOWN) ▪ PAPER ▪ DIMENSIONS UNKNOWN ▪ 814 PAGES ▪ PERSIA

IBN SĪNĀ

Considered a landmark in the history of medicine, *Al-Qānūn fi al-Tibb*, or the *Canon of Medicine*, was written in 1025 by Persian polymath Ibn Sīnā. It became a standard reference source for medical practitioners in both the Islamic world and the universities of Europe until the eighteenth century. A vast work of over half a million words, the *Canon of Medicine* surveyed the entire field of known medical knowledge, including the work of Galen of Pergamum (129–216 CE), and ancient Arabian and Persian texts. It examined diseases of every part of the body, while also recommending herbal cures and surgical interventions. It was the first book to lay out principles for experimental and evidence-based medicine, and to spell out protocols for testing new drugs. Ibn Sīnā wrote it in five distinct volumes, each addressing a different aspect of medicine. Book I covers the theory of medicine; Book II looks at simple, medically active substances; Book III describes diseases of each organ; Book IV looks at whole body diseases; and Book V is a directory of 650 drugs.

As well as bringing together existing knowledge, the work also contained some of Ibn Sīnā's own highly perceptive insights. He was the first to recognize that

> **IBN SINA**
>
> c.980–1037
>
>
>
> Known in the West by the Latin name Avicenna, Ibn Sīnā was a Persian polymath and physician, and one of most significant thinkers and prolific writers of Islamic Golden Age.
>
> Abū 'Alī al-Husayn ibn 'Abd Allāh ibn Sīnā was born in Bukhara (modern-day Uzbekistan). He knew the Qur'an by heart by the age of 10, studied Greek and mathematics as a teenager, and by 16 was a qualified physician. He spent some years working in medicine before being appointed as a minister to a prince in Buyid (an area of modern-day Iran). He wrote about 450 books, of which 250 survive. His body of work includes *The Book of Healing*, a landmark book on philosophy, writings on astronomy, geography, mathematics, alchemy, and physics, as well as medicine. In the latter period of his life he was in service to a governor in Persia who sponsored much of his work.

tuberculosis is contagious; that diseases can spread through soil and water; that a person's emotions can affect their state of physical health; and that nerves transmit both pain and signals for muscle contraction.

The *Canon* was first translated into Latin in the twelfth century and adopted by the faculty of medicine at the University of Bologna in the thirteenth century. Between 1500 and 1674, some 60 editions of part or all of the *Canon* were published. The pages shown here are from a seventeenth-century Arabic edition, thought to have been copied from Ibn Sīnā's original writings.

In detail

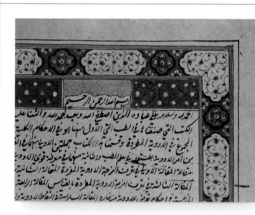

▲ **ELABORATE DECORATION** Many pages of this edition are illuminated with colored ink and gold leaf. Showing motifs from Islamic architecture, they may have been added at a later date.

▲ **THE PREFACE** In this text, Ibn Sina describes the task of the physician in preserving the well-being of his patient, and the art of restoring a person's health using the appropriate procedures and medications.

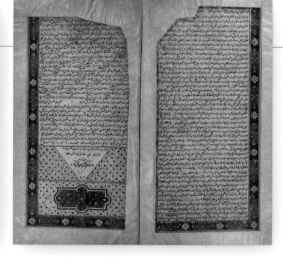

▲ **HANDWRITTEN PAGES** Printing was well established by the seventeenth century, but this edition written by hand was painstakingly copied directly from Ibn Sīnā's original work, indicating its importance.

Therefore in medicine we ought to know the causes of sickness and health.

IBN SĪNĀ, ON MEDICINE, C.1020

COMPREHENSIVE DIRECTORY OF MEDICATIONS These pages come from Book V, in which Ibn Sīnā described hundreds of drugs, attributing them to Arabic, Indian, and Greek sources. He included ingredients and recipes, and added his comments on the effectiveness of the remedies.

IN **CONTEXT**

Ibn Sīnā's original text was translated into Latin in around 1140 by Italian scholar Gerard of Cremona (1114–1187). Cremona traveled to Toledo in Spain, a seat of Islamic learning, specifically to learn Arabic in order to translate Ptolemy's *Almagest*—a study of astronomy. He was one of the most prolific translators of Arabic texts, completing around 80 works. In addition to the *Canon of Medicine*, Cremona also translated several works by Aristotle and significantly helped to spread the wealth of Arabic knowledge.

▶ **Medical miniatures** are used to illustrate a range of health problems in this fourteenth-century version of Gerard's Latin translation.

The Domesday Book

1086 ▪ PARCHMENT ▪ LITTLE DOMESDAY–c.11 × 8 in (28 × 20 cm), 475 PAGES ▪
GREAT DOMESDAY–c.15 × 11 in (38 × 28 cm), 413 PAGES ▪ ENGLAND

SCALE

VARIOUS SCRIBES

England's earliest surviving public record, compiled between 1085 and 1086, exists as two books known collectively as the Domesday Book. It was instigated in December 1085, when the Norman ruler, William the Conqueror commissioned what was to be the largest land survey carried out in Europe until the nineteenth century. The king instructed his officials to prepare a land registry of all the shires, or counties, of England.

Representatives traveled across England and parts of Wales, and counted 13,418 places, or manors, within the realm. They recorded how much land, livestock, and resources each one owned, and what they were worth. By the following August, the officials began passing the information on large rolls (hence the survey's official title The Winchester Roll, or King's Roll) to the scribe to begin the compilation. There were two books: the Little Domesday Book, which is considered a first draft, includes details of three eastern counties; the Great Domesday Book, which was never fully completed, includes most counties apart

from Northumberland and Durham. Both were written in Medieval Latin, a language that was used in government documents and by the Church, but that most of the population barely understood. Today both volumes are kept in a locked chest at the National Archives in Kew, London.

The reasons for commissioning the survey are unknown. William may have wanted to calculate tax due to the Crown from England's landowners, as in the eleventh century English kings needed to raise money to pay a levy, known as the *Danegeld*, to protect the country from marauding Scandinavian armies. However, 1086 also marked the twentieth anniversary of William's victory at the Battle of Hastings over Harold Godwinson, the last Anglo-Saxon monarch. As the Domesday Book records the land and holdings of King Edward the Confessor, who died in 1066 and those of King William, it may have been a means of legitimizing his reign–if so, it was in vain considering William died in 1087 before the project was completed. The survey was dubbed the Domesday Book because it was considered the final word on who owned what, and as such was compared with the Last Judgment, or domesday, in the Bible. Today it is valued as a key source for historians.

In detail

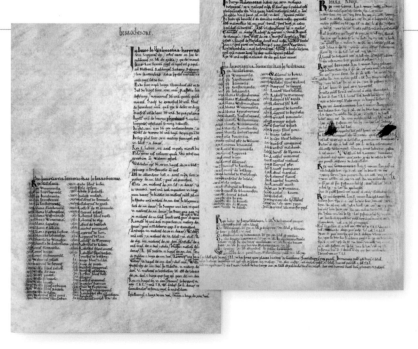

▶ **LANDOWNER LISTINGS** (*left*)
Each county "chapter" begins with a list of landowners, starting with the king, followed by the bishops, abbots, and lastly those of the lay barons. Each of their lands are divided into "hundreds" (areas) and then into the manors held within it. This page for Berkshire lists 63 landowners.

▶ **MARGINAL NOTES** (*center*)
Historians believe that one scribe was responsible for compiling the Great Domesday Book, but the hand of a second scribe appears to have made some amendments. Here, the scribe was given new information after the entries were completed, so it has been included as a footnote.

▲ **HIGHLIGHTING SUBJECTS** In order to draw the reader's attention to a word or place-name, the scribe would strike through it with a red line, as shown in this detail from the chapter on Yorkshire. This process is another form of rubrication (see right).

> … there was no **single hide** nor a yard of **land,** nor indeed …
> **one ox** nor one **cow** nor one **pig** which was left out.

ANGLO-SAXON CHRONICLE, TWELFTH-CENTURY ACCOUNT OF THE RECORDING OF THE DOMESDAY BOOK

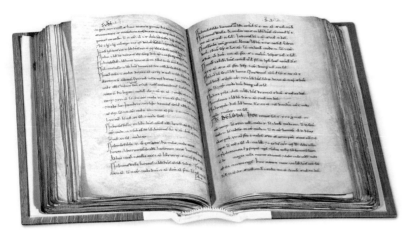

▲ **LITTLE DOMESDAY BOOK** This smaller, but longer, book covers only the counties of Essex, Norfolk, and Suffolk, and is more detailed than the Great Domesday Book, showing how much information was omitted from the latter. The text in it is also written across the page, differing from the columns used in the Great Domesday. It is thought that at least six scribes worked on it.

ON **TECHNIQUE**

Writing the Domesday Book began with the preparation of parchment from around 900 sheepskins. The skins were soaked in lime and scraped clean, then stretched over a frame and allowed to dry. Scribes prepared quills from the wing feathers of large birds, often geese. A right-handed scribe would take a feather from the left wing of the bird, as it curves to the right; a left-handed scribe would use a right wing. The plumes were cut back and the tip was placed in hot sand to strengthen it, then carved to shape. The resulting quills resembled a chisel. Scribes worked with a quill in one hand and a knife in the other to sharpen the quill and scrape away mistakes before the ink dried.

▲ **A scribe** used a small, sharp knife to shape the "nib" and cut a "slit" in the tip, like a fountain pen.

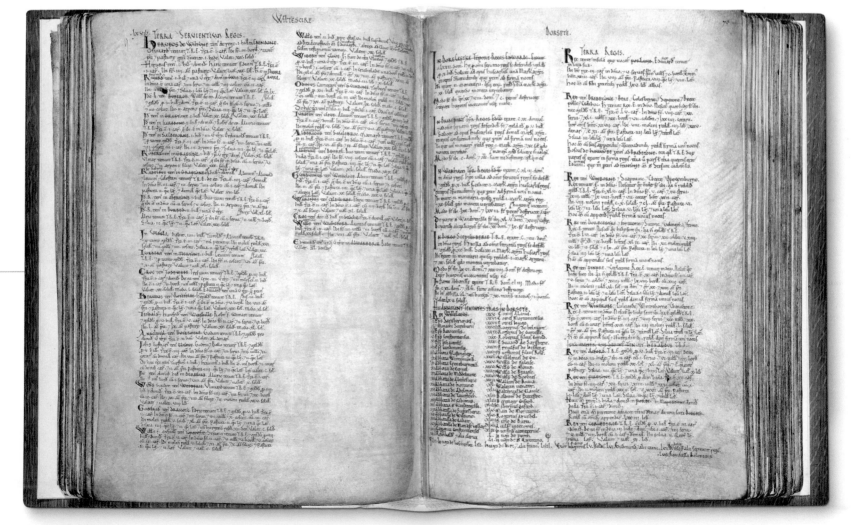

▲ **COLOR CODING** The scribes wrote most of the Great Domesday Book, shown above, with black ink, which was made from oak galls—small fungal growths on oak bark. They used red ink, made from lead, for initial letters and numbers before a name and for the most well-known method of rubrication, where the scribe added text in red for emphasis.

The Gospels of Henry the Lion

C.1188 ▪ PARCHMENT ▪ 13 × 10 in (34.2 × 25.5 cm) ▪ 266 PAGES ▪ GERMANY

SCALE

MONKS OF HELMARSHAUSEN

One of the masterpieces of Romanesque German medieval art, *The Gospels of Henry the Lion* is an illuminated manuscript of the four biblical gospels by Matthew, Mark, Luke, and John. This work of extraordinary beauty was created by the Benedictine monks of the Helmarshausen Abbey in Germany, who were commissioned around 1188 by Henry the Lion, Duke of Saxony. It is so highly prized that when it was sold at auction by Sotheby's in 1983, a consortium paid $17.1 million (€16 million) to buy it for Germany—the highest price paid for such a book up to that time. It is now kept in the Herzog August Library in Lower Saxony, Germany, where, due to its fragile condition, it is only rarely exhibited.

The book consists of 266 parchment pages, brilliantly colored in reds, blues, and greens. Expensive pigments and gold leaf feature extensively throughout. There are 50 full-page miniature illustrations, and every page is ornamented with either initials, decorative borders, or images. Both the exquisite calligraphy and illuminations are identified as the work of a single monk, Herimann, in the dedication, but it is possible that he led a team.

The *Gospels* was commissioned by Henry in honor of the recently completed Brunswick Cathedral, and was intended for the altar in the chapel of St. Mary. Henry may have been inspired to commission the manuscript when he and his young wife Matilda, daughter of Henry II and Eleanor of Aquitaine, were in exile in England in the early 1180s, with time to strengthen their biblical appreciation.

▼ **DECORATIVE CANON TABLE** This canon table—the final of five at the beginning of the *Gospels*—depicts John the Baptist in the upper center as he points to the Lamb of God. The detail, however, is in the intricately patterned columns and the gold lettering, which set a grand tone for the remaining book.

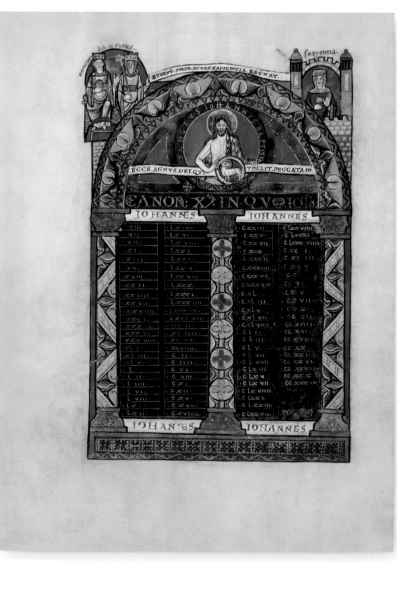

HENRY **THE LION**

c.1129-95

The Duke of Saxony and Bavaria, Henry was one of the Welf dynasty's most powerful princes. A patron of the arts, Henry founded several cities, the most notable being Munich in Bavaria.

When Henry was made Duke, first of Saxony (1142), then Bavaria (1156), he became one of the most powerful rulers in the Holy Roman Empire, second only to the Emperor Frederick Barbarossa, his cousin. His first marriage, to Clementia of Zähringen, was annulled under pressure from the Emperor, who felt it made Henry too powerful; in 1168, he married 12-year-old English Princess Matilda. Henry and Matilda presided over a time of expansion and cultural enrichment for Saxony and Bavaria, including the founding of Munich and the building of Brunswick Cathedral. In later years, Henry's relationship with the Emperor soured, and he was twice forced into exile and eventually deprived of his dukedoms. His nickname came from the bronze lion made for his castle in Brunswick. There is also a legend of a loyal lion that accompanied Henry on his pilgrimage to the Holy Land, and refused to eat after he died.

Peter, this book is the work of thy monk Herimann.

THE MONK HERIMANN, AN INVOCATION TO ST. PETER FROM THE PREFACE OF *THE GOSPELS OF HENRY THE LION*

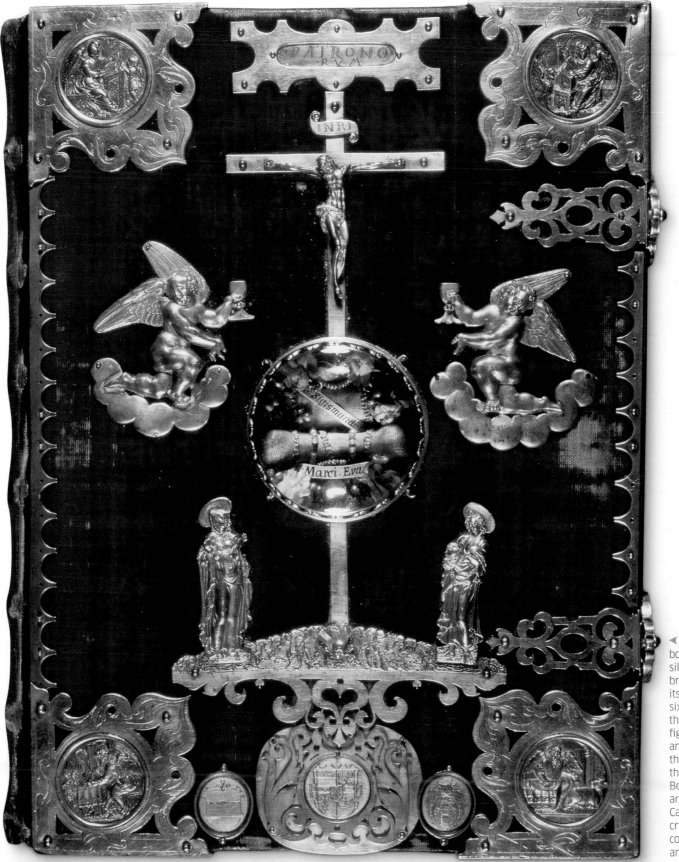

◄ **ORNATE BINDING** The book was rebound with red silk velvet and elaborate brasswork in 1594, reflecting its perceived value in the sixteenth century. Beneath the silver gilt crucifix are figures of the Virgin Mary and St. John. They stand on the hill of Golgotha, on which the skull of Adam is visible. Below this is the coat of arms of the Dean of St. Vitus Cathedral in Prague. The crystal dome at its center contains relics of St. Mark and St. Sigismund.

In detail

◄ **WORDS OF ST. JEROME** The Latin translation used in the book was written in 383 CE by St. Jerome. The preface by St. Jerome dedicates the *Gospels* to his patron, the Blessed Pope Damasus, and opens with a beautiful illuminated "B" for *Beatus*, meaning "blessed" (above).

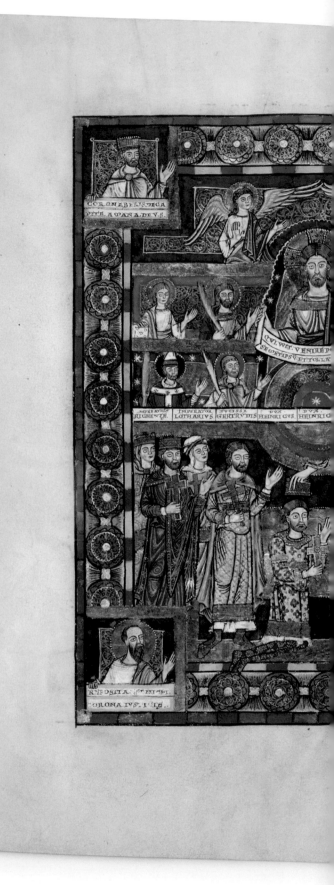

◄ **ATTENTION TO DETAIL** This page, though less lavish than most, is rich in colored details, with five small illuminated capitals, three friezes, and a romanesque arch. Herimann would have written the black text first, leaving space for the illustration to be added afterward. More complex illustrations would be sketched out on wax tablets, then traced onto the manuscript before being colored in. The glorious pigments in illuminated manuscripts, such as in these *Gospels*—the vivid reds, blues, and greens—were intended to reflect God's glory.

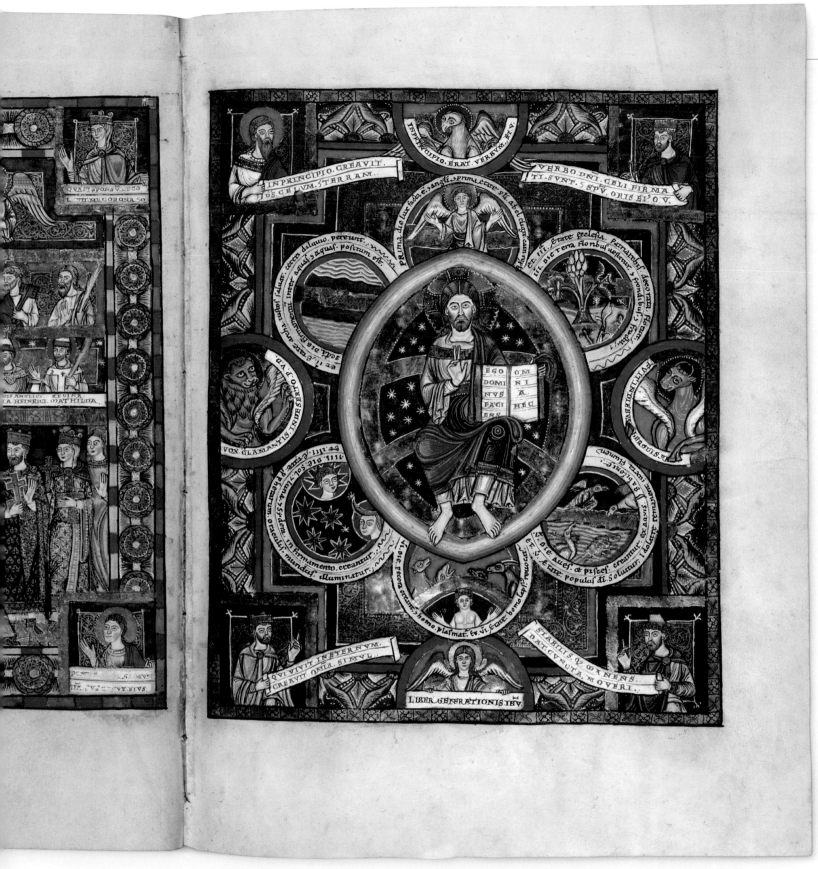

▲ **SPIRITUAL CORONATION** The most famous illustration in the Gospels shows the coronation of Henry and Matilda (bottom left), with Christ placing the crown on Henry's head. As Henry was never crowned, the crown may be symbolic of eternal life, a reward for his part in commissioning the book. The upper frieze shows Christ with eight saints, and these include Thomas Becket, whose death Matilda's father, Henry II, was implicated in—a gesture of atonement. The right-hand page shows Christ with the four gospel writers and six roundels with images of the Creation.

... a national treasure that was witness to the emergence of the German nation.

MR. HERMANN ABS, THE PURCHASERS' SPOKESMAN AT THE SOTHEBY'S AUCTION, 1983

Les Très Riches Heures du Duc de Berry

c.1412–16 ▪ VELLUM ▪ 11 × 8 in (29 × 21 cm) ▪ 206 BOUND SHEETS ▪ FRANCE

SCALE

LIMBOURG BROTHERS

The crowning achievement of illuminated book illustration, *Les Très Riches Heures du Duc de Berry* is the finest surviving example of a medieval "book of hours": a compendium of prayers, Bible verses, psalms, and other Church texts designed for private use by laypeople rather than clergy. These pocket-sized volumes became widely popular in the fourteenth century, and by the 1500s were being mass-produced by scribes and illuminators who hand-painted them with decorative letters, borders, and miniatures in glowing, vibrant colors. Many books of hours were modestly decorated, but others were luxurious status symbols that reflected both the piety and wealth of their owners.

Les Très Riches Heures, commissioned by the French prince Jean, duke of Berry, was created between 1412 and 1416 by three Dutch illuminators known as the Limbourg brothers. The book is large and elaborate, with Latin text skillfully interwoven with naturalistic illustrations. Many of

JEAN, **DUKE OF BERRY**

1340–1416

The third son of King II of France (1319–64), Jean, duke of Berry, is regarded as one of history's greatest patrons of the arts, involved in architecture, jewelry, and publishing.

Jean was a wealthy and powerful aristocrat, who was awarded the duchies of Berry and Auvergne, and later Poitou. Throughout his life, the duke was an active sponsor of the arts and invested a fortune in the acquisition of beautiful artifacts, including jewelry, fine fabrics, tapestries, paintings, and illuminated manuscripts. He commissioned many of the pieces in his collection of treasures, and was always highly involved in the artistic process. Yet the duke's lifestyle was extravagant and profligate, and the heavy taxes he imposed on his lands to support the war made him unpopular, leading to a peasants' revolt in 1381–84. By the time he died, his estate was so impoverished that it was unable to pay for his funeral.

its 206 folios of vellum boast full-page paintings, as well as 132 exquisite miniatures. There are scenes from the Bible and the lives of the saints, but the best-known section is a beautiful liturgical calendar, illustrated with the "Labours of the Months," which, seen from the perspective of an aristocrat, offers an idealized view of social and economic life in early fifteenth-century feudal Europe. The calendar's 12 full-page miniatures show the seasonal activities performed by the duke and his court, and the peasants who worked on his land. In 1416 all three brothers and the duke died and the book was left unfinished. It then passed through the hands of several owners before being completed by artist Jean Colombe (1430–93) in around 1485, although other painters may have worked on it. Held by France's Condé Museum, a facsimile is on display to prevent light damaging the original.

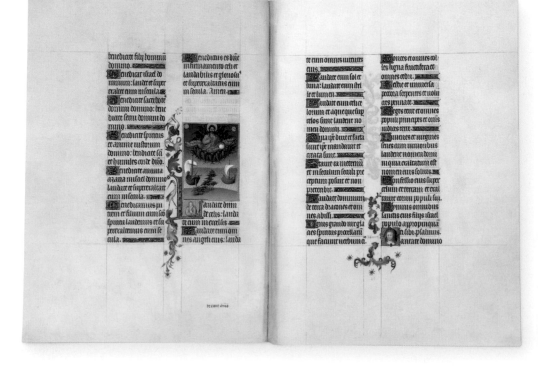

◀ **ILLUMINATED PSALMS** The vivid illustrations throughout *Les Très Riches Heures* serve to convey both God's power and his message. Here Jesus Christ is depicted holding a globe, hovering above the land and sea, demonstrating his dominion over Earth.

▼ **OPENING OF THE LITANIES** This large double-page miniature appears at the beginning of the book's litanies—a structured series of prayers or invocations used in church services and processions. Litanies were also used at a time of crisis, as shown in this illumination, which depicts the newly elected Pope Gregory (reigned 590–604) leading a vast procession through the city of Rome during an outbreak of plague. The pontiff is shown begging God for mercy, while the presence of Archangel Michael with his sword sheathed symbolizes the end of the plague.

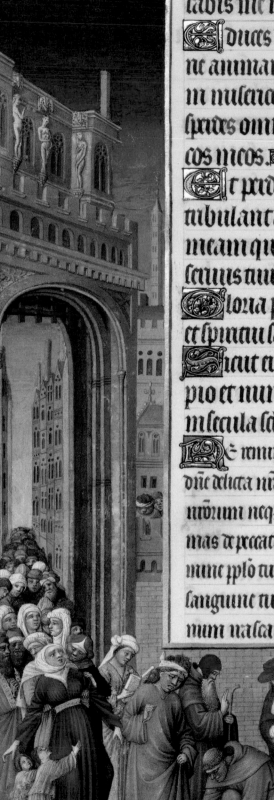

In detail

► LATER ILLUSTRATORS
Following the death of the Limbourg brothers, numerous illuminations were needed to complete *Les Très Riches Heures*, including this miniature, attributed to Jean Colombe. It is one of many by the artist that depicts David, King of Israel, kneeling before God in various settings.

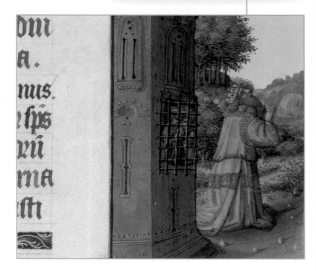

▲ DETAIL FROM PRAYER OF DAVID The figures peering out from the barred window in the tower are probably the servants and handmaid referred to in Psalm 122—"Behold as the eyes of servants are on the hands of their masters".

			Januier a .xxxi. iour et la lune .xxx.	La chitte Des iours lunt.ap.	Nobre dor. nouel.	
				viij	xxvi	xix
	b	iiij n̄	Octaues saint estienne.	viij	xxix	
xi.	c	iij. n̄	Oct. s. iehan. se grneuieue.	vij	xxx	vij
	d	ij. n̄	Octaues des innocens.	vij	xxxij	xvi.
xix.	e	Nonas	saint symeon.	viij	xxxiij	v.
viij	f	viij jd		viij	xxxiiij	
	g	vij id	saint firmoiut.	viij	xxxix	xij.
xvi		vj. id	saint lucien.	viij	xli	
v.	b	v. id	saint pol. pmier hermite.	viij	xliij	ij
	c	iiij id	saint guillaume.	viij	xlv.	x.
xiij	d	iij. id	saint sauueur.	viij	xlvj.	
ij.	e	ij. id	saint satur.	viij	xlix.	xviij
	f	Idus.	saint hylaire.	viij	lij.	
x.	g	xix. kl	saint felix.	viij	lv.	vij.
		xviij kl	saint mor.	viij	lviij	xv.
xviij	b	xvij kl	saint marcel.	.ix.	o	
vij	c	xvi. kl	saint anthoine.	ix.	ij.	iiij.
	d	xv. kl	saint prisce.	.ix.	v.	xij.
xv.	e	xiiij kl	saint lomer.	ix.	vij.	.i.
iiij	f	xiij kl	saint sebastien.	.ix.	x.	
	g	xij. kl	sainte agnes.	ix.	iiij.	ix.
xij.		xj. kl		ix.	xvi.	xvij
i.	b	.x. kl	sainte emeranciene.	.ix.	xix.	
	c	.ix. kl	saint babile.	ix.	xxij	vi.
ix	d	viij kl		ix.	xxvij	
	e	vij. kl	saint policarpe.	ix.	xxx.	xiiij
xvij	f	vj. kl	saint iulien.	ix.	xxxiij	
vi.	g	v. kl	sainte agnes.	ix.	xxxvi	iij.
		iiij kl	sainte paule.	ix.	xxxix.	xi.
xiiij	b	iij kl	sainte baudour.	ix.	xlij	
iij.	c	ij. kl	saint metran.	.ix.	xlv.	xix

▲ CALENDAR *Les Très Riches Heures* opens with a liturgical calendar that lists key dates in the church year, month by month; the page above is for January. The feast days of saints were listed according to their date, with the more important ones written in red. Opposite each page is a painting representing the Labour of the Months (see pp.68-69).

IN **CONTEXT**

In the fifteenth century artists were typically commissioned by wealthy patrons, who would bear the cost of their labor and materials, which enabled the creation of lavish works of art that reflected the high status of their sponsor.

The Limbourg brothers, Paul, Jean, and Herman, were born into an artistic family in the Netherlands, and became innovative, highly gifted miniaturists. Their first commission came in 1402, when Philip, duke of Burgundy asked them to illuminate a bible, now believed to be the Bible moralisée (held in the National Library of France). Burgundy died in 1404, before the bible was finished. Shortly after the duke's death, the Limbourgs were engaged by his brother Jean, duke of Berry. Under his patronage they produced their two most renowned works: their masterpiece, the *Belles Heures* (c.1405-09), noted for its realism and technical experimentation, and *Les Très Riches Heures*, which more closely followed the artistic convention of the time.

The Limbourgs died in 1416, probably during an outbreak of plague. It was only when the book was purchased in the mid-eighteenth century (its whereabouts unknown since the sixteenth century) that the brothers' work came to light.

► The Limbourg brothers produced a series of extraordinary works in their lifetimes, including this scene of the Pentecost in *Les Très Riches Heures*.

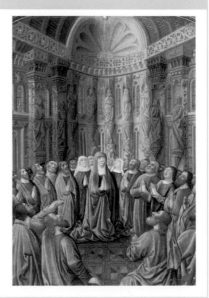

► ANATOMICAL MAN The calendar concludes with a depiction of the 12 signs of the zodiac encircling front and back views of a nude youth. This illustration is often referred to as Anatomical Man because each zodiacal sign corresponds to a different part of his body, with the fish representing Pisces positioned at the feet, and continuing upward to the ram, which represents Aries, at the head.

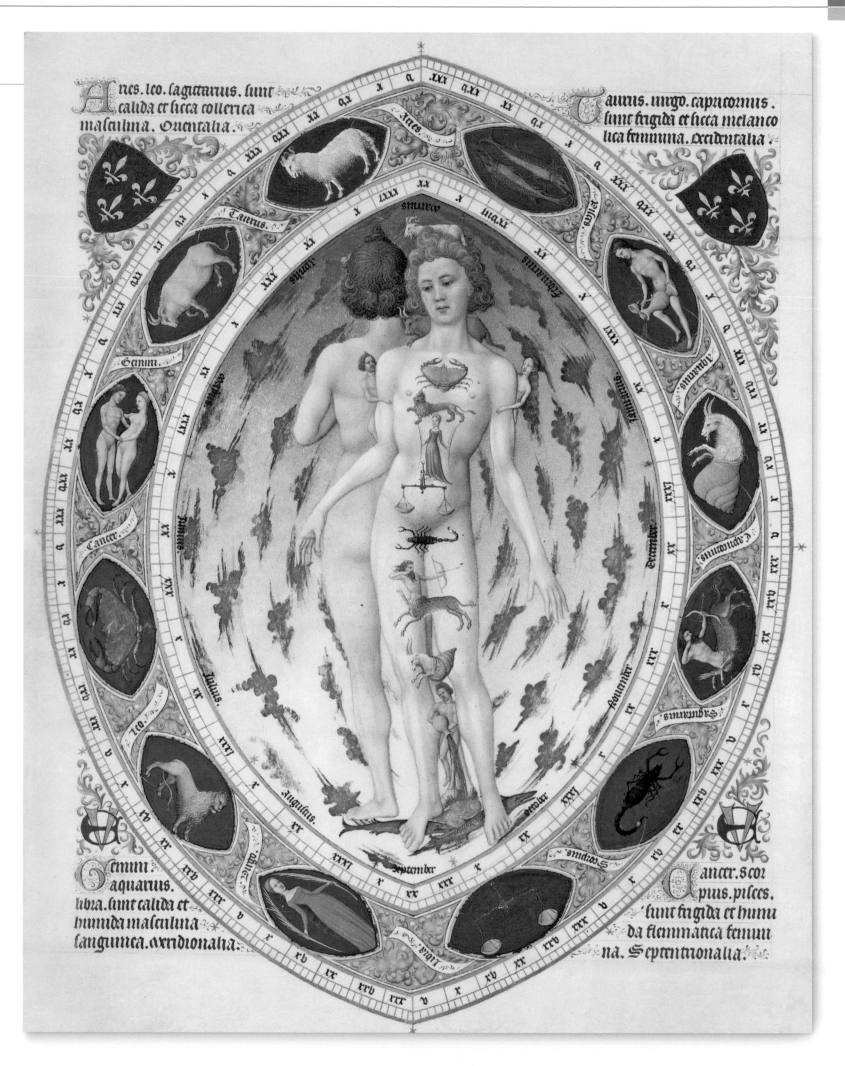

In detail

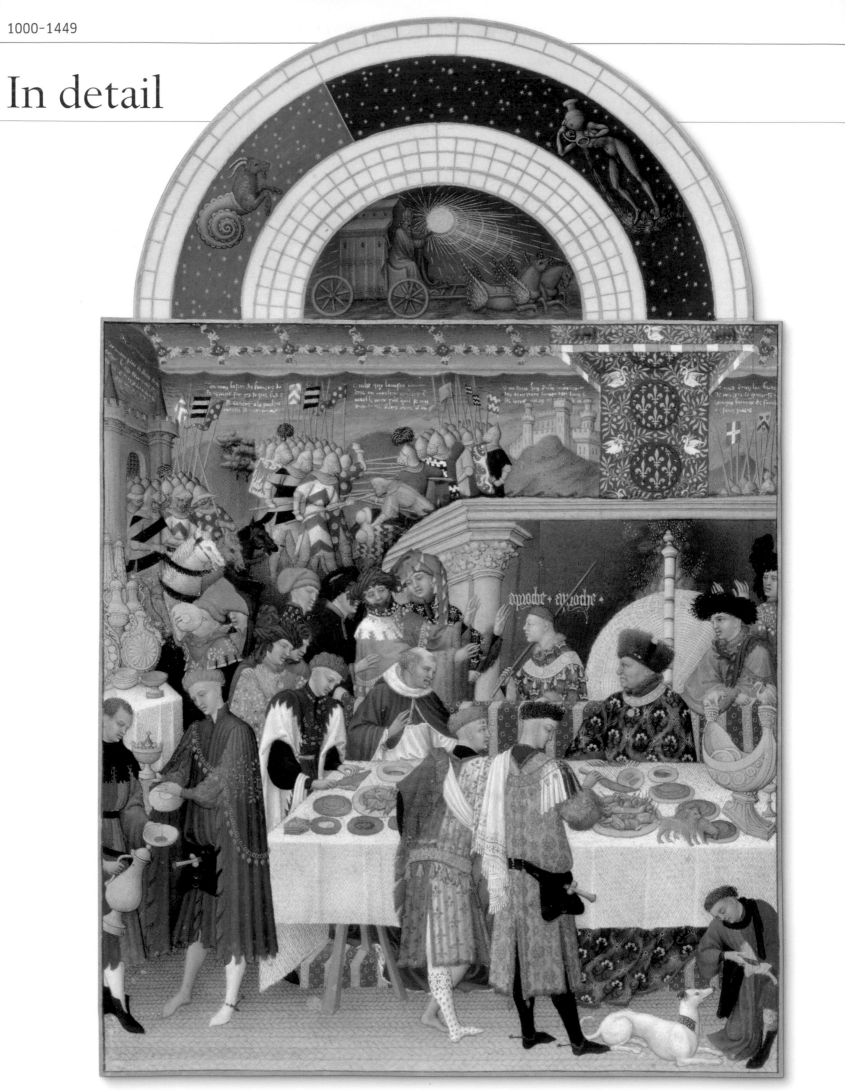

DE LA CONQUÊTE DE CONSTANTINOPLE
GEOFFREY DE VILLEHARDOUIN

FRANCE (C.1209)

This book, known in English as *On the Conquest of Constantinople,* is a first-hand account of the events of the Fourth Crusade (1202–04) written by the thirteenth-century French crusader and knight Geoffrey de Villehardouin (c.1150–c.1213). It is the oldest surviving example of historical French prose, and tells the story of the battle for Constantinople (modern-day Istanbul), the capital of the Byzantine Empire, between the Christians of the West and the Christians of the East on April 13, 1204. Villehardouin wrote in the third person—a style that was unprecedented in French texts at the time. He gave vivid descriptions of the events, and followed these with personal views and religious reasons for the outcomes. The narrative used in *De la Conquête de Constantinople* influenced a series of histories and became a characteristic of medieval French literature. This work is one of the primary sources of the events that culminated in the fall of the city of Constantinople. Villehardouin supposedly gave an eyewitness account; however, scholars doubt the accuracy of certain details. The manuscript was not illustrated, but illuminations in the form of decorated initials, borders, and miniatures were added to later printed editions.

SUMMA THEOLOGICA
THOMAS AQUINAS

ITALY (WRITTEN 1265–1274)

An extensive theological compendium, *Summa theologica,* or *Summa,* is the greatest work by the Italian Dominican theologian Thomas Aquinas (c.1224–74), although he died before it was completed. One of the most important works of medieval theology and philosophy, *Summa* is a comprehensive summary of the teachings of the Catholic Church, and was intended as an instructional guide for students of theology. Among nonscholars, it is perhaps most famous for its five arguments for the existence of God, known as the "five ways." It addresses many other fundamental questions of Christianity, such as Christ, the nature of man, and incarnation. Throughout the work, Aquinus cites sources from many traditions—Islam, Judaism, and Paganism—as well as Christianity. *Summa* is an expanded version of one of Aquinas's earlier works, *Summa Contra Gentiles. Summa Theologica* was published in 1485, after it had been completed using material from Aquinus's extensive texts.

THE TRAVELS
IBN BATTUTA

MOROCCO (1355)

This book, also known as *Rihla* in Arabic, is regarded as one of the world's most famous travel books, and its author, the fourteenth-century Moroccan scholar Ibn Battuta (1304–c.1368), as the world's greatest medieval Muslim traveler. Ibn Battuta set out on his journey in 1325 and returned in 1354, 29 years later. During this time he traveled around 75,000 miles (120,000 km), from North Africa to Southeast Asia, over most of the lands of the Islamic world (Dar-al-Islam), as well as many other areas. On his return to Morocco, Ibn Battuta was asked by the Sultan to dictate an account of his travels. At the time *The Travels* was met with limited appreciation, and it was not until European scholars found the manuscript in the nineteenth century that it gained international acclaim. Ibn Battuta made no written notes, and although scholars have questioned parts of his narrative, overall he is regarded as a reliable source who offers a key insight into the cultural and social context of the Islamic world in the fourteenth century.

▶ LE LIVRE DE LA CITÉ DES DAMES
CHRISTINE DE PISAN

FRANCE (1405)

Known in English as *The Book of the City of the Ladies,* this is the best-known work by French Renaissance writer Christine de Pisan (1364–c.1430), who argued for the rights of women in fifteenth-century society. *Le Livre de la Cité des Dames* was the first feminist text to be written by a woman in Western literature. In it Pisan created an allegorical world that she used to shed light on the role of women. Many copies of the book were printed with illuminations, in which de Pisan took a deep interest. In her lifetime she was famed both for her success as a writer and her pursuit of the cause of women. Widely regarded as the first female author in Europe, Christine de Pisan was hugely popular and influential long after her death.

THE BOOK OF MARGERY KEMPE
MARGERY KEMPE

ENGLAND (C.1430)

In the early 1430s, the English mystic Margery Kempe (c.1373–1440) dictated the story of her life to scribes (claiming illiteracy), and in doing so she is believed to have created the first "written" autobiography in the English language. The book was dictated entirely from memory and offers a fascinating window into the domestic, religious, and cultural aspects of fifteenth-century life from a female perspective. Kempe was an orthodox Catholic, and gave birth to 14 children, after which she negotiated a chaste marriage. Kempe went on many pilgrimages during her lifetime and claimed to converse directly with Jesus, Mary, and God. Excerpts from her spiritual autobiography appeared in print in 1501 and again in 1521. The manuscript itself was lost until the 1930s when the only complete copy was discovered in a private library. Her book has since been reprinted and translated into numerous editions.

This detail from *Le Livre de la Cité des Dames of Ladies* shows de Pisan in her study, above left, and building the city, above right.

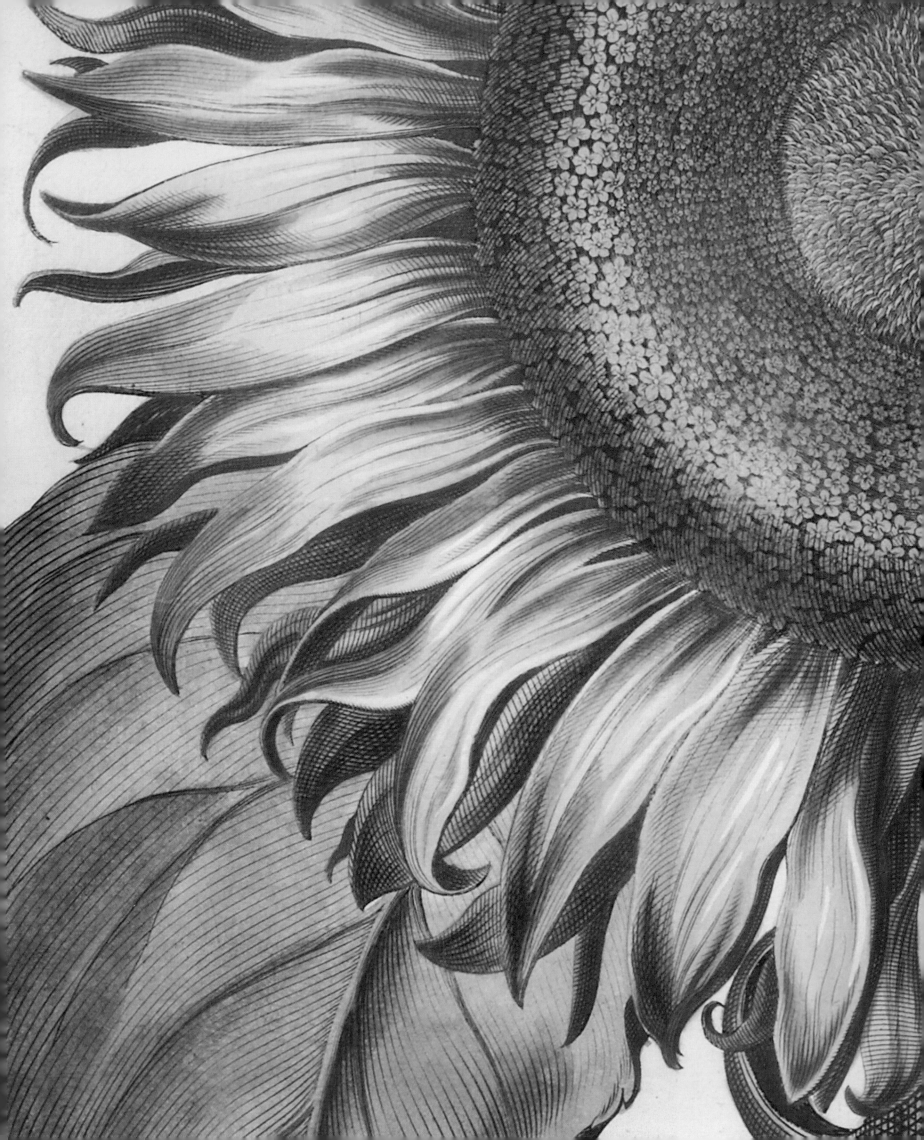

1450—1649

CHAPTER 3

Gutenberg Bible

1455 ■ VELLUM OR PAPER ■ c.16 × 11 in (40 × 28.9 cm) ■ 1,282 PAGES (VELLUM IN 3 VOLUMES) ■ GERMANY

SCALE

JOHANN GUTENBERG

As the first significant book to be printed in Europe using mass-produced movable type, the Gutenberg Bible marked a transformation in the way that books were created. Before the 1450s books were copied out by hand or made using wooden blocks: they were owned by the wealthy, or the monasteries where most were scribed. Books were so rare that even the greatest works were seen by only a few people. In the mid-fifteenth century Johann Gutenberg invented a mechanical printing press that transformed book production—for the first time in Europe, many copies of the same text could be printed speedily. By the end of the fifteenth century, millions of books were in circulation across the continent.

Gutenberg had adopted the concept of movable type first developed by the Chinese; and while he had "printed" pamphlets before, the Bible was his first book. He designed 300 different letters to include capitals and punctuation, and is likely to have used a crude sand-casting system in which metal alloy was poured into molds. Each page of his

bible used about 2,500 individual pieces of type. The letters were arranged side-by-side in a frame which could be used to print any number of copies of the same page. Gutenberg developed a special oil-based ink (scribes traditionally used water-based inks) that could be applied to type with leather pummels and then used to print on paper and vellum.

It is thought that the initial print run of the Gutenberg Bible comprised at least 180 copies: 145 on paper and the rest on vellum. The paper copies were printed on fine handmade paper imported from Italy—each page bore watermarks left by the paper mold of either an ox, a bull, or bunches of grapes. The Gutenberg Bible was a copy of the Latin Vulgate Bible, a version translated by Saint Jerome in the fourth century. It was printed after Constantinople fell to Turkish invaders in 1453, during a period when scholars with their Greek and Latin translations dispersed toward the West.

▶ **TRADITIONAL STYLING** Gutenberg designed fonts now known as Textualis, or Textura, and Schwabacher, which are elegant and clear. The text, as shown here, is "justified" (has straight margins)—another of his innovations. Each page had two 42-line columns, hence the book's alternative name, the 42-line Bible. The initial letters or *rubrics* were originally printed in red ink, but this method was too time consuming, so Gutenberg left the spaces blank for scribes to draw them in by hand.

In detail

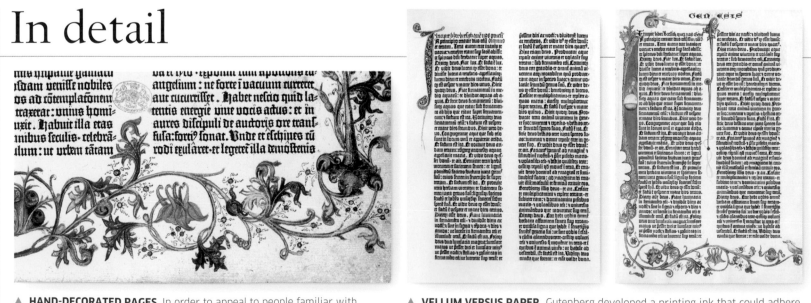

▲ **HAND-DECORATED PAGES** In order to appeal to people familiar with illuminated manuscripts, artists were commissioned to hand paint floral motifs, decorative initial letters, and lavish borders in the wide margins surrounding the text. The level of illumination differed from copy to copy, depending on how much the buyer was prepared to pay.

▲ **VELLUM VERSUS PAPER** Gutenberg developed a printing ink that could adhere to either vellum - prepared calfskin (above left) or paper (above right). He printed his new Bible on both mediums. It is not known how many Bibles were produced altogether, but 48 survive today—36 printed on paper (in two volumes) and 12 printed on vellum (bound in three volumes, as it is heavier).

(Facing pages of the Gutenberg Bible showing two columns of Latin text on each page, headed "Cantica" and "Canticoz".)

> The **script** was very **neat** and **legible** … **your grace would be able** to **read** it without effort, **and indeed without glasses.**
> 🙶
>
> **FUTURE POPE PIUS II**, IN A LETTER TO CARDINAL CARVAJAL, MARCH 1455

IN **CONTEXT**

The invention of movable type and the printing press in fifteenth-century Europe had an enormous impact on society. Literacy was no longer the preserve of the elite, and the dissemination of knowledge through books led to ever-increasing numbers of educated people. Rulers were challenged by those who now understood national politics more thoroughly. The Church in particular was confronted by critics who opposed both parts of its teaching and its discipline. When the sixteenth-century German Augustinian friar and university lecturer Martin Luther (1483–1546) campaigned for Church reform, he was assisted by the accessibility of printing. In particular, Luther's translation of the Bible from Latin into German had a profound impact on modern German language.

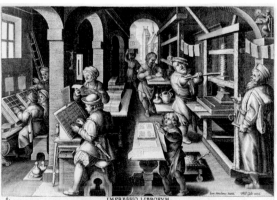

▲ **By 1500**, there were 1,000 Gutenberg printing presses operating across western Europe, rolling out more than 3,000 pages a day and making books accessible to wider society.

Elementa Geometriae

1482 ▪ PRINTED ▪ 12 × 9 in (32 × 23.2 cm) ▪ 276 PAGES ▪ ITALY

EUCLID

SCALE

Euclid's *Elements of Geometry* is the most influential mathematical treatise ever published. It was compiled around 300 BCE in Alexandria, Egypt, which was newly under Greek rule and a burgeoning center of learning. The strength of the work lies not in its originality—much of the material came from other sources—but in its achievement of presenting within a single text the striking advances that had been made in Greek mathematics over the previous three centuries. To a large extent the text focuses on geometry—this being the basis on which Greek mathematics developed—and Euclid himself is commonly referred to as the "father of geometry." However, this 13-volume work ranges across the entire mathematical world as it was known to the Greeks.

Its lasting significance lies in Euclid's treatment and organization of his varied source material: by logically arranging the theorems of other mathematicians he was able to show development from a set of propositions to results. Euclid's methods formed the bedrock of mathematical teaching in both the West and the Arab

> ### EUCLID
> **c.400–c.300 BCE**
>
> Euclid was a highly prominent Greek mathematician, although little is known about his life. His book *Elements of Geometry* is one of the most successful textbooks of all time.
>
> Euclid was active in Alexandria at the time of Ptolemy I Soter (323–285 BCE), but the date, place, and exact circumstances of his birth and death are unknown. According to the Greek philosopher Proclus (c.410–485 CE), Euclid drew on previous work proposed by pupils of Plato—Eudoxus of Cnidus, Theactus, and Philip of Opus—in order to compile *Elements*. Many other books are also ascribed to him, including *Optics*, *Data*, and *Phaenomena*.

world for more than 2,000 years. *Elements* owes its survival to its translation from Greek to Arabic in about 800 CE. It was this Arabic text that was translated into Latin and disseminated across Christendom by an English monk in the early twelfth century. Later, medieval translations from Greek to Latin were also undertaken.

The first printed edition (shown here) was *Elementa Geometriae*, which is a work of huge importance—it was the first mathematical textbook ever to be printed, and is also one of the first to feature geometric illustrations. As such, it represents a breakthrough in Renaissance printing.

In detail

▲ **EXQUISITE DESIGN** *Elementa Geometriae* is a beautifully presented Latin translation of Euclid's text. The perfectly proportioned wide outer margins are interspersed with simple, carefully designed geometric diagrams that complement the central solid block of text.

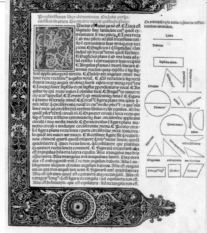

▲ **BOLD WOODCUT** The title page of the *Elementa* is enhanced by an elegant three-sided woodcut border. Most of the typography on the page is in black, with some text highlighted in red.

▲ **DECORATIVE TYPE** The book is lavishly produced with intricately decorated small capitals at the start of every section or "proposition." Delicately drawn botanical forms curl around the type like intertwining vines.

▼ **GEOMETRY** The first printed edition of Euclid's book was published in Venice in 1482 by a German, Erhard Ratdolt, as *Elementa Geometriae*. The spread shown here is typical of the book's design—neat geometric illustrations, precisely unified with the accompanying text.

Elements is one of the **most perfect monuments** of the Greek intellect. 🙶

BERTRAND RUSSELL, *A HISTORY OF WESTERN PHILOSOPHY*, 1945

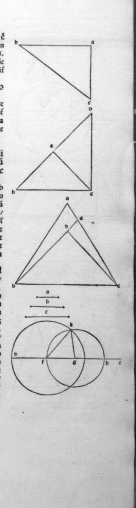

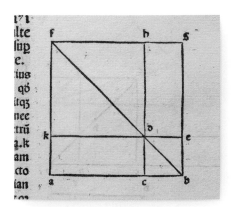

▲ **GEOMETRICAL DIAGRAMS** A key aspect of Ratdolt's edition is the inclusion of 420 precisely printed geometrical diagrams, yet it is debatable whether these were created from woodcuts or metalcuts. The simple line diagrams are integrated with the relevant text and are used to illustrate key points.

IN **CONTEXT**

It is generally believed that more than 1,000 different versions of Euclid's *Elements* have been published. Among the most innovative editions was an 1847 English publication produced by civil engineer Oliver Byrne. Byrne's edition presents Euclid's proofs in the form of pictures, using as little text as possible. He uses colored blocks to explain the first six books of Euclid's theories of elementary plane geometry and the theory of proportions, although Byrne insisted that "Care must be taken to show that color has nothing to do with the lines, angles, or magnitudes, except merely to name them." The book's striking use of color makes it a masterpiece of early graphic design.

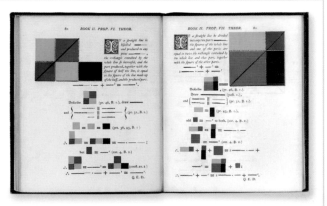

▲ **The vivid colors** of Byrne's edition of *Elements* were intended to help the reader understand by simplifying Euclid's complex concepts. Yet they also possess an abstract quality, and their crisply printed colors and shapes seem to prefigure twentieth-century graphics, such as the work of the Dutch abstract painter Piet Mondrian (1872–1944).

Nuremberg Chronicle

1493 ▪ PRINTED ▪ 18 × 12 in (45.3 × 31.7 cm) ▪ 326 PAGES (LATIN), 297 PAGES (GERMAN) ▪ GERMANY

SCALE

HARTMANN SCHEDEL

The _Book of Chronicles_ or the _Nuremberg Chronicle_, as it is more popularly known, presents an encyclopedic world history from a biblical and classical perspective, and is one of the most impressive and technically advanced examples of fifteenth-century printing. The book is extensively illustrated with over 1,800 woodcuts created from 645 different woodblocks (many of the pictures used the same woodblock), which are hand-colored in many copies. In addition to depictions of biblical and historical events, portraits, and family trees, the book includes views of nearly 100 different major cities throughout Europe and the Near East (many never recorded before), as well as a map of the world.

The _Nuremberg Chronicle_ is named for the German city in which it was published, then one of the Roman Empire's most prosperous cities. It was commissioned by two merchants, Sebald Schreyer (1446–1520) and Sebastian Kammermeister (1446–1503), and the printing and binding were entrusted to the celebrated printer Anton Koberger (1440–1513). Published in two different languages in 1493, the Latin text written by Hartmann Schedel was issued in Nuremberg on July 12, and the German translation appeared on December 23. About 1,500 Latin copies were made and around 1,000 produced in German. Today, the book is highly valued by collectors, with about 700 partial or entire copies held in institutes or private collections.

HARTMANN **SCHEDEL**

1440–1514

Hartmann Schedel was a humanist, physician, cartographer, and book collector who is best known for his groundbreaking work on the _Nuremberg Chronicle_.

Hartmann Schedel studied liberal arts at the University of Leipzig, then medicine at the Italian University of Padua in 1463. There, he encountered the humanist ideals of the Renaissance, which was then at its peak. He lived in Nördlingen and Amberg, southern German towns, from 1470 to 1480, then returned to Nuremberg, where he frequented humanist circles. Noting his eclectic knowledge, the merchant Sebald Schreyer and his son-in-law Sebastian Kammermeister commissioned him to write the world chronicle. Schedel compiled material from ancient sources for the book, many from his own library, which grew to hold 370 manuscripts and more than 600 books—a vast quantity, as printing had been invented only 50 years earlier.

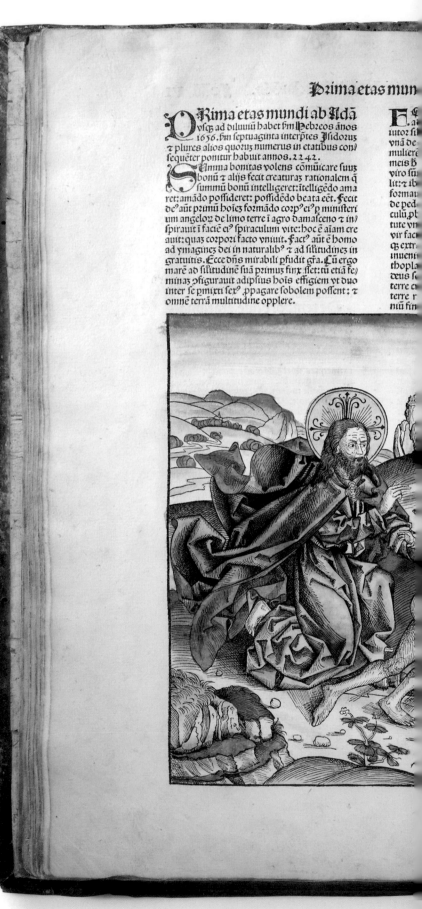

▼ **BIBLICAL VIEW** In creating his *Chronicle* Schedel drew on traditional Christian biblical understanding. In the early pages he presents the story of the world's creation. Adam and Eve, shown here, eat from the Tree of Knowledge in the Garden of Eden, from which they are expelled by an angel on God's orders. The tree is depicted as an apple tree—*malum* in Latin means both "apple" and "evil."

Etas prima mundi Folium VII

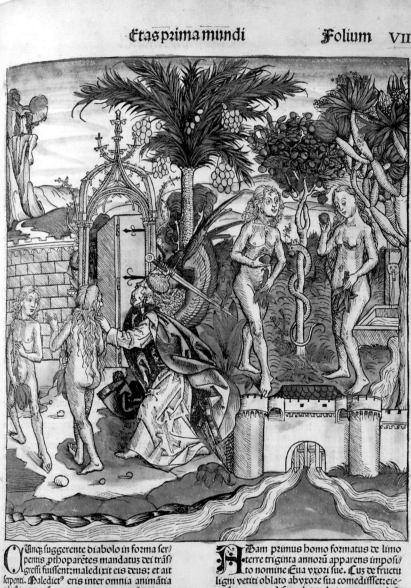

Cunq3 suggerente diabolo in forma ser/ pentis pthoparetes mandatus dei trãs/ gressi fuissent: maledirit eis deus: et ait serpenti. Maledict9 eris inter omnia animãtia z bestias terre: super pectus tuum gradieris: et terram comedes cunctis diebus vite tue. Muli/ eri quoq3 dirit. Multiplicabo erũnas tuas: z cõ/ ceptus tuos: in dolore paries filios z sb viri po testate eris: z ipe dominabitur tibi. Ade vo dirit Maledicta terra in opere tuo i laboribus come des ex ea: spinas z tribulos germinabit tibi: in sudore vultus tui vesceris pane tuo: donec reuer taris in terram de qua sumptus es. Et cũ fecissS eis deus tunicas pelliceas eiecit eos de paradi/ so collocans ante illum cherubin cum flammeo gladio: vt viam ligni vite custodiat.

Adam primus homo formatus de limo terre triginta annorũ apparens imposi/ to nomine Eua vrori sue. Cuz de fructu ligni vetiti oblato ab vrore sua comedisset: eie/ cti sunt de paradiso voluptas: in terram maledi ctionis vt iurta imprecationez domini dei. Adã in sudore vultus sui operaretur terram: et pane suo vesceretur. Eua quoq3 in erũnis viueret fili/ os quoq3 pareret in dolore. quam incomparabili splendore decorauit. eã felicitatis sue inuid9 ho stis decepit: cũ leuitate feminea fructus arboris temerario ausu degustauit: z virũ suũ in senteti/ am suam trarit. Deinde perizomatibus foliorũ susceptis ex delitiaz orto in agro ebron vna cuz viro pulsa erul venit. Tandem cuz partus dolo res sepius erpta fuisset cuz laboribus in senũ z tande in mortes sibi a domino predictã deuenit.

In detail

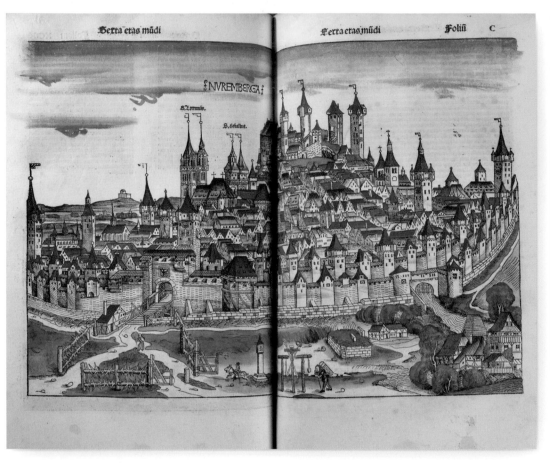

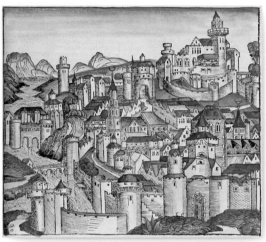

◄ **ACCURATE DEPICTIONS** This hand-colored illustration of Nuremberg is one of around 30 of the city views in the book believed to be an accurate portrayal. Many of the drawings are used several times to represent different places, but this one appears only once. With a population of 45,000–50,000, Nuremberg was one of the most important cities in the Holy Roman Empire and the center of Northern humanism.

▲ **REPEATED IMAGES** The city of Troy played an important part in Greek mythology, and Schedel recounted the story based on Homer's *Iliad*. Here the woodcut depicts Troy, but the identical image was also used for Ravenna, Pisa, Toulouse, and Tivoli.

IN **CONTEXT**

The *Nuremberg Chronicle* is highly significant in the history of print for its scope, its integration of text with lavish illustrations, and for its portrayal of the humanist movement, which had extended to northern Europe.

Humanism originated in Florence, Italy, as part of the Renaissance movement, which began around 1300. Italian scholars studied the writings and works of the Ancient Greeks and Romans, and wished to revive their cultural, literary, and moral philosophical traditions. Education, art, music, and science were key to this renewed way of thinking, and the invention of the printing press in around 1440 helped to record and disseminate these humanist ideals.

Humanism spread from Florence to the rest of Italy, then on to Spain, France, Germany, the Low Countries, and England, as well as eastern Europe. Schedel, who was exposed to humanist thought while studying in Italy, played a significant role in advancing the ideas of his humanist contemporaries, as he collected many of their thoughts in his *Chronicle*. His extensive library was the basis for his book—only a small percentage was his original work—and his most frequently referenced source was another humanist chronicle, *Supplementum Chronicarum*, by Jacob Philip Foresti of Bergamo. There is also evidence that Schedel did much to foment humanist thought by loaning the titles in his notable collection to other local scholars.

Schedel's outlook was shared by Sebald Schreyer, who commissioned the *Chronicle*. A businessman and patron of the arts, he was also a self-taught humanist.

▲ **Metal dyes** were gently hammered onto the pigskin cover to provide the elegant designs in a technique called blind printing. Pages were stitched together using cotton at five points.

▲ **COMETS** The *Chronicle* features the first printed images of comets—13 were depicted throughout the book, which cited appearances from 471–1472 CE. The comets are represented by only four varying woodblocks and are rotated according to the page layout.

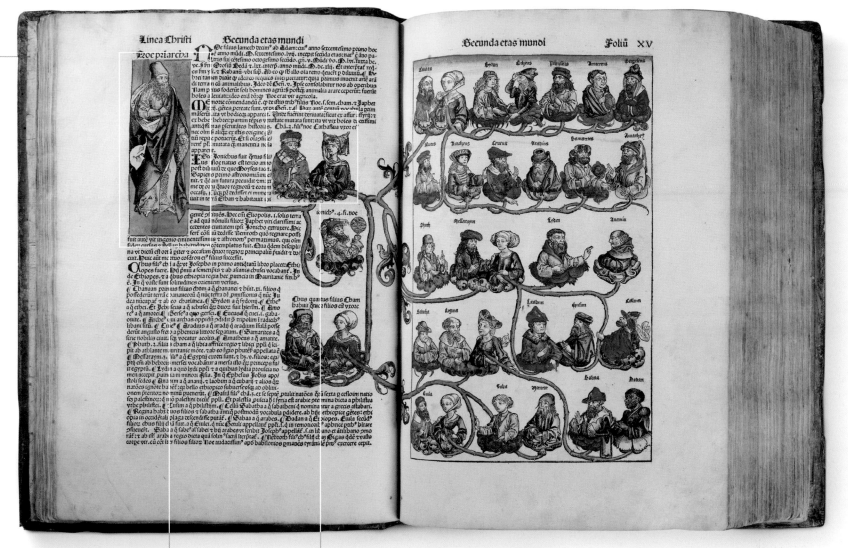

▲ **FAMILY TREE** The lineage of Jesus Christ, depicted in this family tree, is derived from St. Matthew's Gospel. On the left page the biblical character of Noah opens the text, while on the right are the ancestors of Christ. Hundreds of historical figures were portrayed in the *Nuremberg Chronicle*, although many of these illustrations were reused, with the same figures appearing up to six times to represent different people.

◄ **NOAH'S DESCENDANTS** The first generational branch from Noah is to Ham, his second son, who is portrayed along with his wife, Cathaflua. The *Chronicle* follows a medieval custom of beginning with the middle, rather than the eldest, child in detailing the order of offspring on a family tree.

◄ **THE PATRIARCH NOAH** The history of the *Chronicle* commences with the "First Age of the World" from Adam up until the Flood, detailing the building of the Ark by Noah and his family. The "Second Age of the World" traces events from after the Flood to Abraham's birth.

Visual tour

KEY

> **MAP OF THE WORLD** This woodcut map of the world is illustrated with Europe at its center. Although the book appeared a year after Columbus had landed in the Americas, it does not reflect this discovery, but shows only Africa, Europe, and Asia. Twelve heads depict the directions of various winds, knowledge of which was important for sailing, while Noah's three sons (who repopulated the earth following the Flood) encircle the map.

1

▲ **SIX-HANDED FIGURE** The *Chronicle* records that "In the histories of Alexander the Great one reads of people in India who have six hands," as this detail shows. Numerous other unlikely peoples are also described and illustrated over several pages. These oddities are to be found in exotic lands, as the text notes: "In Ethiopia, toward the west, some have four eyes," while in Eripia, in Greece, there are "people with necks like those of cranes, and bills for mouths."

2

▲ **JAPHETH TAKES EUROPE** After the Flood, Noah's three sons supposedly divided the then-known world of Asia, Europe, and Africa. Noah's firstborn, Japheth, who holds the northwestern corner of the map, was given the continent of Europe.

3

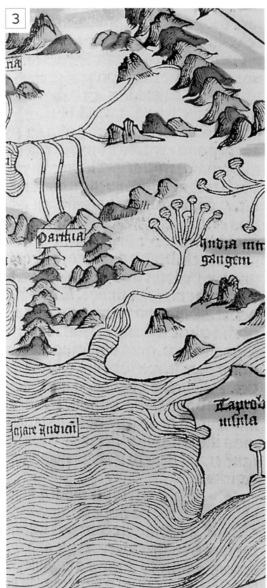

▲ **THE EAST** Compared to Europe, the map of Asia has far fewer annotations, with a huge swath of northern and central Asia simply labeled Tartaria. Other, now obsolete, place names include Scythia— a region of central Eurasia; Media and Parthia—both part of modern-day Iran; and Serica—a northwest area of China named perhaps for the silk it produced.

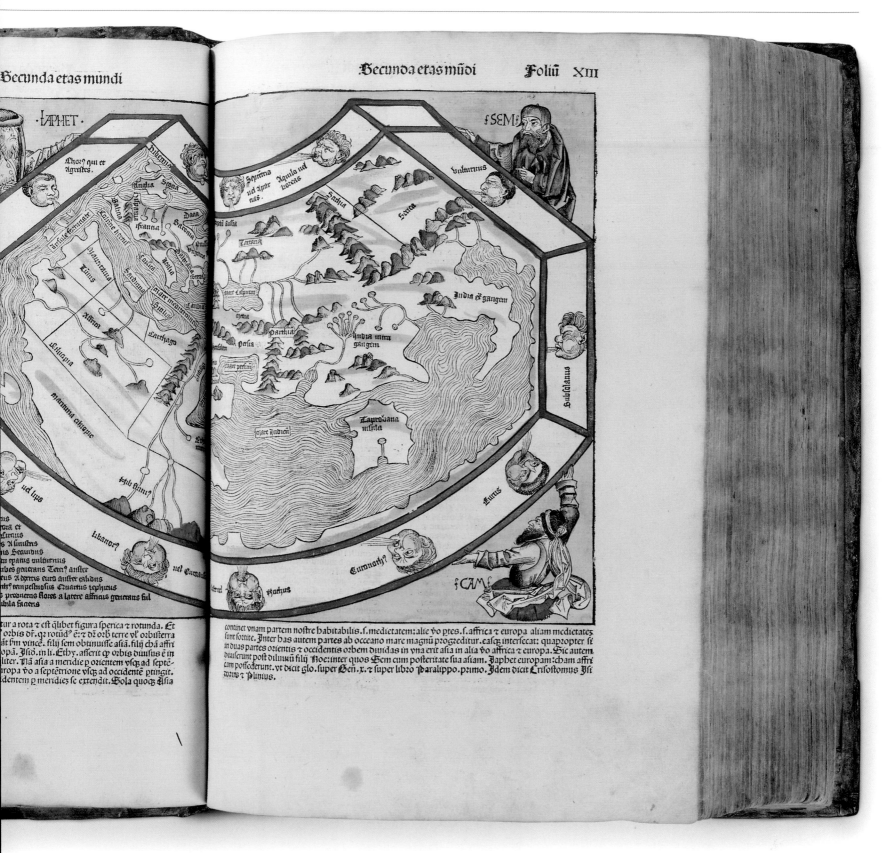

Divine Comedy

1321 (WRITTEN) 1497 (VERSION SHOWN) ▪ PRINTED WITH WOODCUT ILLUSTRATIONS ▪
12 × 8 in (32 × 21.6 cm) ▪ 620 PAGES ▪ ITALY

SCALE

DANTE ALIGHIERI

Dante's *Divine Comedy* is one of the greatest of all poetic works. Completed in 1320 while Dante was in exile from his native Florence and staying in Verona, it runs to over 14,000 lines, and tells the story of a poet's imaginative journey through the afterlife. Dante drew inspiration from a wide range of philosophies and ideas, including those of St. Thomas Aquinas (1225–74), to capture the medieval worldview.

The journey begins at nightfall in a supernatural forest, where the poet is met by the Roman poet Virgil, who has been sent by Dante's great love, Beatrice, to guide him. After an epic tour through the "Inferno" (Hell) and "Purgatory" to "Paradise", the poet eventually reaches "the Love that moves the sun and other stars."

The poem is structured around the number three to reflect the holy Trinity of God, the Son, and Holy Ghost. There are three parts, each part containing 33 cantos or songs, and the verses are in *terza rima*, an ingenious interlocking rhyming scheme of three-line verses.

DANTE **ALIGHIERI**

1265-1321

Dante Alighieri, universally known as Dante, was Italy's greatest poet. His seminal work, the *Divine Comedy*, marked the beginning of the Renaissance and inspired generations of poets.

Born in Florence, Dante was betrothed at age 12 to Gemma Donati, but fell in (unrequited) love with a Florentine woman, Beatrice Portinari. Beatrice died in 1290, at age 24, but would play a key role in the *Divine Comedy*. Dante included many other figures from his life, both friends and enemies. He became embroiled in the political battles dividing Florence between the Ghibellines (Holy Roman Empire) and Guelph (Pope) factions and was driven into exile around 1302. It was while in exile that he wrote his masterpiece.

Remarkably, Dante wrote the poem not in Latin, despite his classical education, but in his native Tuscan language (close to modern Italian). He did it with such skill that it is regarded as the most beautiful poetry ever composed. It not only revolutionized the way poetry was written, but also led to the adoption of Tuscan as the language of Italy.

▶ **TEXTUAL ANALYSIS** The *Divine Comedy* was so layered with meaning that early print editions included lengthy explanatory texts. Here, a small section from "Inferno" is surrounded by a dense commentary by scholar Cristoforo Landino.

In detail

▶ **VENETIAN EDITION** This 1497 edition combines the most popular commentary from Landino with 99 wood engravings by Matteo da Parma. The poem had previously circulated in manuscript form and then in print from 1472. Typical of the drawings in this edition, Dante and Virgil are illustrated twice here to demonstrate the progression of their journey.

▲ **HIGH ART** Matteo da Parma's work, shown here, first featured in the 1491 edition. For the Benali edition (1481), the artist chosen to illustrate it was the celebrated Sandro Botticelli.

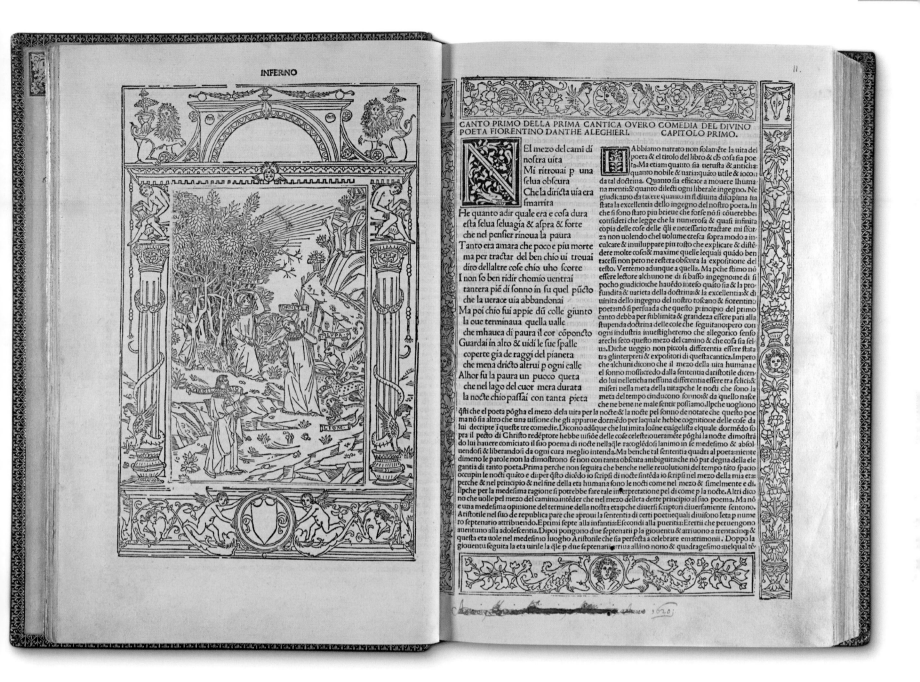

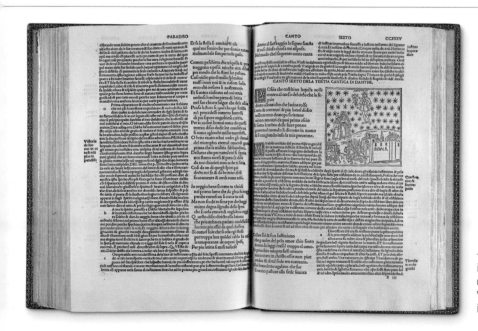

> ## Abandon all hope, ye who enter here. ,,

DANTE, *DIVINE COMEDY*

◄ **ILLUSTRATIVE LINKS** The simple images accompanying each canto were intended to be easily understood by contemporary readers. This image comes from "Paradise," reflected in its inclusion of a spirit among stars. Such Venetian woodcuts, with their highly expressive characters, had a great influence on woodcut styles emerging in Western Europe over the next century.

Hypnerotomachia Poliphili

1499 ▪ PRINTED WITH WOODCUT ILLUSTRATIONS ▪ 12 × 9 in (32.7 × 22.2 cm) ▪ 468 PAGES ▪ ITALY

SCALE

AUTHOR UNKNOWN

Often cited as the most beautiful illustrated printed book of the Italian Renaissance, *Hypnerotomachia Poliphili* (or *The Dream of Poliphilus*) was the masterpiece of printer and publisher Aldus Manutius. Printed in Venice in 1499, it was remarkable for the elegance of its 172 woodcut illustrations, and for the visual integration of type and image. Throughout the volume, there is an imaginative interplay between the function and position of text on the page—it flows freely around the illustrations and even forms shapes and patterns. The typeface was created by Manutius's typographer, Francesco Griffo (1450–1518), who recut one of his existing fonts, Bembo—named after Cardinal Pietro Bembo (1470–1547)—creating larger and lighter uppercase letters specifically for this book. Also notable is the treatment of double-page spreads, which Manutius often designed as a single entity rather than as separate pages, featuring paired images on both sides.

Manutius's printing house, which he founded in 1494, was called the Aldine Press. It was one of the most influential printing houses in Europe, renowned for its masterful innovations in type, illustration, and design. This volume, which is unique among Manutius's works for being the only illustrated book he ever printed, set a new standard for book design and typography.

The literary merit of *The Dream of Poliphilus* is debatable, however. Published anonymously, it is a story about a quest for lost love, written in a combination of Latin, a regional form of Italian, and a language of the author's own invention. It also featured some Greek and Hebrew, as well as the first Arabic words to appear in Western printing. It was consequently hard to understand, which in part contributed to the book's very poor sales.

▶ **DOUBLE-PAGE SPREADS** This spread shows the innovative nature of Manutius's design. The sequential images across the pages give an impression of movement, suggesting progression within the story. The pair of illustrations at the top of both pages feature parts of the same procession, as if it were marching through the book.

In detail

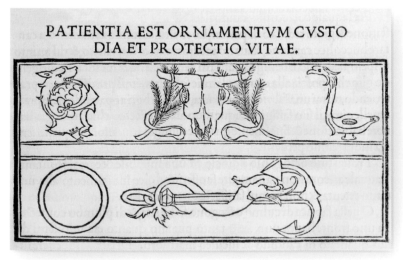

▲ **PRINTER'S MARK** The entwined dolphin and anchor became the emblem for the Aldine Press, with the dolphin symbolizing speed, and the anchor, stability. Manutius adapted the emblem from a coin he received from Cardinal Bembo bearing Emperor Titus on one side, and the dolphin and anchor on the other.

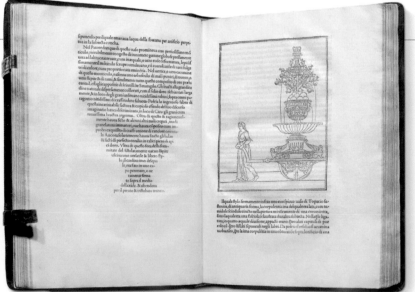

▲ **INNOVATIVE TYPE** The book shows an imaginative use of type to create shapes and patterns on the page. Forgoing traditional page layout, where the text extends to both margins, the text on the left-hand side of this double page has been typeset to form a goblet shape. At the time of publication the Bembo typeface (which is still in use today) was one of the most modern in appearance.

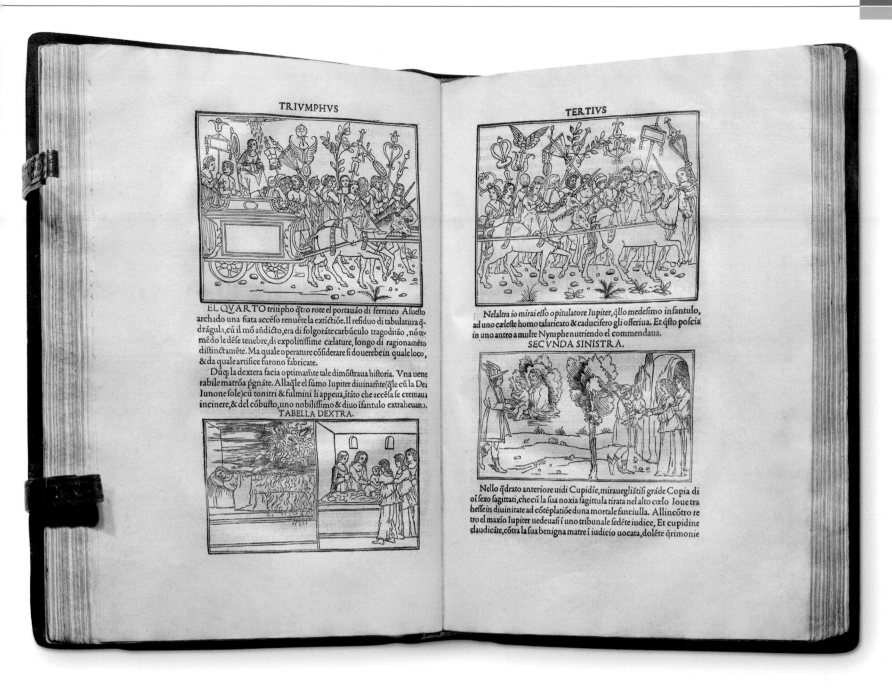

IN CONTEXT

The Dream of Poliphilus was published anonymously, and the author's identity has long been a matter of debate among scholars. However, most believe that it was written by a Dominican friar named Francesco Colonna (1433–1527). This theory is largely based on the ingenious Latin acrostic formed by the illustrated initial letters that begin each chapter of the book. Strung together, they spell out *Poliam Frater Franciscus Colonna peramavit*, which translates as "Brother Francesco Colonna loved Polia immensely." Colonna's name is mentioned only in the acrostic but, if he was indeed the author of the book he may have chosen to hide behind anonymity due to the erotic content of the story and his profession as a friar. Colonna was accused of immorality in 1516 and died in 1527, at the age of 94.

▶ **This ornately decorated letter "L"** at the start of one of the 38 chapters forms part of the acrostic that suggests that Francesco Colonna was the author.

▲ **LATIN TEXT** This sample of Latin text is from an illustration of a mausoleum. Appropriately the all-capital-letters text imitates the Latin inscribed by chisel on classical monuments, with rounded letters, such as "U," represented by a "V."

Harmonice Musices Odhecaton

1501 (FIRST PUBLISHED) 1504 (VERSION SHOWN) ▪ PRINTED ▪ 7 × 10 in (18 × 24 cm) ▪ 206 PAGES ▪ ITALY

SCALE

OTTAVIANO PETRUCCI

The publication of *Harmonice Musices Odhecaton* (*One Hundred Songs of Harmonic Music*) by publisher Ottaviano Petrucci was a breakthrough in the circulation of music. It was the first book of "polyphonic" music—where several melodic lines combine to produce harmonies—to be printed using movable type. This enabled the printing of multiple copies, and for the first time polyphonic music could be distributed widely.

The publication of the collection of 96 secular songs for three, four, five, and six instruments had a dramatic effect. Suddenly musicians had a valuable but affordable resource. The book, edited by the Dominican friar Petrus Castellanus in Venice, was reprinted in 1503 and 1504. Early editions did not have words, suggesting it was initially for instruments, and only later editions were for voices, too. A few songs were anonymous, but most were written by celebrated French-Flemish composers, such as Jacob Obrecht (1457–1505) and Loyset Compère (1445–1518). The emphasis was very much on these composers, and the book helped to ensure that their harmonic style came to dominate European music for the next hundred years.

Polyphony is now a common musical texture and one that is almost universal. But in the fifteenth century it was still a novelty, and a shock to ears used to plainchant—music in which all the voices sing an identical melody in unison. Indeed, some Church members regarded polyphony as the devil's music. Petrucci's book played a major part in gaining widespread acceptance for harmonies.

▶ **FOUR-PART HARMONY** The 1504 edition corrected errors from earlier editions. Here, four parts are printed over a spread, allowing a quartet to sing the prayer "Ave Maria" from one copy. Unlike modern notation, the notes are not split into bars. The Latin text above Petrucci's heart-shaped symbol threatens penalties for reprinting.

In detail

◀ **ELABORATE LETTER** Each song is introduced with an elaborate capital letter at the start of the first staff. In this example, the letter "U" introduces the song "Ung franc archier" ("A French archer") by the composer Compère. The letter is followed by a clef, a key signature, and time signature, much as in modern notation. For clarity, a blank staff separates the voices.

▶ **ODHECATON A** This is the title page of the first edition of Petrucci's polyphonic songs. The work contained many errors that were corrected in later editions. No complete volume of this edition survives today.

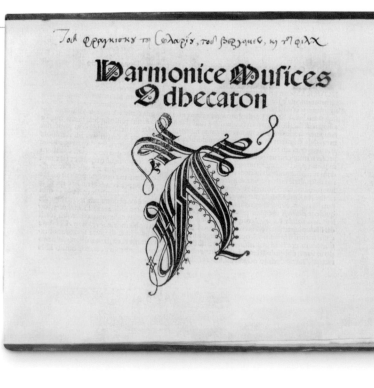

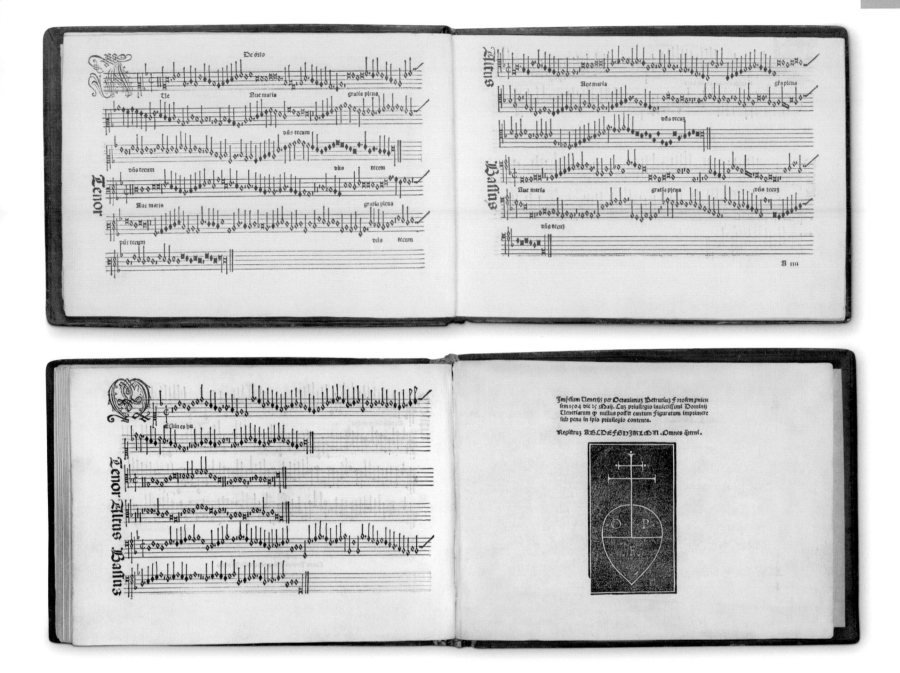

> To my longstanding friend the good Jerome; the best patron. This is the monument of your choice ...
>
> **PETRUCCI'S** DEDICATORY LETTER INTRODUCING *ODHECATON* TO GIROLAMO DONATO, A VENETIAN NOBLEMAN WHOSE BLESSING WOULD ENSURE THE BOOK WAS WIDELY ACCEPTED

OTTAVIANO **PETRUCCI**

1466–1539

Ottaviano Petrucci was an Italian printer and publisher. He was a pioneer in the publication of printed sheet music with movable type, and became famous for creating the first printed book of polyphonic music, the *Odhecaton*.

Born in Fossombrone, Italy, Petrucci lived there until 1490 when he went to live in Venice, a major printing center. In 1498 it is likely that the Doges (magistrate) granted his request for the sole 20-year license to print musical scores in the Venetian Republic. In 1501, Petrucci created the *Odhecaton*, modeling his work on the staff and notation system devised around the eleventh century by Benedictine monk Guido d'Arezzo. He left Venice at the outbreak of war in 1509 and returned to Fossombrone. As this town lay in the Papal States, he was granted a license to print by Pope Leo X, but later had his right revoked after failing to make any keyboard music. During the battles of the papacy, Petrucci's printing equipment is thought to have been destroyed by papal troops in 1516 when the town was invaded. In 1536 he returned to Venice, where he printed Greek and Latin texts. The first major publisher of sheet music, Petrucci produced 16 books of masses, five of motets (polyphonic chorals), 11 of *frottole* (comic songs), and six of lute music.

The Codex Leicester

1506-10 ▪ PEN AND INK ON PAPER ▪ 11 × 9 in (29 × 22 cm) ▪ 72 PAGES ▪ ITALY

SCALE

LEONARDO DA VINCI

The *Codex Leicester* is a collection of scientific writings recorded in a notebook by the Italian polymath, Leonardo da Vinci. One of several notebooks compiled by da Vinci, the Codex Leicester is one of the most remarkable artefacts of the Renaissance. The *Codex* consists of 18 parchment sheets, each folded in two. The result is 72 pages of densely written text, with a series of over 300 ink-drawn illustrations, some hastily sketched in the margins, others more obviously considered and detailed. The work highlights the interest that Leonardo took in the world around him, as well as his belief that it could only be explained by precise observation. As such, the *Codex* is a clear precursor to the scientific revolution of the seventeenth and eighteenth centuries.

Leonardo produced about 13,000 such pages, of which approximately half have survived in similar notebooks. Their subjects range from academic treatments of paintings to studies of human anatomy, designs for flying and siege machines, and architecture. The principal subject matter of the *Codex Leicester* is water and its properties, but it also touches on a range of other topics. These include why the sky is blue and that mountains may once have been underwater, as well as subjects such as meteorology, cosmology, shells, fossils, and gravity.

The *Codex Leicester* takes its name from its acquisition in 1719 by an English nobleman, the Earl of Leicester. It is sometimes also known as the *Codex Hammer*, a reference to the American, Armand Hammer, who bought it in 1980 before selling it to Bill Gates for $30.8 million in 1994. Today it is not just the most expensive written work in the world, but the only one of Leonardo da Vinci's numerous notebooks to be kept in the United States.

▶ **PRECISELY WRITTEN TEXT** Though littered with corrections and amendments, and jotted, marginal illustrations, Leonardo's neat handwriting, shown here, is typical of the *Codex*. The diagram on the bottom-right page illustrates the luminosity of the moon, with Leonardo showing, correctly, that the light of the moon is no more than a partial reflection of the light shone on it by the sun.

> You will not laugh at me, Reader, if I make big jumps from one subject to another …

LEONARDO DA VINCI, THE *CODEX LEICESTER*

In detail

> It's an inspiration that one person ... kept pushing himself that he found knowledge itself to be the most beautiful thing. "

BILL GATES, CURRENT OWNER OF THE *CODEX LEICESTER*

LEONARDO **DA VINCI**

1452–1519

Italian polymath Leonardo da Vinci was one of the greatest creative minds in history. Best known as an artist and the painter of the *Mona Lisa*, he was also a talented sculptor, engineer, inventor, and scientist.

Born near the town of Vinci in Tuscany, Leonardo da Vinci was apprenticed aged 15 to the renowned Florentine artist Andrea de Verrocchio, and qualified in 1478. He spent the next 17 years in Milan as a sculptor and artist, but also practicing engineering and architecture. While in Milan he painted *The Last Supper*, a mural at the refectory of Monastery Santa Maria delle Grazie. After 1499, Leonardo returned to Florence where he painted his most famous portrait, the *Mona Lisa*. Although Leonardo is known primarily as an artist, the versatility of his brilliant mind is demonstrated in his collection of unpublished notebooks, including the *Codex Leicester*, which are filled with inventions and theories on a vast array of subjects, from anatomy to geology. As such Leonardo is regarded as being the finest example of the "Renaissance Man"—one with diverse talents and curiosity about multiple subjects. He died in France in the service of the French king, François I.

▲ **MIRROR WRITING** Leonardo composed the *Codex* in his characteristic mirror writing, where the text is written in reverse, and intended to be read from right to left. The reason for this is not known, as he only used the technique for his private works. It may have been an attempt to keep his works secret by making it harder to read.

▲ **MARGINAL ILLUSTRATIONS** Leonardo was interested in showing his ideas, as much as he was in explaining them, and he frequently added sketches to the margins of his work. On this page, he explores how water flows, and suggests experiments designed to study erosion. Among other things, his illustrations on this page consider the passage of water around different arrangements of obstructions.

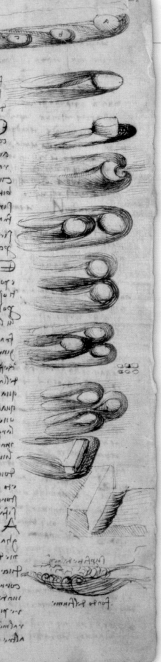

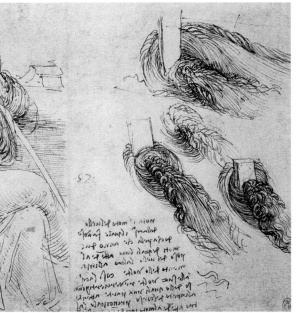

◄ **HAPHAZARD ENTRIES** The seemingly chaotic quality of the notebooks is exhibited in this unlikely juxtaposition of an aging man sitting on a rock (age was a recurring feature in Leonardo's work), with studies of water flowing, often violently, past obstacles. The capacity of water to erode even the most resistant objects was a subject that fascinated him.

► **SEESAW STUDY** Leonardo's hastily drawn image of two men on a seesaw was intended to show the impact of weight and distance on equilibrium. It also made a wider point: that Earth's hemispheres had unequal masses. Leonardo believed that the heavier hemisphere was sinking to the center, causing rocks of the lighter hemisphere to rise up, forming mountains.

Vier Bücher von menschlicher Proportion

1528 ▪ PRINTED WITH WOODCUT ILLUSTRATIONS ▪ 11 × 8 in (29 × 20 cm) ▪ 264 PAGES ▪ GERMANY

ALBRECHT DÜRER

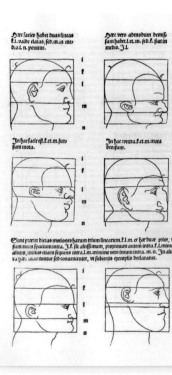

SCALE

Translated as *Four Books on Human Proportion*, Albrecht Dürer's seminal work is an illustrated exploration of the human form through all the stages of life. It built on anatomical observations from antiquity, such as those of the first-century BCE Roman architect Marcus Vitruvius, and of Dürer's own contemporaries, such as Leonardo da Vinci. Unlike Vitruvius, who believed in an ideal set of human proportions, Dürer felt that the beauty of form was a relative quality. He created a system of anthropometry (the scientific study of measurements and proportions of the human body) that would enable artists to draw people of all shapes and sizes, as close to nature as possible.

There were woodcut illustrations on almost every page: around 136 full-length drawings of the human figure (men, women, and infants), as well as smaller proportional woodcuts detailing limbs, heads, hands, and feet, and four fold-out diagrams. To make the work accessible to a wider audience it was written in German, rather than Latin, using an ornate Gothic type in double columns.

Dürer's work existed only in manuscript form until his death in April 1528—it was published posthumously by his wife and a friend, Willibald Pirckheimer, in October 1528 as four books. The first two cover anthropometry; the third considers variations, such as over- and underweight people, and irregular physical features; the fourth shows the human body in motion. The result was the first published work that attempted to harness the science of human anatomical proportions and apply it to aesthetics.

▶ **MEASURING STICK** Dürer devised a "canon of proportion" for portraying the idealized human form. Here the artist shows female models holding a measuring stick against which each section of the body could be measured and proportions gauged. In the book Dürer also pioneered the use of cross-hatching in his wood engravings to represent shade and shadows.

In detail

▲ **TITLE PAGE** Albrecht Dürer's distinctive monogram, "AD," appears on the title page of the original publication.

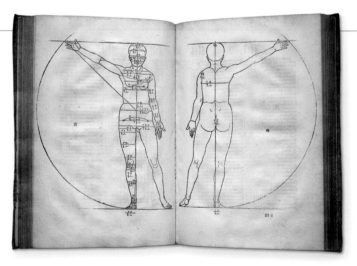

▲ **CIRCLES** Dürer not only illustrated the book, but wrote and designed it, too. Some of his woodcuts follow Leonardo's approach to the study of anatomy, and depict figures within a circle with the navel indicated as the central point of the human adult. These diagrams show the measurements of the human form. Different parts of the body were described in more detail in charts on the following pages. Dürer's style of drawing was later adapted for use in books on medical anatomy.

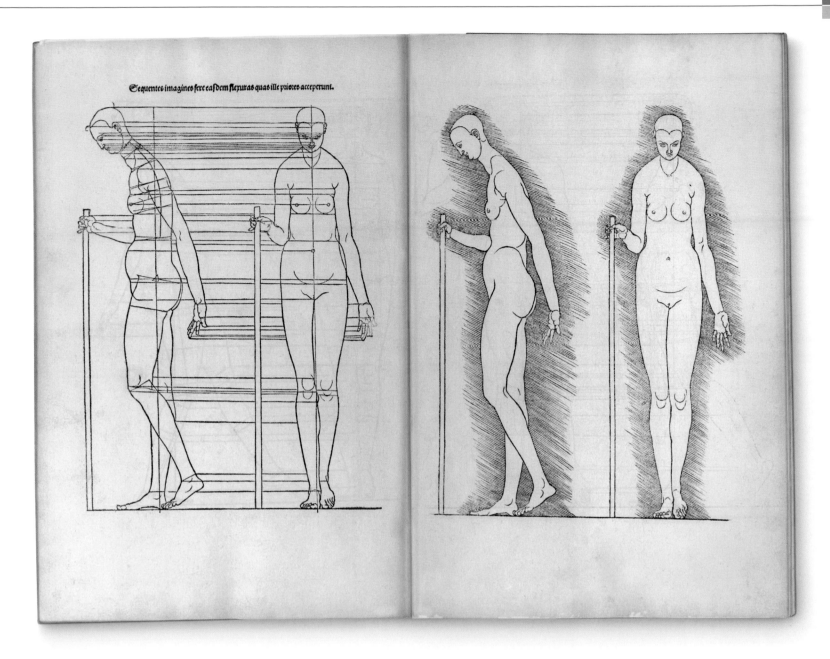

Sequentes imagines fere eafdem flexuras quas ille priores acceperunt.

> I hold that **the perfection of form** and **beauty** is contained in the sum of **all men.** 🙶

ALBRECHT DÜRER, *VIER BÜCHER VON MENSCHLICHER PROPORTION*

◄ **USING GRIDS** In the third book Dürer adjusts the "proper" proportions of the human form using mathematical rules and grids. This page focuses on the human head and shows the various proportional possibilities of facial features using a grid-box. These grids serve to demonstrate the unique structure of the human head, for example highlighting different nose lengths and shapes.

ALBRECHT **DÜRER**

1471-1528

Painter, printmaker, and mathematician, Albrecht Dürer is widely acknowledged as the greatest artist of the German Renaissance. Credited with some of the most sophisticated woodcuts ever produced, his graphic work had the greatest influence.

As a child Dürer showed prodigious artistic talent and was apprenticed at the age of 15 to the eminent painter and printmaker Michael Wolgemut. He furthered his studies between 1490 and 1494 when he traveled to Northern Europe and Alsace. Returning to Nuremberg in the summer of 1494, he married Agnes Frey before leaving to spend a year in northern Italy. During a second trip to Italy (1505-07) Dürer encountered the work of Leonardo da Vinci, among other artists, and deepened his knowledge of human anatomy and proportion, which he continued to study for the rest of his career. On his return to Nuremberg he furthered his knowledge of geometry, mathematics, Latin, and humanist literature, although he still painted, becoming Court Painter to Emperor Maximilian in 1512. He died in Nuremberg on April 6, 1528, while still working on *Vier Bücher von menschlicher Proportion*. He left behind a huge body of work, from drawings and paintings to woodcuts and treatises.

Il Principe

1532 ▪ PRINTED ▪ 8 × 5 in (21 × 13.5 cm) ▪ 50 PAGES ▪ ITALY

NICCOLÒ MACHIAVELLI

SCALE

More than 500 years after it was conceived, *Il Principe* (*The Prince*) is still considered one of the most important treatises on political power. A handbook for politicians, it advises that rulers should be amoral in order to serve their own ambitions and overcome their enemies. It was written around 1515 and published in 1532, five years after the death of the author, Niccolò Machiavelli. The book was so influential that the author's name spawned the word "Machiavellian," meaning unscrupulous and cunning.

Machiavelli, a foreign policy envoy for the regional state of Florence, wrote from experience. The main premise of his book, a relatively short text comprising 26 chapters, is that the well-being of the state is a priority, and that a ruler is justified in using any means to achieve that end—betraying others, manipulating human weakness—but being consistent no matter what the cost. The book was also intended as a blueprint for how Italy, weakened by internal fighting, could be restored to a strong position within Europe. In an attempt to ingratiate himself with the ruling Medici family, Machiavelli dedicated his book to the young prince Lorenzo de' Medici. A copy was given to the prince,

> ### NICCOLÒ **MACHIAVELLI**
> #### 1469–1527
> Credited with founding the science of modern politics, Niccolò Machiavelli changed the course of history with his theories on power, and the ruthlessness required of a leader.
>
> Born during the height of the Renaissance in Florence, Machiavelli studied law, but became a diplomat working on behalf of his native city. This was a time of unrest in Italy, with its different regions fighting for dominance. In 1494 the ruling Medici family was expelled and the Republic was restored, during which time Machiavelli acted as an envoy in Italy and abroad. Machiavelli also worked for an enemy of the Medici family, and when they returned to power in 1513 Machiavelli was arrested and tortured on suspicion of conspiracy. He was released from prison soon after but confined to his family estate outside Florence, his political career over. Machiavelli wrote *Il Principe* at this time, as well as a play *The Mandrake*. He died in poverty.

and handwritten copies were circulated privately. The book only acquired its title on publication nearly 20 years later. Considered shocking and immoral by critics—Pope Paul IV put it on the Vatican's Index of Forbidden Books in 1557—it remains one of Western civilization's most influential texts. Its cynical chapters have inspired despots and tyrants, such as Hitler and Stalin, for over five centuries.

◀ **TITLE PAGE** The book's first edition bears a dedication to Lorenzo di Piero de' Medici, ruler of the city-state of Florence from 1513 to 1519. While Machiavelli hoped this inscription would win him favor with Medici, historians have found no evidence that the prince ever read the book.

▶ **ITALIAN TYPESETTING**
Il Principe is a fine example of sixteenth century Italian Renaissance printing, which was much more technically advanced than in Northern Europe. This edition is from the printing press of Antonio Blado de Asola in Rome, a renowned Italian printer.

IL FINE DEL PRINCIPE.

▲ AN ELEGANT APPEARANCE
Although controversial, *Il Principe* was widely admired for technical reasons: firstly, for its accomplished use of Italian grammar, the rules for which had only just been formalized; and secondly, for the page design, which reflected the Renaissance ideals of harmony and symmetry. Text is mostly centered and justified, with tightly controlled spacing, while sections arranged in inverted pyramids draw the eye downward. Wide margins were typical, to allow for the reader's notes.

> … since **love and fear** can hardly exist **together,** if we must **choose** between them, it is **far safer** to be feared than **to be loved.**

NICCOLÒ MACHIAVELLI, *IL PRINCIPE*

▲ ARREST OF A TRAITOR A proclamation read by the town crier of Florence in 1513 (recently found with a drawing of the trumpet the town crier used, left) declares the arrest of Niccolò Machiavelli on suspicion of plotting to overthrow the de Medicis. He was later released, and the following year began writing *Il Principe*.

IN CONTEXT

Il Principe provided the basis for some important principles adopted by the founding fathers of the United States. Leadership based on merit, not birthright, is enshrined in the Declaration of Independence, inspired by Machiavelli's idea that "he who obtains sovereignty by the assistance of the nobles maintains himself with more difficulty than he who comes to it by the aid of the people."

▲ John Trumbull's painting *Declaration of Independence* shows the Founding Fathers, all of whom had read Machiavelli's ideas on power in *Il Principe*.

Epitome

1543 ■ PRINTED ON VELLUM AND PAPER ■ 22 × 14 in (55.8 × 37.4 cm) ■ 27 PAGES ■ SWITZERLAND

SCALE

ANDREAS VESALIUS

Setting a new standard for anatomical illustration, the *Epitome* by Andreas Vesalius combined scientific accuracy with exquisite artistry in a way not seen before. It was a shortened version of his larger work *De humani corporis fabrica libri septem* (*On the Fabric of the Human Body in Seven Volumes*), a comprehensive investigation of the workings of the human body. Intended as a handy guide for medical students, the *Epitome* was printed in a large format that allowed the illustrations to be hung as wall charts, and had minimal text compared to the complex seven-volume version of 80,000 words.

Vesalius's masterful work is particularly remarkable for its innovative layout. The first half of the book shows the human body being gradually built up from its basic components. The skeleton is depicted first, then organs, muscles, and skin are added to it in layers, culminating in complete male and female nudes in the center of the book. If the reader instead started at the center of the book and worked toward the beginning, they could replicate the process of a dissection. The book also included pages to cut out and assemble into a 3D paper model.

Published in June 1543 this book was four years in the making. The illustrations are thought to have been commissioned by Vesalius from the Venice workshop of the artist Titian (1490–1576). When ready, Vesalius traveled to Basel in Switzerland, then the publishing center of Europe, where he chose printer Johannes Oporinus to engrave and print the book. Oporinus was one of the best at his trade—meticulous and innovative. Most of the woodblocks he produced for the book were housed in the Bavarian State Library in Munich, Germany, but were destroyed during Allied bombing in 1944.

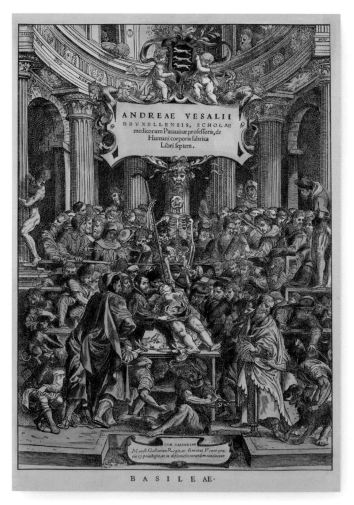

▲ **FRONTISPIECE** Considered one of the finest engravings of the sixteenth century, the frontispiece shows author and publisher Vesalius at the center, surrounded by his students and fellow physicians, along with nobles and church dignitaries. Vesalius indicates his break with convention by demonstrating his knowledge of dissection on the cadaver next to him, rather than by lecturing from his chair.

ANDREAS **VESALIUS**

1514-1564

Flemish physician and surgeon, Andreas Vesalius emerged as the most gifted anatomist of the Renaissance, reviving the practice of human dissection after it fell from favor during the Middle Ages.

Born in Brussels and educated in Paris, Vesalius studied medicine at the University of Padua, Italy. It was one of the few institutions that promoted human dissection, a technique that had all but disappeared after the fall of the Roman Empire as it was considered immoral under the codes of medieval Catholicism. Unlike most medical practitioners at the time, Vesalius advocated the use of dissection as the key to understanding how the body worked.

At the age of 23 he became Professor of Surgery at the University of Padua. He dissected cadavers in front of his students, and made new discoveries that contradicted and challenged existing theories about the human body, most notably those of the Greek physician, Galen of Peramum (129–c.216).

In 1543 Vesalius published his groundbreaking work, *De humani corporis fabrica libri septem*, which became the definitive volume on human anatomy. He was made physician to the Holy Roman Emperor, Charles V, and later to his son.

> these things **should be learned,** not from pictures but from **careful dissection** and examination **of the actual objects**

ANDREAS VESALIUS, *DE HUMANI CORPORIS FABRICA LIBRI SEPTEM,* 1543

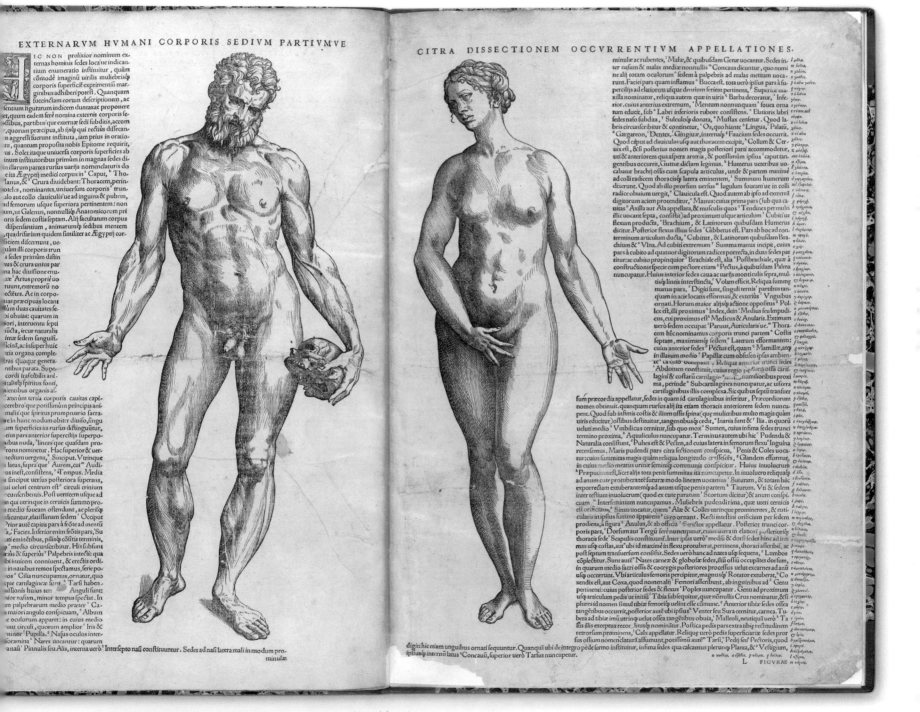

▲ **THE CENTERPIECE** At the center of the book are male and female nude figures drawn in the style of classical Greek sculpture. The typesetting flows around them, creating an impression of balance and harmony. The male figure is depicted in a pose reminiscent of Hercules, with a full beard and sturdy muscular body, holding a skull in his left hand. His female counterpart is posed like a classical Venus, with her hair braided and pinned up, her eyes downcast, and her right hand positioned to maintain her modesty.

In detail

UPPERMOST MUSCLE LAYERS Apart from the female figure of the centerpiece, all other dissected figures in the book are male. They are posed in an active fashion with the arms outstretched, the legs in a natural stance, and the head in varying positions. This figure shows the two uppermost layers of muscle in detail, revealing how they overlap and fit together.

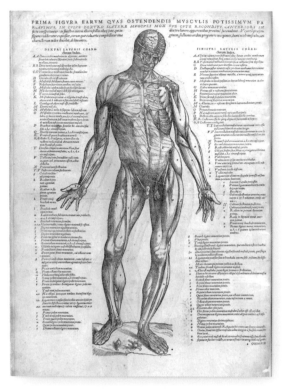

FURTHER DISSECTION This figure shows the next stage of dissection. The upper (superficial) layers of muscle have been stripped away to reveal the deeper muscles beneath. An additional lower layer of muscle has been peeled away on the right-hand side of the figure to enable the reader to see deeper still into the body.

END OF SERIES The final figure in the series (when reading from the center to the front of the book) is a full skeleton. The ribcage is shown opened up and peeled back at one side to reveal its curved structure. In the skeleton's left hand is a skull, which has also been opened up. The skull is supported in a casual pose against the figure's hip.

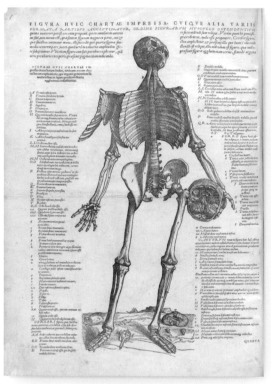

DIGESTIVE SYSTEM Continuing on from the nude figures at the center of the book, Vesalius provides meticulously detailed charts of the digestive system, with intricately drawn organs.

FINE DETAILS Vesalius reveals the tightly packed tube of the small intestine within the surrounding loop of the large intestine.

CLEAR IDENTIFICATION This section is carefully angled to reveal the structure and position of the kidneys, liver, and gallbladder inside the upper abdomen.

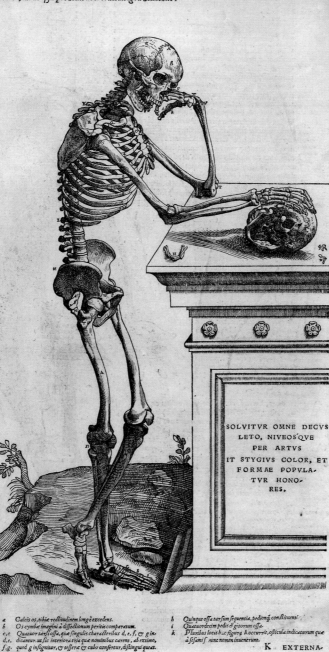

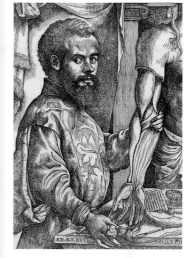

▲ DETAIL FROM THE FRONTISPIECE
Vesalius believed that medicine had suffered because physicians had lost their practical knowledge of the body. The frontispiece, showing Vesalius holding a cadaver during a dissection, shows the hands-on approach he favored for his research, and indicates that the images and information in the book are a direct result of the author's own observations.

◄ NATURAL POSTURE Striking a thoughtful pose beside a grave, this skeleton is apparently contemplating the certainty that all humans die. It is positioned in a natural way, which demonstrates how all of the bones fit together and work to make the body move. Vesalius was the first to depict a male skeleton with 24 ribs, countering the biblical view that God took a rib from Adam to make Eve, meaning men had one rib fewer than women.

I am **not accustomed** to saying anything with **certainty** after only one or two **observations**.

ANDREAS VESALIUS

Cosmographia

1544 ▪ PRINTED WITH WOODCUT ILLUSTRATIONS ▪ 12 × 8 in (32 × 20 cm) ▪ 1,280 PAGES ▪ GERMANY

SEBASTIAN MÜNSTER

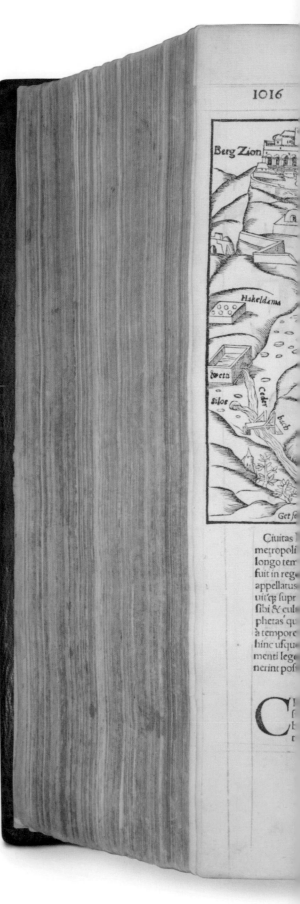

1016

SCALE

One of the most popular releases of the sixteenth century was Sebastian Münster's *Cosmographia*, the first visual guide to the known world to be published in the German language. In the mid-1500s the spirit of the Renaissance was still strong in northern Europe, and prosperous Germany led the field of publishing, catering for a wealthy audience hungry for knowledge. The *Cosmographia* was based on a work written by the Greek mathematician Ptolemy (100–168 CE) in around 150 CE, but was updated with more recent material from travelers. Encyclopedic in its scope, the six-volume publication set the standard for geographic illustration. Maps are a key feature of the book. Münster, who is considered one of the finest cartographers of the age, drew detailed maps of the continents and major European cities, and collaborated with over 100 talented artists to fill *Cosmographia*'s pages with views of countryside, towns and villages, history, industry, and customs. In an age when information spread slowly and new discoveries about the world took decades or longer to establish, the book remained influential throughout the sixteenth century.

Cosmographia was widely cited by other mapmakers and scholars, and sections of the text were reprinted by publishers long after the book's initial publication. Although Münster died in 1550, his stepson Heinrich Petri took over the job of refining and republishing new editions. Around 40 different editions were published between 1544 and 1628, including translations into Latin, French, Italian, and Czech.

SEBASTIAN **MÜNSTER**

1488–1552

Münster was an outstanding academic, and earned an extraordinary reputation as a theologian, lexicographer, and cartographer. In returning to the mathematical principles adopted by Ptolemy, he helped to restore cartography as a scientific endeavour.

Born in Nieder-Ingelheim on the Rhine River, Münster's education shaped how he would approach the job of mapmaking. After studying arts and theology at Heidelberg University, he immersed himself in mathematics and cartography under the tutelage of mathematician Johannes Stöffler. He first trained as a Franciscan monk, but then converted to Lutheranism in order to become a professor of Hebrew at the University of Basel, where he eventually settled in 1529.

Münster was the first cartographer to make separate maps of each continent, and to list the sources he had used to draw them. While earlier mapmakers, such as Ptolemy, had taken a more empirical view of the world, maps produced during the Middle Ages were based largely on religious beliefs. At a time when most of his peers were simply making copies of Ptolemy's antiquated maps, Münster made his as accurate as possible by incorporating the recent discoveries of European explorers. His most famous publications were his reworkings of Ptolemy's *Geographia* (1540), and his own work, *Cosmographia* (1544).

▼ **CITY VIEWS** *Cosmographia* showcased Münster's cartography skills and those of the artists whose cityscapes and country views filled its pages. Here, the distinctive dome of the Mosque of Omar in Jerusalem takes center stage, while other annotated features appear in the surrounding landscape, including Mount Zion in the top left-hand corner.

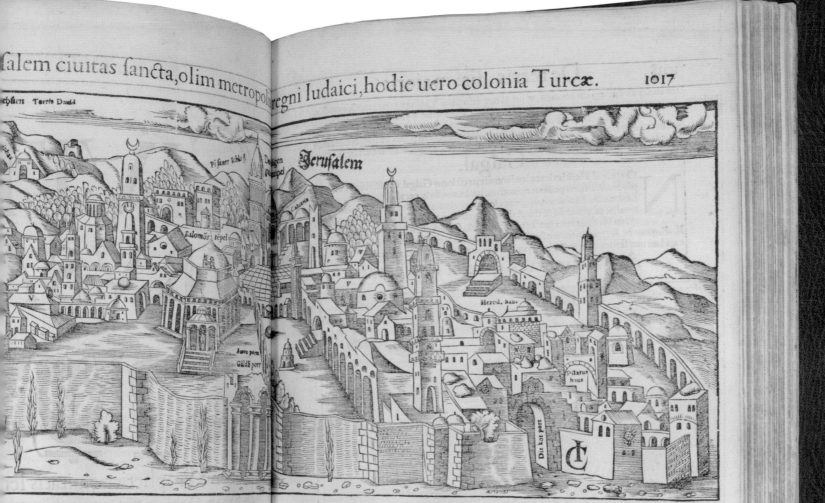

salem ciuitas sancta, olim metropol regni Iudaici, hodie uero colonia Turcæ. 1017

e multa tēpora sub rege Malkizedec uocata fuit Salem, fuitꝗ tunc
i regni: deinde uero dicta fuit Iebus à Iebusæis incolis, quos Iudæi
m terram eijcere nequiuerūt, donec Dauid mortuo Saule unctus
ortalicio huius ciuitatis, monte Zion, qui & postea ciuitas Dauid
is Iebusæis, trāstulit regiam sedem ex Hebron in Ierusalem, dilica
regni eius: quin et dominus deus hanc unicam in uniuerso mundo
ns nomen suum in medio eius, iubens cōstrui in ea templum, pro-
cerēt, hinc salutem prodituram in uniuersum mundi m. Quantam
icitatem & infelicitatem habuerit usque ad Christum passum, atꝗ
, nemini non constat, qui saltem historias & oracula ueteris testa-
undè multa ex historijs adduximus, quæ ei & habitatorib. eius eue
Romanis factam.

Iericho.

ius ciuitatis in Iehosuæ libro. Ager eius cōiunctus olim ualli syluæ
i hodie est mare mortuū, ostendit eximiam fertilitatē terræ quā ha
buersione Sodomæ & Gomorrhæ Creuit enim in sola Hierichun
i herba, à qua urbs nomen illud est sortita. Nam sonat יריחו He
braica

braica uox bonum odorē. De hoc Plinius sic scribit: Omni
bus odoribus præfertur balsamum, uni terræ Iudææ conces-
sum. Quondam in duobus tantū hortis, utroque regio, cre-
uit. Malleolis seri dicitur, uincitur ut uitis, nec sine admini-
culis se sustinet. Properat nasci, intra tertiū annum fructum
ferens. Folium proximū rutæ perpetua coma. Inciditur ui-
tro, lapide, osseis ue cultellis. Ferro lædi uitalia, odit. Inciden
tis manus libratur, ne quid ultra corticē uioler. Succus è pla-
ga manat, quem opobalsamum uocāt, eximiæ suauitatis, sed
tenui gutta. Alexandro magno ibi res gerente, toto die æsti
uo unam concham impleri iustū erat. Præcipua gratia est la
chrymæ, secūda semini, tertia cortici, minima ligno. Cæterū
postꝗ Ro. princeps Titus destruxit Ierosolymā in ultionē
mortis Christi & Iudæos in perpetuū exilium adegit, balsa-
mi quoꝗ herba & plantatio trāslata est in Aegyptū: de quo
& iuxta urbem Cairi nonnihil dicam. De rosis Hierichunti
nis quæ ad terras nostras portātur, sciendū, ꝗ illæ non in agro Iericho, sed ultra Iordanē è regio-
ne Iericho distantia quatuor milliariorū in Arabia crescunt. Habent autem denominationem à

Balsamum.

Rosa Iericho

YY 5 Iericho,

In detail

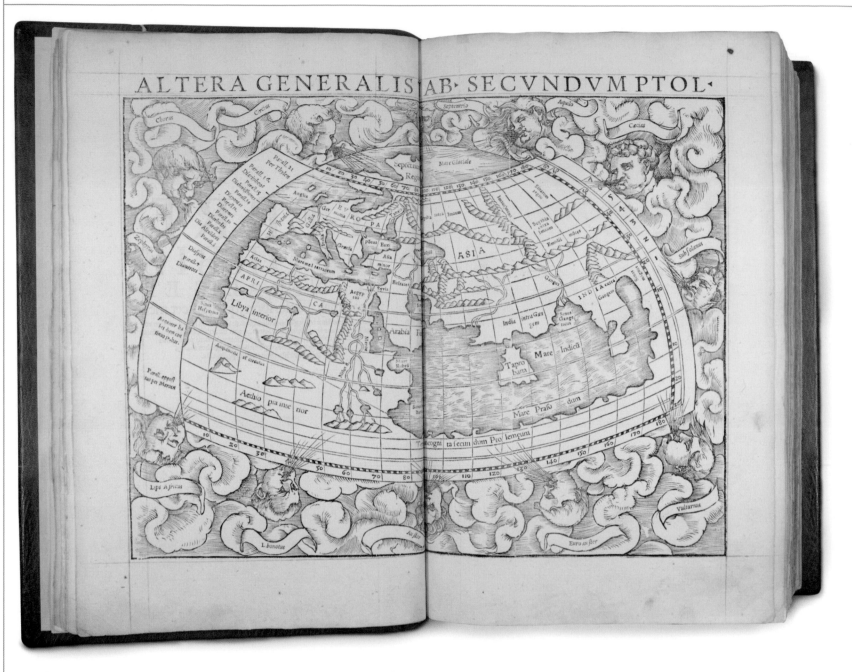

ALTERA GENERALIS·AB·SECVNDVM PTOL·

RELATED **TEXTS**

Before Münster, the most influential mapmaker was Claudius Ptolemaeus (100–170 CE). Ptolemy, as he was better known, lived in Egypt but wrote in Greek, and is thought to have been of Greek heritage. A mathematician, astronomer, and geographer, Ptolemy established geography as a science, setting out the techniques required for accurate mapmaking. One of his chief innovations was in calculating the size of countries mathematically. It would take almost a millennium before Ptolemy's work became known in Europe, when Byzantine scholars copied and translated his maps. Sebastian Münster's *Geographica* was one of the most reliable versions of Ptolemy's work to be produced during the Renaissance.

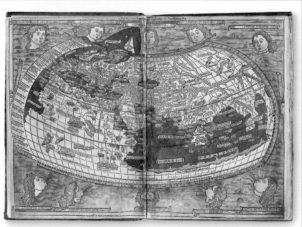

▲ **Lines of longitude and latitude** on Ptolemy's map give an impression of Earth's spherical surface.

▲ **PTOLEMIC STYLE** Münster styled his world map after that of Ptolemy, who had produced the world's first atlas in the second century CE. Here Africa is depicted as extending east from the equator to meet Asia, making a landlocked Indian Ocean. The continents are surrounded by the 12 ancient winds, which represent different points of the compass.

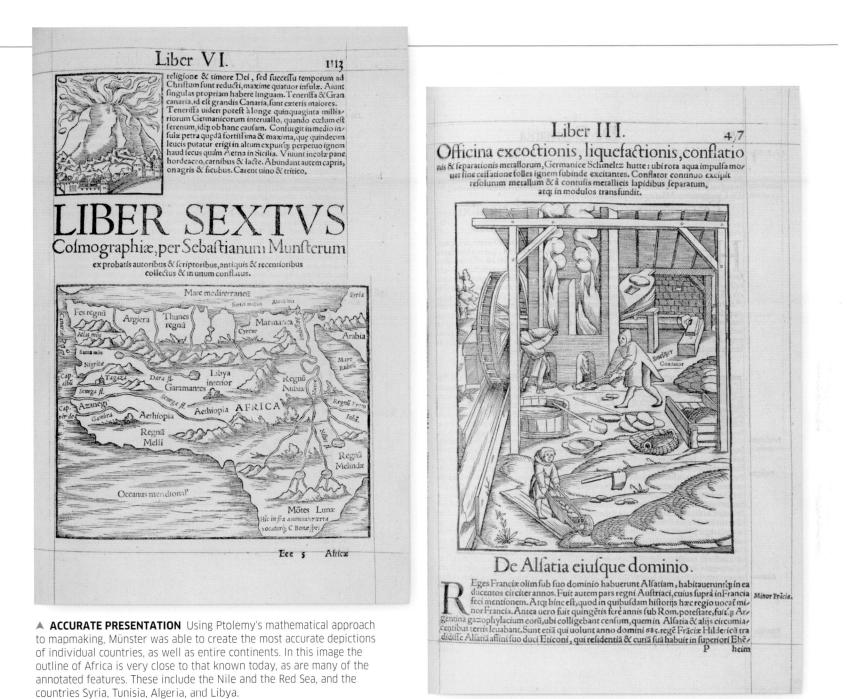

▲ **ACCURATE PRESENTATION** Using Ptolemy's mathematical approach to mapmaking, Münster was able to create the most accurate depictions of individual countries, as well as entire continents. In this image the outline of Africa is very close to that known today, as are many of the annotated features. These include the Nile and the Red Sea, and the countries Syria, Tunisia, Algeria, and Libya.

▲ **DETAILED ENGRAVING**
An extensive section of Münster's book was devoted to mining and smelting, which had boomed in Central Europe in the early 1500s. Here the engraving shows the process of smelting metals, with a waterwheel powering the bellows that fired the furnace.

◀ **DOMESTIC SLANT** Münster focused large sections of the book on Germanic history and landscape. This graphic print depicts German Christians engaging in battle for King Otto I the Great against the Hungarians, who invaded Germany, south of the Danube, in 954 CE.

Visual tour

KEY

▼ **LAND AND SEA MONSTERS** This plate was derived from the *Carta marina*, a map made by Swedish scholar Olaus Magnus in 1539. The map's index of sea creatures captured the popular imagination, and Münster felt it essential to include a variant in his own book six years later.

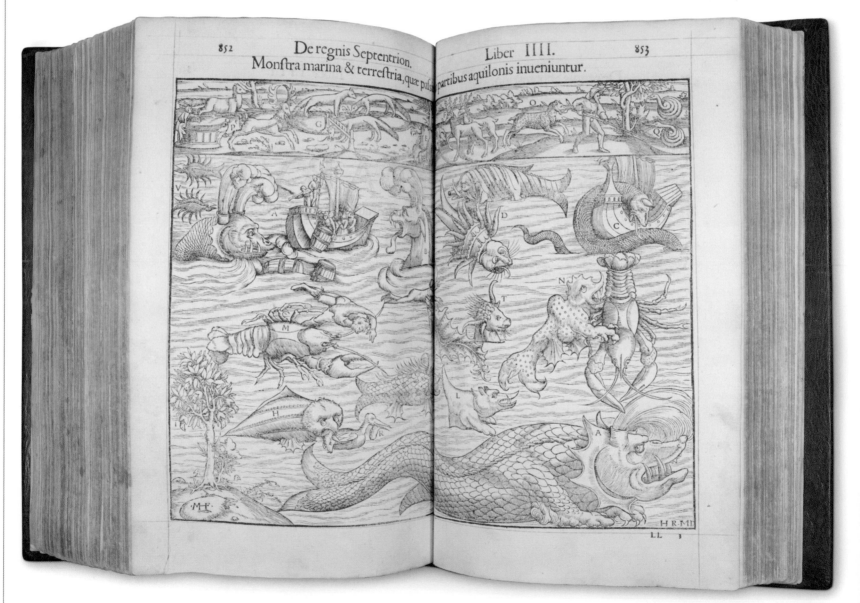

> Wonders of the sea and rare animals, as they are found in the midnight lands in the sea and on the land.

SEBASTIAN MÜNSTER, *COSMOGRAPHIA*

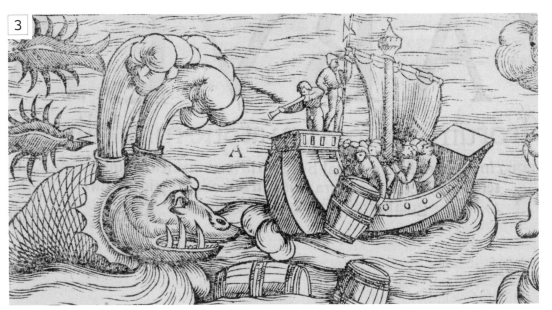

> ▶ **CREATURES OF THE LAND**
> Depictions of land animals like the snakes being warded off here, also included reindeers, bears, martens, and wolverines, which were all based on real animals. However, some of the descriptions were more fanciful; for example, the entry for the wolverine notes that the "nature of people wearing this fur is often changed into this beast's nature."

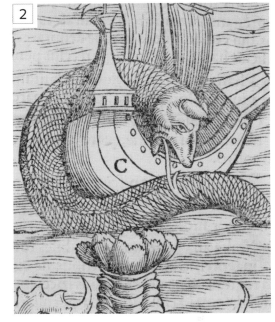

▲ **SEA SERPENT** The book describes sea snakes measuring between 200 and 300 ft (60–91 m) long, which "twist around the ship, harm the sailors, and attempt to sink it, especially when it is calm." The real creature in question is likely to have been a giant squid, which has been the subject of folklore since ancient times.

▲ **FROM THE DEEP** Münster's collection of beasts from the midnight sea and lands, includes animals from countries such as Norway and Sweden. In this image, a galleon ditches its cargo in an attempt to outrun a sea creature spouting water from its blowhole, while one shipmate takes aim with his musket. Earlier written accounts of whale sightings had generated fascination about the existence of sea monsters.

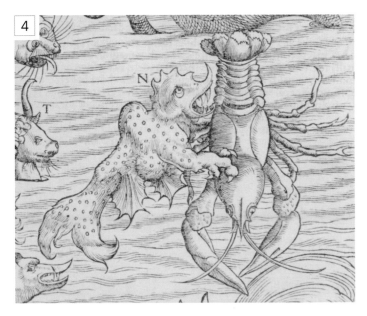

◀ **CREATURE IDENTIFICATION**
Each monster is labeled with a letter, linked to an index. The explanation for "N" read: "A gruesome beast, partly resembling a rhinoceros. Pointed at the nose and the back, eats large crabs called lobsters, is twelve feet long."

Les Prophéties

1555 ▪ PRINTED ▪ DIMENSIONS AND EXTENT UNKNOWN ▪ FRANCE

NOSTRADAMUS

French apothecary, physician, and astrologer Nostradamus published *Les Prophéties*, which translates as *The Prophecies*, in 1555. The book contained 353 four-line verses, or quatrains, that purported to forecast future events. These quatrains were arranged in groups of 100, or centuries. Further editions added more quatrains to bring the total to nine centuries with 942 verses. The book had a mixed reception when first published. Although very popular among the French nobility and royalty, who believed the prophecies to be genuine, others considered Nostradamus to be either mad or a charlatan. It was widely criticized by churchmen, who hinted that it was the work of the devil, although the prophecies were never actually condemned and Nostradamus never claimed they were spiritually inspired, but that they were based on "judicial astrology."

To make his predictions Nostradamus calculated the future positions of the planets and searched for similar planetary alignments in the past. Then, by borrowing freely from ancient historians—such as Suetonius and Plutarch—and from earlier prophecies, he matched those past alignments to recorded events. In the belief that history repeats itself he created an overall picture of the future. Inevitably his predictions were full of major disasters such as plague, fire, wars, and floods.

MICHEL DE **NOSTREDAME**

1503–1566

After a career as an apothecary and a physician, Nostradamus began to write prophecies based on astrology. He is most famous for his book *Les Prophéties* and the predictions contained therein.

Michel de Nostredame, better known by his Latinized name, Nostradamus, was born in Saint-Rémy-de-Provence, France. After an outbreak of plague forced him to curtail his studies for his baccalaureate at the University of Avignon, he spent time researching herbal remedies and became an apothecary. In the 1530s he started his medical practice, albeit with no medical degree, and gained a reputation for his innovative plague treatments. He began writing prophecies around 1547, and came to the notice of Catherine de' Medici, the French queen, drawing up the horoscopes of her children. By the time of his death Nostradamus was the King's Counselor and Physician-in-Ordinary.

Professional astrologers were highly critical of his methodology and accused him of incompetence and devoid of even basic astrological skills.

Perhaps to guard against criticism, or even charges of heresy, Nostradamus deliberately obscured the meaning of the prophecies by using codes, metaphors, and a mix of languages, such as Provençal, Ancient Greek, Latin, and Italian. The result is that the prophecies are so open to interpretation that almost anything can be read into them, yet enthusiasts claim they predict everything from the rise of Napoleon to, more recently, the election of Donald Trump as U.S. president.

IN **CONTEXT**

Nostradamus started publishing almanacs in 1550, which included astrological predictions, weather forecasts, and tips for when to plant crops. Their success led to commissions for horoscopes from the wealthy, as well as prompting him to compose more complicated prophecies in poetic form, which he published as *Les Prophéties*.

▶ **Nostradamus incorporated** his visions into popular almanacs that were published yearly until his death. *Almanachs* were detailed predictions; *Prognostications* or *Presages*, were more generalized.

> I had **determined** to go as far as **declaring** … the future causes of the "**common advent**."
>
> **NOSTRADAMUS**, IN A LETTER TO HIS SON CESAR, MARCH 1555

LES VRAYES CENTURIES

ET PROPHETIES

De Maiſtre MICHEL NOSTRADAMUS.

CENTURIE PREMIERE.

1.

STANT aſſis, de nuiĉt ſecret eſtu-
de,
Seul, repoſé ſur la ſelle d'airain ?
Flambe exigue, ſortant de ſolitude
Fait proferer qui n'eſt à croire en
vain.

2.

La verge en main miſe au milieu des branches,
De l'onde il moulle & le limbe & le pied,
Un peur & voix fremiſſent par les manches,
Splendeur divine, le devin pres s'aſſied.

3.

Quand la liĉtiere du tourbillon verſée
Et feront faces de leurs manteaux couverts :
La republique par gens nouveaux vexée,
Lors blancs & rouges jugeront à l'envers.

4.

Par l'univers ſera fait un Monarque,
Qu'en paix & vie ne ſera longuement,
Lors ſe perdra la piſcature barque,
Sera regie en plus grand detriment.

5.

Chaſſez ſeront ſans faire long combat,
Par le pays ſeront plus fort grevez :
Bourg & Cité auront plus grand debat
Carcas, Narbonne, auront cœurs eſprouvez.

6.

L'œil de Ravenne ſera deſtitué,
Quand à ſes pieds les aiſles failliront,

A Les

◀ **MEMORABLE VERSE** This page shows the start of the first century (100 quatrains) of *Les Prophéties*, in the original French, with its decorated initial letter "E." All but one of Nostradamus's prophecies rhymed in an ABAB pattern, known as alternate rhyme. The use of such simple verse made the prophecies particularly memorable, as intended, and gave them a resonance that made the reader inclined to believe that they were divine wisdom. The book brought Nostradamus fame and fortune. To date, over 200 editions have been published worldwide, and it has rarely been out of print.

Aubin Codex

1576 ▪ PAPER BOUND IN LEATHER ▪ 6 × 5 in (15.5 × 13.4 cm) ▪ 81 FOLIOS ▪ MEXICO

SCALE

VARIOUS AUTHORS

Few rare books document a moment in history as eloquently as the *Aubin Codex*, which was written and beautifully illustrated by indigenous Mexicans in the sixteenth century, but bound in the European style. The volume tells the history of the Mexican people and records firsthand their experience with Spanish colonists, including their arrival and the subsequent death of locals by smallpox, a disease the Spanish brought with them. Manuscripts written by South American cultures prior to colonization were typically written on bark or hide, which was then folded up. The *Aubin Codex* differs in that it is written on paper made in Europe and bound in red leather. This native Mexican point of view, presented in the format of the Spanish conquistadors, marks a transition from an autonomous people to a colony in which European, Catholic ways would eventually become the norm.

Following in the style of precolonial documents, events are depicted visually. Full-page paintings introduce the main sections of the book, with smaller pictograms conveying dates and the identity of royal figures in the Aztec dynasty. The supporting text is penned in Nahuatl, the native language used for centuries by the people of Central and South America. Historians believe that several contributors wrote and illustrated the book, probably under the guidance of the Dominican missionary, Diego Durán (1537–1588). Although Durán was initially credited as author, the codex takes its name from the French intellectual Joseph Marius Alexis Aubin (1802–1891), who acquired the manuscript while living in Mexico between 1830 and 1840.

◄ **ONE OF A KIND** The *Aubin Codex* is unique; the only copy known to exist is the one held at the British Museum in London. Although most of the pages are filled with pictograms, dense text is used by the authors to describe more complex events such as war.

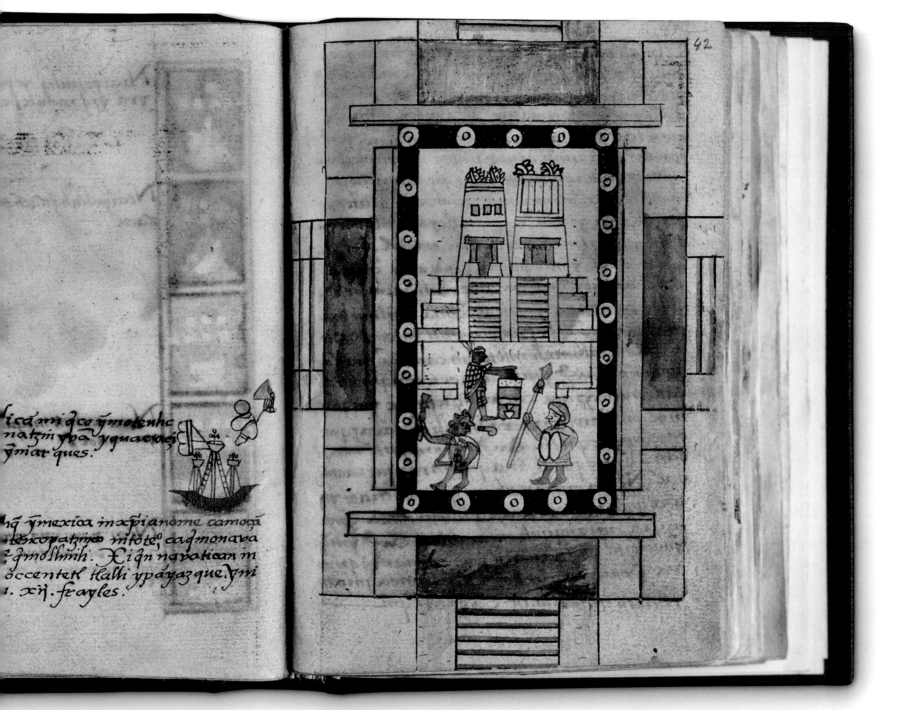

▲ **DEPICTING THE SPANISH CONQUEST** The column of blocks on the left-hand page show the date; the notes second from bottom refer to the arrival of Spanish ships. The full-page painting depicts an Aztec warrior and a Spaniard facing each other on the steps of the twin temples of Templo Mayor in the ancient city of Tenochtitlan.

Here is the written **history** of the Mexica **who came from** the **place of Aztlan.** 99

THE *AUBIN CODEX*

In detail

▶ **RICH RED** One of the dominant colors of the *Aubin Codex* is a reddish-brown tint called annatto, which is used for the background of each small pictogram. Made from the seeds of the native achiote tree, *Bixa orellana*, the tint was common in Mexican manuscripts of the sixteenth century. Annatto was also a colorant in textiles, and is still used today as food coloring.

▼ **DOCUMENT OF EVENTS** The text and pictures on this page record significant events. The illustration of the Sun sits alongside an account of a solar eclipse, during which "all the stars appeared and Axayacatzin died." The figure in blue seated on the golden throne is Tizozicatzin, who took his place, becoming the seventh "tlàtoani," or ruler, the following year.

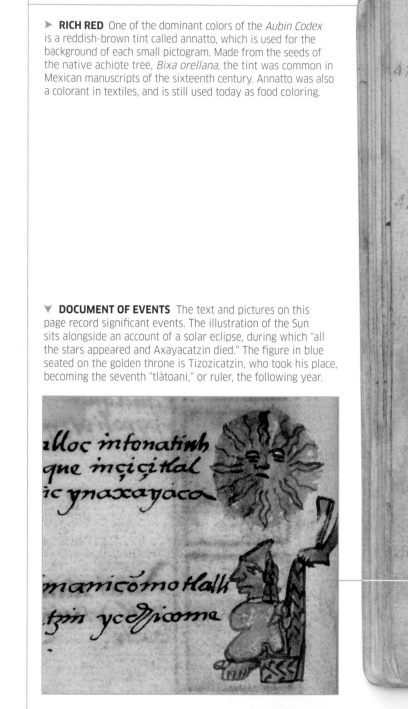

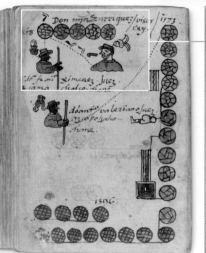

▶ **SYMBOLIC DISCS** An important aspect of the book is its listing of the monarchs who reigned during several Aztec dynasties. The blue discs beside each ruler denote the number of years each ruler was in power. On the left is Diego de Alvarado Huanitzin, who was the first emperor under the colonial government.

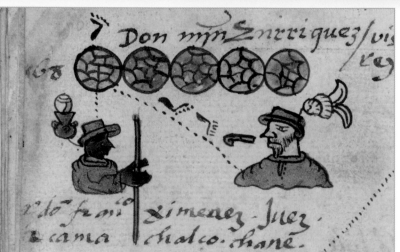

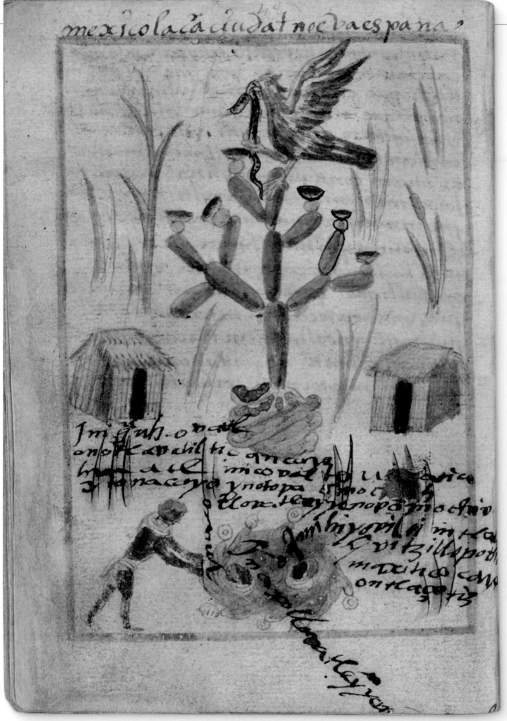

◀ **FULL-PAGE PAINTING** This illustration is used to introduce the story of how the Mexican people founded a new imperial capital, Tenochtitlan, in 1325. Built on an island in Lake Texcoco, it served as a base for the growing Aztec Empire. The event is represented by an eagle eating a snake on a prickly pear cactus—elements that are still found on the Mexican coat of arms.

▼ **ILLUSTRATIONS** The stylized paintings illustrate what is recorded in the text. Events depicted here, running from top to bottom down the right-hand side, are: the death of an Archbishop; the capture of black slaves; the digging of a boat canal; memorial prayers; the burial of a monk; the construction of a wooden church; and the arrival of some clerics.

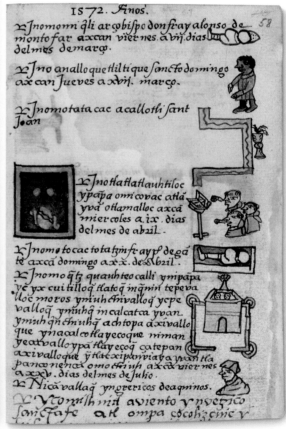

RELATED **TEXTS**

In the centuries before European colonization, the people of Central and South America cultivated a rich tradition of using art and hieroglyphics to record information, such as annual calendars, astronomical observations, and ritual practices. These documents, referred to as codices, or codex in the singular, consisted of leaves of bark cloth joined in an accordion format. The Dresden Codex is one of best examples and is also the oldest surviving Mayan manuscript. Little is known about the origin of this codex, but it is dated to around 1200–50. After disappearing from the Americas, it resurfaced in Dresden, Germany, in 1739, when the director of the city's Royal Library bought it for the collection from a private owner in Vienna.

▲ The **Dresden Codex** consists of 39 leaves, painted on both sides. It measures 11 ft (3.5 m) when laid out flat.

The Discoverie of Witchcraft

1584 ▪ PRINTED WITH WOODCUT ILLUSTRATIONS ▪ 7 × 5 in (17.2 × 12.7 cm) ▪ 696 PAGES ▪ ENGLAND

SCALE

REGINALD SCOT

Writing at a time when witchcraft was recognized as a crime, Reginald Scot published a highly controversial work in which he argued against its very existence, advocating that a belief in witches and magic was irrational and unchristian. Considered heretical when published, it can now be seen to be a radical and forward-thinking exposé.

Scot blamed the Roman Catholic Church for fostering paranoia and fueling the ongoing witch-hunts, and he attributed psychological disorders to self-confessed "witches" or witnesses of witchcraft.

The volume was divided into 16 books, within which Scot outlined contemporary beliefs about witchcraft before systematically discrediting them. In the later chapters, he concerned himself with magic tricks, explaining the mechanics behind those most commonly performed at the time. This is believed to be the first written record in the history of conjuring.

The Discoverie of Witchcraft was vilified by James VI of Scotland, later James I of England, in his 1597 treatise Daemonologie. Copies of Scot's book are very rare–many were allegedly burned on the orders of James I on his ascension to the throne in 1603–yet it was widely read. It is even believed to have influenced Shakespeare's portrayal of the witches in Macbeth.

REGINALD **SCOT**

1538-1599

A country gentleman, Reginald Scot is best known for his seminal and contentious work The Discoverie of Witchcraft, in which he discredited widely held beliefs about witchcraft and magic.

Privately tutored, Scot entered Hart Hall College in Oxford at the age of 17, although there are no records of his graduation. He married twice and devoted himself to managing his family estate. He served a year as a Member of Parliament and was a Justice of the Peace. Although a member of the Church of England, Scot was affiliated with a religious sect called the Family of Love, which taught that the devil's influence was psychological, not physical. This teaching fostered Scot's scepticism about witchcraft and led to him writing his book.

In detail

▶ **SEVERED HEAD** A popular trick among conjurors in the sixteenth century, and one that is still practiced today, was to "sever" a person's head. In The Discoverie of Witchcraft, Scot unmasked the deception, showing in this woodcut how a second person was placed underneath a table in which a hole had been inserted. The "severed head," covered with flour and bull's blood, then protruded from the hole to the delight and amazement of the crowds.

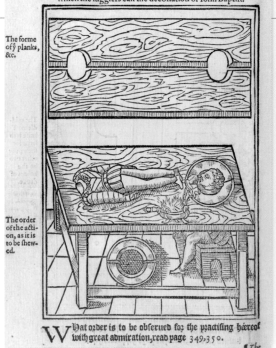

▲ **WOODCUT DECORATIONS** Large, embellished initial letters, such as this "T," entwined with flowers and foliage, were featured at the start of every chapter. These, together with many other woodcuts (some purely decorative, others instructive) and the ornate Gothic script made the work attractive as well as insightful.

> But whatsoever is reported or conceived of such maner of witchcrafts, I dare avow to be false and fabulous …

REGINALD SCOT, *THE DISCOVERIE OF WITCHCRAFT*

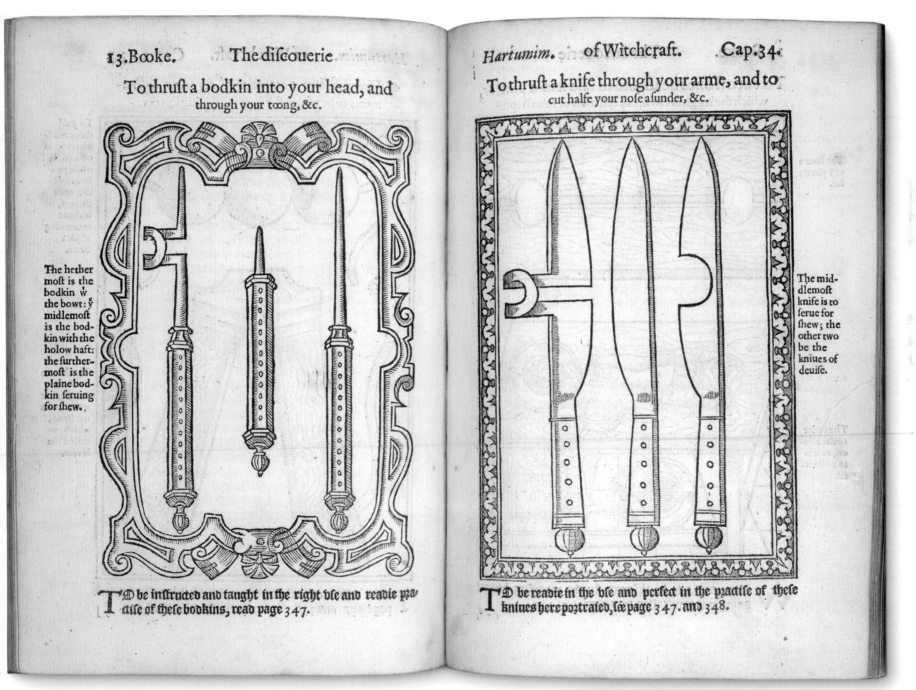

13.Booke. The difcouerie

To thruft a bodkin into your head, and through your toong, &c.

The hethermoft is the bodkin w̅ the bowt: y̅ midlemoft is the bodkin with the holow haft: the furthermoft is the plaine bodkin feruing for fhew.

T̅O be inftructed and taught in the right vfe and readie practife of thefe bodkins, read page 347.

Hartumim. of Witchcraft. Cap.34.

To thruft a knife through your arme, and to cut halfe your nofe afunder, &c.

The middlemoft knife is to ferue for fhew; the other two be the kniues of deuife.

T̅O be readie in the vfe and perfect in the practife of thefe kniues here portraied, fee page 347. and 348.

▲ **TRICKS UNMASKED** In spite of the law passed by Henry VIII (1491–1547) in 1542 that forbade conjuring as well as witchcraft, magic tricks were still widely performed. In his book Scot gave clear written instructions on how to dupe the onlooker with illusion and sleight of hand, and he also provided woodcut illustrations to make the tricks easier to understand. Here, he shows how magicians could create the illusion of inflicting stab wounds by using "bodkins" (daggers) or knives with either retractable blades, or blades with portions removed or extensions added to wrap around the body part in question.

Don Quixote

1605 AND 1615 ▪ PRINTED ▪ 5¹/₂ × 3¹/₂ in (14.8 × 9.8 cm) ▪ 668 AND 586 PAGES ▪ SPAIN

SCALE

MIGUEL DE CERVANTES SAAVEDRA

Published in two parts in 1605 and 1615, *Don Quixote* is often regarded as the first "modern" novel. Touching on themes of class, morality, and human rights, it combines humor, fantasy, and brutality, as well as social critique, in a way not seen before in other novels at the time.

Miguel de Cervantes Saavedra sold the rights to part one of the book to Madrid publisher Francisco de Robles, who, in the hope of greater profits, exported the majority of the first edition to the New World, but all were lost in a shipwreck. Despite this setback *Don Quixote* proved an instant success with the public, and it was soon translated into French, German, and Italian—the first English edition was published in 1620. Since that time it has been translated into more than 60 languages, in almost 3,000 editions.

Don Quixote is open to endless interpretations. Its subject is an elder, minor Spanish nobleman driven mad by endless readings of chivalric romances. Seeing himself as a knight errant, he travels through Spain on horseback hoping to right the wrongs of the world, accompanied by

MIGUEL DE CERVANTES SAAVEDRA

1547–1616

Miguel de Cervantes Saavedra is considered one of the greatest Spanish writers of all time, best known for his fictional creation, Don Quixote–the most celebrated figure in Spanish literature.

Cervantes was born near Madrid, although little is known of his early life. In 1569 he moved to Italy, and a year later enlisted in a Spanish infantry regiment near Naples. Cervantes fought at the great naval battle of Lepanto in 1571, where he lost the use of his left hand. Between 1575 and 1580 he was a prisoner of Algerian pirates, and held for ransom. He eventually returned to Spain but found only menial employment and unsuccessful literary endeavors, which left him impoverished and bitter. It was almost 25 years before Cervantes achieved success through publication of part one of his masterpiece, *Don Quixote*. He died in 1606, a year after part two was published.

the peasant Sancho Panza. Propelled on by an image of his imagined love, Dulcinea, the result is both comic and tragic–Don Quixote is humiliated, stripped of his dreams, and forced to admit that he has been pursuing an illusion.

The impact of *Don Quixote* on the development of the novel as an art form was profound. Without the model it provided, it is impossible to imagine the great outpouring of nineteenth- and twentieth-century novel writing from the likes of Dickens, Joyce, Flaubert, and Hemingway.

In detail

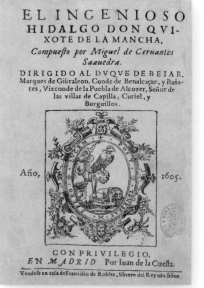

◀ **ORNAMENTAL ILLUSTRATIONS** Although Don Quixote and Sancho Panza lend themselves well to illustration, the pair and their exploits were not depicted in early editions. Woodcut illustrations were reserved for ornamentation and the opening and closing pages, such as the elaborate crest on this title page from the first 1605 Madrid edition.

▶ **CONTENTS PAGE** The contents page, shown here, appears at the back of the book, and lists 54 chapters spread over four parts. In addition to the main story, the book also includes a prologue by Cervantes, explaining to the "idle reader" why he wrote the novel.

Nunca fereys de alguno reprochado,
Por home de obras viles, y foezes.
Seran vueffas fazañas los joezes,
Pues tuertos desfaziendo aueys andado,
Siendo vegadas mil apaleado,
Por follones cautiuos, y rahezes.
Y fi la vueffa linda Dulzinea,
Deffaguifado contra vos comete,
Ni a vueffas cuytas mueftra buen talante.
Ental defman vueffo conorte fea,
Que Sancho Pança fue mal alcaguete,
Necio el, dura ella, y vos no amante.

DIALAGO ENTRE BABIECA, y Rozinante.

SONETO.

B. COmo eftays Rozinante tan delgado?
R. Porque nunca fe come, y fe trabaja,
B. Pues que es de la ceuada, y de la paja?
R. No me dexa mi amo ni vn bocado.
B. Andà feñor que eftays muy mal criado.
 Pues vueftra lengua de afno al amo vltraja,
R. Afno fe es de la cuna a la mortaja,
 Quereyflo ver, miraldo enamorado.
B. Es necedad amar? R. Nó es gran prudencia.
B. Metafifico eftays. R. Es que no como.
B. Quexaos del efcudero. R. No es baftante.
Como me he de quexar en mi dolencia,
Si el amo, y efcudero, o mayordomo,
Son tan Rozines como Rozinante.

PRI-

Fol. 1

PRIMERA PARTE DEL INGENIOSO
hidalgo don Quixote de la Mancha.

Capitulo Primero. Que trata de la condi-cion, y exercicio del famofo hidalgo don Quixote de la Mancha.

N Vn lugar de la Mancha, de cuyo nombre no quiero acor-darme, no ha mucho tiempo que viuia vn hidalgo de los de lança en aftillero, adarga anti-gua, rozin flaco, y galgo corre-dor. Vna olla de algo mas vaca que carnero, falpicon las mas noches, duelos y quebrátos los Sabados, lantejas los Viernes, algun palomino de aña-diduralos Domingos: confumian las tres partes de fu hazienda. El refto della concluian, fayo de velarte, calças de velludo paralas fieftas, con fus pantuflos de

A lo

▲ **ILLUSTRATED INITIALS** The chivalric setting of *Don Quixote* is reflected by the decorated initial letters at the start of each chapter, which were a feature of many medieval documents of the period.

QVARTA PARTE DEL INGENIOSO hidalgo don Quixote de la Mancha.

Cap. XXVIII. Que trata de la nueua, y agrada-ble auentura que al Cura, y Barbero fucedio en la mefma Sierra.

ELICISSIMOS Y ven-turofos fueron los tiempos, donde fe echò al mundo el audacifsimo cauallero don Quixote de la Mancha, pues por auer tenido tan honrofa determinacion, como fue el querer refucitar, y boluer al mundo, la ya perdida, y cafi muerta orden de la andante caualleria. Gozamos aora en efta nueftra edad necefsitada, de alegres entretenimientos, no folo de la dulçura de fu verdadera hiftoria, fino de los cuentos, y epifodios della, que en parte, no fon menos agradables, y artificiofos, y verdaderos, que la mifma hiftoria: la qual profiguiédo fu raftrillado, torcido, y afpado hilo, cuenta, que afsi como el Cu-ra començo a preuenirfe para confolar a Cardenio,

Io

◄ **SECOND VOLUME**
Despite being published 10 years after the first installment, the second volume of *Don Quixote* bears a strong visual resemblance. In the chapter opener shown here, the illustrated initial letter and woodcut decorations are almost identical to those found in volume one.

IN **CONTEXT**

Such was the popularity of *Don Quixote* that there were soon calls for illustrated editions that would bring his adventures to life. The first of these appeared in a Dutch translation printed by Jacob Savery in 1657, and featured 24 engravings depicting some of the more dramatic scenes from the novel. Many other illustrated versions followed, with the main characters changing in appearance each time. This changed in the 1860s, when a French edition illustrated by renowned painter and engraver Gustave Doré captured the spirit and personality of *Don Quixote* and his fellow characters so well that their popular appearance was established.

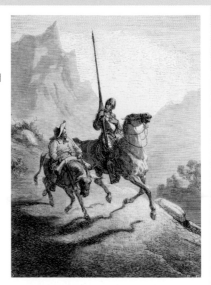

► **Gustave Doré's 1863 illustration** depicts Don Quixote and his portly servant, Sancho Panza, setting out for another adventure.

SCALE

King James Bible

1611 ▪ PRINTED ▪ 17 × 12 in (44.4 × 30.5 cm) ▪ 2,367 PAGES ▪ ENGLAND

TRANSLATION COMMITTEE

There were five English versions of the bible in 1603 when James VI of Scotland became James I of England, but only two of them had been authorized by the Anglican Church. One was the Great Bible (1539), which was also authorized by King Henry VIII of England. The other, the Bishop's Bible (1568), translated during Elizabeth I's reign, was so obscurely written that few used it. The Geneva Bible (1560) proved much more popular, but was unauthorized and full of antiroyalist notes.

King James wanted to unite his fractured kingdom with a bible that was accurate, yet in plain language and without contentious footnotes. And so, in January 1604 he summoned bishops and scholars to Hampton Court Palace and commissioned a new Bible. A translation committee of 50 scholars based in Oxford, Cambridge, and London was divided into six groups, each working on different parts of this bible using Hebrew, Aramaic, and Greek texts, as well as Tyndale's English version of 1525. Each person made a translation of their own, which was then tested by reading it out loud. The best were then sent forward to the overseeing committee. It is the commanding beauty of the resulting prose, repeated in churches across the world every Sunday, that has ensured the lasting influence of the King James Bible.

Finally published in 1611 by royal command for use in all Anglican church and cathedral services and Divine public services, the first edition of the King James Bible was printed by Robert Baker. Copies of this first edition were available unbound for 10 shillings, or leather bound for 12 shillings. The widest distributed book ever, today over 6 billion copies have been published, making it one of the world's most influential religious texts.

◄ **DEDICATION TO KING JAMES** Every edition of the King James Bible included a dedication written by the translators. It was largely based on one included in the Geneva Bible of 1560 written by the humanist scholar Erasmus of Rotterdam. The dedication thanks the king, but is also a powerful political act, as it firmly linked the king with the authorization of the Bible. It was only in editions that were printed in the twentieth century that publishers were permitted to drop the dedication.

► **CLEAR PRESENTATION** Intended as a book to be read out in church, this bible has no color. The text is presented in an old-fashioned Gothic "black letter" script that not only gives it weight and authority, but is also clear and easy to read. A simple Roman typeface is used to differentiate the summaries given at the head of each chapter.

> We desire that the Scripture may speake like it selfe that it may bee understood even of the very vulgar.
>
> **PREFACE TO THE 1611 KING JAMES BIBLE**

HAP. XV.

...ound, and accused before Pi... the clamour of the common ...rderer Barabbas is loosed, and ...vp to be crucified: 17 hee is ...hornes, 19 spit on, and moc... ...teth in bearing his crosse: 27 ...ene two theeues, 29 suffreth ...g reproches of the Iewes: 39 ...by the Centurion, to bee the ...: 43 and is honourably bu...

...nd * straightway in the ...orning the chiefe Priests ...elde a consultation with ...he Elders and Scribes, ...nd the whole Councell, ...esus, and caried him a... ...red him to Pilate.

...ate asked him, Art thou ...e Iewes? And hee an... ...nto him, Thou sayest it. ...hiefe Priests accused him ...s: but hee answered no...

...ilate asked him againe, ...rest thou nothing? be... ...y things they witnesse a...

...s yet answered nothing, ...narueiled.

...hat Feast he released vn... ...soner, whomsoeuer they

...re was one named Ba... ...h lay bound with them ...e insurrection with him, ...mitted murder in the in...

...multitude crying alowd, ...him to doe as he had euer ...n.

...te answered them, say... ...t I release vnto you the ...ewes?

...e knew that the chiefe ...uered him for enuie.)

...hiefe Priests mooued the ...ee should rather release ...o them.

...te answered, and said a... ...n, what will yee then ...vnto him whom ye call ...e Iewes?

...cried out againe, Cruci... ...ilate saide vnto them,

why, what euill hath hee done? And they cried out the moze exceedingly, Crucifie him.

15 ¶ And so Pilate, willing to content the people, released Barabbas vnto them, and deliuered Jesus, when he had scourged him, to be crucified.

16 And the souldiers led him away into the hall, called Pretozium, and they call together the whole band.

17 And they clothed him with purple, and platted a crowne of thoznes, and put it about his head,

18 And beganne to salute him, Haile King of the Iewes.

19 And they smote him on the head with a reed, and did spit vpon him, and bowing their knees, woeshipped him.

20 And when they had mocked him, they tooke off the purple from him, and put his owne clothes on him, and led him out to crucifie him.

21 * And they compell one Simon a Cyrenian, who passed by, comming out of the country, the father of Alexander and Rufus, to beare his Crosse.

22 And they bring him vnto the place Golgotha, which is, being interpzeted, the place of a skull.

23 And they gaue him to dzinke, wine mingled with myzrhe: but he receiued it not.

24 And when they had crucified him, they parted his garments, casting lots vpon them, what euery man should take.

25 And it was the third houre, and they crucified him.

26 And the superscription of his accusation was written ouer, THE KING OF THE IEWES.

27 And with him they crucifie two theeus, the one on his right hand, and the other on his left.

28 And the Scripture was fulfilled, which sayeth, * And hee was numbzed with the transgressours.

29 And they that passed by, railed on him, wagging their heads, and saying, Ah thou that destroyest the Temple, and buildest it in three dayes,

30 Saue thy selfe, and come downe from the Crosse.

31 Likewise also the chiefe Priests mocking, said among themselues with the Scribes, He saued others, himselfe he cannot saue.

32 Let Chzist the King of Israel descend now from the Crosse, that we may

*Matth.27. 32.

*Esay 53. 12.

may see and beleeue: And they that were crucified with him, reuiled him.

33 And when the sixth houre was come, there was darkenesse ouer the whole land, vntill the ninth houre.

34 And at the ninth houre, Jesus cryed with a loude voice, saying, * Eloi, Eloi, lamasabachthani? which is, being interpzeted, My God, my God, why hast thou forsaken me?

35 And some of them that stood by, when they heard it, said, Behold, he calleth Elias.

36 And one ranne, and filled a spunge full of vineger, and put it on a reed, and gaue him to dzinke, saying, Let alone, let vs see whether Elias will come to take him downe.

37 And Jesus cryed with a loude voice, and gaue vp the ghost.

38 And the vaile of the Temple was rent in twaine, from the top to the bottome.

39 ¶ And when the Centurion which stood ouer against him, saw that hee so cryed out, and gaue vp the ghost, hee said, Truely this man was the Sonne of God.

40 There were also women looking on afarre off, among whom was Mary Magdalene, and Mary the mother of James the lesse, and of Ioses, and Salome:

41 Who also when hee was in Galile, * followed him, and ministred vnto him, and many other women which came vp with him vnto Hierusalem.

42 ¶ * And now when the euen was come, (because it was the Prepazation, that is, the day befoze the Sabbath)

43 Joseph of Arimathea, an honourable counseller, which also waited for the kingdome of God, came, and went in boldly vnto Pilate, and craued the body of Jesus.

44 And Pilate marueiled if he were already dead, and calling vnto him the Centurion, hee asked him whether hee had beene any while dead.

45 And when he knew it of the Centurion, he gaue the body to Joseph.

46 And hee bought fine linnen, and tooke him downe, and wrapped him in the linnen, and laide him in a sepulchze, which was hewen out of a rocke, and rolled a stone vnto the dooze of the sepulchze.

47 And Mary Magdalene, and

*Mx.27. 46.

*Luke 8, 3.

*Mat.27. 57.

Mary the mother of Ioses beheld where he was laide.

CHAP. XVI.

1 An Angel declareth the resurrection of Christ to three women. 9 Christ himselfe appeareth to Mary Magdalene: 12 to two going into the countrey: 14 then, to the Apostles, 15 whom he sendeth foorth to preach the Gospel: 19 and ascendeth into heauen.

AND when the Sabbath was past, Mary Magdalene, and Mary the mother of James, and Salome, had bought sweete spices, that they might come and anoint him.

2 * And very early in the morning, the first day of the week they came vnto the sepulchze, at the rising of the sunne:

3 And they said among themselues, Who shall roll vs away the stone from the dooze of the sepulchze?

4 (And when they looked, they saw that the stone was rolled away) for it was very great.

5 * And entring into the sepulchze, they sawe a young man sitting on the right side, clothed in a long white garment, and they were affrighted.

6 And hee sayth vnto them, Be not affrighted, ye seeke Jesus of Nazareth, which was crucified: he is risen, hee is not here: behold the place where they laide him.

7 But goe your way, tell his disciples, and Peter, that hee goeth befoze you into Galile, there shall ye see him, * as he said vnto you.

8 And they went out quickely, and fledde from the sepulchze, for they trembled, and were amazed, neither sayd they any thing to any man, for they were afraid.

9 ¶ Now when Iesus was risen early, the first day of the weeke, * he appeared first to Mary Magdalene, * out of whom he had cast seuen deuils.

10 And she went and told them that had beene with him, as they mourned and wept.

11 And they, when they had heard that he was aliue, and had beene seene of her, beleeued not.

12 ¶ After that, he appeared in another forme * vnto two of them, as they walked, and went into the countrey.

13 And they went and tolde it vnto the residue, neither beleeued they them.

*Luk.24.1 ioh.20.1.

*John 20. 11.

*Mat.26. 32.

*John 20. 14. *Luke 8.2.

*Luke 24. 13.

F 14 ¶ Af

In detail

Brotherly vnitie. Pſalmes. Idoles are vanitie.

18 His enemies will I clothe with ſhame : but vpon himſelfe ſhall his crowne flourish.

PSAL. CXXXIII.
The benefite of the communion of Saints.

¶ A ſong of degrees of Dauid.

BEhold how good and how pleaſant it is : for brethren to dwell † together in vnitie.

2 It is like the precious oyntment vpon the head, that ranne downe vpon the beard, euen Aarons beard : that went downe to the skirts of his garments.

3 As the dew of Hermon, and as the dewe that deſcended vpon the mountaines of Zion, for there the LORD commanded the bleſſing : euen life for euermore.

PSAL. CXXXIIII.
An exhortation to bleſſe God.

¶ A ſong of degrees.

BEholde, bleſſe yee the LORD, all yee ſeruants of the LORD : Which by night ſtand in the houſe of the LORD.

2 Lift vp your hands in the Sanctuary : & bleſſe the LORD.

3 The LORD that made heauen and earth : bleſſe thee out of Zion.

PSAL. CXXXV.
An exhortation to praiſe God for his mercy, 5 for his power, 8 for his iudgements. 15 The vanitie of Idoles. 19 An exhortation to bleſſe God.

PRaiſe ye the LORD, Praiſe ye the Name of the LORD : prayſe him, O ye ſeruants of the LORD.

2 Yee that ſtand in the Houſe of the LORD : in the courts of the houſe of our God.

3 Praiſe the LORD, for the LORD is good : ſing praiſes vnto his Name, for it is pleaſant.

4 For the LORD hath choſen Iacob vnto himſelfe : and Iſrael for his peculiar treaſure.

5 For I know that the LORD is

great : and that our LORD is aboue all gods.

6 Whatſoeuer the LORD pleaſed, that did he in heauen and in earth : in the Seas, and all deepe places.

7 * Hee cauſeth the vapours to aſcend from the ends of the earth, he maketh lightnings for the raine : he bringeth the winde out of his treaſuries.

8 * Who ſmote the firſt borne of Egypt : † both of man and beaſt.

9 Who ſent tokens and woonders into the midſt of thee, O Egypt : vpon Pharaoh, and vpon all his ſeruants.

10 * Who ſmote great nations : and ſlew mightie kings :

11 Sihon king of the Amorites, and Og king of Baſhan : and all the kingdomes of Canaan.

12 * And gaue their land for an heritage : an heritage vnto Iſrael his people.

13 Thy Name, O LORD, endureth for euer : and thy memoriall, O LORD, † throughout all generations.

14 For the LORD will iudge his people : and he will repent himſelfe concerning his ſeruants.

15 * The idoles of the heathen are ſiluer and golde : the worke of mens hands.

16 They haue mouthes, but they ſpeake not : eyes haue they, but they ſee not :

17 They haue eares, but they heare not : neither is there any breath in their mouthes.

18 They that make them are like vnto them : ſo is euery one that truſteth in them.

19 Bleſſe the LORD, O houſe of Iſrael : bleſſe the LORD, O houſe of Aaron.

20 Bleſſe the LORD, O houſe of Leui : ye that feare the LORD, bleſſe the LORD.

21 Bleſſed be the LORD out of Zion, which dwelleth at Ieruſalem. Praiſe ye the LORD.

PSAL. CXXXVI.
An exhortation to giue thankes to God for particular mercies.

O Giue thankes vnto the LORD, for hee is good : for his mercy endureth for euer.

2 O giue thankes vnto the God of gods : for his mercy endureth for euer.

Hhh 2 3 O giue

Margin references: *Ier.10.13. — *Exod.12. 29. †Heb. from man vnto beaſt. — *Num.21. 2.and 4.25, 26,34,35. — *Ioſ.12.7. — †Heb. to generation and generation. — *Pſal.115. 4,5,6,7,8, 9,10. — *Pſa.106.1. and 107.1. and 118.1.

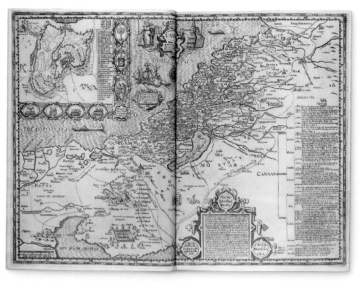

◀ **THE PSALMS** A collection of 150 prayers and songs, the psalms were used by Hebrews to express their relationship with God. They are the most enduring part of the King James Bible. Even when modern bibles were introduced in the mid-twentieth century, churches continued with the King James versions of the psalms because of their lyrical beauty.

▲ **MARGIN NOTES** The translators made a point of avoiding long notes and commentaries, so that readers could simply focus on the holy text. The only exceptions were when a word or phrase in the Greek or Hebrew original could not be translated easily. As shown above, a simple explanation of the alternative translation is then given in the margin.

▶ **DECORATIVE INITIAL LETTERS**
The King James Bible was designed as a text to be read, not admired from a distance. Elegant in their simplicity, the initial capitals illustrated in simple black line at the beginning of each section, or, as here, at the start of each psalm, were there to help readers find their place easily.

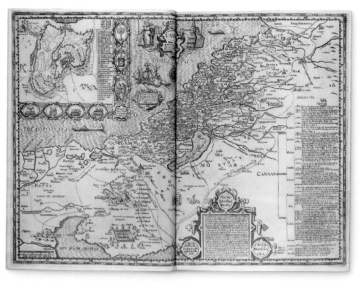

▲ **FOLD-OUT MAP OF THE HOLY LAND** One of the few illustrations in the King James Bible is this map of the Holy Land by John Speed. The map is there to inform readers of the locations in the bible stories, not simply to add decoration. Only about 200 copies of the first edition that include this map are known to survive.

▼ **FROM GOD TO CHRIST** At the beginning of the Bible is a 30-page genealogy that traces the ancestral path from God the Father (below) to Christ the Son (right). To overcome the fact that Jesus' father is not Joseph, but rather the Holy Spirit, the King James Bible uses a reading of St. Luke's Gospel to follow the line back through his mother Mary, rather than Joseph, so Jesus can be traced to Adam and Eve.

▼ **COMPLETING THE GENEALOGY** This is the last page of the genealogy that links Christ to Adam and Eve. Altogether, there are 1,750 names given, including some well-known biblical figures such as Jonah, Job, Lot, Abraham, Sarah, David, Solomon, Delilah, Goliath, and Moses. As with other illustrations, the genealogy "tree" is presented as a diagram in the style popular in the seventeenth century.

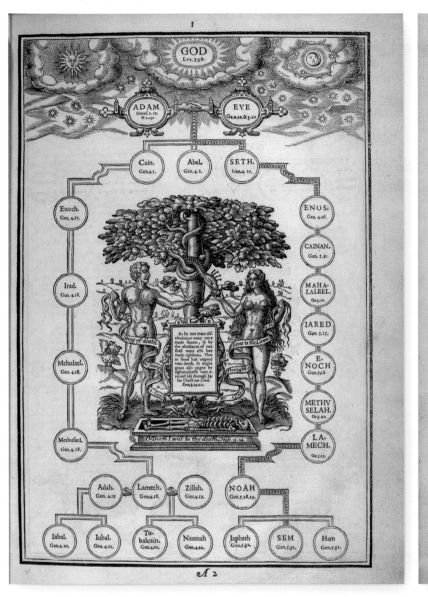

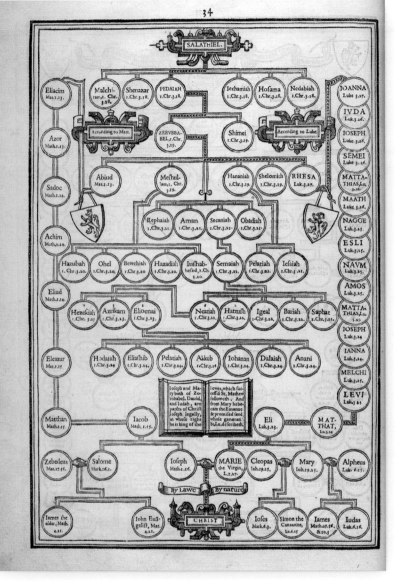

RELATED **TEXTS**

Central to the Protestant Reformation was the provision of bibles in the language of the people. In 1395 John Wycliffe produced the first translation of the Bible into English (based on a Latin script). William Tyndale followed in 1525, but his translation came from Greek and Hebrew. Both versions were banned by the Church, who considered the translation of the Bible into English blasphemous, but Tyndale's was the basis for the first "authorized" bible in English, Henry VIII's Great Bible of 1539. A group of Protestants published a new translation, the Geneva Bible, in 1560, but as this failed to reflect the theology of the Church, the Elizabethan church countered it with the official Bishop's Bible of 1568.

▶ **The Geneva Bible** was popular but full of antiroyal margin notes. It was the bible that William Shakespeare chose to quote extensively from in many of his plays.

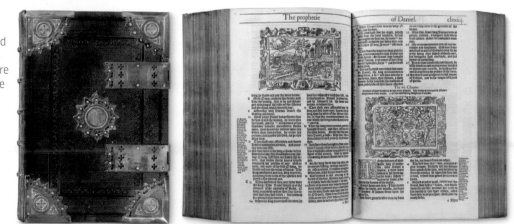

Hortus Eystettensis

1613 ▪ LETTERPRESS PRINTING FROM COPPER-ENGRAVED PLATES, HAND-COLORED ▪
22 × 18 in (57 × 46 cm) ▪ 367 ILLUSTRATED PLATES ▪ GERMANY

SCALE

BASILIUS BESLER

The finest illustrated botanical work of the early seventeenth century, *Hortus Eystettensis*, with its 367 beautifully illustrated plates, is a visual catalog, or florilegium, of the gardens established by Prince Bishop Johann Konrad von Gemmingen (1561–1612) around his episcopal palace of Willibaldsburg at Eichstätt, near Nuremberg, Germany. Pleasure gardens were in vogue around 1600, and Johann Konrad was especially proud of his. In 1601 he commissioned the Nuremberg apothecary Basilius Besler to oversee publication of the *Hortus*. Artists worked to produce drawings of the most spectacular specimens in the prince's garden, which were then transferred onto copper plates by a team of 10 engravers. Previous florilegiums had tended to focus on medicinal and culinary herbs, using crude drawings that failed to enable a clear identification of each featured plant, and did not value the aesthetic qualities that the *Hortus* showcased.

The book was published in 1613 in two editions: one with black-and-white plates, with the text backing onto them; the other with separate text and illustration pages, allowing the botanical plates to be colored by hand. The original budget was 3,000 florins, but the final cost of the work was estimated at 17,920 florins. Color copies excited huge demand, in part because the initial print run was just 300 copies—and the price soon rose to 500 florins per copy (at a time when the grandest house in Nuremberg cost 2,500 florins). Johann Konrad did not live to see the *Hortus* completed, having died in 1612, but its breadth and beauty stand testament to one of the age's greatest botanical patrons.

▶ **DETAILED DEPICTIONS** The detail on this page, which shows five species of hollyhock, depicts the *Hortus*'s botanical illustration at its finest. The plants would have been familiar to the apothecary, Besler, as they were commonly used in medicines for sore throats.

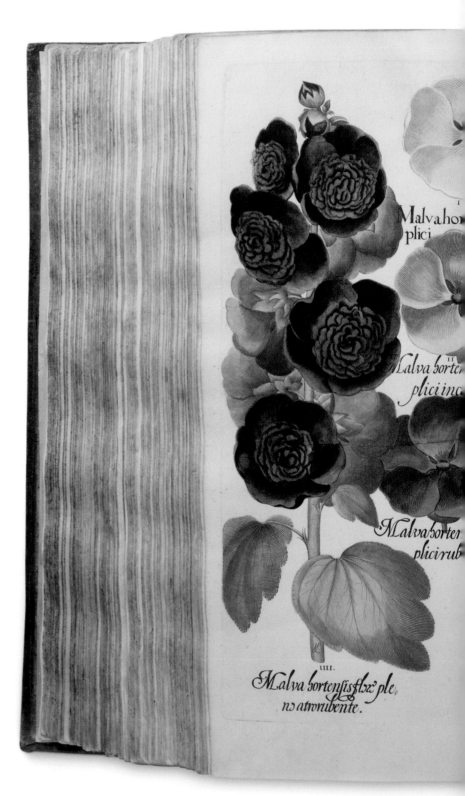

Malva hor[tensis] plici[...]

Malva horten[sis] plici inc[...]

Malva horten[sis] plicirub[...]

Malva hortensis fl[ore] ple[no] no atrorubente.

> Some **while ago** I have ordered **sketches** to be made of what had been **observed** in my own modest, narrow little **garden.**

PRINCE BISHOP JOHANN KONRAD VON GEMMINGEN, LETTER TO DUKE WILHELM V OF BAVARIA, MAY 1, 1611

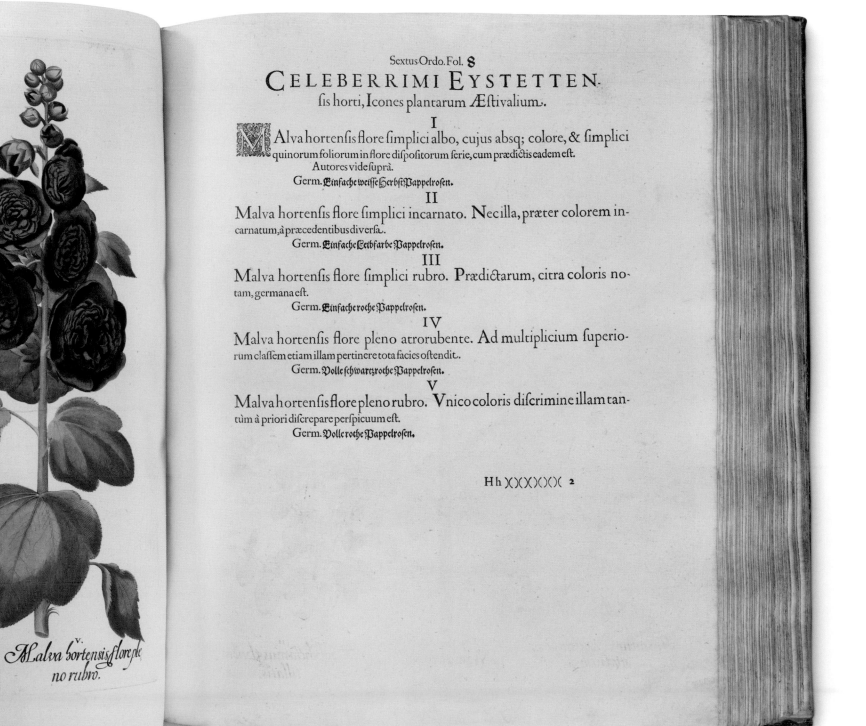

Sextus Ordo. Fol. 8

CELEBERRIMI EYSTETTEN.

sis horti, Icones plantarum Æstivalium.

I

Malva hortensis flore simplici albo, cujus absq; colore, & simplici quinorum foliorum in flore dispositorum serie, cum prædictis eadem est. Autores vide suprà.

Germ. Einfache weisse Herbst Pappelrosen.

II

Malva hortensis flore simplici incarnato. Nec illa, præter colorem incarnatum, à præcedentibus diversa.

Germ. Einfache Leibfarbe Pappelrosen.

III

Malva hortensis flore simplici rubro. Prædictarum, citra coloris notam, germana est.

Germ. Einfache rothe Pappelrosen.

IV

Malva hortensis flore pleno atrorubente. Ad multiplicium superiorum classem etiam illam pertinere tota facies ostendit.

Germ. Volle schwartzrothe Pappelrosen.

V

Malva hortensis flore pleno rubro. Vnico coloris discrimine illam tantùm à priori discrepare perspicuum est.

Germ. Volle rothe Pappelrosen.

Hh XXXXXX(2

V.
Malva hortensis flore pleno rubro.

In detail

▲ **COAT OF ARMS** The title page of the *Hortus* shows the Prince Bishop's coat of arms mounted above an archway. On either side of it are figures representing Ceres, the Roman goddess of agriculture, and Flora, the Roman goddess of flowers. At the base of the arch stand King Solomon and King Cyrus of Persia, next to whom is a Mexican agave plant, one of the few plants in the book to come from the Americas.

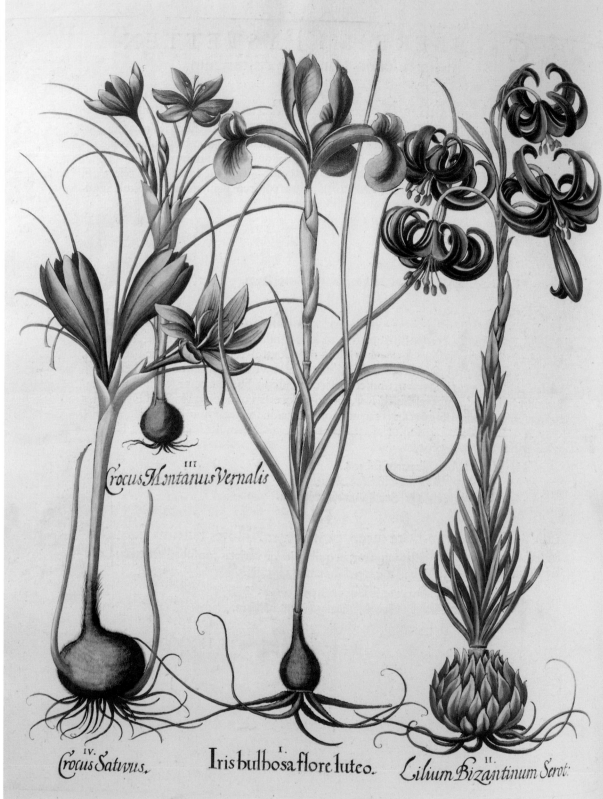

▲ **LIFE-SIZE IMAGES** The florilegium was printed on royal paper, the largest sheet size then available. This allowed the plants to be illustrated at almost life-size and at a level of intricacy that had rarely been possible before. Here (clockwise from top left), the Dutch Crocus, Spanish Crocus, Spanish Iris, and Scarlet Turk's Cap Lily are shown. In the convention of botanical illustration of the time, the roots are also included.

▼ SOPHISTICATED COLORING
The many shades of yellow used to show the contours of each petal indicate a high level of artistry and accuracy, as well as aesthetics.

▼ METICULOUS REPRESENTATION The large scale of the book allowed for very fine work enabling depiction of minute plant features. Here, a detail shows the individually painted disc florets, the tiny flowers at the sunflower's center.

◄ SEASONALITY
The *Hortus* was arranged broadly by season. It began with winter and finished with fall. This sunflower appeared in the largest section of the book—summer plants.

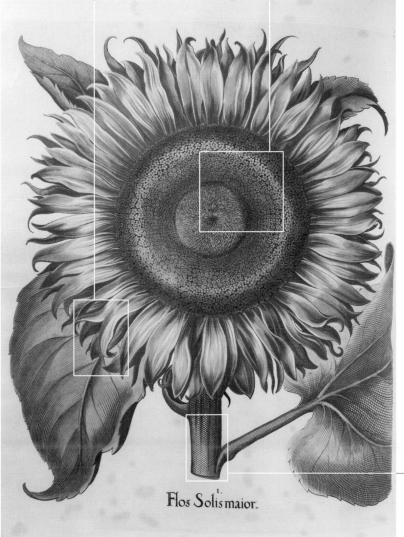

Flos Solis maior.

▼ CROSSHATCH This detail of the stalk shows fine hatching used as a tint, a method that was characteristic of the miniaturist's technique.

IN **CONTEXT**

Besler's *Hortus* drew on a strong tradition of botanical drawing that began with the Conrad Gesner (1516-65) the Swiss botanist, and which included Joachim Camerarius the Younger (1534-98), who may have helped lay out the gardens at Willibaldsburg.

The *Hortus* marks the definitive transition from woodcut techniques to copper plates. Besler sent weekly shipments of flowers from Eichstätt to studios in Nuremberg, where they were sketched. These images were then finely etched onto copper printing plates by a team of 10 engravers, including Wilhelm Killian. Pages printed for the color edition were then hand-colored by expert illustrators, such as Georg Mack, who could take up to a year to complete a single copy of the book.

Just over half of the 667 species portrayed in the *Hortus* were native to Germany. The remainder were imported from around the world: a third came from the Mediterranean, 10 percent from Asia (notably tulips), and around 5 percent from the Americas.

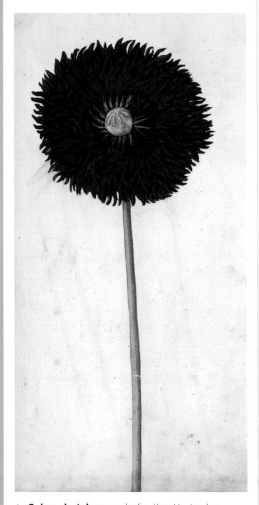

▲ **Color sketches** made for the *Hortus* by Nuremberg artist Sebastian Schedelare, including this opium poppy, are compiled in a book called Schedel's *Calendarium*.

Tutte l'opere d'architettura, et prospetiva

1537-75 (WRITTEN), 1619 (VERSION SHOWN) ▪ PRINTED ▪ 10 × 7 in (25.5 × 18.5 cm) ▪ 243 PAGES ▪ ITALY

SCALE

SEBASTIANO SERLIO

Published in seven volumes, *The Complete Works on Architecture and Perspective* was the most influential treatise on architecture produced in the Renaissance, and was widely studied in Europe after being translated from the original Italian. As an architect, Sebastiano Serlio's legacy is modest, but with his *L'Architettura* (as the work is often known), he created the first practical architectural handbook, and the most widely used edition is shown here.

Prior to *L'Architettura*, the principal tome on Renaissance architecture was the 1485 work *Dei re aedificatoria* (*Ten Books on Architecture*) by Florentine architect Leon Battista Alberti. Although authoritative, it was written in Latin, purely theoretical, and largely unillustrated. Serlio took a radically different approach: his books addressed the needs of architects, builders, and craftsmen by providing explanatory text alongside detailed drawings. Among the

SEBASTIANO **SERLIO**

1475-1554

Sebastiano Serlio was an Italian architect who is celebrated for his theoretical writing, which greatly influenced the development of Western architecture. His own buildings, however, left little impact.

Serlio was born in Bologna, Italy, where he trained as a perspective painter in his father's workshop. In 1514, he moved to Rome to study architecture; later, he practiced there, and in Venice, although he devoted much of his time to *L'Architettura*. In 1541, Serlio's writing came to the attention of Francis I of France, who summoned him to become part of an Italian design team he had assembled to consult on the rebuilding of the royal residence at Fontainebleau, outside Paris. Through his work at Fontainebleau, and through the hugely informative volumes of his treatise, Serlio transmitted the principles of Classical architecture from Italy to France, and elsewhere in northern Europe.

books' practical elements were a set of models for copying, and solutions for everyday design problems. The volumes did not appear in sequence—what became Books I and II were, respectively, the third and fourth to be published, but as a set they helped to cement the Renaissance belief in the primacy of Classical architecture.

In detail

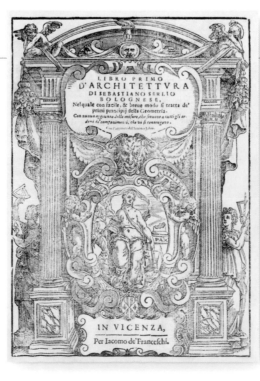

▶ **A LIFE'S WORK** Each volume of *L'Architettura* was written and published gradually, while Serlio was practicing as an architect in Italy and France; Books VI and VII were published after his death. Book I (1545), whose lavish title page is seen here, investigates the essentials of Classical architecture: above all, the rules of geometry and perspective. The perfect symmetry of the Classical columns, illustrated here, reflects the fascination with Ancient Greece and Rome that characterized the Renaissance period. Indeed, for the next 250 years, most significant European buildings were designed along Greco-Roman lines.

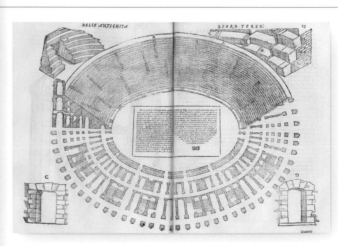

▲ **ARCHITECTURAL PLAN** Carefully rendered in fine detail, this plan of the first-century-CE arena in Verona, Italy, reflects Serlio's dedication to the Classical style. He derived his knowledge from two sources: the ruins of ancient buildings, and the treatise *On Architecture* (c.27 BCE) by Roman architect Vitruvius.

▼ **CLASSICAL MEETS CHRISTIAN** No subject exercised a greater hold on the imagination of Renaissance architects than churches. The goal was to find ways of adapting Classical precedents to Christian use. In reality, the ideal solution—the symmetrical "Greek cross" building in this illustration—proved impossible to reconcile with the practical needs of the Church.

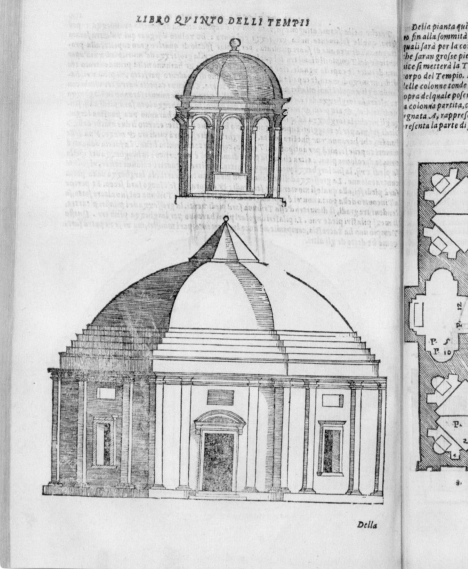

…much more can be **learned from the figure** than from the **text** since it is such a **difficult thing to write** about.

SEBASTIANO SERLIO

▲ **COMPOSITE COLUMNS** Serlio included illustrated examples of different types of Classical columns: Tuscan, Doric, Ionic, Corinthian, and Composite (shown here)—arranged in an order of increasing intricacy. Serlio had studied these in situ at ancient sites in Italy. *L'Architettura* was the first work to give a systematic guide to the main orders of Classical architecture, which are defined by their columns.

Mr. William Shakespeares Comedies, Histories, & Tragedies

1623 ▪ PRINTED BY ISAAC JAGGARD AND EDWARD BLOUNT ▪ 13 × 8 in (33 × 21 cm) ▪ C.900 PAGES ▪
COMPILED BY JOHN HEMINGE AND HENRY CONDELL ▪ ENGLAND

WILLIAM SHAKESPEARE

SCALE

The *First Folio*, as it is also known, was the first authoritative publication of all but one of the 37 plays widely attributed to William Shakespeare. Its importance is absolute. When it appeared seven years after his death, only 17 of his plays had been published—most in rogue editions.

It is almost certain that without the *First Folio* those plays which had not yet appeared in print, including *Macbeth* and *The Tempest*, would have been lost. In addition to being as definitive a collection of Shakespeare's plays as was possible, the *First Folio* marked a deliberate attempt to celebrate the impact of the playwright. Its format was as imposing as its goal which, according to his contemporary Ben Jonson, was to present Shakespeare "not of an age but for all time." The *First Folio*

WILLIAM **SHAKESPEARE**

1564-1616

Shakespeare is one of the greatest writers in the English language and perhaps the greatest dramatist of all time. Between 1590 and 1613 he wrote at least 37 plays and collaborated on several more.

Little is known about Shakespeare's early life. In 1582, he married Anne Hathaway in Stratford-upon-Avon, and had three children with her. The first mention of his presence in London is 1592, by which time he was a successful playwright. He became a shareholder in the Lord Chamberlain's Men, a theater company, which performed before Queen Elizabeth I (1533-1603). In 1599, the company moved to the Globe Theatre in London. When the theater was destroyed by fire in 1613, Shakespeare returned to Stratford-upon-Avon.

remains arguably the most important, and certainly the most sought-after, English-language book ever published. Approximately 750 copies are believed to have been printed; of these, 235 survive, but only 40 are complete.

In detail

▶ **LATE ADDITION** Only 35 plays are listed in the table of contents, or Catalogue, of the *First Folio*. The thirty-sixth play, *Troilus and Cressida*, written in around 1602 and the last to be printed, was included only at the last minute, and was therefore not included on the contents page. The grouping of the plays into the three categories of Comedies, Histories, and Tragedies was first implemented in the *First Folio*, and the works are still defined in that way.

▶ **FIRST APPEARANCE** *The Tempest* is the first play to feature in the *First Folio*, although it is believed to be one of the last plays that Shakespeare ever wrote—at least, that he wrote alone around 1610. It is listed on the Catalogue page under the heading of Comedies, even though there are elements of tragedy to the play.

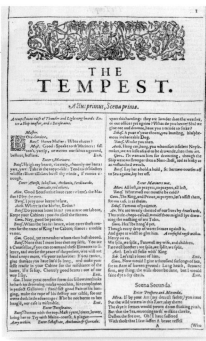

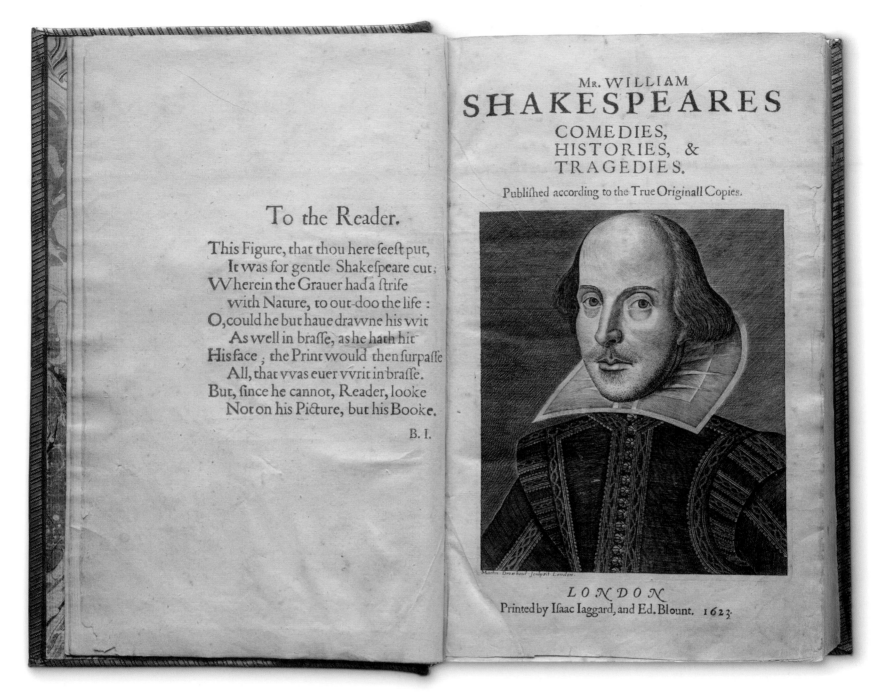

To the Reader.

This Figure, that thou here feeſt put,
 It vvas for gentle Shakeſpeare cut;
Wherein the Grauer had a ſtrife
 with Nature, to out-doo the life :
O, could he but haue dravvne his vvit
 As well in braſſe, as he hath hit
His face ; the Print would then ſurpaſſe
 All, that vvas euer vvrit in braſſe.
But, ſince he cannot, Reader, looke
 Not on his Picture, but his Booke.

 B. I.

MR. WILLIAM
SHAKESPEARES
COMEDIES,
HISTORIES, &
TRAGEDIES.

Publiſhed according to the True Originall Copies.

Martin Droeſhout ſculpſit London

LONDON
Printed by Iſaac Iaggard, and Ed. Blount. 1623.

IN CONTEXT

More than 400 years after Shakespeare's death, his plays have lost none of their appeal or relevance. They are studied and performed throughout the world, with new editions still being printed in English and in translation. One of the most ambitious editions to date is that of *Hamlet* by the German publisher Cranach-Presse. First published in German in 1928, then in English two years later, the margins feature original and translated extracts from two of Shakespeare's likely sources—a twelfth-century Norse folk tale and a sixteenth-century French story. Illustrating the edition are 80 striking woodcuts by Edward Gordon Craig.

▶ **Only 300 hand-printed copies** of Cranach-Presse's 1930 edition of *Hamlet* were produced, using handmade paper and featuring bold imagery and elegant typefaces.

▲ **SHAKESPEARE'S LIKENESS** Martin Droeshout's engraving of Shakespeare on the title page is one of only two images of the playwright generally accepted as a true likeness. Although Droeshout did not know Shakespeare personally, the compilers of the *First Folio*, John Heminge and Henry Condell, did and it is unlikely they would have accepted an unfaithful representation.

Dialogo sopra i due massimi sistemi del mondo

1632 ▪ PRINTED ▪ 8 × 6 in (21.9 × 15.5 cm) ▪ 458 PAGES ▪ ITALY

SCALE

GALILEO GALILEI

This is the book that changed people's view of the Universe. In *Dialogo sopra i due massimi sistemi del mondo* (*Dialogue Concerning the Two Chief World Systems*) the Italian mathematician Galileo Galilei (1564–1642) compared the Copernican view of the Universe (1541) which proposed that the Earth revolved around the Sun, with the traditional Ptolemaic view, which placed the Earth at the center of the Universe.

Galileo's book, written in Italian rather than scholarly Latin, takes the form of an imaginary discussion, set over four days, between three fictitious characters. Salviati argues in favor of the Copernican view, Simplicio favors the Ptolemaic view, and Sagredo is the neutral foil, who is eventually won over by Salviati. Copernicus had already presented his theory, but Galileo based the *Dialogo* on his own observations. In discussing a number of viewpoints, the book poked fun at those who refused to accept the possibility that the Earth revolved around the Sun.

Galileo's findings set him on a collision course with the Catholic Church, which opposed Copernicus's theory. In 1633 Galileo was found to be "vehemently suspect of heresy." He was taken to Rome and forced to recant his views, then placed under house arrest. *Dialogo* was put on the Vatican's Index of Prohibited Books, remaining there until 1835. A modified version, *The Dialogue on the Tides,* was permitted by the Church in 1741.

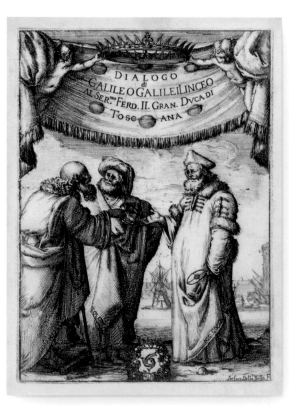

◀ **FRONTISPIECE** Stefano della Bella's engravings feature Aristotle and Ptolemy in debate with Copernicus, and a dedication to Galileo's patron, the Grand Duke of Tuscany. The illustration reflects the imaginary discussion Galileo uses in the book to convey his theory.

▶ **MAPS OF PLANETS AND STARS** Galileo included 31 woodcuts and diagrams to illustrate how the Copernican theory works. This one, from the third day's discussion, shows the orbit of Jupiter and Earth around the Sun.

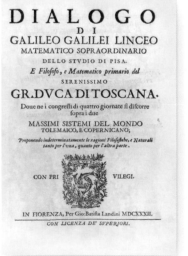

◀ **FIRST EDITION TITLE PAGE** This bears another dedication to the Grand Duke, and describes Galileo as an extraordinary mathematician. *Dialogue* was printed in Florence by Giovanni Battista Landini; this page bears his family crest of three circling fish.

> I have written many direct and indirect arguments for the Copernican view, but until now I have not dared to publish them, alarmed by the fate of Copernicus himself. "

GALILEO, IN A LETTER TO KEPLER, 1597

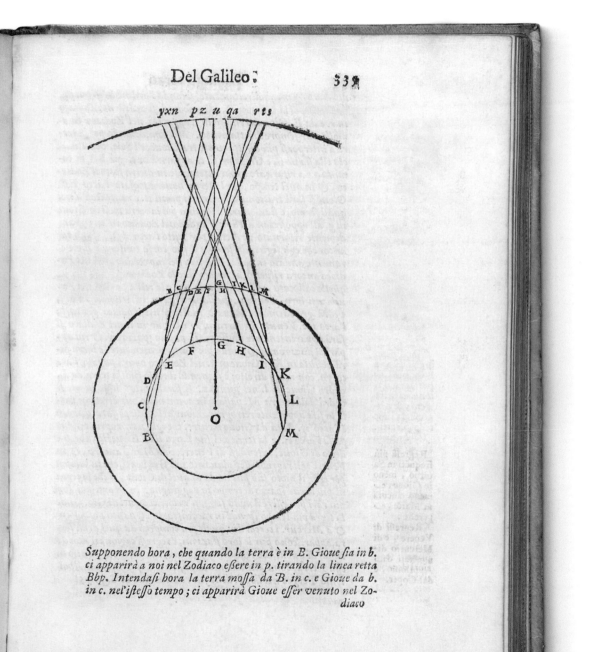

Dialogo terzo

...e diremo noi dell'apparente mouimento de i pianeti tanto ...ifforme, che non solamente hora vanno veloci, & hora più ...ardi, ma taluolta del tutto si fermano;& anco dopo per mol- ...spazio ritornano in dietro? per la quale apparenza salua- ...introdusse Tolomeo grandissimi Epicicli, adattandone vn ...er vno a ciaschedun pianeta, con alcune regole di moti incô- ...ruenti, li quali tutti con vn semplicissimo moto della terra ...tolgono via. E non chiamereste voi Sig. Simpl. grandiss- ...o assurdo, se nella costruzion di Tolomeo, doue a ciascun ...aneta sono assegnati proprij orbi, l'vno superior all'altro, ...isognasse bene spesso dire, che Marte,costituito sopra la sfera ...el Sole,calasse tanto,che rompendo l'orbe solare sotto a quello ...endesse, & alla terra più, che il corpo solare si auuicinasse, e ...oco appresso sopra il medesimo smisuratamente si alzasse? E ...ur questa, & altre esorbitanze dal solo, e semplicissimo mo- ...imêto annuo della terra vengono medicate.

. Queste stazioni regressi, e direzioni, che sempre mi son ...arse grandi improbabilità,vorrei io meglio intendere, come ...ocedano nel sistema Copernicano.

. Voi Sig. Sagredo le vedrete proceder talmente, che questa ...la coniettura dourebbe esser bastante a chi non fusse più che ...oteruo, ò indisciplinabile, a farlo prestar l'assenso a tutto il ...manente di tal dottrina. Vi dico dunq; che nulla mutato ...l mouimêto di Saturno di 30. anni, in quel di Gioue di 12. ...quel di Marte di 2.in quel di Venere di 9. mesi, e in quel di ...ercurio di 80. giorni incirca, il solo mouimento annuo del- ...terra tra Marte, e Venere,cagiona le apparenti inegualità ...e moti di tutte le 5. stelle nominate. E per facile, e piena in- ...lligenza del tutto ne voglio descriuer la sua figura. Per tan- ...supponete nel centro O. esser collocato il Sole, intorno al ...ale noteremo l'orbe descritto dalla terra co'l mouimêto an- ...uo BGM. & il cerchio descritto vgr. da Gioue intorno al ...le in 12. anni sia questo bgm. e nella sfera stellata inten- ...amo il Zodiaco yus. In oltre nell'orbe annuo della terra prê- ...remo alcuni archi eguali BC.CD.DE.EF.FG.GH.HI. ...K.KL.LM. e nel cerchio di Gioue noteremo altri archi pas- ...ti ne' medesimi tempi,ne' quali la terra passa i suoi, che sieno ...cd.de.ef.fg.gb.ik.kl.lm. che saranno a proporzione cia- ...beduno minor di quelli notati nell'orbe della terra, si come il ...ouimêto di Gioue sotto il Zodiaco è più tardo dell'annuo . Suppo-

Del Galileo: 339

yxn pz u qa rts

Supponendo hora, che quando la terra è in B. Gioue sia in b. ci apparirà a noi nel Zodiaco essere in p. tirando la linea retta Bbp. Intendasi hora la terra mossa da B. in c. e Gioue da b. in c. nel'istesso tempo; ci apparirà Gioue esser venuto nel Zo- diaco

Bay Psalm Book

1640 ▪ PRINTED ▪ 7 × 4 in (17.4 × 10.4 cm) ▪ 153 PAGES ▪ USA

SCALE

RICHARD MATHER

Commonly heralded as the first book to be printed in British North America, the *Bay Psalm Book* was a translation of the Book of Psalms. It was created for a group of Christian evangelical dissenters, who sailed from England to America in 1620, where they settled in Plymouth, Massachusetts. Facing persecution in England, the group, who are sometimes called the Pilgrim Fathers, sailed for the colonies in search of religious tolerance. There, they established a form of worship that placed particular emphasis on the *Book of Psalms*, which contains hymns of praise and appears in the Hebrew Bible and Old Testament of the Christian Bible.

The settlers wanted a new translation of the *Book of Psalms* that was closer to the original Hebrew. And so they commissioned 30 translators to prepare the new version, and produced *The Whole Booke of Psalms*, now known as the *Bay Psalm Book*. The book was a metrical psalter, with verses rhythmically arranged for singing to familiar tunes. Although a revised version was published in 1761, taking contemporary language into account, the updated psalms

RICHARD **MATHER**

c.1596-1669

Richard Mather was a Puritan minister and one of the 30 "pious and learned Ministers" who helped to create the new translation of the *Book of Psalms*. He also authored several other titles.

Richard Mather was born in Lancashire and was ordained in the Anglican (Episcopalian in the U.S.) Church. It was a tumultuous era in which several branches of Protestantism developed in England. Mather was suspended for nonconformity to liturgical regulations by the Archbishop of York in 1634. The next year, he decided to emigrate and sailed with his wife, Katherine Holt, and four sons to the New World, settling in Dorchester, Massachusetts. Mather was a persuasive preacher and assisted the clergy, who translated the Hebrew psalter as the *Bay Psalm Book*, taking responsibility for some of the largest sections. In the early years of New England Congregationalism, he wrote extensively on questions of discipline for the new community.

lacked finesse, and none are in use today. The *Bay Psalm Book* was the third text to be printed in British North America, 20 years after the settlers' arrival. The pressman was unskilled and, as a result, there are many errors throughout the book. Only 11 copies of the first edition are known to exist. In 2013, a rare copy of the 1640 *Bay Psalm Book* was sold by the British auction house, Sotheby's, for a staggering $14,165,000.

In detail

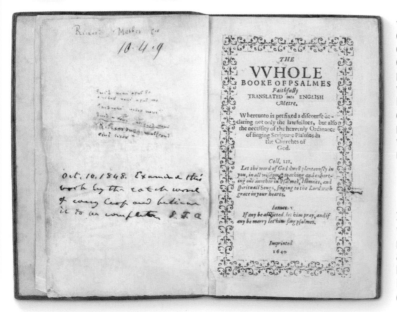

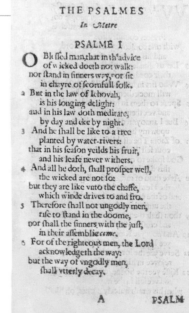

◀ **PRINTING ERRORS** The first edition was poorly printed, and contains numerous typographical errors. The type was uneven, punctuation mixed up, and words incorrectly broken over lines. More than 1,700 copies of the 298-page volume were printed in the first run in 1640, with a further 26 smaller print runs following.

▶ **RHYMING METER** The psalms were written in a crude meter, particularly in the first edition, an example of which is shown here. The writers placed more importance on faithful translation of the text than poetic finesse.

▼ **NUMBERED VERSE** Each psalm was numbered in accordance with the relevant Biblical verses. Without any accompanying musical notation, musicians had to choose a suitable tune to fit the meter.

PSALM xlɪ.

mercifull unto mee;
heale thou my foule, becaufe that I
have finned againſt thee.
5 Thoſe men that be mine enemies,
with evill mee defame:
when will the time come hee ſhall dye,
and periſh ſhall his name?
6 And if he come to ſee *mee*, hee
ſpeaks vanity: his heart
ſin to it ſelfe heaps, when hee goes
forth hee doth it impart.
(2)
7 All that me hate, againſt mee they
together whiſper ſtill:
againſt me they imagin doe
to mee malicious ill.
8 *Thus doe they ſay* ſome ill diſeaſe
unto him cleaveth ſore:
and *ſeing now* he lyeth downe,
he ſhall riſe up noe more.
9 Moreover my familiar freind,
on whom my truſt I ſet,
his heele againſt mee lifted up,
who of my bread did eat.
10 But Lord me pitty, & mee rayſe,
that I may them requite.
11 By this I know aſſuredly,
in mee thou doſt delight:
For o're mee triumphs not my foe.
12 And mee, thou doſt mee ſtay,
in mine integrity; & ſet'ſt

mee

PSALME xlɪ, xlɪɪ.

mee thee before for aye.
13 Bleſt hath Iehovah Iſraels God
from everlaſting *been*,
alſo unto everlaſting:
Amen, yea and Amen.

THE
SECOND BOOKE.
PSALME 42
To the chief muſician, *Maſchil*, for the
Sonnes of Korah.
Ike as the Hart panting doth bray
after the water brooks,
even in ſuch wiſe o God, my ſoule,
after thee panting looks.
2 For God, even for the liuing God,
my ſoule it thirſteth ſore:
oh when ſhall I come & appeare,
the face of God before.
3 My teares have been unto mee meat,
by night alſo by day,
while all the day they unto mee
where is thy God doe ſay.
4 When as I doe in minde record
theſe things, then me upon
I doe my ſoule out poure, for I
with multitude had gone:
With them unto Gods houſe I went,
with voyce of joy & prayſe:

I with

...We have a **printery here** and thinke to goe to worke with some special things ...

HUGH PETER, DECEMBER 10, 1638, ON THE ARRIVAL OF THE PRINTER IN CAMBRIDGE, MASSACHUSETTS

ON TECHNIQUE

The first printing press was brought to British North America by a minister named Joseph Glover, who in 1638 had sailed from England with his wife and five children, taking his second-hand printing press with him. When Glover died at sea, his widow employed one of his technicians, a near-illiterate locksmith, Stephen Daye, to assist her in setting up a business in Massachusetts. Among the first commissions was the newly translated *Bay Psalm Book.*

The early printing presses were made from wood and used ink and paper. The typeface was covered in an oil-based ink and placed in reverse. The wooden screw was turned to apply pressure to the page, which absorbed the ink. When the page was printed, the pages were hung to dry.

▲ **The printing press,** with its two trays of second-hand type, was shipped from England, along with ink and reams of paper.

Directory: 1450-1649

MORIAE ENCOMIUM
DESIDERIUS ERASMUS

HOLLAND (1511)

A satirical essay written in Latin, but known in English as *In Praise of Folly,* this is one of the best-known works of Desiderius Erasmus (1469–1536), the Dutch humanist scholar and leading intellectual of the sixteenth century. With subversive and ironic humor, the narrator (a personification of Folly, who parades as a goddess) celebrates life's pleasures while criticizing corrupt theologians and clergymen, and the Catholic doctrine. Erasmus wrote the essay to amuse his friend Sir Thomas More (see right). It was extremely popular at the time, much to Erasmus's astonishment—36 Latin editions were printed in his lifetime, as well as French, German, and Czech translations. Pope Leo X and Cardinal Cisneros were said to have been amused by it. But 20 years after Erasmus's death, *Moriae Encomium* was put on the Vatican's Index of Forbidden Books—listed until 1930.

▼ DA COSTA HOURS
SIMON BENING

BELGIUM (1515)

A book of hours by the celebrated Flemish manuscript illuminator from Bruges, Simon Bening (1483–1561), the *Da Costa Hours* was named after the Portuguese family who commissioned it and whose coat of arms appears in the book. The manuscript is richly illustrated, boasting 121 miniatures including colorful landscapes, highly detailed portraits, and 12 full-page calendars, the likes of which had not been seen since the *Trés Riches Heures* a century earlier (see pp.64-69). This is one of Bening's earliest manuscripts, and its lavish illuminations demonstrate his exceptional talent: even when he used traditional templates he reinterpreted and embellished them to create truly original works. Bening, who learned the skill of illumination from his father, Alexander Bening, was painting at the height of the Ghent-Bruges School, an artistic movement of manuscript illumination that developed in Belgium, and his work was famous across Europe. Yet with the rise of the printing press, manuscript illumination had become a dying art, and on Bening's death the Ghent-Bruges School died with him.

A miniature from *Da Costa Hours* depicting the month of May.

UTOPIA
THOMAS MORE

ENGLAND (1516)

This work of fiction is the best-known book by the English statesman and lawyer Sir Thomas More (1478–1535). More describes a fictitious island located in the Atlantic ocean where humans live harmoniously in a society that advocates peace, religious tolerance, equality, shared ownership, and euthanasia. He named the Island "Utopia," from the Greek *ou-topos,* meaning "nowhere." More's text is a strong criticism of European society immediately before the Reformation; yet as a devout Roman Catholic, More's own views on tolerance sat in contrast to those outlined in the book. *Utopia* was extremely popular when it was published, establishing More as one of the leading humanists of the era. While More may not have intended his island to be viewed as an image of perfection, the word "utopia" has become a by-word for an idealized society or place. The utopia of More's fiction has largely been eclipsed by the literary genre that evolved from it—the Utopian novel.

DE REVOLUTIONIBUS ORBIUM COELESTIUM
NICOLAUS COPERNICUS

GERMANY (1543)

Translated as *On the Revolutions of Celestial Spheres,* this ground breaking work by Polish astronomer Nicolaus Copernicus (1473–1543) was published in Nuremberg just before his death. It was the most important and controversial scientific publication of the sixteenth century. Copernicus proposed a "heliocentric system" of planetary motion that identified the sun as the center of the universe around which all other planets, including Earth, revolved. This view challenged Ptolemy's accepted "geocentric system" (which placed Earth at the centre of the universe) and was met with controversy from philosophers, scientists, and theologians alike. Copernicus dedicated his book to Pope Paul III, but 70 years later the Vatican placed it on the Index of Forbidden Books, pending alterations—it was not fully condemned because Copernicus's theory meant that the Church could calculate the date of Easter Sunday accurately. *De Revolutionibus Orbium Coelestium* transformed the way that the solar system was viewed. It led to further studies by Galileo (see pp.130-31) and Sir Isaac Newton (see pp.142-43), and formed the basis of modern astronomy.

HISTORIA ANIMALIUM
CONRAD GESNER

SWITZERLAND (VOLUMES 1-4 1551-58; VOLUME 5 1587)

The *History of the Animals* (or *Historia Animalium*) was a comprehensive study of natural history by the Swiss

naturalist scholar and doctor of medicine Conrad Gesner (1516-65). It was published in Zurich, initially in four volumes, but a fifth volume was published posthumously in 1587. *Historia Animalium* was a complete compendium of all animals, including newly discovered species, detailing their place in folklore, mythology, art, and literature. Gesner's text drew on contemporary research, as well as classical sources, such as that of the Ancient Greeks Aristotle and Pliny the Elder. This exhaustive work, which spanned over 4,500 pages, was remarkable for the vast quantity of images—around 1,000 woodcut illustrations, mostly by Lucas Schan from Strasbourg, feature in the book. *Historia Animalium* was very popular and became the most widely read of all Renaissance natural histories—an abridged version was published in 1563, and an English translation appeared in 1607. However, it was placed on the Vatican's Index of Forbidden Books, as Pope Paul IV (1476-1559) felt that Gesner's views would be biased because he was a Protestant.

I QUATTRO LIBRI DELL'ARCHITETTURA
ANDREA PALLADIO

ITALY (1570)

Written by the Italian architect Andrea Palladio (1508-1580) *I quattro libri dell'architettura* (or *The Four Books on Architecture*) has been heralded the most successful and influential treatise on the design and construction of buildings in the Renaissance, and Palladio as one of the most important figures in Western architecture. Palladio based his ideas on the purity and simplicity of the palaces and classical temples of the ancient world, and founded the movement that takes its name from him—Palladian architecture. First published in four volumes, the book was extensively illustrated with woodcuts after Palladio's own drawings. His classical style was immediately popular and was widely adopted by contemporary designers and builders across Europe. While Palladio was responsible for many outstanding buildings, mostly in the Republic of Venice, it is for this treatise that he is best known.

ESSAIS
MICHEL DE MONTAIGNE

FRANCE (1580)

French writer and philosopher Michel de Montaigne (1533-92) was one of the most significant figures of the late French Renaissance, and has been credited with establishing the "essay" as a new literary genre. All of his literary and philosophical works are contained within *Essais* (meaning *Attempts*, but known in English as *Essays)*, a collection of 107 texts that he began writing in 1572. Montaigne covered a vast range of topics in *Essais* and demonstrated a new and modern way of writing and thinking that proved highly popular. Montaigne made many changes and additions to his work, but never deleted any preexisting text, as he wanted to create a record of the developments in his views over time. His work influenced a great many writers, philosophers, and theologians.

EXERCITATIO ANATOMICA DE MOTU CORDIS ET SANGUINIS IN ANIMALIBUS
WILLIAM HARVEY

GERMANY (1628)

The English physician to King James I, William Harvey (1578-1657) wrote this seminal work of physiology, in Latin, translating as *An Anatomical Study of the Motion of the Heart and Blood in Animals*. It was first published in Frankfurt at the annual book fair, and an English edition followed in 1653. This 72-page scientific paper, with 17 chapters, outlined Harvey's ground-breaking discovery that the blood circulates around the human body in a single system. At the time it was thought that blood did not flow, but was produced and absorbed by the body within two separate systems. Based on his experiments, Harvey's calculations revealed that the volume of blood pumped by the heart was too great to be absorbed, suggesting that the blood circulated within a single closed system. Harvey's book provided a detailed description of the structure of the heart, as well as the different blood vessels. His findings were met

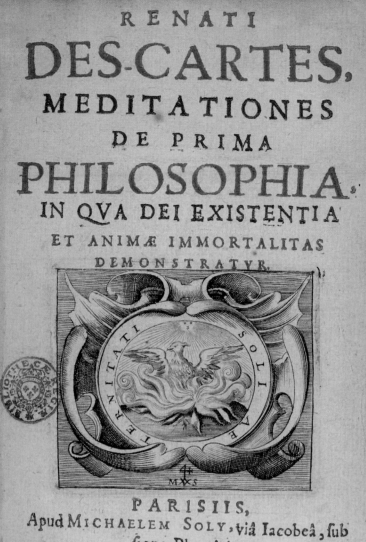

with scepticism, but by the time of his death the circulation of blood was accepted theory. Harvey's work had a significant impact on the study of physiology, and eventually led to the possibility of blood transfusion.

▲ MEDITATIONES DE PRIMA PHILOSOPHIA
RENÉ DESCARTES

FRANCE (1641)

René Descartes's (1596-1650) book *Meditations on First Philosophy* subtitled *In which the existence of God and the immortality of the soul are demonstrated* was a groundbreaking philosophical text.

Title page from the first edition of René Descartes's *Meditationes de Prima Philosophia*.

First published in Latin, it was written at a time when scientific advances were threatening the teachings of the Church. *Meditationes de Prima Philosophia* attempted to bridge the gap between science and religion by offering a philosophical foundation for scientific theory. By doing this Descartes abandoned the accepted wisdom of Aristotelian philosophy, which lead to him being branded a revolutionary by many. The Vatican considered his views dangerous and placed the book on the Index of Forbidden Books in 1663. Descartes's most popular work, *Meditationes* is heralded as the foundation of modern Western philosophy, and Descartes as the "father of modern philosophy".

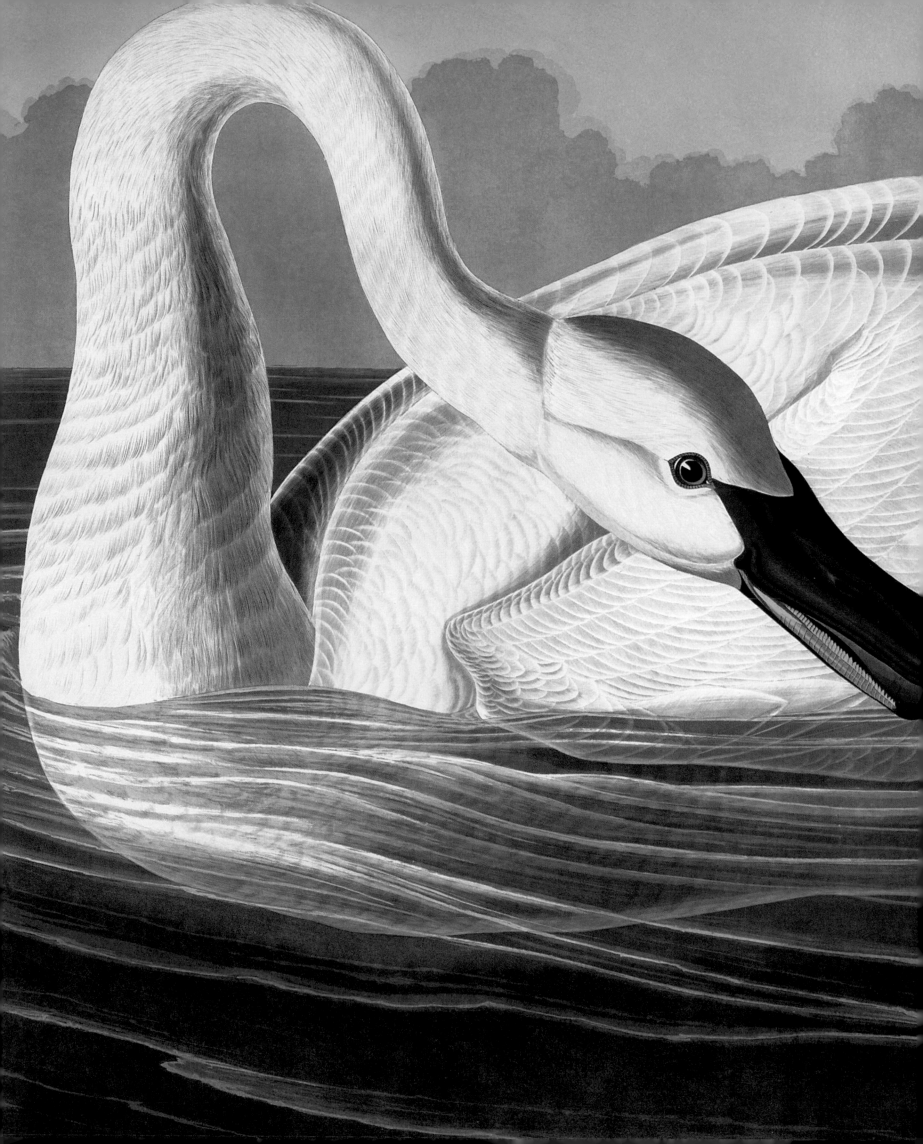

1650—1899

- Micrographia
- Philosophiæ Naturalis Principia Mathematica
- Systema Naturae
- L' Encyclopédie ... des Sciences, des Arts et des Métiers
- A Dictionary of the English Language
- Bucolica, Georgica, et Aeneis
- Tristram Shandy
- Fables in Verse
- The Wealth of Nations
- Rights of Man
- Songs of Innocence and of Experience
- Birds of America
- Procedure for Writing Words, Music, and Plainsong in Dots
- Baedeker guidebooks
- The Pickwick Papers
- The Holy Land
- Photographs of British Algae: Cyanotype Impressions
- Uncle Tom's Cabin
- Leaves of Grass
- On the Origin of Species
- Alice's Adventures in Wonderland
- Das Kapital
- The Works of Geoffrey Chaucer Now Newly Imprinted
- Un Coup de Dés

CHAPTER 4

Micrographia

1665 ▪ PRINTED ▪ 12 × 7 in (30.3 × 19.8 cm) ▪ 246 PAGES ▪ ENGLAND

SCALE

ROBERT HOOKE

Robert Hooke's pioneering work

Micrographia, published in 1665, was the world's first book on microscopy (the examination of minute objects through a microscope). Hooke studied insects, microbes, and inanimate objects under a microscope and recorded his observations with intricate detail and accuracy. His scientific discoveries are brought to life in *Micrographia* by a magnificent series of illustrations, drawn with the aid of his friend Sir Christopher Wren (1632–1723). These spectacular copperplate engravings, some so large that they required fold-out pages, are arguably the book's most notable feature.

The book also records Hooke's discovery of the plant cell, which he identified while studying slices of cork. Prior to the invention of the microscope, scientists were unable to see such small details, and the discovery of plant cells paved the way for a new branch of scientific research. Other areas that Hooke touches on in the book include wave of light theory, and observations of distant planets.

Micrographia was a masterpiece of scientific observation, revealing a miniature world that had never been seen before, and its impact on the public was enormous. The great diarist, Samuel Pepys (1663–1703), is recorded as having stayed up most of the night marveling at the extraordinary illustrations. It was the first publication released by the Royal Society—the national academy of science in England, founded in London in 1660—and became a bestseller, giving scientists in the field a brilliantly illustrated introduction to the little-known world of microscopic observation.

ROBERT **HOOKE**

1635–1703

Robert Hooke was a scientist, architect, inventor, and natural philosopher. He made significant contributions to many scientific fields, and in 1660 discovered the law of elasticity, also known as Hooke's Law.

Hooke studied science at Christ Church, Oxford, before settling in London. He was a founding member of the Royal Society, the national academy of science, and became their Curator of Experiments in 1662. Two years later, he was made Professor of Geometry at Gresham College in London. Hooke's scientific interests were varied. His investigation into elasticity led to his formulation of Hooke's Law, and he correctly identified fossils as having once been living creatures. He was fascinated by astronomy and helped construct telescopes. After the Great Fire of London in 1666, he was commissioned as Surveyor to the City of London to oversee rebuilding along with Sir Christopher Wren. Among the buildings under Hooke's care were the Royal Observatory at Greenwich and the Bethlehem Royal Hospital. He died at age 67 a wealthy man.

> By the help of microscopes, there is **nothing so small, as to escape our inquiry;** hence there is **a new visible world discovered** to the understanding. 🙸

ROBERT HOOKE, *MICROGRAPHIA*

▼ **INTIMATE DETAIL** Hooke's famous fold-out engraving of a flea is the largest illustration in the book, measuring 12 x 18 in (30 x 46 cm). While most readers were familiar with the minute creature, none had seen such a large-scale drawing, and so the result was both monstrous and spectacular. Through his magnification of this tiny insect, Hooke illuminates the possibilities of the microscopic world—the ability to study in intimate detail the anatomy of any creature, no matter how small. At this time nobody knew that the minuscule parasite was largely responsible for the spread of many diseases in seventeenth-century Britain, including the devasting Bubonic plague.

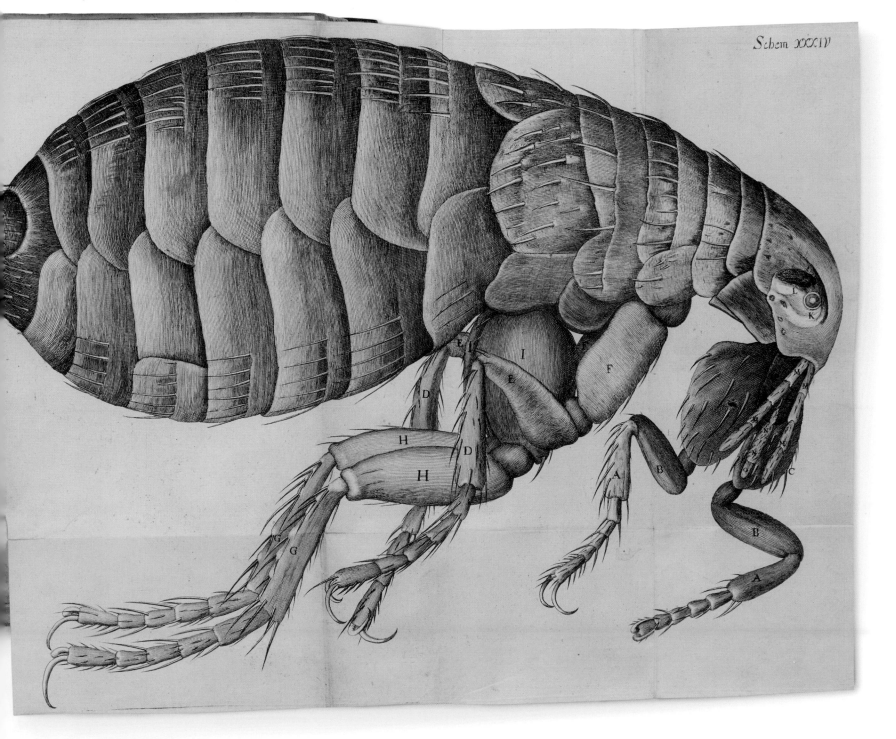

In detail

▲ ROYAL DEDICATION Hooke dedicated *Micrographia* to the reigning monarch, Charles II (1630–1685) (as was the practice of the day). Having seen microscopic drawings of insects by Sir Christopher Wren, the king had approached the Royal Society asking for an illustrated book on microscopy. As Wren was busy, Hooke was given the job, and by dedicating his book to a royal patron, he increased the likelihood of financial assistance from other aristocrats.

▶ FOLD-OUT ILLUSTRATIONS Hooke's portrait of a louse holding a human hair was a shocking revelation. The drawing folded out to four times the size of the book. Lice were a common feature of seventeenth-century life, but never before had insects been represented in fine detail.

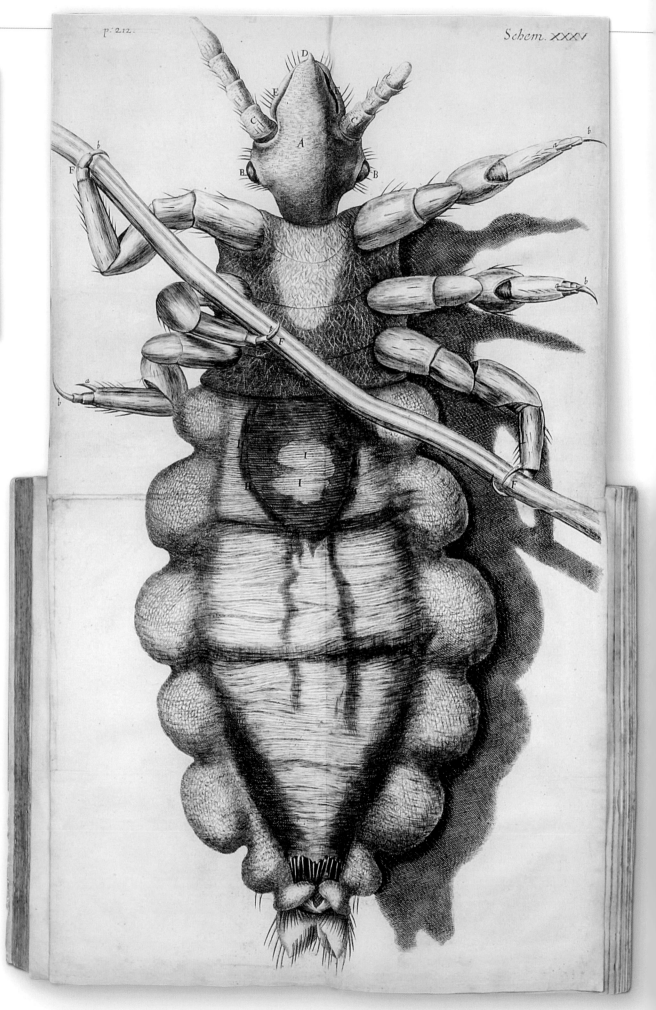

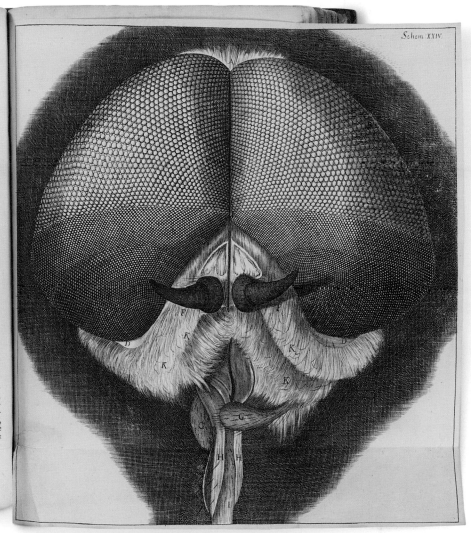

▲ **ACCURATE ETCHING** The illustrated head of a gray drone fly shows the extraordinary precision of Hooke's observations. To achieve this level of accuracy, Hooke employed an etching technique, whereby an illustration was scratched onto a copperplate through an acid-resistant coating. The plate was dipped in acid, which bit through the exposed metal until the image was etched onto the plate. It could then be transferred onto paper with ink.

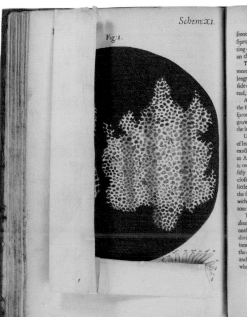

▲ **ADDING THE IMAGES** The insertion of the illustrations into each individual copy of the book was done manually. The copperplate engravings were first folded by hand and then glued onto the page. This time-consuming task increased the price of the volumes. In these prints Hooke illustrates his study into the properties of a *Mimosa pudica* leaf–a peculiar plant that appears "sensitive" to touch, as it shrinks back in response.

Philosophiæ Naturalis Principia Mathematica

1687 ▪ PRINTED ▪ 10 × 8 in (24.2 × 20 cm) ▪ 506 PAGES ▪ ENGLAND

SCALE

SIR ISAAC NEWTON

The publication of one of the most influential scientific works of all time, the *Philosophiae Naturalis Principia Mathematica*, or *Mathematical Principles of Natural Philosophy* by Sir Isaac Newton (1643–1727) arose in part from an academic dispute. A groundbreaking text that laid out in mathematical terms Newton's three laws of motion, as well as his theory of universal gravity, the book provided incontrovertible support for Copernicus's much-disputed world system (see p.134).

The quarrel that sparked the book arose in 1684 between Robert Hooke (see p.138) and English astronomer Edmund Halley (1656–1742) over the nature of planetary orbits, for which Hooke offered a theory but no proof. Halley consulted his friend, the mathematician and physicist Isaac Newton, who claimed to have already solved the problem. Newton sent a short written document, *De motu corporum* (*On the motion of bodies*), to Halley three months later, but continued to work on the text, tailoring it to a general audience. However, when the first volume of the expanded work—the *Principia*—was presented to the Royal Society in 1686, Hooke claimed the ideas about what came to be called "gravity" were his. In response, Newton developed his third volume into a densely reasoned mathematical work. The publication was overseen by Halley, funded by the Royal Society, and took three years. The *Principia* was a scientific tour de force and, despite its small print run of 250–400 copies, it won Newton instant fame.

RELATED **TEXTS**

Ever since the German astronomer Johannes Kepler (1571–1630) had formulated laws explaining the motion of the planets in 1609, scholars had struggled to explain the force that shaped their orbits. French philosopher René Descartes (1596–1650) tried to provide a comprehensive explanation of the physical workings of the solar system, in his *Principia Philosophiæ* (*Principles of Philosophy*) of 1644. His idea that the motion of a body will remain stable—and in a straight line—unless altered by another force was adopted by Newton as his First Law of Motion. However, Newton criticized Descartes' theory that the planets were held in their orbits by bands of particles he called "vortices."

RENATI
DES-CARTES
PRINCIPIA
PHILOSOPHIÆ.

*Ultima Editio cum optima collata , diligenter
recognita, & mendis expurgata.*

AMSTELODAMI,
Apud DANIELEM ELZEVIRIUM.
Anno cIↃ IↃc LXXII.

▶ Descartes' *Principia Philosophiæ* summarized knowledge about the universe, combining metaphysics, philosophy, physics, and mathematics.

Hoc experimen
illud aliquando de
numerorum partes
fus fum. Nam c
cum unco infirmc
Cauſam quærendo
pyxidis, & ejus of
batur. Parabam
nis immotum mai
defcripſimus.
Eadem method
ricorum in Aqua &
porum figurarum
exiguis conſtructæ
aptiſſimæ ſint, ſun

S

De

Preſſio non prop
ubi particulæ Fluid.
Si jaceant parti
preſſio directe pr
particula e urgebit
litas f & g oblique
non ſuſtinebunt pro
ciantur a particul
quatenus autem fu
ticulas fulcientes ;

Newton has brushed aside all the difficulties together with the Cartesian vortices.

CHRISTIAAN HUYGEN, NOTE MADE ON *PRINCIPIA*, 1688

▼ **DETAILED DIAGRAMS**
Newton's *Principia* is illustrated with diagrams that explain his mathematical reasoning. This page from Book II shows how force exerted will travel in a straight line unless diverted by particles placed at an oblique angle (left-hand page) or by a barrier (right-hand page).

[354]

i memoriter. Nam charta, in qua intercidit. Unde fractas quafdam ɔoria exciderunt, omittere compul-o tentare non vacat. Prima vice, , pyxis plena citius retardabatur. ɔod uncus infirmus cedebat ponderi obfequendo in partes omnes flecte-m firmum, ut punctum fufpenfio-nc omnia ita evenerunt uti fupra

imus refiftentiam corporum Sphæ-o, inveniri poteft refiftentia cor-fic Navium figuræ variæ in Typis ferri, ut quænam ad navigandum is tentetur.

T. VIII.

Fluida propagato.

Theor. XXXI.

luidum fecundum lineas rectas, nifi jacent.

d, e in linea recta, poteft quidem a ad e; at blique po-æ illæ f & g am, nifi ful-ous h & k; emunt par-uftinebunt preffionem nifi fulcian-tur

[355]

tur ab ulterioribus *l* & *m* eafque premant, & fic deinceps in in-finitum. Preffio igitur, quam primum propagatur ad particulas quæ non in directum jacent, divaricare incipiet & oblique pro-pagabitur in infinitum; & poftquam incipit oblique propagari, fi inciderit in particulas ulteriores, quæ non in directum jacent, ite-rum divaricabit; idque toties, quoties in particulas non accurate in directum jacentes inciderit. Q. E. D.

Corol. Si preffionis a dato puncto per Fluidum propagatæ pars aliqua obftaculo intercipiatur, pars reliqua quæ non intercipi-tur divaricabit in fpatia pone obftaculum. Id quod fic etiam

demonftrari poteft. A puncto *A* propagetur preffio quaqua-verfum, idque fi fieri poteft fecundum lineas rectas, & obftacu-lo *NBCK* perforato in *BC*, intercipiatur ea omnis, præter par-tem Conformem *APQ*, quæ per foramen circulare *BC* tranfit. Planis transverfis *d e*, *f g*, *h i* diftinguatur conus *APQ* in frufta

X x 2 &

Systema Naturae

1735 ▪ PRINTED ▪ DIMENSIONS UNKNOWN ▪ 11 PAGES ▪ NETHERLANDS

CAROLUS LINNAEUS

A large-format pamphlet of just 11 pages, *Systema Naturae* was written by Swedish botanist Carl Linnaeus under his Latinized name Carolus Linnaeus; in it Linnaeus introduced a scheme for the classification of living things. 13 editions of the work were printed in total, with the extent increasing each time, so that by the twelfth edition (the last that Linnaeus oversaw himself) there were 2,400 pages. The system of classification proved so effective that it is still used by scientists today. At the time of the book's publication, many naturalists were attempting to classify life, but Linnaeus's hierarchical system prevailed because of its beautiful simplicity. He divided the natural world into three kingdoms—minerals, plants, and animals—then subdivided living things initially into class, then order, then genus, and, finally, species.

In the 1735 edition of *Systema Naturae*, Linnaeus argued that nearly all plants have sexual or reproductive organs, just like animals, and that these could be used to classify them through easy-to-learn structural differences. He divided all flowering plants into 23 classes according to the length and number of their stamens (the male reproductive organs, which produce pollen), then subdivided them into orders according to the number of pistils (the female organs, which produce the ovules).

He also gave each species a two-part (or binomial) Latin name, such as *Linnaea borealis* (twinflower), supposedly his favorite plant; the first part of the name referring to the genus to which the species belongs, the second, the species name. In the 1735 edition of *Systema Naturae*, Linnaeus used this binomial only for plants, but in later editions he extended it to animals. During his life he named almost 8,000 plants, as well as many animals, and was also responsible for the scientific designation for humans: *Homo sapiens*.

CARL **LINNAEUS**

1707-1778

Carl Linnaeus was a Swedish botanist who devised the system that all scientists use today to label living things under a two-part Latin name. Considered the "Father of Taxonomy", he was also a pioneer in the study of ecology and the relationship between living things and their environments.

Born in Småland in southern Sweden, Carl Linnaeus was the son of a clergyman, a keen gardener who shared his botanical knowledge with his son. Linnaeus started training as a medical student in Uppsala, which included studying the use of plants, minerals, and animals in medicine, but finished his degree in the Netherlands. While there, he sketched out his system for classifying plants according to their sexual organs in his 1735 publication *Systema Naturae*. In 1738, back in Sweden, he first practiced medicine, then became a botany professor at Uppsala Unversity in 1741, where he established a botanical garden to which his many students brought back specimens from around the world. Linnaeus published other books using his system of classification, including *Species Plantarum* (1753). When he was given a knighthood in 1757, he took the name Carl von Linné. He died in Uppsala in 1778 and is buried in the city's cathedral.

> … objects are **distinguished** and **known** by classifying them methodically and giving them **appropriate names** … the foundation of our science.

CAROLUS LINNAEUS, *SYSTEMA NATURAE*

INNÆI

III. AMPHIBIA

REGNUM ANIMALE.

IV. PISCES.

V. INSECTA.

VI. VERMES.

PARADOXA.

▲ CLASSIFICATION CHART In this large chart drawn by artist Georg Ehret, Linnaeus organizes the animal kingdom into six classes: quadrupeds, birds, amphibia (including reptiles), fish, insects, and worms. He also added the class Paradoxa, mysterious creatures that included unicorns and phoenixes. Classes are then further divided—for example, quadrupeds into humanlike animals (such as primates) and Ferae (such as dogs, cats, and bears). In the tenth edition Linnaeus replaced the label Quadrupedia—a term that he adopted from Aristotle—with Mammalia.

L'Encyclopédie… des Sciences, des Arts et des Metiers

1751-72 ▪ PRINTED ▪ 10¹⁄₂ × 15¹⁄₂ in (26.5 × 39.5 cm) ▪ 28 VOLUMES, 18,000 PAGES OF TEXT ▪ FRANCE

EDITED BY DENIS DIDEROT AND JEAN D'ALEMBERT

SCALE

Few books have had such a profound influence on the world as *L'Encyclopédie, ou Dictionnaire raisonne des sciences, des arts et des metiers*. This huge work, translated as *Encyclopedia, or a Classified Dictionary of the Sciences, Arts, and Trade*, provided the first complete summary of human knowledge, and aimed to guide people towards the Enlightenment idea that the future belonged to humanity and reason.

The *Encyclopédie* began simply as a French translation of the groundbreaking English work *Cyclopaedia*, written by Ephraim Chambers in 1728. Yet under the leadership of Denis Diderot and mathematical editor Jean d'Alembert (1717–83), it grew into a vast work in its own right that employed more than 150 writers, including some of the greatest thinkers of the age, such as Voltaire (1694–1778) and Jean-Jacques Rousseau (see p.211). In the *Encyclopédie,* Diderot and d'Alembert aimed to bring together all that was known about the world, and they divided this information into three categories: Memory, Reason, and Imagination. No subject was too grand or too small; the work covered big ideas, such as absolute monarchy and intolerance, as well as everyday skills, like jam-making.

The *Encyclopédie*'s democratic message deliberately challenged the Jesuits of the Catholic Church, who jealously guarded knowledge, as well as the idea that any person had the right to rule over another. In an effort to avoid conflict with censors, criticism of the Church and State was often hidden within obscure articles. However, Louis XV (1710-74) placed a ban on the work in 1759, which resulted in contributors having to write in secret, and Diderot commissioning volumes of illustrations (which were exempt from the ban) to be printed. Diderot continued to oversee the work until 1772, by which time it had grown to 28 volumes, with over 72,000 articles and 3,000 illustrations.

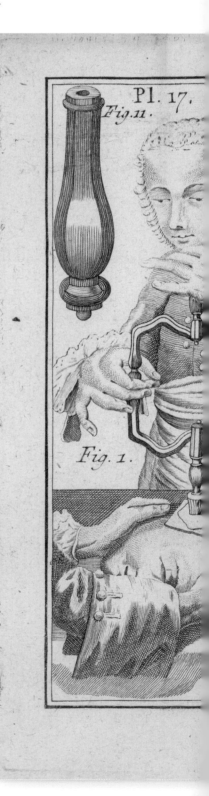

Pl. 17. Fig.11.

Fig. 1.

DENIS **DIDEROT**

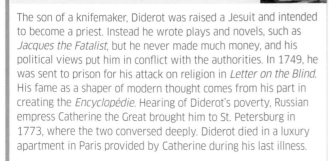

1713-1784

Denis Diderot was a French philosopher and one of the great writers of the eighteenth century. He dedicated his life to the *Encyclopédie.*

The son of a knifemaker, Diderot was raised a Jesuit and intended to become a priest. Instead he wrote plays and novels, such as *Jacques the Fatalist,* but he never made much money, and his political views put him in conflict with the authorities. In 1749, he was sent to prison for his attack on religion in *Letter on the Blind.* His fame as a shaper of modern thought comes from his part in creating the *Encyclopédie.* Hearing of Diderot's poverty, Russian empress Catherine the Great brought him to St. Petersburg in 1773, where the two conversed deeply. Diderot died in a luxury apartment in Paris provided by Catherine during his last illness.

▲ **CENSORED WORK** American collector Douglas Gordon purchased this unique "18th volume" in 1933; he was interested in its censored article proofs, 46 of which were written by Diderot. It is thought to have belonged to *Encyclopédie* publisher André Le Breton.

The **goal** of an encyclopedia is to **assemble** all the **knowledge scattered** on the surface of the earth … so that … our **descendants**, by becoming more **learned**, may become more **virtuous & happier.** "

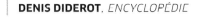

DENIS DIDEROT, *ENCYCLOPÉDIE*

▼ **BRANCHES OF KNOWLEDGE** The *Encyclopédie* is divided into three main branches of knowledge: Memory, Reason, and Imagination. Memory covers history, Reason focuses on philosophy, and Imagination covers poetry. Reason is subdivided into the physical sciences, mathematics, and logic, and then further divided to include medicine and surgery. The plate below shows a surgeon drilling into a patient's skull alongside a selection of surgical instruments.

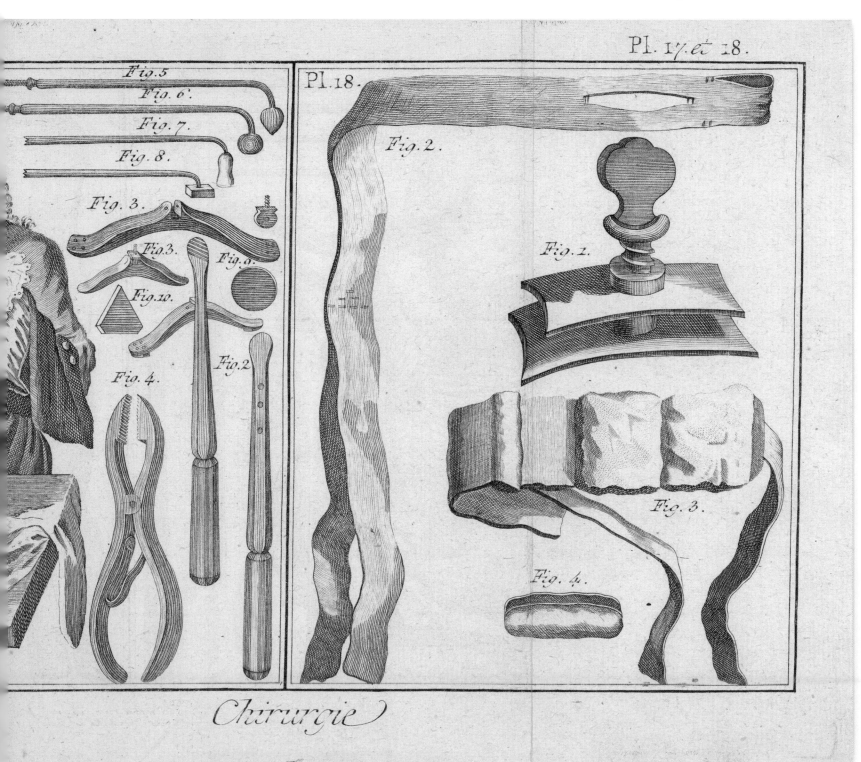

Chirurgie

In detail

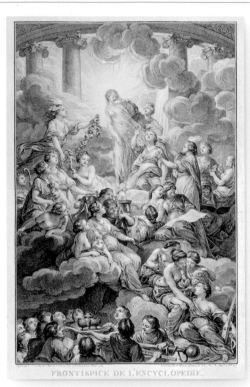

FRONTISPICE DE L'ENCYCLOPEDIE.

◀ **ENLIGHTENED ILLUSTRATION** The illustration for the *Encyclopédie*'s frontispiece was drawn by the French engraver Charles-Nicolas Cochin (1715–90) in 1764, and is a reflection of the way the book divides knowledge. It puts the figure of Truth at the center of the book's vision, between Imagination and Reason, with illustrations of other figures such as Memory, Geometry, and Poetry underneath. The Enlightenment heralded the supremacy of Truth over superstition and prejudice, which is why it presented such a challenge to the Church. Significantly, this illustration shows Truth wearing a veil, receiving her light from Reason and Philosophy above, while Theology is merely one of her handmaidens. Diderot described it as "a very ingeniously composed piece."

▼ **TRADE DRAWINGS** The illustrations for this entry on fireworks, from the Memory section, are typical of the *Encyclopédie*. The upper half depicts a scene from an artist's workshop; the lower, catalogues tools of the trade. While the editors insisted that they visited workshops in order to present these trades realistically, this scene is clean and tranquil, unlike the chaotic reality of such a place.

▼ **ELABORATE ILLUSTRATIONS** The 11 volumes of plates were devised to provide readers with an expansion on the 17 volumes of text, and also offer them quick access to information. The plate below, from the Imagination section, uses a floorplan and a corresponding key to present the ideal system for organizing instruments in an orchestra. Summarizing the topic of music required the editors to include illustrations of musical notations, for example, in order to educate the reader.

Artificier.

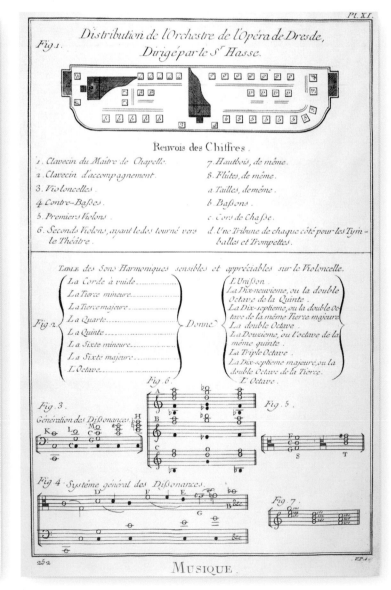

MUSIQUE.

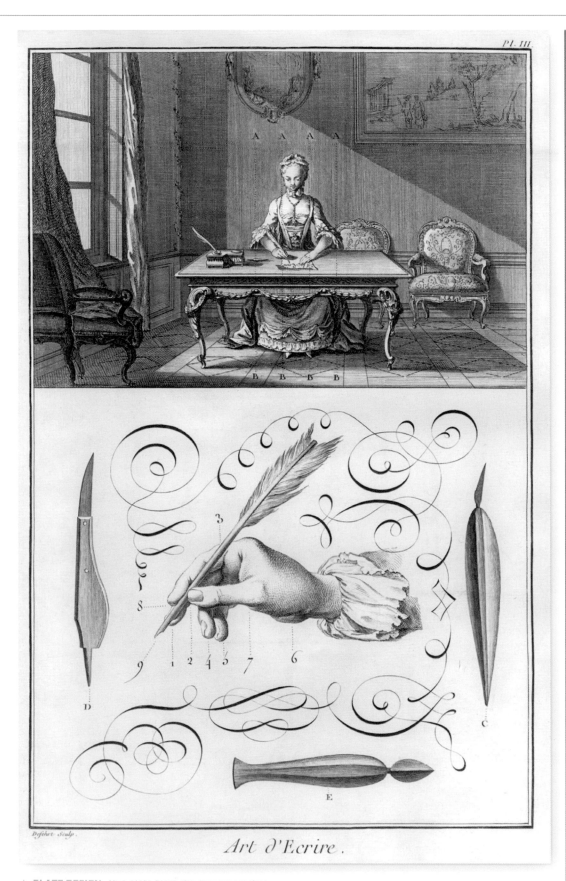

Art d'Ecrire.

▲ **PLATE DESIGN** This plate from the Reason section follows the same template as the trade plates to depict "the position of young ladies to write." The designs of over 900 of the plates are credited to Louis-Jacques Goussier–who also wrote for the *Encyclopédie*–and most of the plates were drawn long after the articles were written.

RELATED **TEXTS**

The *Encyclopaedia Britannica* is often believed to be the world's oldest dictionary, yet it was actually launched 40 years after Ephraim Chambers' *Cyclopaedia*, which was published in 1728 and became the starting point for Diderot's *Encyclopédie*. When the first edition of *Britannica* was published In 1768, the *Encyclopédie* was still being worked on. However, whereas the *Cyclopaedia* did not last beyond Chambers's death in 1740– except for a one-off relaunch in 1778– *Britannica* is still going today, almost 250 years after its initial launch. As such it is the oldest English language encyclopedia still in production.

Britannica was the brainchild of printer Colin Macfarquhar and engraver Andrew Bell, both residents of Edinburgh, Scotland–a city that played an important role in the Enlightenment. The first edition of the *Britannica* was produced in a series of thick weekly pamphlets, known as "numbers," for which customers paid a subscription fee. The numbers were then bound into three volumes: A-B, C-L, and M-Z. The text was edited by a young scholar called William Smellie, who drew on many of the great thinkers of the time for information. It was a huge success, prompting the need for a second edition as early as 1783.

Britannica continued to expand over the course of its 15 official editions, and by the end of the nineteenth century its stature had risen so far that it was seen by many as the ultimate authority on any subject. From 1933 *Britannica* adopted a policy of "continuous revision" by which every article was regularly updated. The last print edition in 2010 ran to a massive 32 volumes. Today, it is only produced in digital form.

▲ **These pages** belong to an edition of *Britannica* from the late 1800s, a time when this encyclopedia reached the height of its prestige with contributions from some of the greatest authorities in each field. It included articles on science written by James Clerk Maxwell and Thomas Huxley.

A Dictionary of the English Language

1755 ▪ PRINTED ▪ 17 × 12 in (43.2 × 30.5 cm) ▪ 2,300 PAGES ▪ UK

SAMUEL JOHNSON

SCALE

The publication in April 1755 of Samuel Johnson's *A Dictionary of the English Language* in two volumes marked the culmination of perhaps the most extraordinary endeavor in English literature. The book began as an initiative by a group of publishers and booksellers in London who wanted to produce a definitive English dictionary, with agreed standards of spelling and usage, to meet the demands of the increasingly literate population. In its aim to fix and understand language as precisely as the scientific discoveries of the period, this ambitious project fit exactly with the demands of the Age of Enlightenment, or Age of Reason–to codify the rapidly expanding world of knowledge. The result remains an astonishing monument to its sole author, Johnson.

The *Dictionary* was a dazzling display of erudition, which set entirely new standards in lexicography. It determined how and why dictionaries should be ordered, explained the etymology of words, and provided precise definitions. Additionally, Johnson illustrated his definitions with a vast array of quotations–more than 114,000 in total. That these came primarily from writers whom Johnson most admired–including Shakespeare, Milton, Dryden, and Pope–reinforced the idea that literature, as Johnson put it, was England's "chief glory."

Although *A Dictionary of the English Language* was produced in only nine years, it was extraordinarily meticulous, comprehensive, and precise. It remained the single most authoritative English dictionary for over 170 years, supplanted only by the publication in 1928 of *The Oxford English Dictionary* in 10 volumes.

SAMUEL **JOHNSON**

1709-1784

Samuel Johnson (often referred to as Doctor Johnson) was an English writer and critic, who through his groundbreaking work on *A Dictionary of the English Language* became one of the greatest figures of eighteenth-century literature.

Johnson came from humble beginnings. Born in Lichfield, a town in the Midlands, he was the son of impoverished booksellers and as a child was prone to illness. He was educated at grammar school before attending Oxford University in 1778, but had to leave early due to lack of funds. To support himself he worked as a journalist in London, and in his mid-20s married a woman 25 years his senior. His prospects seemed bleak, as he was often on the brink of financial ruin, but his talents were obvious: he had a remarkable capacity for work, coupled with an instinctive understanding of the power of words, his own and those of others. His growing literary reputation resulted in him being commissioned to write *A Dictionary of the English Language*, a challenge from which he emerged as the undisputed literary lion of London. Beyond the accomplishment of writing the book itself, Johnson's particular achievement was that he infused the work with such a rich sense of his own personality. Buried in Westminster Abbey in 1784, Johnson remains perhaps the most commanding figure of English literature.

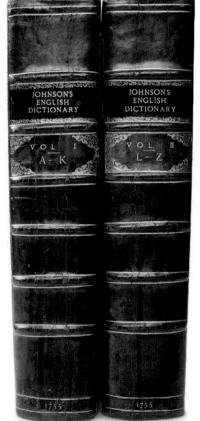

◀ **WEIGHTY TOMES**
Published in two volumes, Johnson's *Dictionary* was as remarkable for its size as it was for its content. An impressive work of scholarship, it remains one of the most famous dictionaries in history.

N | BON

bomb in the chamber beneath.
Bacon's Natural Hist. N° 151.

...filled with gunpowder, and fur-
...er, or wooden tube, filled with
...own out from a mortar, which
...makes. The fufee, being fet on
...the gunpowder, which goes off
...pieces with incredible violence;
...ieging towns. The largeft are
...meter. By whom they were in-
...time is uncertain, fome fixing it
Chambers.

...ffive iron pours,
...g Gradivus roars. *Rowe.*
...n.] To fall upon with bombs;

Tamur,
...er afraid is,
...lure,
...fcare the ladies. *Prior.*
...] A kind of cheft fill-
...metimes only with gunpowder,
...and blow it up in the air, with
...hey are now much difufed.
Chambers.

...of fhip, ftrongly built, to bear
...a mortar, when bombs are to
...with *bomb-veffels*, hope to fuc-
...its arfenal gallies and men of
Addifon on Italy.

...s twelve great *bombards*, where-
...to the air, which, falling down
...the houfes. *Knolles's Hiftory.*
...he noun.] To attack with

...glifh failing in their attempts
...oured to blow up a fort, and
...*Addifon on ancient Medals.*
...rd.] The engineer whofe em-

...s fometimes into the midft of a
...and him with terrour and com-
Tatler, N° 88.
...hard.] An attack made upon
...to it.
...bombardment, though it is not
Addifon on Italy.
...from *bombycinus*, linen, Lat.]
...ng.
...ms to be derived from *Bambaf-*
...celfus; a man remarkable for
...ligible language.] Fuftian; big

...e, foldiers *bombaft*,
...utter, mixt in a due propor-
...e report, and alfo the force of
...t.] Silken; made of filk.D.

...e, foldiers *bombaft*,
...or the terms of law,
...s to draw
Donne.
...oetry to be concluded *bombaft*,
...caufe they are not affected with
...on's State of Innocence, Preface.
...ive.] High founding; of big

...de and purpofe,
...rcumftance,
...of war. *Shakefp. Othello.*
...t, Lat.] Sound; noife; re-

...ence the bombilation of guns,

BON (first main column)

Obferve, in working up the walls, that no fide of the houfe,
nor any part of the walls, be wrought up three foot above the
other, before the next adjoining wall be wrought upto it, fo
that they may be ftill together, and make a good bond.
Mortimer's Husbandry.

4. Chains; imprifonment; captivity.
 Whom I perceived to have nothing laid to his charge, wor-
thy of death, or of bonds. *Acts. xxiii. 29.*

5. Cement of union; caufe of union; link of connexion.
 Wedding is great Juno's crown;
 O bleffed *bond* of board and bed! *Shakefp. As you like it.*
 Love cools, brothers divide, and the *band* is crack'd 'twixt
 fon and father. *Shakefp. King Lear.*

6. A writing of obligation to pay a fum, or perform a contract.
 Go with me to a notary, feal me there
 Your fingle *bond*. *Shakefp. Merchant of Venice.*
 My father's promife ties me not to time;
 And *bonds* without a date, they fay are void. *Dryden.*

7. Obligation; law by which any man is obliged.
 Unhappy that I am! I cannot heave
 My heart into my mouth: I love your majefty
 According to my *bond*, no more nor lefs. *Shakefp. K. Lear.*
 Take which you pleafe, it diffolves the *bonds* of government
 and obedience. *Locke.*

BOND. *adj.* [from *kind*, perhaps for *baand*; from *zebonden*,
Saxon.] Captive; in a fervile ftate.
 Whether we be Jews or Gentiles, whether we be *bond* or
 free. *1 Cor. xii. 13.*

BO'NDAGE. *n. f.* [from *bond.*] Captivity; imprifonment; ftate
of reftraint.
 You only have overthrown me, and in my *bondage* confifts
 my glory. *Sidney, b. ii.*
 Say, gentle princefs, would you not fuppofe
 Your *bondage* happy, to be made a queen?—
 — To be a queen in *bondage*, is more vile
 Than is a flave in bafe fervility. *Shakefp. Henry VI. p. i.*
 Our cage
 We make a choir, as doth the prifon'd bird,
 And fing our *bondage* freely. *Shakefp. Cymbeline.*
 He muft refolve by no means to be enflaved, and brought
 under the *bondage* of obferving oaths, which ought to vanifh,
 when they ftand in competition with eating or drinking, or
 taking money. *South.*
 The king, when he defign'd you for my guard,
 Refolv'd he would not make my *bondage* hard. *Dryden.*
 If fhe has a ftruggle for honour, fhe is in a *bondage* to love;
 which gives the ftory its turn that way. *Pope; notes on Iliad.*

BO'NDMAID. *n. f.* [from *bond*, captive, and *maid*.] A woman
flave.
 Good fifter, wrong me not, nor wrong yourfelf,
 To make a *bondmaid* and a flave of me. *Shakefp. T. Shrew.*

BO'NDMAN. *n. f.* [from *bond* and *man*.] A man flave.
 Amongft the Romans, in making of a *bondman* free, was it
 not wondered wherefore fo great ado fhould be made; the
 mafter to prefent his flave in fome court, to take him by the
 hand, and not only to fay, in the hearing of the publick ma-
 giftrate, I will that this man become free; but, after thofe fo-
 lemn words uttered, to ftrike him on the cheek, to turn him
 round, the hair of his head to be fhaved off, the magiftrate to
 touch him thrice with a rod; in the end, a cap and a white gar-
 ment given him. *Hooker, b. iv. § 1.*
 O freedom! firft delight of human kind;
 Not that which *bondmen* from their mafters find. *Dryden.*

BONDE'RVANT. *n. f.* [from *bond* and *fervant*.] A flave; a fer-
vant without the liberty of quitting his mafter.
 And if thy brother, that dwelleth by thee, be waxen poor,
 and be fold unto thee; thou fhalt not compel him to ferve as a
 bondfervant. *Lev. xxv. 39.*

BONDE'RVICE. *n. f.* [from *bond* and *fervice*.] The condition of
a bondfervant; flavery.
 Upon thofe did Solomon levy a tribute of *bondfervice*.
 1 Kings, ix. 21.

BO'NDSLAVE. *n. f.* [from *bond* and *flave*.] A man in flavery;
a flave.
 Love enjoined fuch diligence, that no apprentice, no, no
 bondflave, could ever be, by fear, more ready at all command-
 ments, than that young princefs was. *Sidney, b. ii.*
 All her ornaments are taken away; of a freewoman fhe is
 become a *bondflave*. *1 Mac. ii. 11.*
 Commonly the *bondflave* is fed by his lord, but here the lord
 was fed by his *bondflave*. *Sir J. Davies on Ireland.*

BO'NDSMAN. *n. f.* [from *bond* and *man*.]
1. A flave.
 Carnal greedy people, without fuch a precept, would have
 no mercy upon their poor *bondfmen* and beafts. *Derh. Ph. Theol.*
2. A perfon bound, or giving fecurity for another.

BO'NDSWOMAN. *n. f.* [from *bond* and *woman*.] A woman
flave.
 My bouds, the fenators
 Are fold for flaves, and their wives for *bondfwomen*.
 Ben. Johnfon's Catiline.
 BONE.

BON (second main column)

BONE. *n. f.* [ban, Saxon.]
1. The folid parts of the body of an animal are made up of hard
fibres, tied one to another by fmall tranfverfe fibres, as thofe
of the mufcles. In a fœtus they are porous, foft, and eafily dif-
cerned. As their pores fill with a fubftance of their own na-
ture, fo they increafe, harden, and grow clofe to one another.
They are all fpongy, and full of little cells, or are of a confide-
rable firm thicknefs, with a large cavity, except the teeth; and
where they are articulated, they are covered with a thin and
ftrong membrane, called the periofteum. Each bone is much
bigger at its extremity than in the middle, that the articula-
tions might be firm, and the *bones* not eafily put out of joint.
But, becaufe the middle of the *bone* fhould be ftrong, to fuftain
its alloted weight, and refift accidents, the fibres are there more
clofely compacted together, fupporting one another; and the
bone is made hollow, and confequently not fo eafily broken, as
it muft have been, had it been folid and fmaller. *Quincy.*
 Thy *bones* are marrowlefs, thy blood is cold. *Macbeth.*
 There was lately a young gentleman bit to the *bone*. *Tatler.*

2. A fragment of meat; a bone with as much flefh as adheres
to it.
 Like Æfop's hounds, contending for the *bone*,
 Each pleaded right, and would be lord alone. *Dryden.*

3. *To be upon the bones.* To attack.
 Pufs had a month's mind *to be upon the bones* of him; but was
 not willing to pick a quarrel. *L'Eftrange.*

4. *To make no bones.* To make no fcruple; a metaphor taken
from a dog, who readily fwallows meat that has no bones.

5. BONES. A fort of bobbins, made of trotter bones, for weav-
ing bonelace.

6. BONES. Dice.
 But then my ftudy was to cog the dice,
 And dext'roufly to throw the lucky fice:
 To fhun ames ace that fwept my ftakes away;
 And watch the box, for fear they fhould convey
 Falfe *bones*, and put upon me in the play. *Dryden's Perf.*

To BONE. *v. a.* [from the noun.] To take out the bones from
the flefh.

BO'NELACE. *n. f.* [from *bone* and *lace*; the bobbins with which
lace is woven being frequently made of bones.] Flaxen lace,
fuch as women wear on their linen.
 The things you follow, and make fongs on now, fhould be
 fent to knit, or fit down to bobbins or *bonelace*. *Tatler.*
 We deftroy the fymmetry of the human figure, and foolifhly
 contrive to call off the eye from great and real beauties, to
 childifh gewgaw ribbands and *bonelace*. *Spectator, N° 99.*

BO'NELESS. *adj.* [from *bone*.] Without bones.
 I would, while it was fmiling in my face,
 Have pluck'd my nipple from his *bonelefs* gums,
 And dafht the brains out. *Shakefp. King Lear.*

To BO'NESET. *v. n.* [from *bone* and *fet*.] To reftore a bone
out of joint to its place; or join a bone broken to the other
part.
 A fractured leg fet in the country by one pretending to bone-
 fetting. *Wifeman's Surgery.*

BO'NESETTER. *n. f.* [from *bonefet*.] A chirurgeon; one who
particularly profeffes the art of reftoring broken or luxated
bones.
 At prefent my defire is only to have a good *bonefetter*.
 Denham's Sophy.

BO'NFIRE. *n. f.* [from *bon*, good, Fr. and *fire*.] A fire made for
fome publick caufe of triumph or exultation.
 Ring ye the bells to make it wear away,
 And *bonfires* make all day. *Spenfer's Epithalamium.*
 How came fo many *bonfires* to be made in queen Mary's
 days? Why, fhe had abufed and deceived her people. *South.*
 Full foon by *bonfire*, and by bell,
 We learnt our liege was paffing well. *Gay.*

BO'NGRACE. *n. f.* [bonne grace, Fr.] A forehead-cloth, or co-
vering for the forehead. *Skinner.*
 I have feen her befet all over with emeralds and pearls, rang-
 ed in rows about her cawl, her peruke, her *bongrace*, and chap-
 let. *Hakewell on Providence.*

BO'NNET. *n. f.* [bonet, Fr.] A covering for the head; a hat;
a cap.
 Go to them with this bonnet in thy hand,
 And thus far having ftretch'd it, here be with them,
 Thy knee buffing the ftones; for, in fuch bufinefs,
 Action is eloquence. *Shakefp. Coriolanus.*
 They had not probably the ceremony of veiling the bonnet
 in their falutations; for, in medals, they ftill have it on their
 heads. *Addifon on ancient Medals.*

BO'NNET. [In fortification.] A kind of little ravelin, without
any ditch, having a parapet three feet high, anciently placed
before the points of the faliant angles of the glacis; being pal-
lifadoed round: of late alfo ufed before the angles of baftions,
and the points of ravelins.

BO'NNET à *prefire*, or prieft's cap, is an outwork, having at the
head three faliant angles, and two inwards. It differs from the
double tenaille, becaufe its fides, inftead of being parallel, grow
narrow at the gorge, and open wider at the front.

BO'NNETS. [In the fea language.] Small fails fet on the courfes

BOO (third main column)

on the mizzen, mainfail, and forefail of a fhip, when thefe are
too narrow or fhallow to cloath the maft, or in order to make
more way in calm weather. *Chambers.*

BO'NNILY. *adv.* [from *bonny*.] Gayly; handfomely.

BO'NNINESS. *n. f.* [from *bonny*.] Gayety; handfomenefs;
plumpnefs.

BO'NNY. *adj.* [from *bon*, bonne, Fr. It is a word now almoft
confined to the Scottifh dialect.]
1. Handfome; beautiful.
 Match to match I have encounter'd him,
 And made a prey for carrion kites and crows,
 Ev'n of the *bonny* beaft he lov'd fo well. *Shakefp. Henry VI.*
 Thus wail'd the louts in melancholy ftrain,
 Till *bonny* Sufan fped acrofs the plain. *Gay's Paftorals.*
2. Gay; merry; frolickfome; cheerful; blithe.
 Then figh not fo, but let them go,
 And be you blithe and *bonny*. *Shakefp. Much ado about N.*
3. It feems to be generally ufed in converfation for plump.

BONNY-CLABBER. *n. f.* A word ufed in fome counties for four
buttermilk.
 We fcorn, for want of talk, to jabber,
 Of parties o'er our *bonny-clabber*;
 Nor are we ftudious to enquire,
 Who votes for manours, who for hire. *Swift.*

BO'NUM MAGNUM. *n. f.* See PLUM; of which it is a
fpecies.

BO'NY. *adj.* [from *bone*.]
1. Confifting of bones.
 At the end of this hole is a membrane, faftened to a round
 bony limb, and ftretched like the head of a drum; and there-
 fore, by anatomifts, called tympanum. *Ray on the Creation.*
2. Full of bones.

BO'OBY. *n. f.* [a word of no certain etymology; *Henfhaw* thinks
it a corruption of *bull-beef* ridiculoufly; *Skinner* imagines it
to be derived from *bobo*, foolifh, Span. *Junius* finds *bouhard* to
be an old Scottifh word for a *coward*, a contemptible fellow;
from which he naturally deduces *booby*; but the original of
bowbard is not known.] A dull, heavy, ftupid fellow; a
lubber.
 But one exception to this fact we find,
 That *booby* Phaon only was unkind,
 An ill-bred boatman, rough as waves and wind. *Prior.*
 Young mafter next muft rife to fill him wine,
 And ftarve himfelf to fee the *booby* dine. *King.*

BOOK. *n. f.* [boc, Sax. fuppofed from *boc*, a beech; becaufe
they wrote on beechen boards, as *liber* in Latin, from the rind
of a tree.]
1. A volume in which we read or write.
 See a *book* of prayer in his hand;
 True ornaments to know a holy man. *Shakefp. Richard III.*
 Receive the fentence of the law for fins,
 Such as by God's *book* are adjudg'd to death.
 Shakefp. Henry IV.
 But in the coffin that had the *books*, they were found as frefh
 as if they had been but newly written; being written on parch-
 ment, and covered over with watch candles of wax. *Bacon.*
 Books are a fort of dumb teachers; they cannot anfwer fud-
 den queftions, or explain prefent doubts: this is properly the
 work of a living inftructor. *Watts.*
2. A particular part of a work.
 The firft *book* we divide into fections; whereof the firft is
 thefe chapters paft. *Burnet's Theory of the Earth.*
3. The regifter in which a trader keeps an account of his debts.
 This life
 Is nobler than attending for a check;
 Prouder, than ruffling in unpaid for filk:
 Such gain the cap of him that makes them fine,
 Yet keeps his *book* uncrofs'd. *Shakefp. Cymbeline.*
4. *In books.* In kind remembrance.
 I was fo much *in his books*, that, at his deceafe, he left me
 the lamp by which he ufed to write his lucubrations. *Addifon.*
5. *Without book.* By memory; by repetition; without reading.
 Sermons read they abhor in the church; but fermons with-
 out book, fermons which fpend their life in their birth, and may
 have publick audience but once. *Hooker, b. v. § 21.*

To BOOK. *v. a.* [from the noun.] To regifter in a book.
 I befeech your grace, let it be *booked* with the reft of this
 day's deeds; or I will have it in a particular ballad elfe, with
 mine own picture on the top of it. *Shakefp. Henry IV. p. ii.*
 He made wilful murder high treafon; he caufed the march-
 ers to read their men, for whom they fhould make anfwer.
 Davies on Ireland.

BOOK-KEEPING. *n. f.* [from *book* and *keep*.] The art of keep-
ing accounts, or recording the tranfactions of a man's affairs,
in fuch a manner, that at any time he may thereby know the
true ftate of the whole, or any part, of his affairs, with clear-
nefs and expedition. *Harris.*

BO'OKBINDER. *n. f.* [from *book* and *bind*.] A man whofe pro-
feffion it is to bind books.

BO'OKFUL. *adj.* [from *book* and *full*.] Full of notions gleaned
from books; crouded with undigefted knowledge.
 The

▲ ALPHABETICAL ARRANGEMENT
This spread is taken from the original 1755 version of Johnson's *Dictionary*, with the content arranged in two columns per page. An abridged edition was published the following year, in which Johnson's abundant quotes were removed, and the contents laid out in three narrow columns. Every single definition in the *Dictionary*—all 42,773 of them—was written by Johnson himself, and the only help he employed was essentially secretarial—the copying and organizing of the definitions into alphabetical order.

> Wherever I turned my view, there was perplexity to be disentangled, and confusion to be regulated.

SAMUEL JOHNSON, PREFACE TO *A DICTIONARY OF THE ENGLISH LANGUAGE*, 1755

In detail

DICTIONARY

OF THE

ENGLISH LANGUAGE:

IN WHICH

The WORDS are deduced from their ORIGINALS,

AND

ILLUSTRATED in their DIFFERENT SIGNIFICATIONS

BY

EXAMPLES from the beſt WRITERS.

TO WHICH ARE PREFIXED,

A HISTORY of the LANGUAGE,

AND

An ENGLISH GRAMMAR.

BY SAMUEL JOHNSON, A.M.

IN TWO VOLUMES.

VOL. I.

Cum tabulis animum cenſoris ſumet honeſti :
Audebit quæcunque parum ſplendoris habebunt,
Et ſine pondere erunt, et honore indigna ferentur,
Verba movere loco ; quamvis invita recedant,
Et verſentur adhuc intra penetralia Veſtæ :
Obſcurata diu populo bonus eruet, atque
Proferet in lucem ſpecioſa vocabula rerum,
Quæ priſcis memorata Catonibus atque Cethegis,
Nunc ſitus informis premit et deſerta vetuſtas. HOR.

LONDON,
Printed by W. STRAHAN,
For J. and P. KNAPTON ; T. and T. LONGMAN ; C. HITCH and L. HAWES ;
A. MILLAR; and R. and J. DODSLEY.
MDCCLV.

LOVE. *n. ſ.* [from the verb.]
1. The paſſion between the ſexes.
 Hearken to the birds *love*-learned ſong,
 The dewie leaves among ! *Spenſer.*
 While idly I ſtood looking on,
 I found th' effect of *love* in idleneſs. *Shakſp.*
 My tales of *love* were wont to weary you ;
 I know you joy not in a *love* diſcourſe. *Shakſp.*
 I look'd upon her with a ſoldier's eye,
 That lik'd, but had a rougher taſk in hand
 Than to drive liking to the name of *love*. *Shakſp.*
 What need a vermil-tinctur'd lip for that,
 Love-darting eyes, or treſſes like the morn ? *Milt.*
 Love quarrels oft in pleaſing concord end,
 Not wedlock treachery, endang'ring life. *Milton.*
 A *love* potion works more by the ſtrength of charm
 than nature. *Collier.*
 You know y' are in my power by making *love*.
 Dryden.
 Let mutual joys our mutual truſt combine,
 And *love*, and *love*-born confidence be thine. *Pope.*
 Cold is that breaſt which warm'd the world
 before,
 And theſe *love*-darting eyes muſt roll no more. *Pope.*
2. Kindneſs ; good-will ; friendſhip.
 What love, think'ſt thou, I ſue ſo much to get ?
 My *love* till death, my humble thanks, my prayers ?
 That *love* which virtue begs, and virtue grants.
 Shakſpeare.
 God brought Daniel into favour and tender *love*
 with the prince. *Daniel.*
 The one preach Chriſt of contention, but the
 other of *love*. *Philippians.*
 By this ſhall all men know that ye are my diſci-
 ples, if ye have *love* one to another. *John.*
 Unwearied have we ſpent the nights,
 Till the Ledean ſtars, ſo fam'd for *love*,
 Wonder'd at us from above. *Cowley.*
3. Courtſhip.
 Demetrius
 Made *love* to Nedar's daughter Helena,
 And won her ſoul. *Shakſpeare.*
 If you will marry, make your *loves* to me,
 My lady is beſpoke. *Shakſpeare.*
 The enquiry of truth, which is the *love*-making or
 wooing of it ; the knowledge of truth, the pre-
 ference of it ; and the belief of truth, the enjoying
 of it, is the ſovereign good of human nature. *Bacon.*
4. Tenderneſs ; parental care.
 No religion that ever was, ſo fully repreſents the
 goodneſs of God, and his tender *love* to mankind,
 which is the moſt powerful argument to the love of
 God. *Tillotſon.*
5. Liking ; inclination to : as, the *love* of
 one's country.
 In youth, of patrimonial wealth poſſeſt,
 The *love* of ſcience faintly warm'd his breaſt. *Fent.*
6. Object beloved.
 Open the temple gates unto my *love*. *Spenſer.*
 If that the world and love were young
 And truth in every ſhepherd's tongue ;
 Theſe pretty pleaſures might we move,
 To live with thee, and be thy *love*. *Shakſpeare.*
 The baniſh'd never hopes his *love* to ſee. *Dryden.*

▲ **TITLE PAGE** Unlike the rest of the work, the title page of the *Dictionary* was printed in red-and-black ink. It includes a quotation in Latin from Horace's *Epistles*, in which the Roman poet addresses those who wish to write poetry. The *Dictionary* was printed on the finest-quality paper available, at a cost of £1,600—more than Johnson's own fee for writing the book.

▲ **EXTENSIVE QUOTATIONS** The immense number of quotations—more than 114,000—that Johnson included was in part due to his incredible memory, but more particularly as a result of his familiarity with an enormous range of literature. In compiling his *Dictionary*, it is claimed he read over 2,000 different books by more than 500 different authors.

OA'TMEAL. *n. f.* [*panicum*.] An herb.
Ainſworth.

OATS. *n. f.* [aten, Sax.] A grain, which in England is generally given to horſes, but in Scotland ſupports the people.

It is of the graſs leaved tribe; the flowers have no petals, and are diſpoſed in a looſe panicle: the grain is eatable. The meal makes tolerable good bread. *Miller*.

The *oats* have eaten the horſes. *Shakſpeare*.

It is bare mechaniſm, no otherwiſe produced than the turning of a wild *oatbeard*, by the inſinuation of the particles of moiſture. *Locke*.

For your lean cattle, fodder them with barley ſtraw firſt, and the *oat* ſtraw laſt. *Mortimer*.

His horſe's allowance of *oats* and beans, was greater than the journey required. *Swift*.

OA'TTHISTLE. *n. f.* [*oat* and *thiſtle*.] An herb. *Ainſw*.

DEOPPILA'TION. *n. f.* [from *deoppilate*.] The act of clearing obſtructions; the removal of whatever obſtructs the vital paſſages.

Though the groſſer parts be excluded again, yet are the diſſoluble parts extracted, whereby it becomes effectual in *deoppilations*. *Brown*.

DEO'PPILATIVE. *adj.* [from *deoppilate*.] Deobſtruent.

A phyſician preſcribed him a *deoppilative* and purgative apozem. *Harvey*.

DEOSCULA'TION. *n. f.* [*deoſculatio*, Lat.] The act of kiſsing.

We have an enumeration of the ſeveral acts of worſhip required to be performed to images, viz. proceſſions, genuflections, thurifications, and de-oſculations. *Stillingfleet*.

▲ **WRY DEFINITIONS** Whatever his claims to literary authority, Johnson also took great pleasure in teasing the reader. For example, he mockingly defined a lexicographer, or compiler of dictionaries, as "a harmless drudge." Similarly, here, under the entry for "Oats," he asserts provocatively that the Scottish people eat oats, which in England are fed only to horses.

▲ **STRANGE OMISSIONS** A curiosity of Johnson's *Dictionary* is his omission of a number of commonplace words, such as "Banknote," "Blond," and "Port" (the drink, not the harbor). Many of the words he did choose to include were also obscure and unfamiliar to the average reader, such as "Deosculation," shown here, which Johnson defined as "The act of kissing."

RELATED **TEXTS**

The first English dictionaries were published in the thirteenth century, and were originally used to provide definitions of French, Spanish, and Latin words. The first English-only dictionary, and also the first to be organized alphabetically, was *A Table Alphabeticall*, compiled by Robert Cawdrey in 1604, listing 2,543 words.

The eighteenth-century desire to organize knowledge was the prime motive behind the compilation and publication of Johnson's *Dictionary*. In 1807, American lexicographer Noah Webster (1758–1843) aimed to build a system of the American language and began composing *An American Dictionary of the English Language*. The first dictionary to include characteristically American words words such as "Chowder," it exceeds Johnson's dictionary with 70,000 entries, and led to Webster being considered the "Father of American Scholarship and Education."

▲ **ABRIDGED EDITION** The prohibitive selling price of £4.10s for Johnson's original 1755 *Dictionary*, to say nothing of its daunting size, contributed to its poor sales—only around 6,000 copies sold over the course of 30 years. The abridged edition, a page from which is shown here, was priced at 10 shillings, and found a much readier and larger audience.

▲ **Webster worked** on his *Dictionary* for 22 years before it was published in 1828. In much the same way, 62 years of work were needed before *The Oxford English Dictionary* made its first appearance, in 10 volumes, in 1928.

Bucolica, Georgica, et Aeneis

1757 ▪ PRINTED BY JOHN BASKERVILLE ▪ 12 × 9 in (30 × 23 cm) ▪ 432 PAGES ▪ UK

SCALE

VIRGIL

The first printing venture of typographer and printer John Baskerville was the publication of Virgil's *Bucolica, Georgica et Aeneis*, which was heralded as a masterpiece of typography and design. Available by subscription, the book was a huge success in part due to its subject: the works of the Ancient Roman poet Virgil. One of the greatest poets in history, Virgil was rediscovered in the late 1600s, when the poet John Dryden (1631–1700) translated his works from Latin into English.

John Baskerville was a groundbreaking publisher. He had studied calligraphy and stone-cutting before making his fortune in manufacturing, and he applied these skills to the design and typsetting of his project. Baskerville oversaw every aspect of production, both technical and creative. Rejecting existing typefaces, he developed a fine, elegant font, now known as Baskerville after its inventor. For the layout, he used wide margins and wide spacing between text, making it easy to read. He opted for James Whatman's wove paper, as its smooth surface allowed for a delicate rendering of his font. As Whatman was only able to supply enough paper for half the book, the remainder was printed on traditional laid paper; both paper types were also glazed.

VIRGIL

70–19 BCE

The man who would become the greatest poet of Ancient Rome, Publius Vergilius Maro was born the son of a cattle farmer. His epic poems have been hugely influential on Western literature.

Virgil's father had ambitions for his son, and planned an education that would lead to a legal career. The shy and thoughtful Virgil went to school in Cremona and Milan before arriving in Rome to study law, rhetoric, and philosophy. His real passion, however, was poetry. One of his fellow students, Octavian, would become the emperor Augustus, and a devoted patron of the budding poet. Virgil's love of the Italian countryside influenced many of the epics he wrote, endearing him to the general public, as well as the political elite. His most notable works include the *Bucolics*, or *Eclogues* (pastoral poems), the *Georgics* (about farming), and *Aeneis*, or *Aeneid*, the poet's last, unfinished piece, which told the story of Rome's foundation. After his death from fever, Virgil became a national hero, and his works were taught in schools. His influence on other poets has been huge, and he has inspired many, including Ovid, Dante, and Milton.

In detail

PUBLII VIRGILII

MARONIS

BUCOLICA,

GEORGICA,

ET

AENEIS.

BIRMINGHAMIAE:

Typis JOHANNIS BASKERVILLE.

MDCCLVII.

◀ **SIMPLE STYLE** In contrast to the typical title pages of books at the time, Baskerville's version was remarkably minimal. He cut the information to the book's title, author, publisher, date, and city of publication—a convention that is still used today.

▲ **LANDMARK TYPEFACE** Baskerville's early interest in calligraphy, and the hours he spent practicing lettering, influenced the typeface he created for his first book. The Baskerville font has sharp edges, rounded lines, and a spacious appearance. Existing printing presses did not do justice to his new font, so Baskerville modified his press so it would dry the ink as soon as it touched the paper. He also invented a richer, more lustrous black ink to provide a crisper finish.

242 *P. VIRGILII AENEIDOS* LIB. VI.

Scrupea, tuta lacu nigro, nemorumque tenebris:
Quam super haud ullæ poterant impune volantes
240 Tendere iter pennis: talis sese halitus atris
Faucibus effundens supera ad convexa ferebat:
Unde locum Graii dixerunt nomine Aornon.
Quatuor hic primum nigrantes terga juvencos
Constituit, frontique invergit vina sacerdos:
245 Et summas carpens media inter cornua setas,
Ignibus imponit sacris libamina prima,
Voce vocans Hecaten, cœloque Ereboque potentem.
Supponunt alii cultros, tepidumque cruorem
Suscipiunt pateris. ipse atri velleris agnam
250 Aeneas matri Eumenidum magnæque sorori
Ense ferit; sterilemque tibi, Proserpina, vaccam.
Tum Stygio Regi nocturnas inchoat aras:
Et solida imponit taurorum viscera flammis,
Pingue superque oleum fundens ardentibus extis.
255 Ecce autem, primi sub lumina Solis et ortus,
Sub pedibus mugire solum, et juga cœpta moveri
Silvarum, visæque canes ululare per umbram,
Adventante Dea. Procul, o, procul este profani,
Conclamat Vates, totoque absistite luco:
260 Tuque invade viam, vaginaque eripe ferrum:
Nunc animis opus, Aenea, nunc pectore firmo.
Tantum effata, furens antro se immisit aperto.
Ille ducem haud timidis vadentem passibus æquat.
Di, quibus imperium est animarum, umbræque silen-
265 Et Chaos, et Phlegethon, loca nocte silentia late; (tes,
Sit mihi fas audita loqui: sit numine vestro
Pandere res alta terra et caligine mersas.
Ibant obscuri sola sub nocte per umbram,

 Perque

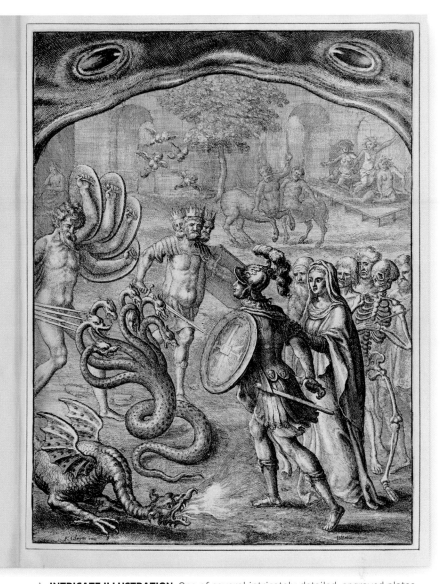

▲ **INTRICATE ILLUSTRATION** One of several intricately detailed, engraved plates in Baskerville's edition of the collected works, this plate depicts the hero of Virgil's *Aeneis*. Here, Aeneis wears armor and bears a shield given to him by his mother as he encounters the underworld. The inks used in the engraving process could be "burnished", or polished, on the plate to give the impression of light.

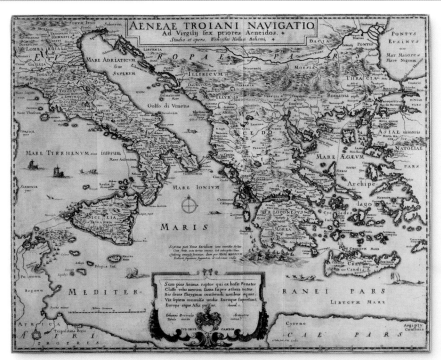

◄ **MAPPING ROUTES**
A fold-out map of Italy and Greece inserted before the title page, set the scene for Virgil's *Aeneis*. It marks the journeys made by the hero, Aeneis, a Trojan warrior who travels to Italy, where he becomes the founding ancestor of Rome.

It gives me great Satisfaction, to find that my Edition of Virgil has been so favourably received. 99

JOHN BASKERVILLE

Tristram Shandy

1759-67 ■ PRINTED ■ 6 × 4 in (16.4 × 10.4 cm) ■ 1,404 PAGES ■ UK

LAURENCE STERNE

SCALE

A comic masterpiece that gleefully overturned existing notions of how a novel should be written, structured, and even printed, *The Life and Opinions of Tristram Shandy, Gentleman* continues to this day to pose questions about the nature of fiction and of reading itself. Published in nine volumes over an eight-year period, the novel toys with the reader with its disjointed narrative and playful typographical and visual quirks that pushed at the prevailing limits of print design. Laurence Sterne frequently substitutes "bad" words with dashes or asterisks, bringing attention to them while giving the appearance of showing discretion. Whole pages are also left blank, colored black, or marbled, as he turns the familiar structure of a printed book on its head.

The novel is a fictional autobiography in which Shandy tells of his peculiar existence. Sterne dispenses with an orderly, linear plot, however, and narrative themes are dropped and resumed at random; chapters are skipped, only to crop up later, their absence commented on; and the pagination is muddled. Sterne/Shandy also makes regular appeals to the reader, forcing them to take part in the story.

In volume one, Shandy realizes the difficulty in determining precisely *when* his life began. Thereafter he continually interrupts his narration with a stream of digressions that dwell on a diverse array of topics, and sweep back and forth in time. Stories-within-stories, and the expression of his own and other characters' opinions, also serve to postpone the "action": by volume three, Shandy has still not been born. Details of his life are offered via the views and actions of his eccentric family, notably his father and war veteran uncle, Toby.

Tristram Shandy was a huge success when published. Today it is regarded as a forerunner of postmodern literature.

LAURENCE **STERNE**

1713-1768

Laurence Sterne was an Irish-born novelist who, after 20 years as a rural parson, became a celebrated literary luminary with the publication of the first volume of *Tristram Shandy* in 1759.

Having spent his early childhood in Ireland following his father (a soldier) to a succession of postings, in 1724, Sterne was sent to the northern English county of Yorkshire to be educated. Later he was admitted to Cambridge University, graduating in 1737. The following year he was ordained in the Anglican Church and became vicar of Sutton-on-the-Forest, near York. In 1741, he married Elizabeth Lumley, with whom he had a daughter, but the marriage was unhappy; she had a nervous breakdown and he was unfaithful.

Sterne's emergence as a major literary figure came abruptly in 1759 with the publication of *A Political Romance*, a satire of churchmen in York. The book sparked instant controversy and effectively ended his clerical career. That same year the first two volumes of *Tristram Shandy* appeared, published at Sterne's expense. He became a celebrity throughout Europe and made a fortune, fulfilling a long-held ambition: "I wrote," he said, "not to be fed but to be famous." Ill health (he had incurable tuberculosis) forced Sterne overseas in 1762, in search of a warmer climate. The trip provided material for his last novel, *A Sentimental Journey Through France and Italy* (1768), an unorthodox mix of travel memoir and fiction. He died one month after its publication.

▼ **BLACK PAGE** Perhaps the most famous (and notorious) of *Tristram Shandy*'s many typographical tricks is the black page that announces the death of a minor character, Parson Yorick, in volume one. The device is simultaneously shocking and unexpected. The novel, a literary form, is suddenly recast in abstract visual terms.

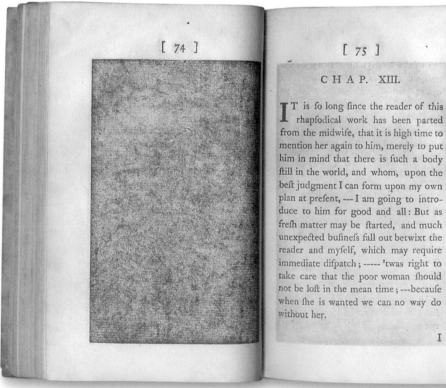

[74]

[75]

CHAP. XIII.

IT is so long since the reader of this rhapsodical work has been parted from the midwife, that it is high time to mention her again to him, merely to put him in mind that there is such a body still in the world, and whom, upon the best judgment I can form upon my own plan at present, — I am going to introduce to him for good and all: But as fresh matter may be started, and much unexpected business fall out betwixt the reader and myself, which may require immediate dispatch; ——'twas right to take care that the poor woman should not be lost in the mean time; —because when she is wanted we can no way do without her.

I

What is all this story about? 🙶

ELIZABETH SHANDY, VOLUME NINE, *TRISTRAM SHANDY*

DEDICATION.

I beg your Lordſhip will forgive me, if, at the ſame time I dedicate this work to you, I join Lady SPENCER, in the liberty I take of inſcribing the ſtory of *Le Fever* in the ſixth volume to her name; for which I have no other motive, which my heart has informed me of, but that the ſtory is a humane one.

I am,

My Lord,

Your Lordſhip's

Moſt devoted,

And moſt humble Servant,

LAUR. STERNE.

L. Sterne

THE

LIFE and OPINIONS

OF

TRISTRAM SHANDY, Gent.

CHAP. I.

IF it had not been for thoſe two mettleſome tits, and that madcap of a poſtilion, who drove them from Stilton to Stamford, the thought had never entered my head. He flew like lightning——there was a ſlope of three miles and a half——we ſcarce touched the ground——the motion was moſt rapid —moſt impetuous—'twas communicat-

VOL. V. B ed

▲ **AUTHOR'S AUTOGRAPH** The novel's popularity led to the printing of pirate versions. In order to protect his commercial rights, Sterne autographed every copy of the first two editions of volume five, shown above, and the first editions of volumes seven and nine. In doing this, Sterne was able to guarantee the authenticity of almost 13,000 copies.

In detail

[168]

toby's mare!—Read, read, read, read, my unlearned reader! read,—or by the know-ledge of the great faint *Paraleipomenon*—I tell you before-hand, you had better throw down the book at once; for without *much reading*, by which your reverence knows, I mean *much knowledge*, you will no more be able to penetrate the moral of the next marbled page (motly emblem of my work!) than the world with all its fagacity has been able to un-ravel the many opinions, tranfactions and truths which ftill lie myftically hid under the dark veil of the black one.

C H A P.

[169]

▲ **UNIQUE MARBLING** Partway through volume three (published with volume four in 1761) Sterne plays an especially elaborate and exotic visual game. Shandy claims that his "book of books" is utterly unique and "describes" this using two marbled pages. In the novel's original publication, each would have been made by hand, so no two would have been alike. The facing text challenges readers to say what the page is doing there.

▶ **SHORTEST CHAPTER** Typical of the playfully disjointed structure of Sterne's novel is the way he swapped chapters between the different volumes. Shown here is chapter seven from volume eight, published as part of volume seven. It is the shortest chapter in the whole novel, consisting of a single, wonderfully inconsequential, 10-word sentence: "My uncle Toby's map is carried down into the kitchen."

[118]

C H A P. XXVII.

MY uncle Toby's Map is carried down into the kitchen.

C H A P.

[119]

C H A P. XXVIII.

AND here is the *Maes*—and this is the *Sambre*; faid the Corporal, pointing with his right hand extended a little towards the map, and his left upon Mrs. Bridget's fhoulder——but not the fhoulder next him—and this, faid he, is the town of Namur—and this the citadel—and there lay the French—and here lay his honour and myfelf——and in this curfed trench, Mrs. Bridget, quoth the Corporal, taking her by the hand, did he receive the wound which crufh'd him fo miferably *here*——In pronouncing which he flightly prefs'd the back of her hand towards the part he felt for——and let it fall.

I 4 We

◄ VISUAL LANGUAGE
On occasion Sterne favors graphic elements over words to convey meaning—an innovation way ahead of its time. This serpentine squiggle represents Corporal Trim—Uncle Toby's loyal servant, a former soldier—waving his baton as he wordlessly comments on the ups and downs, and ins and outs, of marriage.

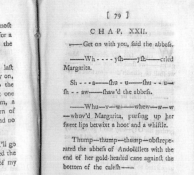

▲ RULE-BREAKING TEXT Throughout the book, words are omitted, entire pages are filled with asterisks or left blank, and odd footnotes appear. En–and–em rules of varying length are used to indicate a meaningful pause, or an impatient wait. The coded appearance of text serves to reinforce the elusive nature of the novel, which tells the reader very little about Shandy himself.

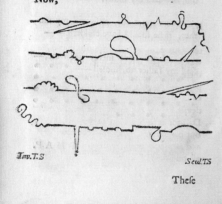

◄ PLOT LINES Here, Shandy draws attention to the haphazard nature of his storytelling, with graphic representations of the routes taken by his plot in the first five volumes of the book. There are occasional advances, followed by setbacks, diversions, and dead ends. It shows how the story, and Shandy's life, progress in anything other than a straight line.

IN CONTEXT

The inevitable question about *Tristram Shandy* is whether it is a virtuoso joke or a seriously intended contribution to the art of the novel. In mid-eighteenth-century Europe the genre was growing in popularity and sophistication, but it was an artificial construct: the realism it boasted existed only within its pages. Perhaps Sterne's most obvious achievement as a writer was his recognition that any novel, however acute its insights, could never reflect the confusion of human existence, with all its arbitrariness and disorder.

His solution was to produce a work as chaotic, unresolved, and farcical as the world itself. It would become real precisely because of its lack of formal structure. *Tristram Shandy* has divided opinion ever since. Dr. Johnson (see p.150), the revered English writer and critic, declared in 1776 that "nothing odd will do long," implying that the book was too idiosyncratic to be taken seriously. Later luminaries disagreed: the German philosopher Schopenhauer declared it one of the four greatest novels ever written. Largely decried in the nineteenth century as buffoonish and irrelevant, *Tristram Shandy* was rehabilitated in the twentieth century and profoundly influenced writers including Virginia Woolf and James Joyce. It is, incontestably, an astonishingly original work.

► Fittingly, Sterne chose William Hogarth, the famous chronicler of English foibles and follies, to provide the first illustrations for *Tristram Shandy* in 1760.

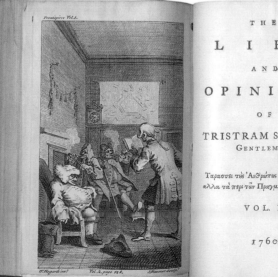

Fables in Verse

1765 ▪ PRINTED BY JOHN NEWBERY ▪ 4 × 3 in (10.6 × 7.2 cm) ▪ 144 PAGES ▪ UK

SCALE

AESOP

For more than 2,000 years, *Aesop's Fables*—a set of cautionary and moralistic tales—have been told, retold, and endlessly reinterpreted. Although there is no certainty that Aesop even existed, he is thought to have been a Greek-speaking slave in the Greco-Roman world, in the fifth or sixth century BCE. The fables, which number over 725, belong to the oral tradition and they highlight truths that are sometimes cruel, often amusing, but always pithy and exact. They use animal characters to represent human qualities, such as greed, deceit, strength, or perseverance—a device that has captured the imagination across cultures and ages. Many moral tales have been attributed to Aesop, even some arising long after his death.

In the context of antiquity, such stories served to develop the conscience of all individuals. A collection of *Aesop's Fables* was produced as early as the fourth century BCE, in the form of a text for orators and public speakers by orator Demetrius of Phaleron (320–280 BCE). His text formed the basis for numerous other versions during the Middle Ages. In the Renaissance, the tales were taught in schools, and with the invention of printing in the fifteenth century were among the earliest works

to be published. The first, produced in Germany, was called simply *Esopus*, appearing in around 1476. Within 25 years, over 150 editions were printed. The tales soon spread across the world, and now there is a translation in nearly every language.

Today, *Aesop's Fables* are primarily viewed as children's stories, which in part could be attributed to John Newbery's 1765 edition (shown here). Newbery reworded the fables, only including those which he thought would appeal to his young audience. The book begins with the "Life of Aesop," some anecdotes, then 38 illustrated *Fables in Verse*, finishing with "The Conversation of Animals."

JOHN **NEWBERY**

1713–1767

The London-based printer John Newbery was one of the first people to publish children's books. He aimed to cater to the interests of the younger generation by creating literature that was both entertaining and informative.

Born in Berkshire in 1713, John Newbery's publishing career began in 1730, when he was hired by William Carnan of the *Reading Mercury*. He started publishing books in 1740 in Reading, before relocating to London, where he expanded his business into children's writing. His first book for children, *A Little Pretty Pocket-Book*, appeared in 1744. Widely considered to be the first children's book, it contained poems and proverbs, and was bound in bright colors. *Fables in Verse* followed in 1765, and pupils often had to memorize the moralistic verses in school. His contribution to children's literature is commemorated in the U.S. with the annual award the Newbery Medal.

In detail

◄ **INSTRUCTIVE TEXT**
Newbery's introduction makes explicit that these stories were intended to instruct, with "such lesson in prudence and morality as may be of service to the riper years," as this layout, with its moral and reflection, shows.

► **TALKING ANIMALS** The book finishes with "The Conversation of Animals"—short, moralistic tales that draw on the parallels between the actions of humans and other animals.

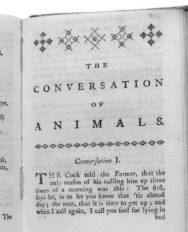

▼ MORAL GUIDANCE All 38 of the fables in Newbery's edition are illustrated with woodcuts, as seen in these pages that tell the familiar story of "The Ants and the Grasshopper." It is easy to see why this fable, with its talking insects, held appeal for children. Yet it is a classic allegory of industry versus indolence, and the cautionary tale advises the reader to prepare for the future.

88 FABLES in VERSE.

The ANTS *and the* GRASSHOPPER.

THE *Ants*, a prudent, painful train,
Brought forth and dry'd their heaps of grain ;
A *Grasshopper* half starv'd was by,
Who bow'd and beg'd their charity.

To

FABLES *in* VERSE. 89

To whom a hoary Ant reply'd,
In harvest how's your time apply'd?
' I sing (the insect said) and play,
' To make the lab'ring *Peasants* gay.'
Ah, cry'd the Ant,—*How just the chance !*
As then you sung—you now may dance ;
In vain you here for food apply,
I'll feed no idle folks, not I.

MORAL.

He will provide, who thinks aright,
In *Summer's* day, for *Winter's* night.

Like those who **dine** well off the **plainest** dishes, he **made** use of **humble** incidents to **teach** great truths.

APOLLONIUS OF TYANA, ON AESOP, FIRST CENTURY BCE

The Wealth of Nations

1776 ▪ PRINTED ▪ 11 × 9 in (28.3 × 22.5 cm) ▪ 1,097 PAGES ▪ UK

ADAM SMITH

SCALE

The publication in 1776 of *An Inquiry into the Nature and Causes of the Wealth of Nations*, also known simply as *The Wealth of Nations,* caused a sensation. In addition to being the first modern economic textbook, it had a revolutionary idea at its core: that the measure of any nation's wealth was not how much gold it held or land it possessed, but the product of the operation of unfettered free markets and free trade. Adam Smith argued that free markets weeded out the inefficient and simultaneously rewarded the enterprising. At the heart of this process was self-interest. By maximizing individual profits in a free market, the prosperity of the nation as a whole was increased.

The influence of Smith's work was huge. It effectively instigated the birth of the free-market economy. People had previously thought of trade as one person getting something at the expense of another, but Smith argued that both parties in a transaction could prosper. This concept forms the basis of modern economics, and *The Wealth of Nations* became a classic text. Indeed, the ideas it outlines form the "Classical school" of economics.

ADAM **SMITH**

1723–1790

Adam Smith was a social philosopher and political economist. He is known primarily for *The Wealth of Nations*, which is often referred to as the "bible of capitalism."

Born in Scotland, Smith studied at Glasgow University and Oxford before he began teaching in Glasgow in 1751. In 1764, he became tutor to the 18-year-old Duke of Buccleuch. During a two-year Grand Tour of Europe with the duke, Smith met many of the continent's leading thinkers, chiefly in France. They included a group of economists, known as the physiocrats, who were concerned by the reckless expenditure of the French state. Smith was impressed by their proposals, but not by their dismissal of the potential of manufacturing and trade. *The Wealth of Nations* was Smith's magisterial response to what to him was this obvious shortcoming. A leading figure in the Scottish Enlightenment, he helped to make Edinburgh one of the most dynamic intellectual centers of Europe. Smith is widely considered to be the father of modern economics.

The timing of the publication of *The Wealth of Nations* in its two volumes was pertinent. Britain was poised on the brink of the Industrial Revolution, which would bring vast increases in trade and manufacturing. That Britain—and all subsequent capitalist societies—was able to prosper so dramatically, however, was very largely the result of the economic liberalism that Smith so compellingly advocated.

In detail

◀ **TITLE PAGE** This title page is from the London printing of the first edition, dated 1776. It lists Smith's credentials as a former professor of moral philosophy at Glasgow University in Scotland.

▲ **EXTENDED CONTENTS** The first edition of the book was produced in two volumes of 510 and 587 pages. These were subdivided into Books, which were split into Chapters, as shown on this contents page.

> # The most important substantive proposition in all of economics. "

GEORGE STIGLER, *U.S. ECONOMIST*

THE NATURE AND CAUSES OF
120

BOOK I.

profit rifes or falls. Double interest is in Great Britain reckoned, what the merchants call, a good, moderate, reasonable profit; terms which I apprehend mean no more than a common and usual profit. In a country where the ordinary rate of clear profit is eight or ten per cent. it may be reasonable that one half of it should go to interest wherever business is carried on with borrowed money. The stock is at the risk of the borrower, who, as it were, insures it to the lender; and four or five per cent. may in the greater part of trades, be both a sufficient profit upon the risk of this insurance, and a sufficient recompence for the trouble of employing the stock. But the proportion between interest and clear profit might not be the same in countries where the ordinary rate of profit was either a good deal lower, or a good deal higher. If it were a good deal lower, one half of it perhaps could not be afforded for interest; and more might be afforded if it were a good deal higher.

In countries which are fast advancing to riches, the low rate of profit may, in the price of many commodities, compensate the high wages of labour, and enable those countries to sell as cheap as their less thriving neighbours, among whom the wages of labour may be lower.

THE WEALTH OF NATIONS,
121

CHAP. X.

Of Wages and Profit in the different Employments of Labour and Stock.

THE whole of the advantages and disadvantages of the different employments of labour and stock must, in the same neighbourhood, be either perfectly equal or continually tending to equality. If in the same neighbourhood, there was any employment either evidently more or less advantageous than the rest, so many people would crowd into it in the one case, and so many would desert it in the other, that its advantages would soon return to the level of other employments. This at least would be the case in a society where things were left to follow their natural course, where there was perfect liberty, and where every man was perfectly free both to chuse what occupation he thought proper, and to change it as often as he thought proper. Every man's interest would prompt him to seek the advantageous and to shun the disadvantageous employment.

PECUNIARY wages and profit, indeed, are every where in Europe extreamly different according to the different employments of labour and stock. But this difference arises partly from certain circumstances in the employments themselves, which, either really, or at least in the imaginations of men, make up for a small pecuniary gain in some, and counter-balance a great one in others; and partly from the policy of Europe, which nowhere leaves things at perfect liberty.

VOL. I. R THE

▲ **CHAPTERS AND PARTS** Each Chapter of the Books was subdivided into smaller sections. For example, the right-hand page above shows Chapter 10, which begins with an introduction on the wages and profits available in different types of employment. The first section of the Chapter then focuses on the inequalities that arise from this.

◄ **TABLES AND CHARTS** Smith's text is broken up in places by his inclusion of charts and calculations. These are used to clarify and demonstrate his arguments. The chart shown here compares annual prices of wheat.

Rights of Man

1791–92 ▪ PRINTED ▪ DIMENSIONS AND EXTENT UNKNOWN ▪ UK

THOMAS PAINE

Two years after the outbreak of the French Revolution British-American political propagandist Thomas Paine wrote *Rights of Man*, a visionary two-part pamphlet whose publication caused a sensation. Paine posited the then radical view that governments have a responsibility to protect the natural and civil rights of their citizens, ensuring their freedom, security, and equal opportunity. And, that crucially, should a government fail to safeguard those rights, then the people would be justified in overthrowing it.

Rights of Man began as a historical account of the French Revolution, of which Paine was an avid supporter. But when Anglo-Irish statesman Edmund Burke denounced the uprising and defended the monarchy in a 1790 book, Paine hastily reworked his text. *Rights of Man* became an incendiary counterargument to Burke's view. It lauded the Revolution's principles, railed against aristocratic privilege, and made a case for representative democratic republican government over hereditary monarchy. In 1792 came *Rights of Man Part II*, which proposed wide-ranging reforms. Paine called on England's government to introduce a system of social welfare to ease the economic hardship endured by the lower classes and uphold their civil rights. His vision included free education, old-age pensions, and public works for the unemployed, all funded by a scaled income tax that would favor the poor.

Rights of Man was a publishing success, selling around 200,000 copies, and today it is regarded as a founding document of modern liberal democracy. But in its day it horrified the authorities. After *Part II* appeared, the work was banned. In December 1792, Paine—who had fled to France—was tried in absentia for advocating an end to monarchy in Britain, found guilty, and declared an outlaw.

THOMAS **PAINE**

1737–1809

From humble beginnings as a laborer in the shipyards of Norfolk, England, Thomas Paine rose to fame as writer whose visionary words shaped political events on both sides of the Atlantic.

Born into a working-class family, Paine had a basic formal education. At 13, he began working with his father, making stays: ropes used to stabilize the masts of sailing ships. From 1756 he tried several other occupations, with little success. In 1772 he was fired from his job as an exise tax collector after printing a political pamphlet arguing for better pay and conditions for workers.

In 1774 Paine met the great American statesman Benjamin Franklin, who suggested he begin a new life across the Atlantic. Paine landed in America just as the 13 colonies were debating whether to declare independence from Britain. He became assistant editor of Philadelphia's *Pennsylvania Magazine*, and began writing articles expressing his sense of injustice at the world. In 1776 he published *Common Sense* (see p.211), a pamphlet containing an impassioned but rational argument in favor of American independence. It sold 500,000 copies and helped garner support for a revolt from British rule. In 1787 Paine returned to England, where he wrote *Rights of Man*. His next work, *The Age of Reason* (1794)—an attack on organized religion, which he wrote in France—alienated many of his admirers. He spent his final years in the U.S., living in poverty.

RIGHTS OF MAN:

BEING AN

ANSWER TO MR. BURKE's ATTACK

ON THE

FRENCH REVOLUTION.

BY

THOMAS PAINE,

SECRETARY FOR FOREIGN AFFAIRS TO CONGRESS IN THE AMERICAN WAR, AND AUTHOR OF THE WORK INTITLED *COMMON SENSE.*

LONDON:
PRINTED FOR J. JOHNSON, ST PAUL's CHURCH-YARD.
MDCCXCI.

[110]

of the Rights of Man, as the basis on which the new constitution was to be built, and which is here subjoined.

DECLARATION OF THE RIGHTS OF MAN AND OF CITIZENS,

BY THE NATIONAL ASSEMBLY OF FRANCE.

" The Representatives of the people of FRANCE formed into a National Assembly, considering that ignorance, neglect, or contempt of human rights, are the sole causes of public misfortunes and corruptions of government, have resolved to set forth, in a solemn declaration, these natural, imprescriptible, and unalienable rights : that this declaration being constantly present to the minds of the members of the body social, they may be ever kept attentive to their rights and their duties: that the acts of the legislative and executive powers of government, being capable of being every moment compared with the end of political institutions, may be more respected : and also, that the future claims of the citizens, being directed by simple and incontestible principles, may always tend to the maintenance of the constitution, and the general happiness.

" For these reasons, the NATIONAL ASSEMBLY doth recognize and declare, in the presence of the Supreme Being, and with the hope of his blessing and favour, the following *sacred* rights of men and of citizens :

' I. Men

[111]

' I. *Men are born and always continue free, and* ' *equal in respect of their rights. Civil distinctions,* ' *therefore, can be founded only on public utility.*

' II. *The end of all political associations is the pre-* ' *servation of the natural and imprescriptible rights* ' *of man ; and these rights are liberty, property,* ' *security, and resistance of oppression.*

' III. *The nation is essentially the source of all so-* ' *vereignty ; nor can any* INDIVIDUAL, *or* ANY ' BODY OF MEN, *be entitled to any authority which* ' *is not expressly derived from it.*

' IV. Political Liberty consists in the power of ' doing whatever does not injure another. The ' exercise of the natural rights of every man, has ' no other limits than those which are necessary ' to secure to every *other* man the free exercise of ' the same rights; and these limits are determinable ' only by the law.

' V. The law ought to prohibit only actions ' hurtful to society. What is not prohibited by ' the law, should not be hindered ; nor should any ' one be compelled to that which the law does ' not require.

' VI. The law is an expression of the will of ' the community. All citizens have a right to ' concur, either personally, or by their representa- ' tives, in its formation. It should be the same to ' all, whether it protects or punishes ; and *all* ' *being equal in its sight, are equally eligible to all* ' *honours, places, and employments, according to* ' *their different abilities, without any other distinc-* ' *tion than that created by their virtues and talents.*

P 2 ' VII. No

▲ **RIGHTS OF MAN PART I** Paine developed an engagingly direct writing style that made his ideas accessible to people from all walks of life. The two parts of *Rights of Man* focused solely on the rights of men as declared above; it was up to his contemporary Mary Wollstonecraft (see p.212) to advocate equal rights for women in her *A Vindication of the Rights of Women* (1792).

◄ **COURTING CONTROVERSY** Paine clarifies his motivation for writing *Rights of Man* on the title page: the subdeck plainly states, the work stands as a rebuke to those who criticized the French Revolution. In particular, his target was a conservative pamphlet *Reflections on the Revolution in France* written by the liberal Anglo-Irish politician Edmund Burke.

IN **CONTEXT**

The French Revolution (1787–99) shook the countries of Europe, with their long tradition of absolute monarchy and feudal privileges for the nobility and clergy. In particular, the 1792 abolition of royalty in France caused a ruckus in Britain, sparking intense debate among political commentators and dividing public opinion. Those who supported the Revolution argued for democratic change, while those against it countered that Britain's constitution protected citizens from disorder and the threat of military oppression.

One of the cornerstones of the Revolution was the Declaration of the Rights of Man and of the Citizen, a charter of 17 articles outlining the principles of human liberty. The most important of these was article 1, which stated that all men are born equal and free and entitled to such basic rights as holding private property and resisting oppression. In 1789 the declaration was adopted as the basis of the constitution of the new French Republic, although women of the time had no access to most of the rights it listed.

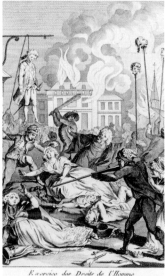

Exercice des Droits de l'Homme et du Citoyen François.

▶ **This engraving from 1792** portrays the events of the Revolution from a royalist perspective: mocking the movement's principles of liberty by showing commoners attacking the aristocracy.

Songs of Innocence and of Experience

1794 ▪ ENGRAVED AND HAND-PRINTED ▪ 7 × 5 in (18 × 12.4 cm) ▪ 54 PLATES ▪ UK

SCALE

WILLIAM BLAKE

This richly illustrated collection of poems, William Blake's most famous work, is lauded for both its literary and artistic value. Originally published as two separate collections, Blake combined and published them as a set in 1794, aiming to juxtapose the innocence of childhood with the corruption that comes with adulthood. In his poems, Blake saw an intimate link between text and illustration, believing that each added a layer of meaning to the other to create an integrated whole. To produce the collection, he developed a new printing technique that combined text and image onto a single etching plate (see p.168). He engraved, hand-printed, and colored every copy of the collection himself, making changes to the color, text, or sequence of the poems that rendered each copy unique. Blake's process was laborious and costly, and only a limited number of copies were circulated during his lifetime. These were initially gifted to family and friends, before Blake decided to sell copies commercially.

The small, colorful format, evocative of a children's book, belied the sophistication of the work—the poems were critical and subversive, questioning society and the role of the Church. On publication they were poorly received and it was not until the early twentieth century that Blake's achievement was recognized.

WILLIAM **BLAKE**

1757-1827

Painter and poet William Blake is considered one of Britain's foremost poets of the Romantic era, although his works went largely unrecognized until after his death.

Blake's early artistic skills led to an apprenticeship with a printmaker at age 12, and he qualified as an engraver at age 21. In 1779, he enrolled at the Royal Academy in London, where he developed his own distinctive style. He married Catherine Boucher in 1782, and published his first set of poems the following year. Although he was a committed Christian, Blake was strongly opposed to institutionalized religion and the controlling influence of the Church on society.

Blake claimed to have visions that inspired his work; he considered the realm of the imagination to be as real and valid as the physical world. In this, he was influenced by the teachings of the Swedish philosopher and mystic, Emanuel Swedenborg (1688-1772). Much of Blake's work was imbued by his view of the Church and his political radicalism, but it failed to find a willing audience at the time. Depressed by his lack of professional success, Blake retreated from society, although he continued working until the very end of his life. He died in 1827, leaving an illustrated manuscript of the *Book of Genesis* unfinished.

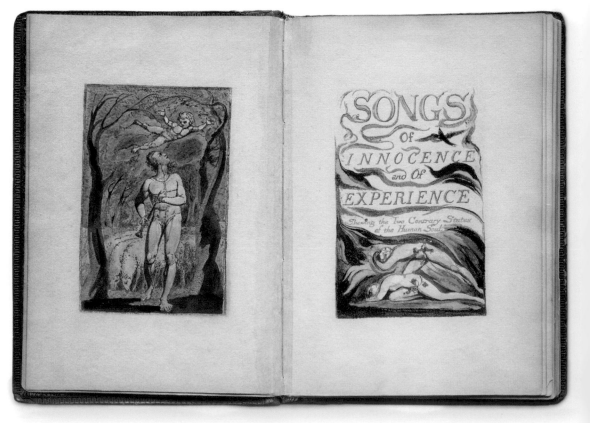

▶ **ARTISTIC DUALITY** The title page reflects the duality that runs through the work, summed up in the subtitle "Shewing the Two Contrary States of the Human Soul." Below it, Blake depicts Adam and Eve cast out of Eden against a background of flames—the loss of innocence. Opposite, a pastoral scene shows a piper looking up at a naked boy flying freely above him.

42

The Tyger

Tyger Tyger, burning bright,
In the forests of the night :
What immortal hand or eye,
Could frame thy fearful symmetry?

In what distant deeps or skies
Burnt the fire of thine eyes!
On what wings dare he aspire!
What the hand, dare seize the fire!

And what shoulder, & what art,
Could twist the sinews of thy heart?
And when thy heart began to beat,
What dread hand? & what dread feet?

What the hammer? what the chain,
In what furnace was thy brain?
What the anvil? what dread grasp,
Dare its deadly terrors clasp!

When the stars threw down their spears
And water'd heaven with their tears :
Did he smile his work to see?
Did he who made the Lamb make thee

Tyger, Tyger burning bright
In the forests of the night :
What immortal hand or eye,
Dare frame thy fearful symmetry?

◄ **DARK EXPERIENCE** The dark artwork mirrors the hidden malevolence of "The Tyger," in this, perhaps the best-loved, poem from *Songs of Experience*. In the poem, Blake poses a series of questions that marvel at the subject's majesty. Few readers would have seen a real tiger but knew that it symbolized power and strength. The clue to the poet's intention comes in the last lines. Could a God who made the meek lamb also create the fierce tiger?

In detail

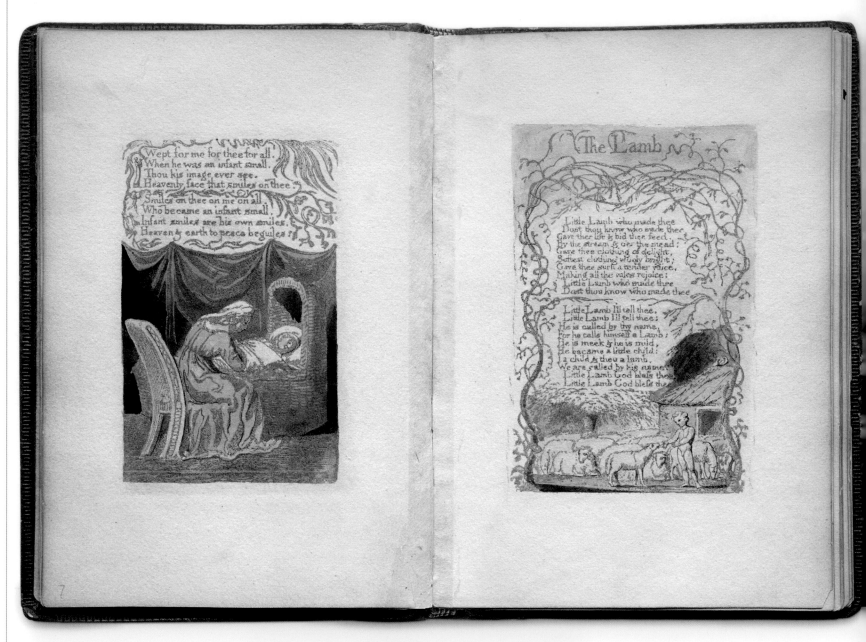

Wept for me for thee for all.
When he was an infant small.
Thou his image ever see.
Heavenly face that smiles on thee,

Smiles on thee on me on all
Who became an infant small.
Infant smiles are his own smiles.
Heaven & earth to peace beguiles.

The Lamb

Little Lamb who made thee
Dost thou know who made thee
Gave thee life & bid thee feed.
By the stream & o'er the mead;
Gave thee clothing of delight,
Softest clothing wooly bright;
Gave thee such a tender voice,
Making all the vales rejoice:
Little Lamb who made thee
Dost thou know who made thee

Little Lamb I'll tell thee,
Little Lamb I'll tell thee;
He is called by thy name,
For he calls himself a Lamb:
He is meek & he is mild,
He became a little child:
I a child & thou a lamb,
We are called by his name.
Little Lamb God bless thee.
Little Lamb God bless thee.

ON TECHNIQUE

From the sixteenth to the early nineteenth centuries, illustrated books were printed by two presses. The first printed the text using raised lead plates; the second added the etchings in the spaces left in and around the text. Blake's innovation was to print his pages in a single process. Writing and illustrating in reverse, he added his text and illustrations to copper printing plates using a special varnish, known as "stop-out" varnish. When the plates were then treated with acid the varnish prevented the areas covered from being dissolved, leaving them raised. Ink could then be carefully applied to the plate in fine layers, before paper was rolled across the plate on a traditional rolling press.

▲ **In the press** shown here, one worker is preparing the print, another inks a copper plate, and a boy turns the handle on the rolling press.

▲ **TRANQUIL BEAUTY** Taken from *Songs of Innocence*, both text and illustrations for "A Cradle Song" and "The Lamb" exude gentleness. The first is a lullaby comparing a sleeping child to Jesus, and is illustrated with a mother gazing at her baby in its cot. In the second the child is described as a pure and gentle lamb, referring to Jesus, Lamb of God. The author asks the child if he knows who made him, before providing the answer: God. The ochre colors are bright and luminous to suggest the tranquil surroundings in which the child lives in the countryside.

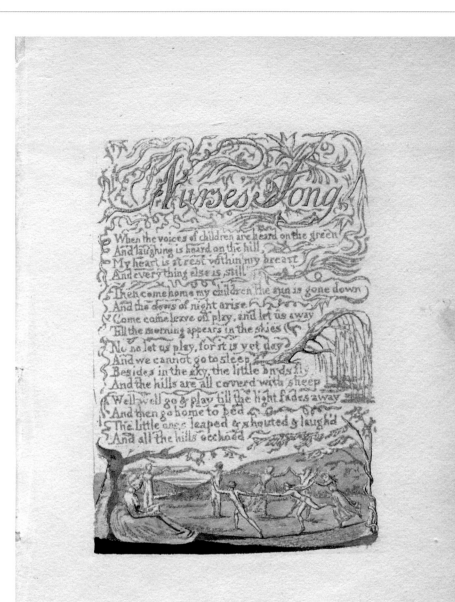

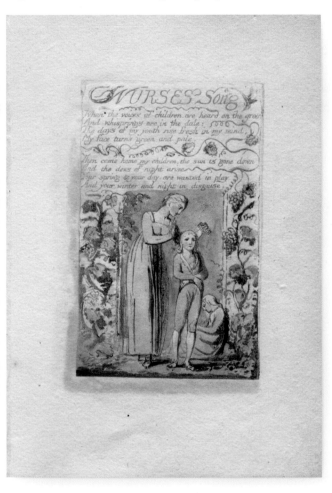

◄ **CONTRASTING PAIRS** Some of the poems in *Songs of Innocence* have counterparts in poems of the same name in *Experience*. For example, the "Nurse's Song" in *Innocence* (see left) joyfully tells children to "go and play till the light fades away," while the "Nurse's Song" in *Experience* (below) commands them to come home. The images reflect this, as children skipping in a ring contrast with a nurse combing a sulky boy's hair.

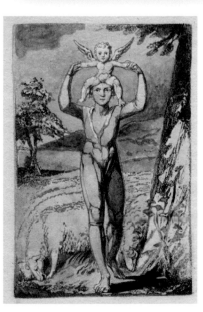

◄ **SCENE-SETTING FRONTISPIECE** In both collections, the frontispieces feature a pastural scene, complete with a flock of sheep, a male figure, and a winged cherub. Here, in the frontispiece for the *Experience* portion of the book, the two figures are holding hands, which represents the constraint of childhood freedoms, or perhaps childhood innocence as a burden to be endured.

➤ **INTIMATE LINK** In *Innocence*, the text of the poem "Infant Joy" is closely enveloped by an illustration of a twining plant, suggesting the natural beauty of the subject–the bond between mother and child. The poem itself reads as a dialogue between a mother and her new baby, shown nestled within a flower, who announces him- or herself as happy: "Joy is my name."

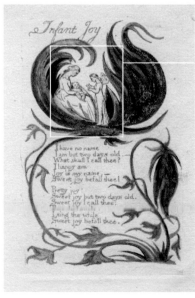

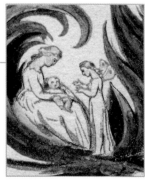

▲ **GOD'S BLESSING** An angel is shown attending the mother and child in "Infant Joy," and all three figures are bathed in a golden glow, suggesting that the maternal bond is blessed by God.

Birds of America

1827–38 ▪ PRINTED ▪ 39 × 26 in (99 × 66 cm) ▪ 435 LIFE-SIZE PRINTS ISSUED IN 87 PARTS ▪ USA

SCALE

JOHN JAMES AUDUBON

John James Audubon's nineteenth-century masterpiece is a hand-drawn, visual catalog of the birds of North America, first published as a series of prints between 1827 and 1838. The book features 435 life-size prints of 497 bird species, each depicted in its natural habitat with exquisite detail and accuracy. Reaching approximately 3 ft (1 m) in height and comprising four separate volumes, *Birds of America* is the largest book ever produced. The original edition was printed using a complex combination of pastel and watercolor illustrations reproduced from hand-engraved plates. At the time of publication, wildlife books typically had blank backgrounds, but Audubon included a detailed backdrop to each picture, giving the reader an idea of the habitats of the birds featured.

The book's great artistic value is equaled by its contribution to cultural and ornithological history. It identifies birds that were not known to inhabit America, and also provides a vital historical record since six of the birds featured are now thought to be extinct. In compiling his book, Audubon discovered 25 new species of bird and 12 new subspecies. *Birds of America* took nearly 12 years to complete, and only 120 complete sets of the illustrations still exist.

▼ **THE BIGGEST BOOK** The original edition of *Birds of America* was printed on "double elephant" folios, sheets of handmade paper measuring 39 x 26 in (99 x 66 cm). The Carolina parrot, shown here feeding on a cocklebur plant, is one of six species of bird drawn by Audubon that is now extinct.

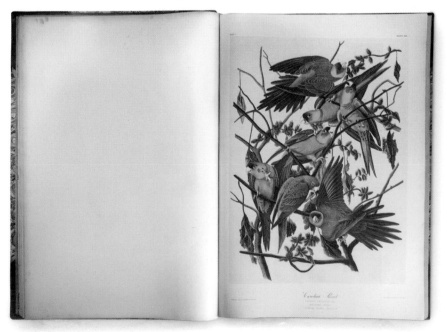

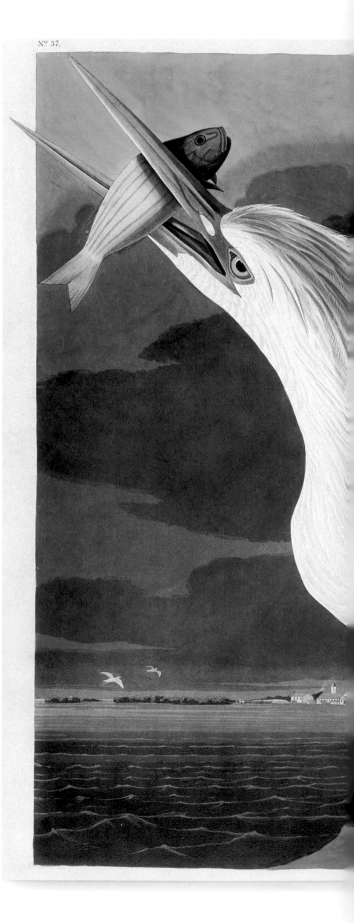

As I grew up I was fervently desirous of becoming acquainted with Nature. **"**

JOHN JAMES AUDUBON

▼ **LIFE-SIZE DRAWINGS** Audubon's patrons received a tin box each month with hand-colored engravings and etchings, including images of large, medium, and small birds. The great white heron, pictured here, is the largest species of heron; Audubon had to draw it with a bent neck in order to enable the life-size drawing.

PLATE CCLXXXI

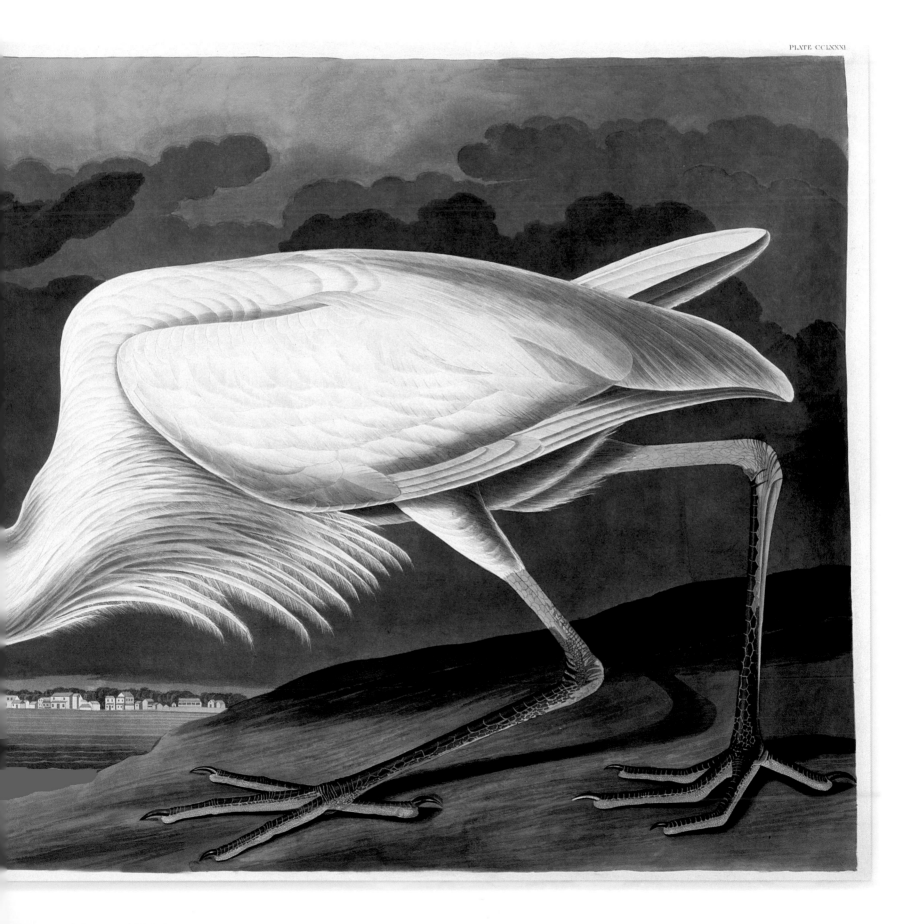

In detail

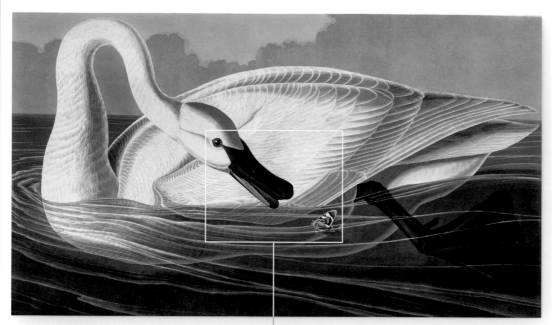

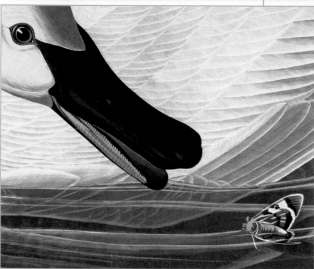

SETTING A SCENE All the birds shown in the book were killed; Audubon then examined the formation of feathers and measured the body and wingspan of the dead specimen. Before he began drawing, the birds were posed by pinning them to a wooden frame with wires—as shown with these gyrfalcons. This allowed Audubon to continue his precise and painstaking work for several days.

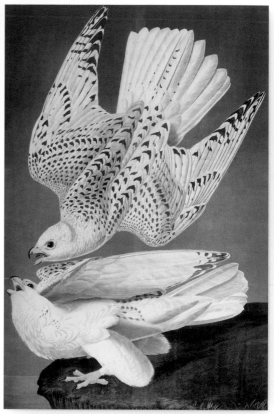

VIBRANT ILLUSTRATIONS This print captures the elegance and majesty of the trumpeter swan, which Audubon praised in his accompanying text. The prints themselves were produced by London-based engraver Robert Havell Jr., and his father. Each was placed on a production line, colorists then applied different tints to specific parts of each print using a variety of techniques.

PRINTING EFFECTS The white lines and highlights on the swan's feathers emphasize the form of its wings, while areas of shadow add a three-dimensional effect. Added aquatint gives graded levels of greenish tone to the water, hinting at its transparency, as well as providing a sense of undulating movement.

JOHN JAMES AUDUBON

1785-1851

John James Audubon was an American naturalist, ornithologist, and artist. He is best known for his detailed paintings and illustrations of North American birds. This extensive and ambitious work, *Birds of America* was to occupy him for most of his life..

Naturalist and painter John James Audubon was born in the French colony of Saint-Domingue (present-day Haiti). As a child he moved to France, where he developed a love for the natural world. At age 18, he emigrated to Pennsylvania (in part to avoid conscription to the Napoleonic Wars) and lived outside Philadelphia with his father, who had secured him a false passport. There, he carried out the first known bird-banding experiment in North America, tying thread to legs of eastern Phoebes. Audubon's early attempts in business failed, and following his marriage in 1808 to Lucy Bakewell, he dedicated himself to naturalism.

In 1820, Audubon embarked on his life's project: to draw all the birds of North America. He set off down the Mississippi with a gun and his drawing materials, traveling for months at a time in search of specimens, which he shot before drawing the birds in precise detail. The epic scale and complexity of the project made financing it difficult and in 1826, having failed to find sufficient funds in America, Audubon sailed to England to secure patronage for his half-finished book. He eventually found wealthy patrons from America, Great Britain, and France to finance his vastly ambitious *Birds of America* (these patrons included King George IV and President Andrew Jackson). Returning to America, Audubon moved with his family to New York in 1841, where he died on January 27, 1851.

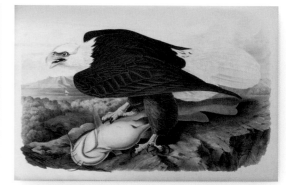

NATURAL HABITATS In an era before photography, Audubon's colored prints, complete with their detailed backgrounds, gave the reader a rare and intimate view of birds in their own environments, such as the bald eagle, depicted here with a fish carcass. Audubon employed up to 150 artists to paint these backgrounds; his assistant, Joseph Mason, painted 50 of them.

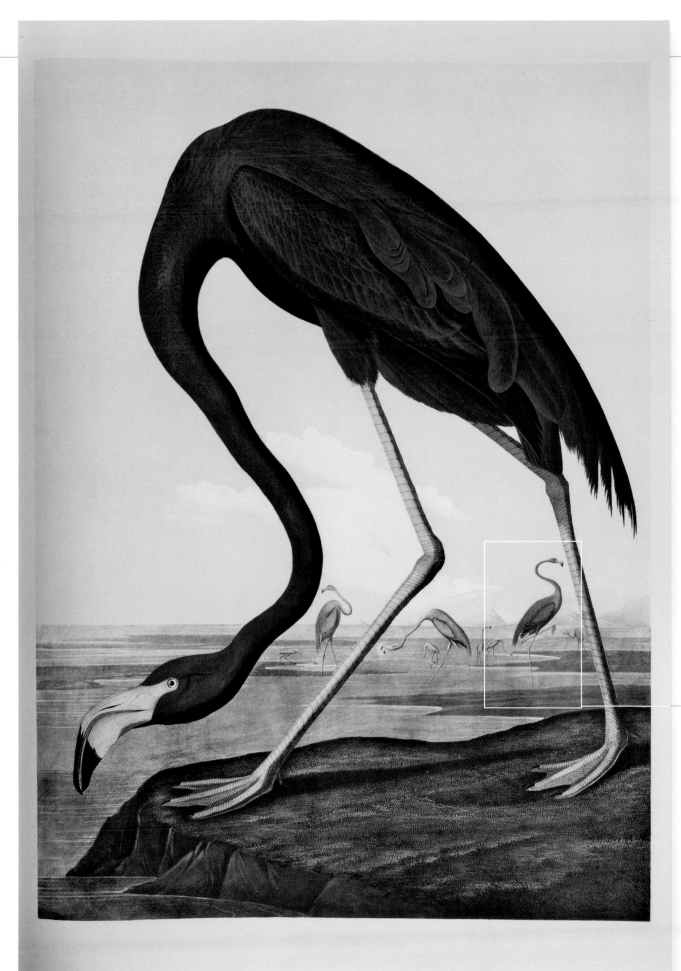

◄ FITTING THE FRAME
Drawing life-sized birds was problematic for species such as the American flamingo, as the bird reaches 5 ft (1.5 m) in height. In order to fit the flamingo within the frame of the page, Audubon shows the bird with its neck bent over and legs at an angle.

▼ BACKGROUND DETAIL
The flamingos perching in the background, including this bird in its characteristic one-legged pose with an outstretched neck, add a dramatic sense of movement to the engraving. Audubon painted the flamingos in a large group, indicating that they are social birds.

Procedure for Writing Words, Music, and Plainsong in Dots

1829 ▪ EMBOSSED ON PAPER ▪ 11 × 9 in (28.5 × 22 cm) ▪ 32 PAGES ▪ FRANCE

SCALE

LOUIS BRAILLE

At the age of just 20, Louis Braille presented his *Procedure for Writing Words, Music, and Plainsong in Dots*, and unveiled a means of reading and writing that would transform the lives of visually impaired people, like himself. Educated in Paris, he was taught to read (but not write) using Valentin Haüy's system of embossed lettering. In 1821, Braille became aware of Captain Charles Barbier's "night reading" code. A French Army officer, Barbier had invented a system in 1808 that allowed soldiers to communicate silently on the battlefield using a series of signals that could be "read" with fingertips. Braille was inspired to develop his own simplified version that would be easy to learn, and could also enable writing. He refined Barbier's system and invented his own code of "cells" or letters using a system of six raised "dots", so that each cell could be "read" with a fingertip. He grouped them in nine "decades," or characters, including letters, numbers,

and punctuation. Braille published his work in 1829, with additional symbols for both mathematics and music. The book was printed with the alphabet embossed on both sides of each page, using a technique that involved wooden blocks being pressed into wet paper. The book introduced the braille system to the world, bringing literacy to generations of visually impaired people.

LOUIS **BRAILLE**

1809–1852

Blind in both eyes from the age of 5, Louis Braille mastered his disability and went on to invent the coding system named after him that enabled visually impaired people to read and write.

Born in a small town outside Paris, Braille was educated at the local school until the age of 10, when he won a scholarship to the Royal Institution for Blind Youth, Paris. He learned to read using a form of embossed lettering devised by the school's founder, Valentin Haüy. At the age of 19, Braille was appointed a teacher and musician at the institute. He died of consumption at the age of only 43, before his system achieved recognition, and is buried in the Pantheon in Paris. Today, Braille is a French national hero.

In detail

▲ **FIRST EDITION** The book had to be printed using Haüy's system of embossed letters to translate Braille's new "dot" system. The full French title, *Procédé pour Écrire les Paroles, la Musique et le Plain-chant au moyen de points*, is shown here using Haüy's letters.

▲ **FIRST AND LAST PAGES** The title page (left) clearly shows the raised letters in the printing. On the last page of the book (right), Braille gives a table, or key, to the letters and the corresponding dots and dashes used in his new system. The dashes were dropped from the second edition printed in 1837.

We (the blind) must be treated as **equals,** and **communication** is the **way** we can bring this about.

LOUIS BRAILLE

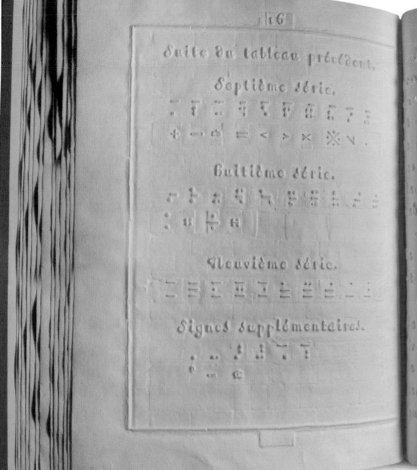
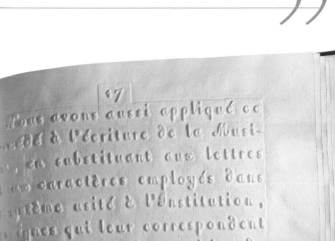

▲ **BRAILLE'S CHARACTERS EXPLAINED** The page above (numbered 16) presents the dot codes for Braille's seventh, eighth, and ninth decades, which relate to mathematics and music. On the opposite page, Braille explains how they are used.

▲ **CREDIT TO CAPTAIN BARBIER** In this preface to *Procédé pour Écrire*, Braille states that he developed his system from Barbier's work, but Barbier's 20 signs did not suffice for writing every word in the French language. Only six copies of this first edition have survived.

IN **CONTEXT**

In 1854, two years after Braille's death, France adopted his system of reading and writing for the visually impaired. In 1878, the World Congress for the Blind adopted braille as their official means of communication around the globe. The system has proved remarkably adaptable, with versions developed for Slavic languages, such as Russian and Polish, as well as the major Asian languages. Its simplicity also made the large-scale production of braille typewriters practical. However, recent developments in audio books and digital technology has resulted in a decline in its use.

▲ **Printers began to develop** braille presses in the nineteenth century. This one dates from the 1920s.

Baedeker guidebooks

FROM 1830s ▪ PRINTED ▪ EARLY EDITIONS 6 × 4½ in (16 × 11.5 cm) ▪ VARYING NUMBER OF PAGES ▪ GERMANY

SCALE

VERLAG KARL BAEDEKER

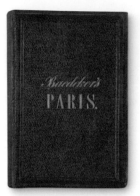

In its heyday, from the 1840s until 1914, the German publishing company Baedeker produced the world's most popular travel guidebooks—a genre it did not invent, but wholly transformed.

In 1835, while revising an 1828 tourist guide to the Rhine Valley acquired from another publisher, founder Karl Baedeker created the practical, user-friendly format for which the Baedeker guides became renowned. He added an innovative feature to the existing guide's coverage of the area's history and attractions: advice on ways to get around and where to stay. The target reader of this book, and of the Baedeker guides that developed out of it, was a new kind of tourist: one who wanted to travel independently, rather than hire a tour guide.

From 1839, the Baedeker guidebook series grew rapidly; before his death in 1859, Karl personally produced a title for every major destination in Europe. Under the ownership of his three sons, the list expanded further, but the brand's hallmarks were maintained: scrupulously researched text, detailed listings, state-of-the art maps and plans, and a "star" system for rating sights, hotels, and restaurants. The

KARL **BAEDEKER**

1801–1859

Karl Baedeker was a German publisher and bookseller who, through his celebrated series of guidebooks, established the template for the modern travel guide.

Born into a family of booksellers and printers in Essen, Germany (then part of Prussia) Baedeker was the eldest of 10 children. He studied in Heidelberg in 1817 and then worked for various booksellers, before starting his own bookselling and publishing business in Koblenz in 1827. Having spotted the emerging market for authoritative travel guidebooks, he exploited it relentlessly. He insisted that Baedeker guides contained accurate information—much of which he researched himself—and also saw the importance of regularly updating existing titles. The last two decades of Baedeker's life were spent tirelessly writing, revising, and updating his guides, and travelling extensively. He died aged 58, and his sons, Ernst, Karl, and Fritz successively took over the business, and increased the Baedeker series range: by 1914 it covered much of the globe.

Baedeker guides' success was driven by the advent of mass travel in late nineteenth-century Europe; for the newly wealthy middle-class, a trip overseas had become affordable and accessible due to the new railways and steamships. But the guides played a role in encouraging this tourism boom, too, particularly after French and English editions were produced. By 1870, a Baedeker, with its distinctive red cover, was a synonym for "guidebook."

In detail

▲ **METICULOUS DETAIL** The books held lots of information. This copy of *The Rhine from Rotterdam to Constance* (1882) shows a table with the river's fall, breadth, length, and depth.

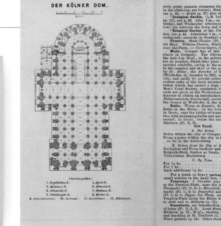

▲ **FLOORPLANS OF KEY SIGHTS** The guidebooks were renowned for the breadth of their historical research: this plan is of Cologne Cathedral, a sight which Baedeker remarks "justly excites the admiration of every beholder."

▲ **PANORAMA** Accurate and technically accomplished hand-drawn views, such as this one of the Eastern Alps, were a mainstay of the earlier guides produced in the era before photographic reproduction.

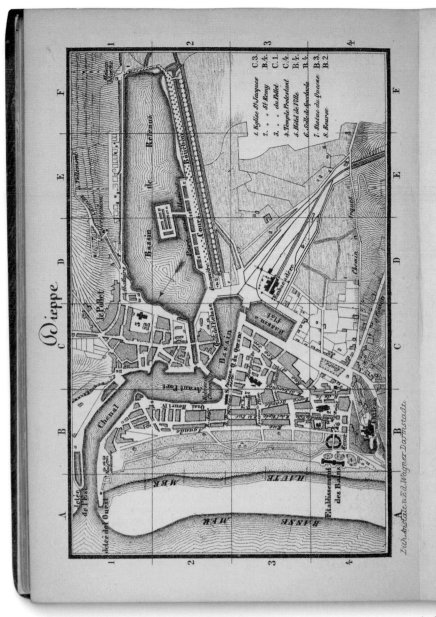

English fleet, then returning from an unsuccessful attack on Brest; an unequal contest which resulted in the total destruction of the town. The view from the summit, and especially from the lofty bridge, is very extensive, but beyond this the castle possesses nothing to attract visitors.

The church of **St. Jacques** (the patron saint of fishermen), in the *Place Nationale*, dates from the 14th and 15th centuries. The interior is, however, sadly disfigured. Near the church is the **Statue of Duquesne**, a celebrated admiral and native of Dieppe (d. 1687), who conquered the redoutable De Ruyter off the Sicilian coast in 1676. The Dutch hero soon after died of his wounds at Syracuse. Duquesne, who was a Calvinist, was interred in the church of Aubonne on the Lake of Geneva.

On market-days (Wednesdays and Saturdays) an opportunity is afforded the stranger of observing some of the singular head-dresses of the Norman country-women.

The **Jetée de l'Ouest**, situated at the N.W. extremity of the town, forms an agreeable evening promenade, and with the opposite *Jetée de l'Est* constitutes the entrance to the harbour. Towards the S.E. the harbour terminates in the **Bassin de Retenue**, flanked by the *Cours Bourbon*, an avenue $3/4$ M. in length, affording a retired and sheltered walk.

This basin contains an extensive **Oyster Park**, formerly one of the principal sources from which Paris derived its supplies. The oysters are first brought from the inexhaustible beds of *Cancale* and *Granville* to *St. Vaast* near Cherbourg, whence they are afterwards removed to Dieppe. Here they are 'travaillées', or dieted, so as materially to improve their flavour and render them fit for exportation. It has been observed that the oyster, when in a natural state, frequently opens its shell to eject the sea-water from which it derives its nourishment and to take in a fresh supply. In the 'park' they open their shells less frequently, and after a treatment of a month it is found that they remain closed for ten or twelve days together, an interval which admits of their being transported in a perfectly fresh state to all parts of the continent. Since the completion of the railway from Paris to Cherbourg, the oyster-park of Dieppe has lost much of its importance, and the metropolis now derives its chief supplies from a more convenient source.

Contiguous to the oyster-park is a restaurant of humble pretensions, where the delicious bivalve (75 c. per dozen), fresh from its native element, may be enjoyed in the highest perfection.

Le Pollet, a suburb of Dieppe inhabited exclusively by sailors and fishermen, adjoins the Bassin de Retenue on the N. side. The population differs externally but little from that of Dieppe. It is, however, alleged that they are the descendants of an ancient Venetian colony, and it is certain that to this day they possess a primitive simplicity of character unknown among their neigh-

BÆDEKER. Paris. 3rd Edition. 15

▲ **CLEAR LAYOUTS** Baedeker guides were viewed as the most reliable of all tourist reference books, giving rise to the English verse: "Kings and governments may err— but never Mr. Baedeker." These pages–from *Paris and Northern France* (1867)–are typical of the well-planned context, which as well as descriptions of attractions, gave information on local customs, and hints on tipping and how best to conduct oneself.

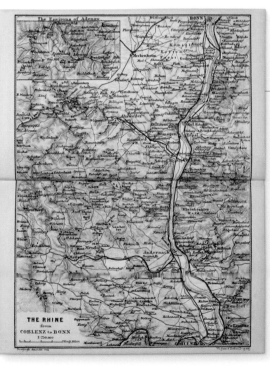

◄ **HIGH-QUALITY MAPS** The guides' maps and plans were as detailed and precise as those produced by cartographic companies. They were mostly colored, and easy to read; the larger maps could be folded out.

Its **principal** object is to keep the **traveler** at as great a distance as **possible** from the unpleasant … and … to assist him in **standing** on his own feet. ❞

KARL BAEDEKER, PREFACE TO *GERMANY*, 1858

The Pickwick Papers

1836-37 ▪ PRINTED ▪ 8 × 5 in (21.3 × 12.6 cm) ▪ 609 PAGES ▪ UK

SCALE

CHARLES DICKENS

The Posthumous Papers of the *Pickwick Club*, commonly known as *The Pickwick Papers*, was Charles Dickens's first novel. Published in 19 monthly installments between April 1836 and November 1837, and as a two-volume book in 1837, it proved a phenomenal publishing success on a scale never seen before. While the first installment sold just 500 copies, the final, double installment sold 40,000 and established Dickens as an author. He would later become the best-known and best-loved of all Victorian novelists.

The periodicals were not initially intended as a novel: Dickens was commissioned to write extended captions for a series of comic sporting scenes by an illustrator, Robert Seymour (1798–1836). However, Dickens proposed that the process be reversed, with Seymour's illustrations serving his text. After two instalments Seymour committed suicide, and the remainder of the story—with text taking a more central role—was illustrated by Habbot Knight Browne ("Phiz") (1815–82) who later illustrated 10 other books by Dickens.

The vivid and gleeful portrait of late Georgian England captivated the public: readers from all strata of society followed the escapades of the four members of the

CHARLES **DICKENS**

1812–1870

Charles Dickens is one of the most famous and best-loved novelists in the English language. He created numerous fictional characters that have captivated generations of readers.

In 1824 Dickens's father was sent to a debtor's prison, and the 12-year-old Charles was forced to work in a boot-blacking factory—an experience that haunted him his whole life. Dickens eventually began a career as a political journalist in 1832, and, having quickly made a name for himself, was offered the chance to work on *The Pickwick Papers* alongside illustrator Robert Seymour. Published in 1836, it was the starting point of his lifelong career as a novelist.
 Dickens married Catherine Hogarth in 1836, and although they had 10 children together, they separated in 1858, after he began an affair with actress Ellen Ternan. In addition to writing novels and plays, Dickens edited periodicals and newspapers, and assisted several charities. A champion of the poor, he created armies of extraordinary characters, and the vast tableaux that emerged played a crucial part in society's awakening social conscience. As a novelist and social commentator, Dickens became one of the age's most famous figures.

Pickwick Club. There was no plot to speak of—just a series of adventures by the friends, led by the ever-genial Samuel Pickwick, as they set out to explore England—but the work teemed with life and humor. Although Dickens still signed his work with his nom de plume, "Boz," the publication of *The Pickwick Papers* ensured his enduring fame, and opened up a 40-year-long career as a novelist and a literary sensation.

In detail

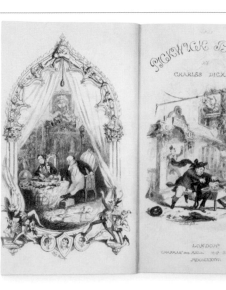

▶ **FRONTISPIECE AND TITLE PAGE** Following the death of the work's first illustrator, Seymour, other artists were tried, such as Robert Buss, but Hablot K. Browne ("Phiz") was ultimately chosen, and his drawings are primarily used in the book. In his frontispiece, Sam Weller and Mr. Pickwick review papers together. The title page shows Tony Weller "baptizing" the pastor, Mr. Stiggins, in the horse trough.

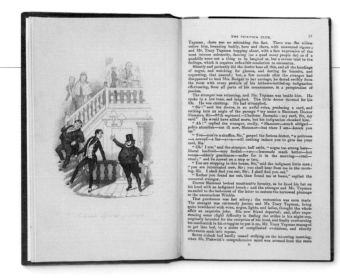

▲ **RIVALS IN LOVE** This is one of the few illustrations drawn by Robert Seymour shortly before he committed suicide. It depicts army surgeon Dr. Slammer challenging Alfred Jingle to a duel after he seduced a wealthy widow that the doctor had been pursuing.

▼ **CHRISTMAS SPECIAL** To profit from the Christmas period, the publishers shrewdly issued a special edition, published on December 31, 1836, for which Dickens wrote a sentimental piece. The image below by "Phiz," a steel engraving, shows detail and humor in the depiction of Mr. Wardle's Christmas party in which partygoers kiss under the mistletoe. Phiz initially studied Seymour's style before later establishing his own. His images often included allegorical references in the background.

296 POSTHUMOUS PAPERS OF

branch of misletoe instantaneously gave rise to a scene of general and most delightful struggling and confusion ; in the midst of which Mr. Pickwick with a gallantry which would have done honour to a descendant of Lady Tollimglower herself, took the old lady by the hand, led her beneath the mystic branch, and saluted her in all courtesy and decorum. The old lady submitted to this piece of practical politeness with all the dignity which befitted so important and serious a solemnity, but the younger ladies not being so thoroughly imbued with a superstitious veneration of the custom, or imagining that the value of a salute is very much enhanced if it cost a little trouble to obtain it, screamed and struggled, and ran into corners, and threatened and remonstrated, and did every thing but leave the room, until some of the less adventurous gentlemen were on the point of desisting, when they all at once found it useless to resist any longer, and submitted to be kissed with a good grace. Mr. Winkle kissed the young lady with the black eyes, and Mr. Snodgrass kissed Emily ; and Mr. Weller, not being particular about the form of being under the mistletoe, kissed Emma and the other female servants, just as he caught them. As to the poor relations, they kissed everybody, not even excepting the plainer portion of the young-lady visiters, who, in their excessive confusion, ran right under the misletoe, directly it was hung up, without knowing it ! Wardle stood with his back to the fire, surveying the whole scene, with the utmost satisfaction ; and the fat boy took the opportunity of appropriating to his own use, and summarily devouring, a particularly fine mince-pie, that had been carefully put by, for somebody else.

Now the screaming had subsided, and faces were in a glow and curls in a tangle, and Mr. Pickwick, after kissing the old lady as before-mentioned, was standing under the misletoe, looking with a very pleased countenance on all that was passing around him, when the young lady with the black eyes, after a little whispering with the other young ladies, made a sudden dart forward, and, putting her arm round Mr. Pickwick's neck, saluted him affectionately on the left cheek ; and before Mr. Pickwick distinctly knew what was the matter, he was surrounded by the whole body, and kissed by every one of them.

It was a pleasant thing to see Mr. Pickwick in the centre of the group, now pulled this way, and then that, and first kissed on the chin and then on the nose, and then on the spectacles, and to hear the peals of laughter which were raised on every side ; but it was a still more pleasant thing to see Mr. Pickwick, blinded shortly afterwards with a silk-handkerchief, falling up against the wall, and scrambling into corners, and going through all the mysteries of blindman's buff, with the utmost relish for the game, until at last he caught one of the poor relations ; and then had to evade the blind-man himself, which he did with a nimbleness and agility that elicited the admiration and applause of all beholders. The poor relations caught just the people whom they thought would like it ; and when the game flagged, got caught themselves. When they were all tired of blind-man's buff, there was a great game at snap-dragon, and when fingers enough were burned with that, and all the raisins gone, they sat down by the huge fire of blazing

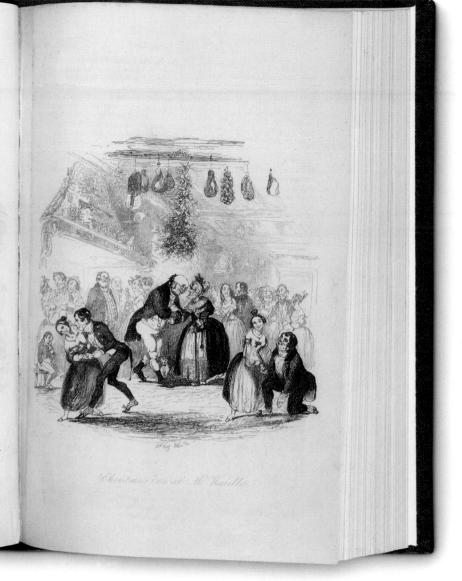

Christmas Eve at Mr. Wardle's

If I were to **live a hundred** years, and write three **novels** in each. I should never be so proud of **them,** as I am of **Pickwick.** 🙶🙷

CHARLES DICKENS, NOVEMBER 1836

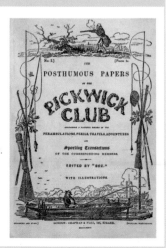

The Holy Land

1842–49 ▪ LITHOGRAPHS ▪ 24 × 17 in (60 × 43 cm) ▪ 247 PLATES ▪ UK

SCALE

DAVID ROBERTS

The publication, from 1842, of the first prints of David Roberts' magisterial *The Holy Land, Syria, Idumea, Egypt and Nubia*–its full title–was a publishing sensation. The impact was reinforced with the publication of more such images in a variety of lavish formats and titles. The immense success of the project reflected not just a deepening European fascination with the perceived exotic allure of the Near East, but also a celebration of the exceptional technical sophistication of the prints themselves. The collaborative venture combined the efforts of David Roberts; Louis Haghe, a Belgian lithographer who made the prints; and publisher Francis Moon, who took a great financial risk in publishing the various volumes.

Roberts arrived in the Middle East in 1838 and spent 11 months sketching and painting a vast range of views: "enough material to serve me for the rest of my life." Haghe then reproduced these as lithographs. This intensely demanding form of printing sees the images recreated in reverse on stones, which were covered with ink, and turned into prints. The resulting black-and-white images were then hand-colored, meaning that no two were identical. The book was one of the first great examples of mass-produced lithography, heralding the rise of mass media. It was also, for the Victorians, an inspiring vision of another world.

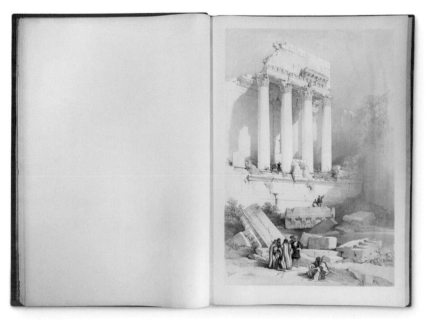

▲ **BINDING** Many of the first subscribers chose to have the plates bound.

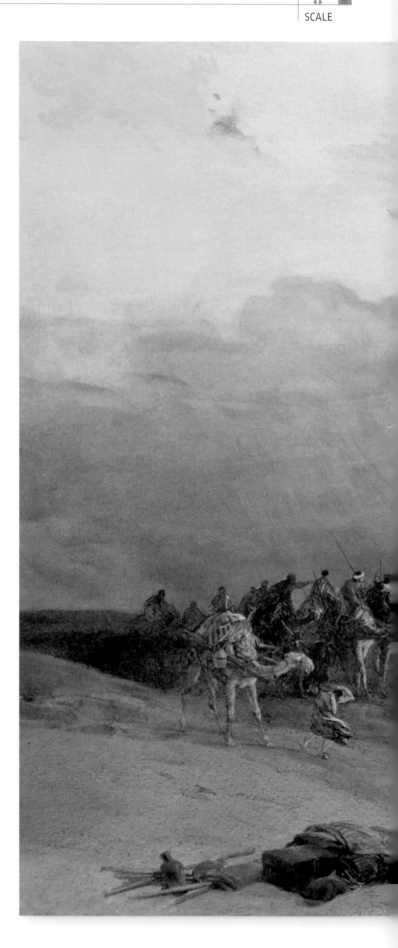

▼ **AESTHETIC AND ACCURATE** Roberts had an inherent sense of the dramatic. His most famous image from *The Holy Land* shows the Sphinx and the Great temple complex at Giza, outside Cairo, during the arrival of the simoom (meaning "poison wind") a hot desert wind, which sweeps before it clouds of suffocating dust and sand. The huge sun adds to the sense of impending doom.

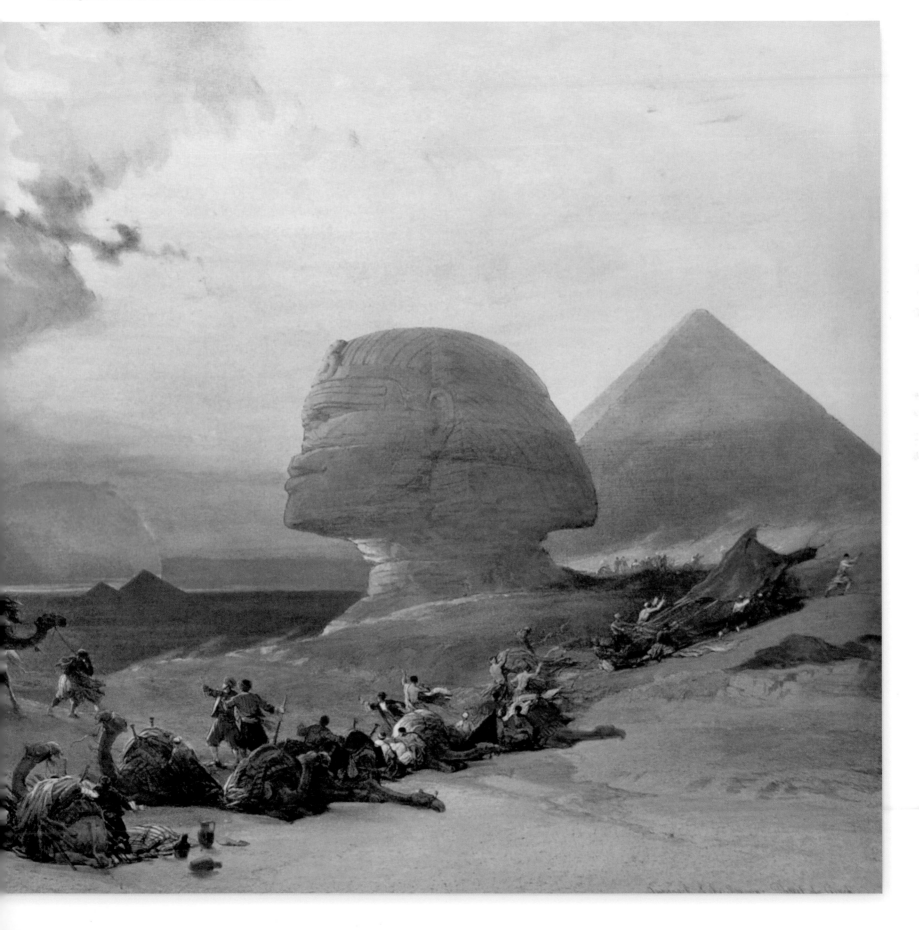

In detail

► **ROBERTS' SKETCH** The spontaneous quality of Roberts' original drawings reflects his experience of painting large volumes of material: he produced over 272 watercolors of temples, monuments, and people for *The Holy Land*. This scene illustrates his bold style, which creates an accurate depiction of the landscape without the need for delicate detail. The orange hues reflect the heat of the atmosphere, while the light reflecting off the top of the buildings enhances this by emphasizing the sun's presence.

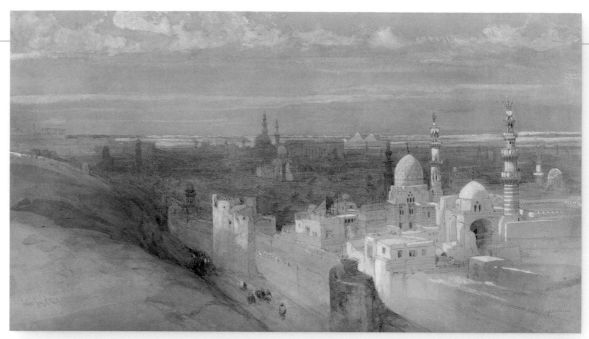

► **HAGHE'S LITHOGRAPH** When creating his lithographs, Haghe made exact copies of Roberts' original sketches and watercolors. However, he brought a visual delicacy to what was essentially a technical exercise through the process of lithography—which sharpens lines, and adds contrast to areas of light and shade—and matched and precisely complemented Roberts' work. In this view Haghe enhances the detail in the foreground, but still manages to capture the warmth found in Roberts' drawing.

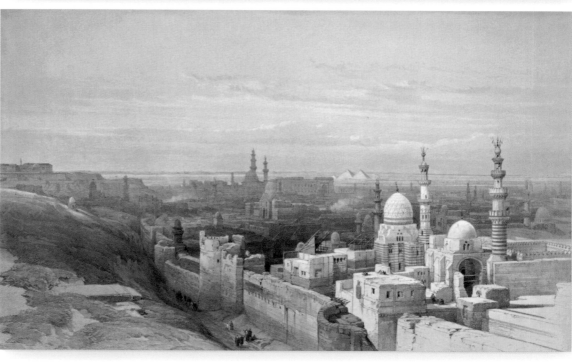

DAVID **ROBERTS**

1796-1864

David Roberts was a prolific British painter and Royal Academician. He later had some success with oil painting, but it was his scenes painted abroad that brought him renown.

Born in Scotland Roberts had no formal training as an artist working instead as a painter of stage sets, initially in Scotland then in London. His obvious talent was such that from the 1820s he was able to establish himself as a landscape painter. A series of journeys to France and the Low Countries, and then to Spain and North Africa, cemented his reputation as a virtuoso painter of architecture. He had exceptional technical skill and a striking capacity for hard work, as well as an instinctive talent for conveying mood and drama in landscapes and buildings alike. *The Holy Land* was a triumph—Queen Victoria was the first subscriber to the prints: her copy is still in the Royal Collection. This success was repeated in a second three-volume work, *Egypt and Nubia*, published between 1846 and 1849. In 1859, he published a similarly sumptuous work on Italy: *Italy, Classical, Historical and Picturesque*.

◄ **ILLUSTRATED FRONTISPIECE** The frontispiece of Roberts' *Egypt and Nubia*, his follow-up to *The Holy Land*, shows travelers surveying the vast statues at the grand entrance to the thirteenth-century BCE Great Temple of Aboo Simbel (Abu Simbel today), in Nubia, in the far south of Egypt. The text for the book was provided by a noted antiquarian, William Brockedon.

► **RICH DECORATION** When Roberts visited the Isis temple complex on the Nile island of Philae, it was already among the most popular archeological sites in Egypt. Roberts' inclusion of Nubian tribesmen in his sketch emphasizes the monumental size of the columns of this temple's portico. He also captures the rich patterning of papyrus and lotus motifs.

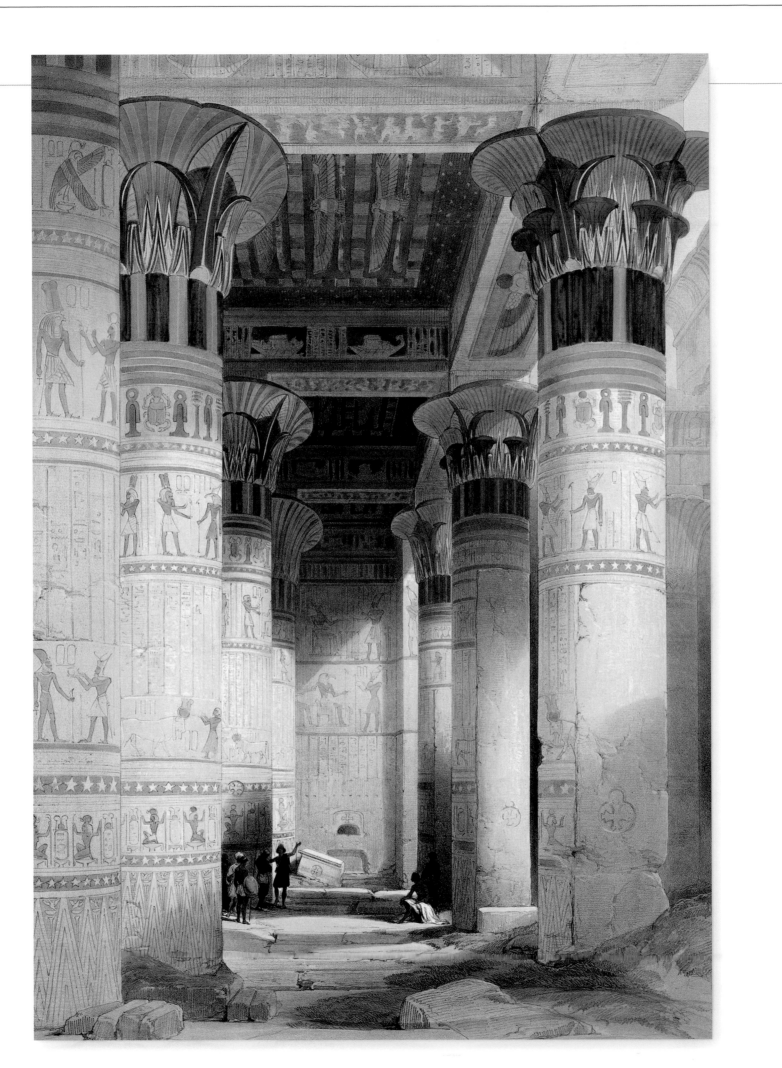

In detail

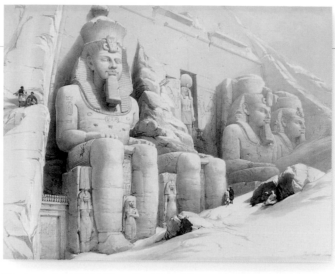

➤ **MASTER OF THE ART** Haghe's ability to exploit lithographic techniques in order to produce dramatic highlights and shadows delighted Roberts. As he stated, "There can be only one opinion as to the masterly manner in which he executed his work." Figures bring touches of color to a palette that is otherwise dominated by sand tones.

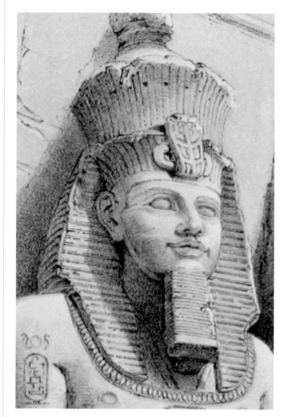

▲ **HIGH CONTRAST** In this detail of Haghe's untinted lithograph, expert shading can be seen, with deep black shadows at the rock's base and bright white highlights at its sunlit top. The figures added to the scene help give a sense of the scale of this colossal statue.

◀ **A FINE TOUCH** This detail from Haghe's untinted lithograph makes clear the exceptional delicacy and accuracy of Haghe's work, with flawless contouring of the statue's face and headdress.

IN **CONTEXT**

The success of Roberts' *The Holy Land* stemmed partly from the financial acuity of the publisher, Francis Moon, but was mainly due to the convergence of two developments in the Victorian world. The first was the burgeoning interest in the mysteries of what were, then, little-known lands. A series of French artists, notably Ingres (1780-1867) and Delacroix (1798-1863), were the first to exploit this. British artists, among which Roberts was a forerunner, soon followed suit, and demand for these compellingly rich images soared. The second development was that of lithography, which occurred at the end of eighteenth century, initially in Germany. The word comes from the ancient Greek *lithos* meaning "stone" and *graphein* meaning "write," since the image was drawn on a lithographic stone with a crayon. In this period, just before the widespread use of photography, it was the first time that such high-quality reproductions were possible. In the hands of two such supreme technicians as Roberts and Haghe, the results were startling.

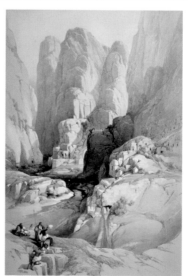

➤ **A view of Petra shows** the entrance to the ravine leading to the Al-Khazneh ("Khusme" in Roberts' title), meaning "The Treasury," a spectacular building carved into the cliff face. Roberts creates a heightened sense of awe with his scaling of huge looming rock and small figures, as well as extremes of light and shade.

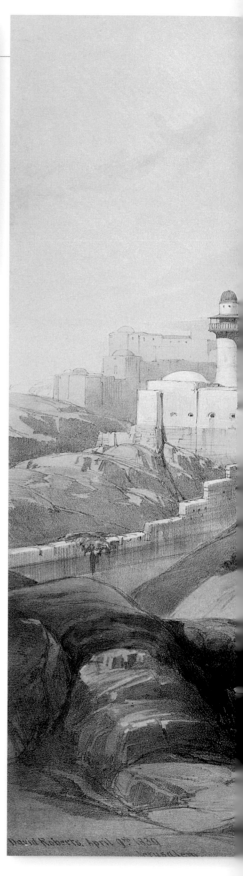

David Roberts, April 1ˢᵗ 1839

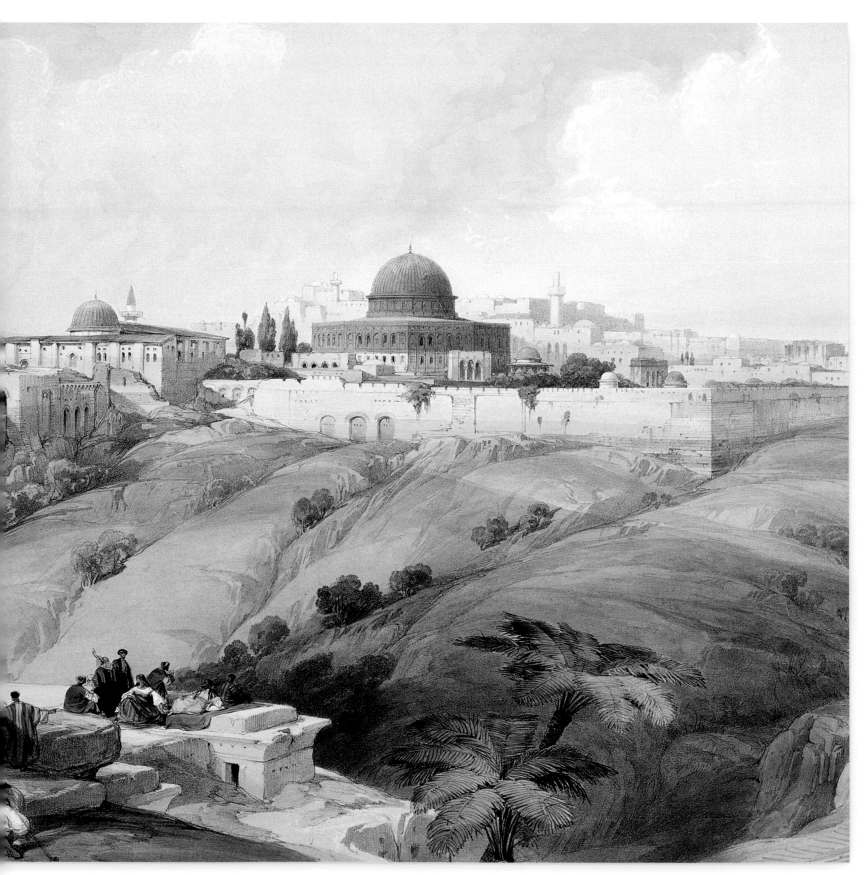

 ROMANTIC VISION Roberts' compositions drew on a European landscape tradition of Romanticism, in which aspects of the natural world were often enhanced and dramatized to convey emotion. This view of Jerusalem, with Arabs in the foreground and the city looming beyond, captured the British public's imagination and led to wealthy Victorians buying Roberts' works in great quantities. Any such major setpiece image took Haghe a month of painstaking labor to complete the lithograph.

They [the prints] are **faithful** and **laborious** beyond any outlines from nature I have **ever seen.**

JOHN RUSKIN, ON *THE HOLY LAND*

Photographs of British Algae: Cyanotype Impressions

1843–1853 ▪ PHOTOGRAMS ▪ 10 × 8 in (25.3 × 20 cm) ▪ 411 SHEETS ▪ UK

ANNA ATKINS

SCALE

Photography was just a few years old when botanist Anna Atkins created the first-ever book to be photographically illustrated and printed. *Photographs of British Algae: Cyanotype Impressions* was a collection of photographs, or rather photograms (shadow images), of seaweeds, and had no text to speak of, apart from the introductory pages and labels. The book was never published, but Atkins made a handful of copies, bound them by hand, and sent them out to friends in three volumes between 1843 and 1853.

Atkins's book was probably intended as a companion to William Harvey's *Manual of British Algae* (1841), which was not illustrated. Although it broke no new ground scientifically, her beautiful, blue-tinged images were an artistic triumph, which Atkins achieved using a cutting-edge photographic technique (see p.189).

It was just four years since Louis-Jacques-Mandé Daguerre (1787–1851) and William Fox Talbot (1800–1877) had independently reported the first two successful photographic processes: the daguerreotype and the calotype. Fox Talbot was a family friend, from whom Atkins learned about calotypes, as was Sir John Herschel (1792–1871), who invented the cyanotype process just a year before Atkins produced her first volume.

There is no proof that Atkins ever took a photograph with a camera. Creating the cyanotype pictures in her book required an intricate scientific process and yet through her careful arrangement of the algae on the page she was able to blend this science with artistic

ANNA **ATKINS**

1799–1871

Anna Atkins pioneered the use of photography in her books on botany, using cyanotypes to illustrate her specimens. She is best known for her book on algae, a work of science as well as beauty.

An early female member of the Botanical Society of London, Anna Atkins was an English amateur botanist and a pioneer of scientific photography. Her mother died soon after she was born and she was brought up by her botanist father, John Children. He was a Fellow of the prestigious Royal Society, who encouraged his daughter's botanical interests and introduced her to many of the leading scientists of the time.

In 1825 she married John Pelly Atkins, who would later become Sheriff of Kent, and went to live in Halstead Place, Kent. The Atkins had no children, allowing Anna to devote time to her interest in botany. On learning about the cyanotype process, she realized that it could be used to produce accurate and highly detailed botanical images. She created her photographic book of algae, specifically seaweed, between 1843 and 1853, and went on to produce similar photographic books of flowers and ferns with her friend Anne Dixon, as well as some unillustrated books on botany.

presentation. With the exposure of algae-covered, light-sensitive paper to sunlight, ghostly silhouettes of the algae appeared against a background of rich blue. The result was wholly original, and Atkins's book is considered one of the most significant landmarks in the art of photography.

▶ **PIONEERING WORK** The first volume of *Photographs of British Algae* came out in October 1843 and so earned its place as the first book to be illustrated photographically, beating Fox Talbot's famous *The Pencil of Nature* by a year. Copies of Atkins's book are rare—there are known to be 13, although not all of them are complete. The cyanotype process was used to create both the seaweed illustrations as well as the text pages, such as this contents page.

The **difficulty** of making **accurate** drawings of **objects** as **minute** as many of the **Algae** and **Confervae**, has induced me to **avail** myself of … Herschel's beautiful process of **Cyanotype.**

ANNA ATKINS, PREFACE TO *PHOTOGRAPHS OF BRITISH ALGAE*

▶ **ARTISTRY** Throughout the book, Atkins combined her detailed botanical knowledge with a rare artistic skill. One of the first images in the 1843 volume, beautifully presented on the page, is of the brown alga *Cystoseira granulata*.

▲ **TITLE PAGE** Inscribed carefully in elegant, handwritten script, the title page was photographed using the cyanotype process. The subtitle, *Cyanotype Impressions*, indicates the artistic approach of the book.

▲ **ARTISTIC INTEGRITY** In her introductory text, Atkins mentions why she chose to use the cyanotype process for her book and acknowledges her debt to Sir John Herschel for his invention.

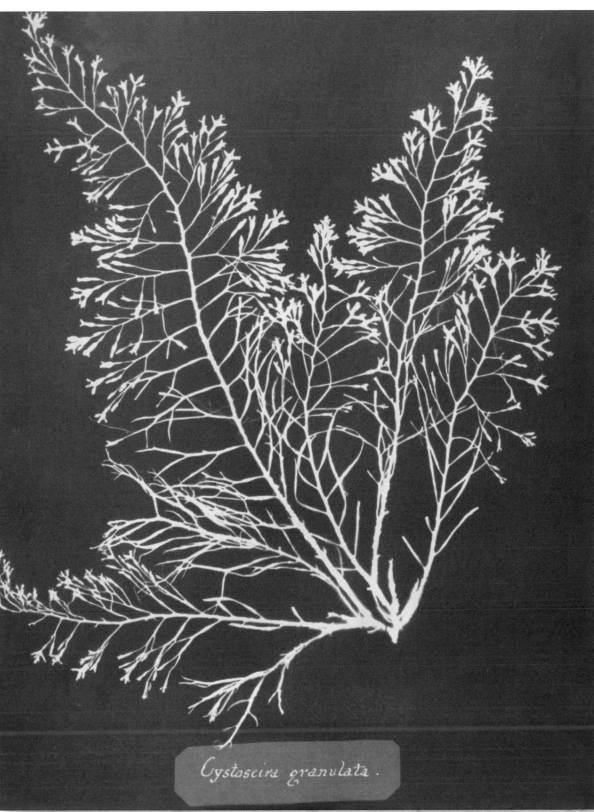

Cystoseira granulata.

In detail

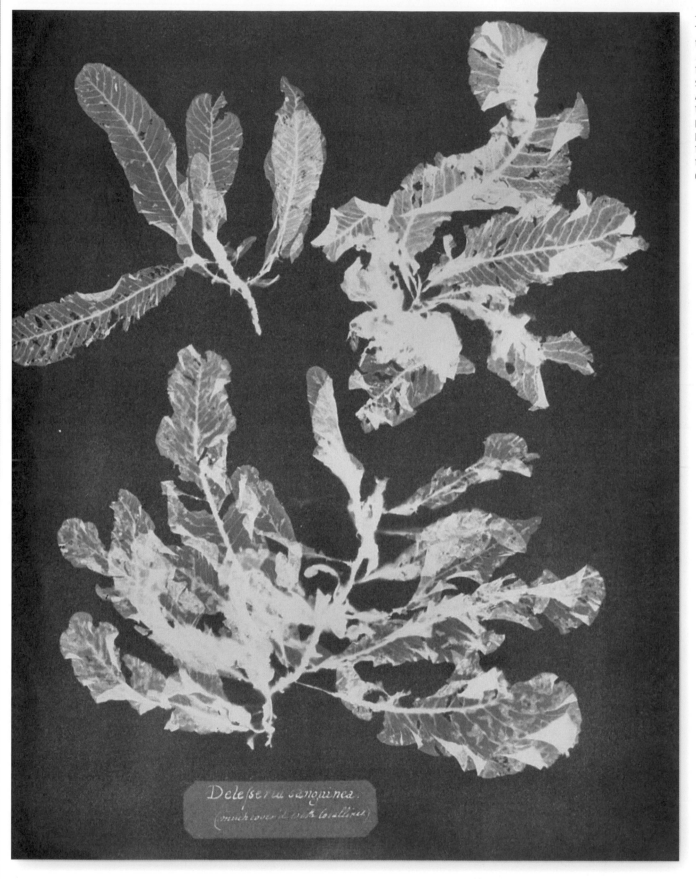

Delesseria sanguinea.
(much covered with Corallines)

◄ **CAPTURING DETAIL**
This cyanotype of the crimson seaweed *Delesseria sanguinea*, from the 1843 volume shows how quickly Atkins had mastered the new photographic process. Even modern photographers would find it a challenge to capture the subtle detailing so accurately.

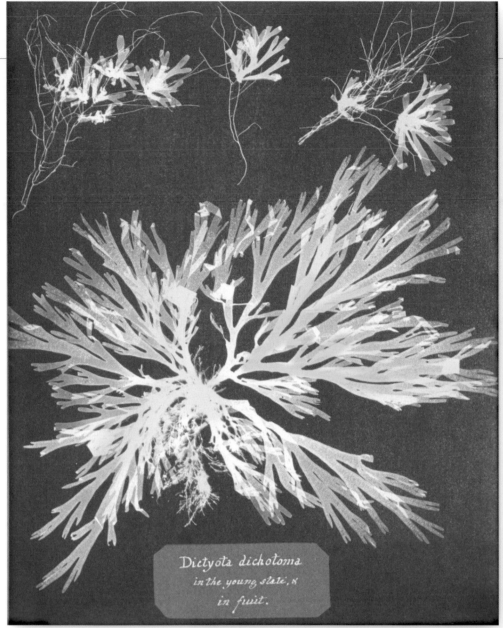

Dictyota dichotoma
in the young state, &
in fruit.

ON **TECHNIQUE**

The cyanotype is a photographic process invented by the English scientist Sir John Herschel, and it does not require a camera. Paper is coated with a mix of ammonium citrate and potassium ferricyanide. To create the image, the object is simply laid on the cyanotype paper and exposed to sunlight. Washing the paper in water reveals a white silhouette on a deep blue background. Cyanotypes are so durable that they came to be the standard process for making copies of technical and architectural plans for everything from ships to cathedrals. The word "blueprint" comes from the blue of cyanotype plans.

▲ **The cyanotype process** was used to create portraits, such as this image taken by Herschel in 1836, titled "The Right Honourable Mrs. Leicester Stanhope."

▲ **ARTISTIC APPROACH** This sample of the golden brown seaweed *Dictyota dichotoma* in its young state and in fruit, was probably made around 1861, eight years after Atkins's first cyanotype, and showcases her command of the photographic process.

➤ **UPDATES** As Atkins issued new volumes she would often include updates and new plates to replace earlier images for which she had found better specimens. The first version of *Ectocarpus brachiatus* (right), for instance, was later replaced with a much more impressive specimen (far right).

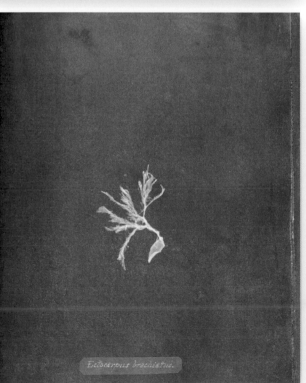

Ectocarpus brachiatus.

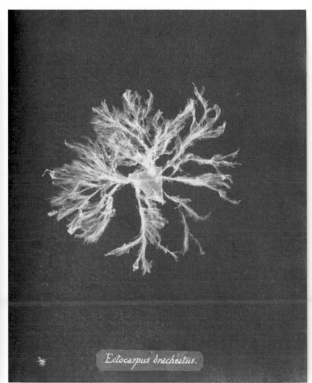

Ectocarpus brachiatus.

Uncle Tom's Cabin

1852 AND 1853 ▪ PRINTED ▪ 7 × 5 in (19.2 × 12 cm) ▪ 312 AND 322 PAGES ▪ USA

HARRIET BEECHER STOWE

SCALE

Carrying the subtitle, *Life Among the Lowly*, *Uncle Tom's Cabin* was originally serialized in 1851 by *The National Era* newspaper in Washington, D.C. The story caused a sensation and was published in book form a year later, featuring six engravings by Hammatt Billings. It sold 300,000 copies in the U.S. and one million in the UK in its first year, and a second edition followed in 1853 with 117 illustrations. In the nineteenth century, only the Bible sold in greater numbers.

Beecher Stowe was a passionate abolitionist, and the theme throughout *Uncle Tom's Cabin* is the immorality of slavery—an issue that became the great fault line of nineteenth-century America. While the industrial North opposed slavery, the agricultural South defended it fiercely, as its economy was dependent on more than four million slaves. This conflict of opinion, possibly inflamed by *Uncle Tom's Cabin*, resulted in the Civil War, starting in 1861. The eventual Northern victory in 1865 freed the slaves, but the war cost an estimated 620,000 lives and left the South in dire economic straits.

HARRIET **BEECHER STOWE**

1811-1896

American abolitionist and writer Harriet Beecher Stowe was an early champion of women's rights and campaigned against inequality her whole life.

Born in Connecticut, she was the daughter of a Calvinist preacher. After her own education she taught in a school set up by her sister, before they moved with their father to Cincinnati, Ohio, in 1832. She continued teaching and in 1836 married a clergyman and passionate abolitionist, Calvin Ellis Stowe. During her time in Cincinnati, Beecher Stowe was exposed to the harsh reality of slavery, which she fiercely opposed, and started writing what would become *Uncle Tom's Cabin*. Its huge success was not matched by any of her later work—she wrote 30 books, including novels and memoirs. Her husband died in 1886 when her own health then declined—her final years were clouded by dementia.

Uncle Tom's Cabin can be seen as maudlin, and is often cloyingly sentimental. It has also been attacked for being patronizing, and almost racist, by a number of modern scholars due to the condescending descriptions of some of the black characters. Yet its success in championing the plight of slaves in the U.S. and helping to bring an end to slavery cannot be questioned. *Uncle Tom's Cabin* is a product of a social conscience outraged that slavery could exist at all in a country that had been conceived in liberty.

In detail

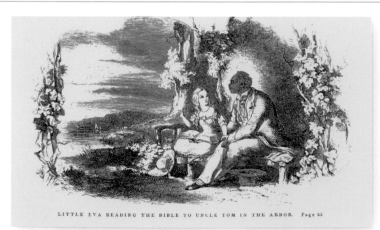

LITTLE EVA READING THE BIBLE TO UNCLE TOM IN THE ARBOR. Page 65

▲ **UNCLE TOM'S FAITH** Central to the book are the encounters between Eva, daughter of Tom's well-meaning second master, Augustine St. Clare, and Tom himself. Though Eva is still a child, her faith crucially reinforces Tom's Christian beliefs. Her subsequent lingering death, illuminated for her by a vision of heaven, presages what amounts to Tom's martyrdom at the end of the book.

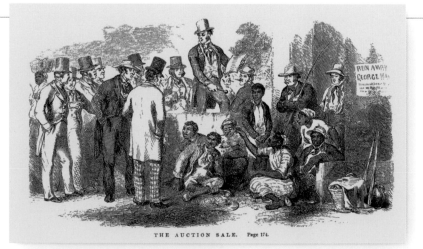

THE AUCTION SALE. Page 174.

▲ **SLAVE OWNERSHIP** Plantation owners in the South counted slaves as their legal property, much like their horses or other domestic animals. Not only did these human beings have no rights, but they could be bought and sold at will, often at auctions. Tom, for example, is sold twice—the first time privately to St. Clare after rescuing his daughter, then to Legree at auction, as shown here.

I did not write it. God wrote it. I merely did His dictation.

HARRIET BEECHER STOWE, ON DESCRIBING THE WRITING OF *UNCLE TOM'S CABIN*

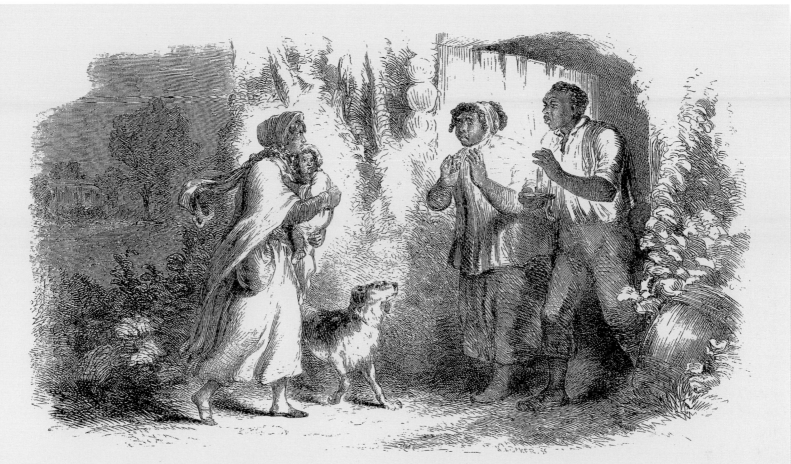

Eliza comes to tell Uncle Tom that he is sold, and that she is running away to save her child. Page 62.

▲ **FIRST IMAGE OF TOM** To encourage sales of the costly two-volume novel, its publisher, John P. Jewett, commissioned Hammatt Billings to produce six full-page illustrations. The first is shown here, and depicts Eliza, a slave, telling Tom that he is to be sold by his current owner, Arthur Shelby, to pay off his debts. Tom is bought by the cruel Simon Legree.

▲ **MARTYRDOM OF TOM** The antislavery movement was heavily influenced by the Christian Church, and it is Tom's devotion to the faith that ultimately leads to him being whipped to death by his owner, Legree. In this illustration, Tom is given water by fellow slave Cassey following the beating that later claims his life.

IN **CONTEXT**

The publication of *Uncle Tom's Cabin* unleashed a storm of criticism in the South. Beecher Stowe was attacked not only for never having visited a plantation, but also for fundamentally misunderstanding what many in the South saw as the "essentially benign nature of slavery": that blacks were like children, requiring the firm but kindly hand of whites to guide them. In 1853, Beecher Stowe published an impassioned defense of *Uncle Tom's Cabin* that documented the sources of her information for the original book.

▶ **Hailed in the North**, Beecher Stowe's *A Key to Uncle Tom's Cabin* was loathed in the South—hostility between the regions was unremitting.

A KEY

TO

UNCLE TOM'S CABIN;

PRESENTING THE ORIGINAL

FACTS AND DOCUMENTS

UPON WHICH THE STORY IS FOUNDED.

TOGETHER WITH

Corroborative Statements

VERIFYING

THE TRUTH OF THE WORK.

BY HARRIET BEECHER STOWE,

AUTHOR OF "UNCLE TOM'S CABIN."

BOSTON:
PUBLISHED BY JOHN P. JEWETT & CO.
CLEVELAND, OHIO:
JEWETT, PROCTOR & WORTHINGTON.
LONDON, LOW AND COMPANY.
1853.

Leaves of Grass

1855 (FIRST EDITION) ▪ PRINTED ▪ 11 × 8 in (29 × 20.5 cm) ▪ 95 PAGES ▪ USA

WALT WHITMAN

SCALE

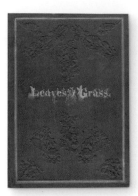

The first edition of Walt Whitman's *Leaves of Grass,* a book of 12 poems, contained only 95 pages, yet it had a huge influence on the development of American literature. In the standard bibliographical reference work *Printing and the Mind of Man* it was referred to as "America's second Declaration of Independence: that of 1776 was political; that of 1855 intellectual."

Age 36, Whitman, was unknown to the literary world when *Leaves of Grass* was published, and not even named as the book's author (although he did identify himself in one of the poems). But his collection revolutionized not just American literature but literature across the English-speaking world. Whitman pioneered a completely new poetic voice that was wild, rapturous, concrete, sensuous, harsh, and unmistakably modern. It deliberately avoided any sort of tone or subject matter that might conventionally be thought poetic. Though infused with an extraordinary lyricism, Whitman's poetic forms similarly disregarded rhythm, meter, and rhyme.

In part the book celebrated America and ordinary Americans, and in World War II the U.S. government gave each soldier a copy to remind them of the America that they were fighting for. More particularly though, the book

WALT **WHITMAN**

1819–1892

Walt Whitman was a poet, journalist, and essayist who became one of the most influential voices in American literature, although he was rarely regarded as more than a curiosity during his lifetime.

Whitman was born on Long Island, New York, and was one of eight children. His early life was impoverished and he undertook a variety of menial jobs, latterly as a printer and journalist. The publication of *Leaves of Grass,* financed by Whitman himself, represented a radical departure. Service as a medical orderly in the Civil War imbued in him a shocked revulsion of the horror of war. His life thereafter was devoted to an endless reworking of *Leaves of Grass.*

celebrated Whitman himself and his astonishingly intense response to, and identification with, every aspect of the world. The initial reaction to the book varied from the baffled to the outraged. Only a handful of critics, most notably Ralph Waldo Emerson (1803–1882), the pre-eminent American literary figure of the time, recognized that here was not just a new poetic vision but an indisputably great one.

Whitman devoted the rest of his life to expanding *Leaves of Grass,* adding poems—the book's final edition in 1881 contained 389—and endlessly revising those already written. Single-handed and unheralded, Whitman recast every expectation of what poetry might mean.

In detail

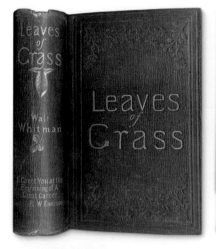

▲ **SECOND EDITION**

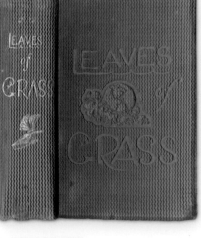

▲ **THIRD EDITION**

▲ **SIXTH EDITION**

◄ **CHANGING TIMES** There were six editions of *Leaves of Grass,* published in 1855, 1856, 1860–61, 1867, 1871–72, and 1881–82. The first two editions were bound in green to reflect the organic nature of Whitman's poetry. For the second edition Whitman designed the font used on the spine himself. The third edition, printed just before the American Civil War, is bound in red to represent looming bloodshed. The sixth edition, with its yellow cover, is suggestive of fall, and reflects Whitman's belief that his life was drawing to an end.

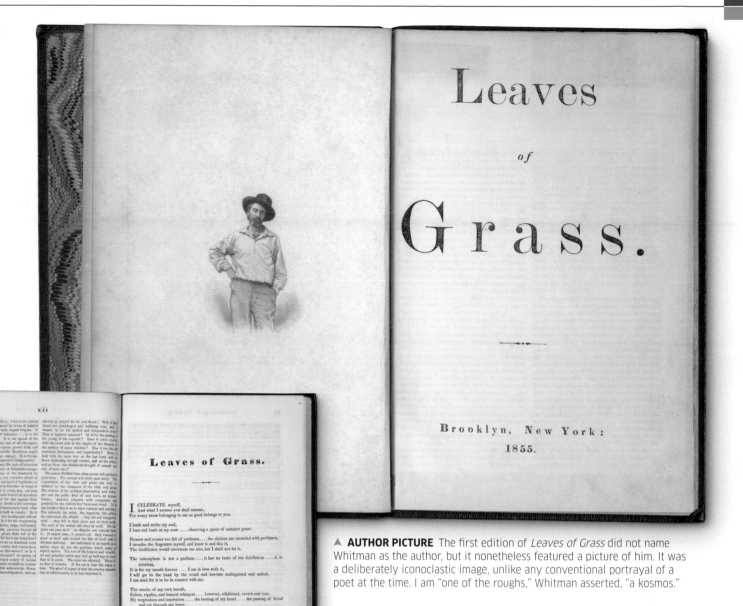

AUTHOR PICTURE The first edition of *Leaves of Grass* did not name Whitman as the author, but it nonetheless featured a picture of him. It was a deliberately iconoclastic image, unlike any conventional portrayal of a poet at the time. I am "one of the roughs," Whitman asserted, "a kosmos."

SELF-ASSERTION In the first line of poetry from the 1855 edition of *Leaves of Grass* Whitman asserted, "I celebrate myself." It was not a boast but a poetic attempt to identify himself with all the peoples of America, whom he invites to identify themselves with him, in turn - not simply as citizens of a new nation but as members of humanity.

INVOLVEMENT With his background in printing, and his keen eye for detail, Whitman was always involved in the design and production of his books. He considered this project to be "The Great Construction of the New Bible", which is reflected in this contents page from the 1860 edition, where the poems are numbered and grouped, resembling divisions in the Bible.

NEW IMAGE For the frontispiece of the 1860 edition, Whitman dropped his American Everyman image (as above) and appeared in Byronic collar and cravat. The poet added a tail to the full-stop after the word "grass" in the title, which makes it look similar to a sperm—reflecting the book's themes of procreation and growth.

On the Origin of Species

1859 ■ PRINTED ■ DIMENSIONS UNKNOWN ■ 502 PAGES ■ UK

CHARLES DARWIN

The publication of Charles Darwin's *On the Origin of Species* sent shock waves through pious Victorian society. His views on the theory of evolution were highly controversial and contradicted what many believed at the time–that all life on Earth had been created intact and was unchanging. In his book, Darwin questioned this widely held belief and suggested that evolution had occurred by a process called "natural selection"–a direct challenge to the Christian view of the divinely created world. As a Christian himself Darwin struggled with this idea, and in old age would come to describe himself as agnostic.

Darwin had first pursued a career in medicine, then in the Church, but in late 1831, he joined an expedition on the HMS *Beagle* as an unpaid geologist. The five years he spent on the ship led him to conclude that species were not fixed, as was popularly thought, but evolved over time through natural selection. Darwin labored for over 20 years formulating these ideas, and delayed publishing his theory as he "kept amassing information he could use to present a lengthy and well-reasoned argument." But in 1858, he was forced to publish an abstract of his work about evolution after receiving word that the anthropologist Alfred Russel Wallace had arrived at the same conclusion independently.

Darwin's book *On the Origin of Species by Means of Natural Selection, or the Preservation of Favoured Races in the Struggle for Life* was published in 1859–the first run of 1,250 copies sold out immediately. A further 3,000 copies were printed, with additions and corrections, for January 1860. Six more editions came out in Darwin's lifetime.

While the concept of evolution in the animal kingdom gained in popularity, the idea that humans had also evolved was opposed by Christians (the book was hugely influential in the separation of the Church and science.) During a debate in 1860, Darwin was as furiously denounced by the Bishop of Oxford, as he was passionately defended by biologist T. E. Huxley. Also present was *Beagle* captain, Robert Fitzroy, clutching a bible and appalled at his companion's betrayal.

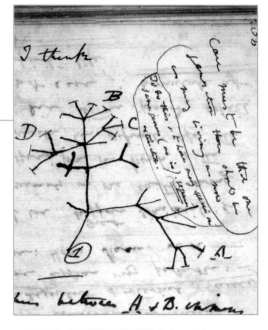

▲ **NOTEBOOK B** Darwin recorded his observations in a series of notebooks, labeled A to N. This is page 36 from book B and dates from July 1837.

▲ **THE "EVOLUTIONARY TREE"** Darwin's notebooks contain sketches and diagrams, such as this version of his evolutionary tree, which describes his theory about the relationship between species in the same family, or genus.

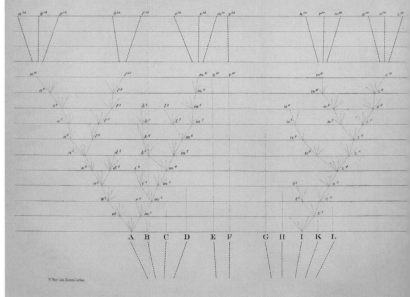

▲ **THE TREE OF LIFE** The only illustration in the first edition of *On the Origin of Species* was this fold-out lithograph by William West based on Darwin's earlier diagram (left). The species in it are labeled A to L along the base (and spaced irregularly to show how distinct they are from each other). The Roman numerals (I–XIV) represent thousands of generations.

ON

THE ORIGIN OF SPECIES

BY MEANS OF NATURAL SELECTION,

OR THE

PRESERVATION OF FAVOURED RACES IN THE STRUGGLE
FOR LIFE.

By CHARLES DARWIN, M.A.,

FELLOW OF THE ROYAL, GEOLOGICAL, LINNÆAN, ETC., SOCIETIES;
AUTHOR OF 'JOURNAL OF RESEARCHES DURING H. M. S. BEAGLE'S VOYAGE
ROUND THE WORLD.'

LONDON:
JOHN MURRAY, ALBEMARLE STREET.
1859.

The right of Translation is reserved.

" But with regard to the material world, we can at least go so far as this—we can perceive that events are brought about not by insulated interpositions of Divine power, exerted in each particular case, but by the establishment of general laws."

W. WHEWELL: *Bridgewater Treatise.*

" To conclude, therefore, let no man out of a weak conceit of sobriety, or an ill-applied moderation, think or maintain, that a man can search too far or be too well studied in the book of God's word, or in the book of God's works; divinity or philosophy; but rather let men endeavour an endless progress or proficience in both."

BACON: *Advancement of Learning.*

Down, Bromley, Kent,
October 1st, 1859.

▲ **FIRST EDITION** Determined to publish ahead of Russel Wallace, Darwin completed his 155,000-word draft in April 1859 and was reading the printer's proofs by October. There was no time to commission engravings, which would also have made the book more expensive than the original price of 15 shillings, so the design is simple. On this left-hand page, from the first edition, there are quotes from the writings of philosophers William Whewell and Francis Bacon.

One general law, leading to the advancement of all organic beings, namely, multiply, vary, let the strongest live and the weakest die.

CHARLES DARWIN, *ON THE ORIGIN OF SPECIES*

IN **CONTEXT**

In 1831 Darwin joined the crew of the HMS *Beagle* as a "gentleman naturalist" and set out on a voyage across the Atlantic. The ship explored the entire coastline of South America, then completed its circumnavigation via Tahiti, Australia, Mauritius, and the Cape of Good Hope. During the voyage Darwin kept a diary, filling up its 770 pages with detailed observations and notes. He meticulously collected fossils and other geological specimens, and drew up catalogs of bones, skins, and carcasses. HMS *Beagle* returned to England five years later in October 1836, and Darwin began formulating his ideas.

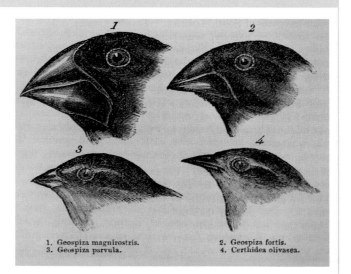

1. Geospiza magnirostris. 2. Geospiza fortis.
3. Geospiza parvula. 4. Certhidea olivasea.

▲ **In September 1835**, HMS *Beagle* visited the Galápagos Islands in the Pacific. Here, Darwin discovered 13 different species of finches, all with different types of beak, which he realized had evolved independently to deal with the food available to the birds.

Alice's Adventures in Wonderland

1865 ▪ PRINTED ▪ 7 × 5 in (18.1 × 12.1 cm) ▪ 192 PAGES ▪ UK

LEWIS CARROLL

SCALE

Lewis Carroll's *Alice's Adventures in Wonderland* is one of the best-loved children's books ever created, and considered a cornerstone of the literary nonsense genre. In the first edition the fanciful story was perfectly matched by the exquisite pen and ink drawings of British illustrator John Tenniel. Countless illustrators have since tried their hands at portraying the Alice story, but none has yet come close to capturing the public's imagination or affection like the illustrations of the first edition.

Carroll originally made up his story about young Alice who falls down a rabbit hole in the summer of 1862. He had befriended the daughters of the Dean of his Oxford College, and captivated the girls with his story while out with them on a boat trip. Alice Liddell was so enchanted that she begged Carroll to put the story down on paper. It took him over a year to write out the tale in his tiny, neat hand, and to illustrate it with 37 of his own sketches. Alice finally received the 90-page book in November 1864, dedicated to "a dear child, in memory of a summer day". This single, handwritten, personally illustrated manuscript, entitled "Alice's Adventures Under Ground," is now one of the British Library's greatest treasures. Friends who saw the manuscript urged him to publish it, and Carroll agreed,

LEWIS **CARROLL**

1832–1898

Lewis Carroll was the pen-name for British mathematician and writer Charles Lutwidge Dodgson, best-known for his *Alice* books.

The eldest of 11 children, Carroll was born in Cheshire but spent his teenage years in North Yorkshire—he often entertained his siblings by making up games and stories. He was a brilliant mathematician and became a lecturer in mathematics at Christ Church, Oxford, where he also wrote the children's books that made him famous: *Alice's Adventures in Wonderland* and its sequel *Through the Looking-Glass*, both of which display his love of wordplay and logic puzzles. Carroll was ordained as a church deacon in 1861 but he never became a priest. He was also an accomplished photographer. The huge popularity of the *Alice* books brought Carroll fame and wealth, although his later writings were less successful. He died of pneumonia in 1898.

extending the story, adding jokes, and retitling it *Alice's Adventures in Wonderland*. He chose John Tenniel, a cartoonist for the magazine *Punch*, to illustrate it.

Tenniel was given precise instructions by Carroll and the author's own sketches to start from, but while the illustrations he created expertly capture Carroll's fantastic tale, they were uniquely his own. Since its initial publication in 1865, *Alice's Adventures in Wonderland* has never been out of print and the perennial children's book remains popular to this day.

◀ **A LABOR OF LOVE** If it had not been for the persuasion of friends, Carroll's manuscript would have remained simply a private memento of a summer day with Alice and her sisters. Alice Liddell might have been the inspiration for Carroll's Alice, but with her short, dark, straight hair (see p.199), she was clearly not the model.

▶ **A COMPLETE VISION** Lewis Carroll's original manuscript is remarkable for how fully the story and images were realized. This page depicts the scene in which Alice plays the Queen at croquet, using hedgehogs as balls and a puzzled ostrich as a mallet. In the final published edition, Tenniel swaps the ostrich for a flamingo in his illustration, heightening the absurdity.

> Why, sometimes I've believed as many as six impossible things before breakfast.

THE QUEEN, *ALICE'S ADVENTURES IN WONDERLAND*

36

20 37.

than she expected : before she had drunk half the bottle, she found her head pressing against the ceiling, and she stooped to save her neck from being broken, and hastily put down the bottle, saying to herself "that's quite enough— I hope I sha'n't grow any more— I wish I hadn't drunk so much!"

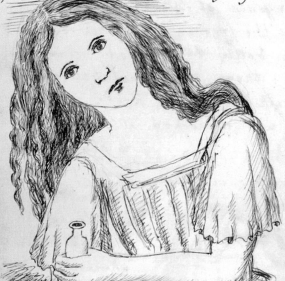

Alas ! it was too late : she went on growing and growing, and very soon had to kneel down : in another minute there was not room even for this, and she tried the effect of lying down, with one elbow against the door, and the other arm curled round her head. Still she went on growing, and as a last resource she put one arm out of the window, and one foot up the chimney, and said to herself "now I can do no more — what will become of me?"

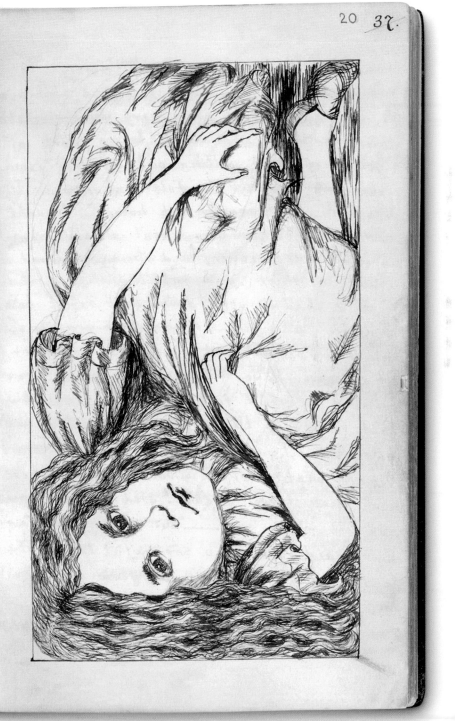

▲ **INTERWOVEN NARRATIVE** Carroll's creative way of combining pictures and text can be seen to great effect in his "handmade copy". Here, the illustration on the left shows the growing Alice, her form appearing to push against the text after drinking a magic potion. On the right she fills the whole page, her large head squeezed into the bottom corner, with her relatively small feet extending to the top.

In detail

THE RED COVER
Conscious of his young readers, Carroll wanted his book to have a bright red cover rather than the green that his publishers, Macmillan, usually used. "Not the best, perhaps, artistically" he wrote to Macmillan, "but the most attractive to childish eyes."

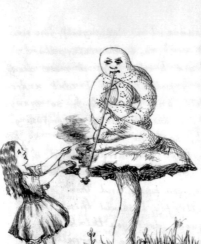

26 **49.**

and her eyes immediately met those of a large blue caterpillar, which was sitting with its arms folded, quietly smoking a long hookah, and taking not the least notice of her or of anything else.

For some time they looked at each other in silence: at last the caterpillar took the hookah out of its mouth, and languidly addressed her.

"Who are you?" said the caterpillar.

This was not an encouraging opening for a conversation: Alice replied rather shyly, "I— I hardly know, sir, just at present— at least I know who I was when I got up this morning, but I think I must have been changed several times since that."

"What do you mean by that?" said the caterpillar, "explain yourself!"

"I can't explain myself, I'm afraid, sir,"

ORIGINAL CHARACTERS A popular character in the book is the caterpillar, which appears smoking a pipe on a mushroom. Carroll drew his own version of the caterpillar in his manuscript—a kind of optical illusion in which the folded length of the caterpillar forms the body of a seated mystic. In keeping with his strange appearance, the caterpillar's speech is obscure and he repeatedly asks Alice the existential question, "Who are you?" in a sleepy, languid tone.

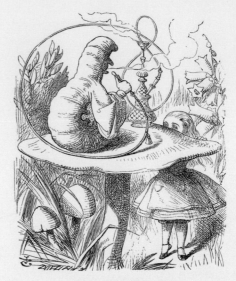

CHAPTER V.

ADVICE FROM A CATERPILLAR.

THE Caterpillar and Alice looked at each other for some time in silence: at last the Caterpillar took the hookah out of its mouth, and addressed her in a languid, sleepy voice.

"Who are *you*?" said the Caterpillar.

TENNIEL'S INTERPRETATION Tenniel drew his own version of Carroll's caterpillar, but an ambiguous one that toyed with visual interpretations: its head could be read as a man's face in profile, with protruding human nose and chin, or as the anatomically correct body of a caterpillar. The elongated, looping hose of the pipe adds to the overall sense of mystery. For many of the illustrations Tenniel received explicit instructions from Carroll, but his style, with its precise classical lines, is instantly recognizable.

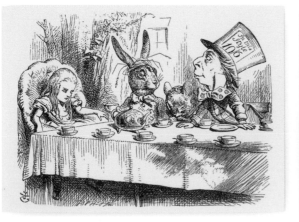

HATTER'S TEA PARTY As he prepared his manuscript for publication, Carroll elaborated on his story considerably, adding scenes such as "The Caucus Race," "Pig and Pepper," and, most famous of all, "A Mad Tea-Party" in which the Hatter and the March Hare bombard Alice with riddles.

150 WHO STOLE

on the trumpet, and then unrolled the parchment scroll, and read as follows:—

"*The Queen of Hearts, she made some tarts,
All on a summer day:
The Knave of Hearts, he stole those tarts,
And took them quite away!*"

"Consider your verdict," the King said to the jury.

"Not yet, not yet!" the Rabbit hastily interrupted. "There's a great deal to come before that!"

"Call the first witness," said the King; and the White Rabbit blew three blasts on the trumpet, and called out "First witness!"

The first witness was the Hatter. He came in with a teacup in one hand and a piece of bread-and-butter in the other. "I beg pardon, your Majesty," he began, "for bringing these in: but I hadn't quite finished my tea when I was sent for."

"You ought to have finished," said the King. "When did you begin?"

The Hatter looked at the March Hare, who had followed him into the court, arm-in-arm

THE TARTS? 151

make out at all what had become of it; so, after hunting all about for it, he was obliged to write with one finger for the rest of the day; and this was of very little use, as it left no mark on the slate.

"Herald, read the accusation!" said the King.

On this the White Rabbit blew three blasts

LINE ENGRAVINGS Tenniel traced his original ink drawings onto woodblocks using a hard pencil. The woodblocks were then engraved by the Brothers Dalziel and used to make the metal electrotypes, which captured the detail of Tenniel's illustrations—as seen here in this drawing of the anthromorphic White Rabbit.

▼ **TALE OF A TAIL** Carroll's wit shone through even in the book's inventive use of typography. The mouse's tale is a multiple pun. Besides being a tale about a tail, it is also typeset in the shape of a tail, and is a "tail rhyme"—a poem in which rhymed lines are followed by a shorter, unrhyming "tail" line.

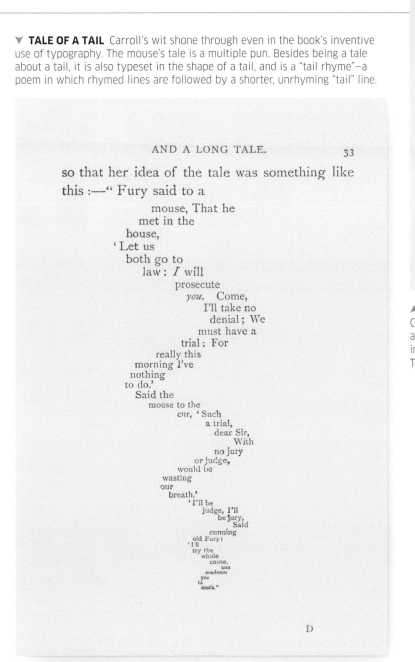

AND A LONG TALE. 33

so that her idea of the tale was something like

this :—" Fury said to a

mouse, That he
met in the
house,
' Let us
both go to
law : *I* will
prosecute
you. Come,
I'll take no
denial ; We
must have a
trial : For
really this
morning I've
nothing
to do.'
Said the
mouse to the
cur, ' Such
a trial,
dear Sir,
With
no jury
or judge,
would be
wasting
our
breath.'
' I'll be
judge, I'll
be jury,'
Said
cunning
old Fury:
' I'll
try the
whole
cause,
and
condemn
you
to
death.' "

D

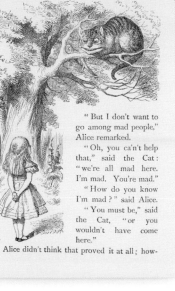

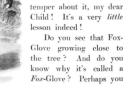

"But I don't want to go among mad people," Alice remarked.

"Oh, you can't help that," said the Cat : "we're all mad here. I'm mad. You're mad."

"How do you know I'm mad ?" said Alice.

"You must be," said the Cat, "or you wouldn't have come here."

Alice didn't think that proved it at all; how-

▲ **EXTRA CHARACTERS** The Cheshire Cat, with its wide, mischievous grin, was added by Carroll when he expanded his initial story for its first publication with Tenniel's black-and-white illustrations.

And that reminds me. There's a little lesson I want to teach *you*, while we're looking at this picture of Alice and the Cat. Now don't be in a bad temper about it, my dear Child ! It's a very *little* lesson indeed !

Do you see that Fox-Glove growing close to the tree ? And do you know why it's called a *Fox*-Glove ? Perhaps you

▲ **CHILDREN'S EDITION** In 1890 Lewis Carroll wrote a shortened version: *The Nursery "Alice,"* aimed at younger readers. It was, in Carroll's words, a book "to be cooed over, to be dogs'-eared." The publication was the first in which Alice appeared in color.

> "How do you know I'm mad ?" said Alice.—"You must be" said the cat "or you wouldn't have come here."

ALICE AND THE CHESHIRE CAT, *ALICE'S ADVENTURES IN WONDERLAND*

IN **CONTEXT**

Experts have long debated the relationship between the Alice of Carroll's book and Alice Liddell. Alice Liddell was born on May 4, 1852, and was just 10 years old when Carroll took her and her sisters, Lorina and Edith, on the memorable boating trip on which he first invented his story. Carroll was fond of his young friend, taking several photographs of her, including a famous one of her dressed as a beggar girl. Carroll was naturally shy and awkward with a pronounced stutter, and he openly preferred the company of children. Sometime during 1863, Alice's mother stopped Carroll from seeing Alice and her sisters, following an argument that has since been the cause of much speculation. However, Alice's links with the book remained. Carroll dedicated both his *Alice* books to her, and in *Through the Looking Glass* he included a poem, "A Boat Beneath A Sunny Sky," in which the first letter of each line combine to spell out her name in full. From the day *Alice's Adventures in Wonderland* was published in 1865 until she died in 1934 at age 82, Alice Liddell was known as "the real Alice." She kept her manuscript of "Alice's Adventures Under Ground" until she was forced to sell it in 1928 for money to pay death duties.

➤ **The dark, short-haired**, sharp-looking Alice Liddell appeared very different to the fair, long-haired Alice of Tenniel's illustrations.

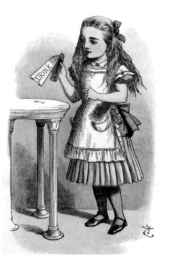

Das Kapital

1867, 1885, AND 1894 ▪ PRINTED ▪ DIMENSIONS UNKNOWN ▪ 2,846 PAGES (IN 3 VOLUMES) ▪ GERMANY

KARL MARX

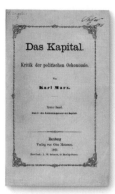

Vast, sprawling, and dense, Karl Marx's theoretical economic and political text *Das Kapital* provided the intellectual foundation of communism. Part history, part philosophy, but with economics at its core, it formed a blueprint of what Marx considered the destiny of humanity. Marx argued that capitalism, the economic system powering a newly industrialized world, was merely a phase in a continuing historical evolution, and therefore would inevitably be superseded.

The text's primary focus was the exploitation of the working classes (proletariat). Marx believed that as the proletariat became increasingly class conscious it would rise up, sweeping away its capitalist oppressors. Marx asserted that in this way, capitalism contained the seeds of its own downfall, and that a rational economic system, centrally planned in the interests of all, would develop in its place. Privilege and subjugation would play no part in this new system, its dominant creed being, "From each according to his ability, to each according to his needs"–a socialist utopia. This message struck a chord at a time of immense social and industrial change (*see opposite*), and *Das Kapital* came to be known as "the Bible of the working classes."

KARL **MARX**
1818–1883

Born to German Jewish parents, Karl Marx was an atheist with a passion for philosophy. Marxism was named after the economic and political theory he originated with Engels.

Marx was a product of the political chaos that engulfed much of Europe after 1830. While at Berlin University for five years studying law and philosophy, he was introduced to the philosophy of the late Georg Hegel, who contended that humanity was destined to suffer from violent change. Marx used his talents as a journalist to criticize the political and cultural establishments of the time, but his writings caused him to be expelled by the French, German, and Belgian governments. In 1848, he co-wrote *The Communist Manifesto* with Friedrich Engels. In 1849, he moved to London, where he stayed for the rest of his life.

The book was published in three volumes. The first, written by Marx alone and published in 1867, was the only one of the three manuscripts to be completed while Marx was still alive. His lifelong friend and editor, Friedrich Engels (1820–1895), compiled the remainder from Marx's notes and his own research. The second and third volumes were published in 1885 and 1894 respectively.

Marx's influence was far-reaching. The Russian Revolution (1917) and Chinese Revolution (1949) both claimed Marxism as their justification. By the mid-twentieth century, half the world lived in self-proclaimed Marxist states.

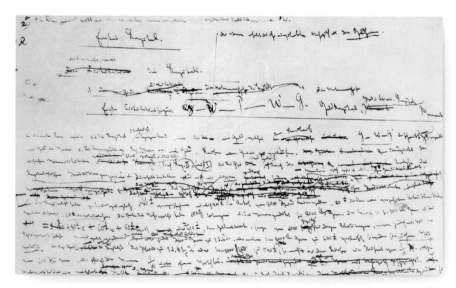

▲ **ORIGINAL NOTES** Marx made vast amounts of notes and amendments when preparing his book. By 1865, he had an indecipherable manuscript of around 1,200 pages. It took a year of editing to reach a final, clean copy that was ready to be published.

▶ **FIRST VOLUME**
The first volume of *Das Kapital* highlights the inherent unfairness that Marx saw in the capitalist mode of production or *Der Produktionsprozess des Kapitals*, as stated in the title here.

Erstes Buch.

Der Produktionsprozess des Kapitals.

Erstes Kapitel.
Waare und Geld.

1) Die Waare.

Der Reichthum der Gesellschaften, in welchen kapitalistische Produktionsweise herrscht, erscheint als eine „ungeheure Waarensammlung"[1]), die einzelne Waare als seine Elementarform. Unsere Untersuchung beginnt daher mit der Analyse der Waare.

Die Waare ist zunächst ein äusserer Gegenstand, ein Ding, das durch seine Eigenschaften menschliche Bedürfnisse irgend einer Art befriedigt. Die Natur dieser Bedürfnisse, ob sie z. B. dem Magen oder der Phantasie entspringen, ändert nichts an der Sache[2]). Es handelt sich hier auch nicht darum, wie die Sache das menschliche Bedürfniss befriedigt, ob unmittelbar als Lebensmittel, d. h. als Gegenstand des Genusses, oder auf einem Umweg, als Produktionsmittel.

Jedes nützliche Ding, wie Eisen, Papier u. s. w., ist unter doppeltem

[1]) Karl Marx: „Zur Kritik der Politischen Oekonomie. Berlin 1859", p. 4.

[2]) „Desire implies want; it is the appetite of the mind, and as natural as hunger to the body the greatest number (of things) have their value from supplying the wants of the mind." Nicholas Barbon: „A Discourse on coining the new money lighter, in answer to Mr. Locke's Considerations etc. London 1696", p. 2, 3.

1. 1

Das Kapital.

Kritik der politischen Oekonomie.

Von

Karl Marx.

Erster Band.

Buch I: Der Produktionsprocess des Kapitals.

Das Recht der Uebersetzung wird vorbehalten.

Hamburg
Verlag von Otto Meissner.
1867.

New-York: L. W. Schmidt, 24 Barclay-Street.

▲ **TITLE PAGE** As recorded on this page, *Das Kapital* was published in Hamburg, Germany, by publisher Otto Meissner, who had previously published Engels' work. Marx delivered the manuscript in 1866, and a small run of 1,000 copies was printed the following year.

> Money is the alienated essence of man's labor and life; and this alien essence dominates him as he worships it. "

KARL MARX, *DAS KAPITAL*

IN **CONTEXT**

It was in the Reading Room of the then British Museum that Marx wrote the first volume of *Das Kapital*, at a time of huge social change. The Industrial Revolution had resulted in workers living in grinding poverty while their masters amassed great wealth. Marx believed it was inevitable that the workers would eventually overthrow their masters, whom he termed the "bourgeoisie." Many of Marx's revolutionary ideas had been published before *Das Kapital*, for example in his *The Communist Manifesto* (1848) (see p.212), which had little impact when published. However, Marx's works became a call to arms for revolutionaries in the twentieth century, and within a hundred years of Marx's death, some of the world's most brutal dictators—including Stalin and Mao—ruled their populations in the name of Marxism.

▶ **This cover** is from the Russian edition of *Das Kapital* (1872). The censors considered it irrelevant, believing no capitalist exploitation occurred in Tsarist Russia.

The Works of Geoffrey Chaucer Now Newly Imprinted

1896 ▪ PRINTED BY KELMSCOTT PRESS ▪ 17 × 12 in (43.5 × 30.5 cm) ▪ 564 PAGES ▪ UK

SCALE

GEOFFREY CHAUCER

This exquisite edition of Geoffrey Chaucer's works is one of the most glorious examples of late Victorian printing, and the crowning achievement of the Kelmscott Press, which was founded by nineteenth-century designer William Morris. Known as the Kelmscott Chaucer and designed by Morris himself, it was a masterpiece of artistry, and exceptional for its lavish ornamentation and the quantity of its illustrations. The book features 87 woodcut illustrations, 14 different richly decorated borders, 18 individual frames, and 26 large ornamental initials. Edward Burne-Jones (1833–1898), the British artist and lifelong friend of Morris, designed the woodcuts and worked closely with Morris throughout the project. Morris's own Troy typeface was used for the titles, while the main text was set in a smaller version of that type and printed in black and red. The book was printed on Batchelor handmade paper with a watermark also designed by Morris.

Morris, a former designer of luxurious fabrics and furniture, believed the quality of book printing had deteriorated with machine printing during the Industrial Age, and wanted to revive old crafts. The labor-intensive hand-printing method that Morris favored resulted in the book taking four years to complete and being hugely expensive to produce. Morris printed (and presold) just 425 copies of the book, as the production costs made it uneconomical to print any more.

The harmonious partnership of Morris and Burne-Jones meant that the level of illustration and decoration that lavished every single page set a new standard for book design: the Kelmscott Chaucer is still considered one of the most beautiful books ever published.

GEOFFREY **CHAUCER**

1343–1400

The great poet Geoffrey Chaucer is considered to be the first writer to celebrate the Middle English vernacular and has become known as the father of English literature.

It is thought that Chaucer was born in London, although the precise date and location of his birth is not known. His father was a vintner (wine merchant) based in London, who came from a line of merchants. Chaucer studied law at the Inner Temple, and then through his father's connections became a page to Elizabeth de Burgh, the Countess of Ulster. This was a kind of apprenticeship, and it brought the young Chaucer into the circle of the court, and was the beginning of his successful career as a bureaucrat, courtier, and diplomat. Chaucer's best-known work is *The Canterbury Tales*, which he started writing around the 1380s, after moving to Kent. The collection of 24 stories paint a twisted picture of English society at the time. The book stands apart from the literature of the day, partly for its language—vernacular English, rather than French and Latin, which were commonly used for the written word—but also for the wide variety of the tales it contains and the naturalism of its narrative and characters. His other works include the epic poem *Troilus and Criseyde*, *Parlement of Foules*, *Treatise on the Astrolabe*, as well as some translations.

▼ **DECORATIVE INITIALS** Several different versions of capital letters were designed to provide variety and interest throughout the text. Each elaborately decorated initial, printed using stiff, black German ink, took up several lines of ordinary text.

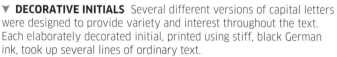

> If we live to finish it, it will be like a pocket cathedral—so full of design and I think Morris the greatest master of ornament in the world.

EDWARD BURNE-JONES, IN A LETTER TO CHARLES ELIOT NORTON, 1894

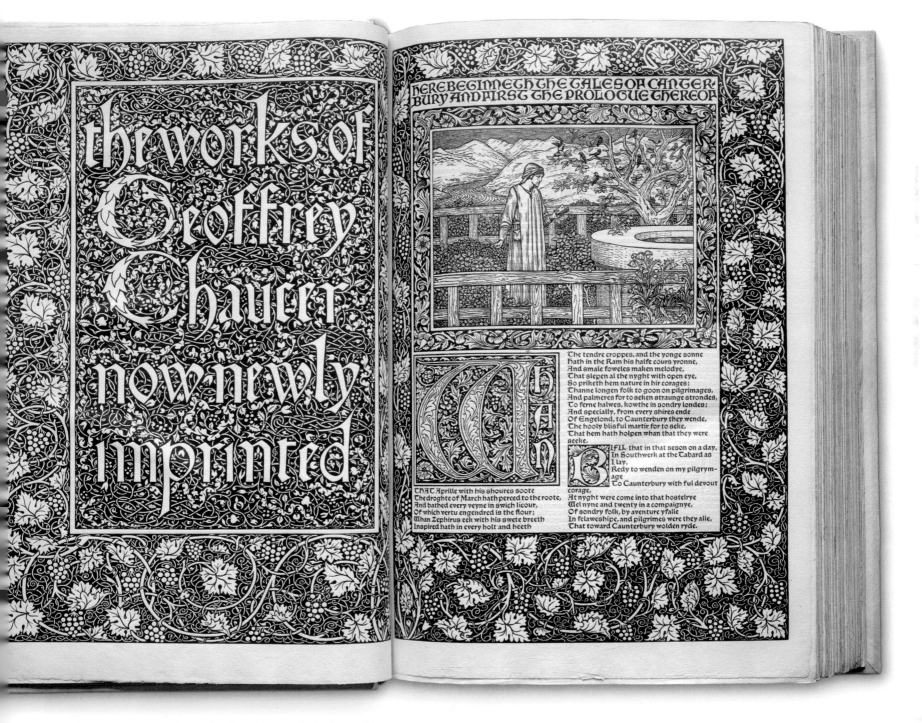

▲ **TITLE PAGE** With its elaborate borders, this spread reflects Morris's desire to revive the quality and elegance of fifteenth-century hand-printing. The Kelmscott Chaucer was printed on Bachelor handmade paper with a perch-shaped watermark, which Morris designed himself. He used rag (cotton) paper and refused to add wood pulp to his paper as it turned pages slightly brown; rag paper retained its brightness for longer.

In detail

▼ **TREATISE ON THE ASTROLABE** Leading on from the last page of *The Book of the Duchess* (left), which was Chaucer's first major poem, is his *Treatise on the Astrolabe*. This treatise is a significant example of early technical writing. The first page (right) has a richly decorated margin enclosing the text and illustration, which shows a man holding an astrolabe, next to a boy who clutches his robe while looking up at the sky. This reflects Chaucer's text, which is addressed to his son, "Lowis."

▶ **FLORAL MOTIF** Morris did not draw his flowers from real life, but copied them from photographs and pictures in books. Many English flora were included in the ornamentation.

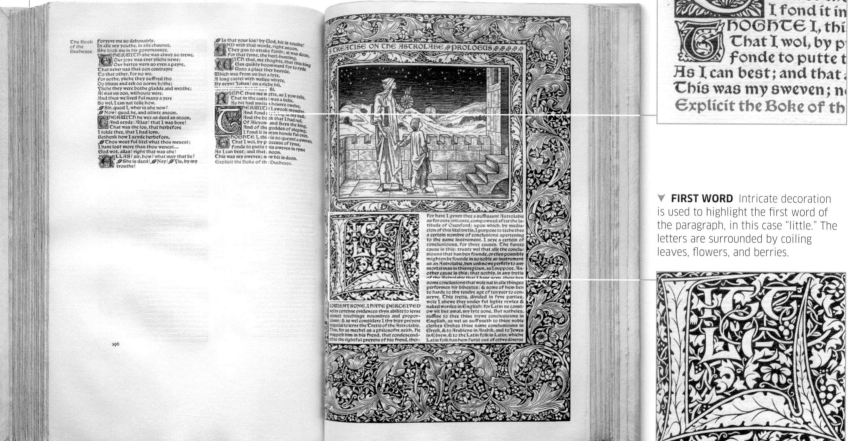

▼ **FIRST WORD** Intricate decoration is used to highlight the first word of the paragraph, in this case "little." The letters are surrounded by coiling leaves, flowers, and berries.

▲ **RUNNING HEAD** Aligned with the top of the column text on each page in the margin is a running head printed in red ink. It simply repeats the title of the text to help orient the reader through the volume.

▶ **TYPOGRAPHY** Morris designed the typeface himself to suit the character of Chaucer's text. The text is set in double columns, printed largely in black ink interspersed with shorter paragraphs of red. The decorative capitals at the beginning of the paragraphs are six lines deep.

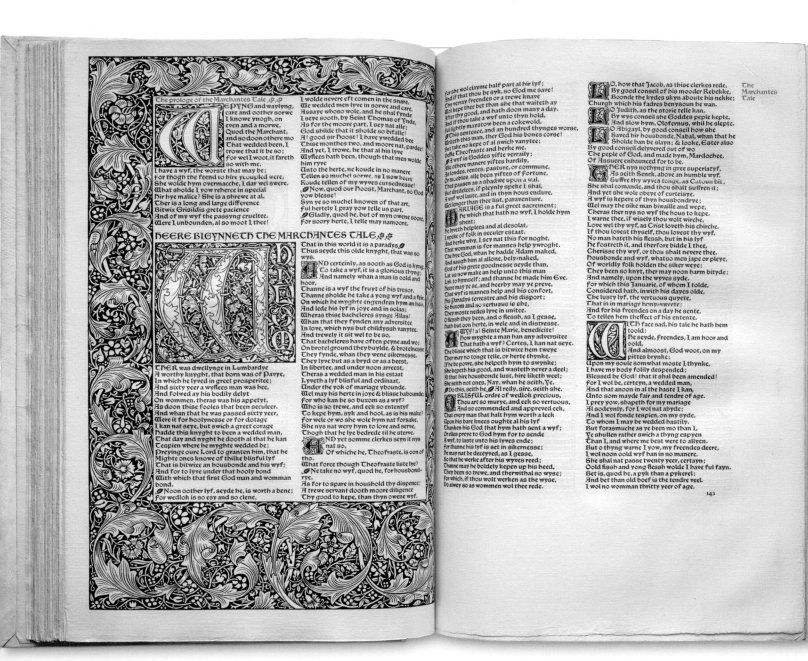

▲ "THE MERCHANT'S TALE"

One of Chaucer's *Canterbury Tales*, "The Merchant's Tale" is deeply satirical and—as with some of his other Tales—somewhat lewd by the standards of the time. Morris presents it inside a deep margin, beautifully decorated with the natural motifs of leaves and flowers that run throughout the volume. The first capital letter of the Tale, after the prologue, takes up the full width of one column and is 19 lines deep. Decorative capitals three lines deep and small capitals are used at the start of each paragraph. A small leaf motif is dropped into the text to indicate the start of a character's speech.

IN CONTEXT

The fifteenth-century printer William Caxton produced the first printed English edition of Chaucer, and this edition influenced Morris in his work at Kelmscott Press. Caxton had observed books printed using movable type during his travels in Europe, and learned the art of printing during his time in Cologne in the early 1470s. In 1476, he returned to London and set up the first printing press in Westminster. His early books included two editions of *The Canterbury Tales*, the second of which featured 26 woodcut illustrations. The illustrations, produced locally, were based on woodcuts that Caxton had seen in France. He used an elegant Burgundian type—the second edition had a smaller version of the script in order to fit more words on each page. It was this second illustrated edition that inspired Morris's Kelmscott Chaucer.

▲ **Mounted pilgrims** precede each tale in Caxton's second edition, decorating the pages and enlivening the text. The woodcuts were made by a local artist and some are used more than once.

In detail

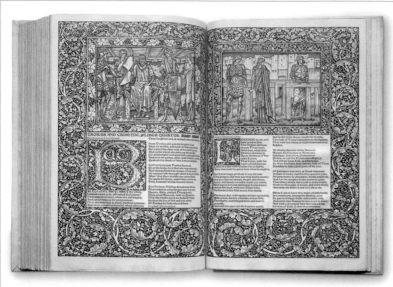

▲ **TROILUS AND CRISEYDE** Chaucer's epic poem was a tragic tale of love and betrayal set against the backdrop of the Trojan wars. These scenes are evocative of the pre-Raphaelite School to which Edward Burne-Jones was affiliated, and which enjoyed popularity in Victorian England.

ON **TECHNIQUE**

Turning his back on the increasing mechanization and industrialization of the age, William Morris prized the beauty and skill of true craftsmanship, and sought to use traditional techniques in the manufacture of all the books produced by Kelmscott Press. Just as he employed hand-printing inside his books, the outer covers were also crafted by hand. The Industrial Revolution threatened bookbinding, and the elaborately decorated first editions of the Kelmscott Chaucer represent a direct reaction against the utilitarian approach that was becoming more commonplace at the time. The pigskin binding is set over oak boards and decorated with a pattern created by hand-stamping. This technique involved creating impressions with hand tools to form a background, while leaving the motifs of the design standing out in relief. The work was undertaken by the Doves Bindery in Hammersmith, London, then operated by T.J. Cobden-Sanderson. Like Morris, Cobden-Sanderson was active in the Arts and Crafts Movement. In creating the Kelmscott Chaucer, they undoubtedly achieved their aim of producing a book that was a work of art in itself rather than simply a useful object.

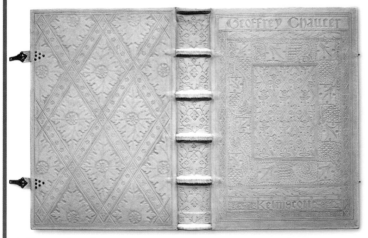

▲ **Four styles of binding** were made—the most luxurious of which was pigskin. Morris sent 48 of the first printed copies to the Doves Bindery for these editions to be specially bound in white pigskin with intricate decorative stamping, and finished with silver clasps on white pigskin straps.

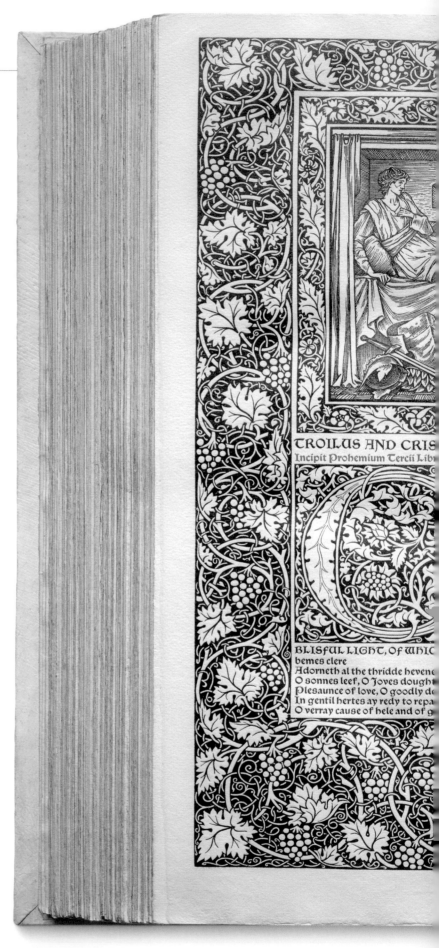

▲ **BOLD DESIGNS** This decorative border is reminiscent of the hand-drawn medieval manuscripts that Morris hoped to emulate in his design of the Kelmscott Chaucer. Burne-Jones completed 87 pencil sketches in total, working long into the night to finish them. Artist Robert Catterson-Smith then used Indian ink and Chinese white to trace the drawings, in preparation for engraving the image onto woodblocks to create bold, black-and-white designs.

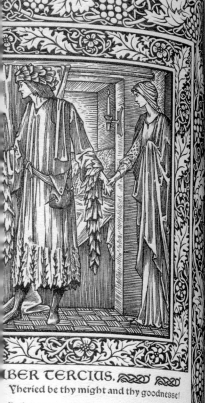

LIBER TERCIUS.

Yheried be thy might and thy goodnesse!

In hevene and helle, in erthe and salte see
Is felt thy might, if that I wel descerne;
As man, brid, best, fish, herbe and grene tree
Thee fele in tymes with vapour eterne.
God loveth, and to love wol nought werne;
And in this world no lyves creature,
Withouten love, is worth, or may endure.

Ye Joves first to thilke effectes glade,
Thorugh which that thinges liven alle and be,
Comeveden, and amorous him made
On mortal thing, and as yow list, ay ye
Yeve him in love ese or adversitee;
And in a thousand formes doun him sente
For love in erthe, and whom yow liste, he
hente.

Ye fierse Mars apeysen of his ire,
And, as yow list, ye maken hertes digne;
Algates, hem that ye wol sette afyre,
They dreden shame, and vices they resigne;
Ye do hem corteys be, fresshe and benigne,
And hye or lowe, after a wight entendeth;
The joyes that he hath, your might him
sendeth.

Ye holden regne and hous in unitee;
Ye soothfast cause of frendship been
also;
Ye knowe al thilke covered qualitee
Of thinges which that folk on wondren so,
Whan they can not construe how it may jo,
She loveth him, or why he loveth here;
As why this fish, and nought that, cometh
to were.

Ye folk a lawe han set in universe,
And this knowe I by hem that loveres be,
That whoso stryveth with yow hath the
werse:
Now, lady bright, for thy benignitee,
At reverence of hem that serven thee,
Whos clerk I am, so techeth me devyse
Som joye of that is felt in thy servyse.

Ye in my naked herte sentement
Inhelde, and do me shewe of thy swetnesse.
Caliope, thy vois be now present,
for now is nede; sestow not my destresse,
how I mot telle anon-right the gladnesse
Of Troilus, to Venus heryinge?
To which gladnes, who nede hath, God him
bringe!
Explicit prohemium Tercii Libri.

Incipit Liber Tercius.

BAY al this mene whyle
Troilus,
Recordinge his lessoun
in this manere:
Ma fey! thought he,
thus wole I seye and
thus;
Thus wole I pleyne un-
to my lady dere;
That word is good, and
this shal be my chere;
This nil I not foryeten in no wyse.
⌖ God leve him werken as he gan devyse.

And Lord, so that his herte gan to quappe,
Heringe hir come, and shorte for to syke!
And Pandarus, that ladde hir by the lappe,
Com ner, and gan in at the curtin pyke,
And seyde: God do bote on alle syke!
See, who is here yow comen to visyte;
Lo, here is she that is your deeth to wyte.

⌖ Therwith it semed as he wepte almost:
A ha, quod Troilus so rewfully,
Wher me be wo, O mighty God, thou wost!
Who is al there? I see nought trewely.
⌖ Sire, quod Criseyde, it is Pandare and I.

Un Coup de Dés

1897 (MAGAZINE), 1914 (BOOK) ▪ **PRINTED** ▪ **12 × 10 in (32 × 25 cm)** ▪ **32 PAGES** ▪ **FRANCE**

STÉPHANE MALLARMÉ

SCALE

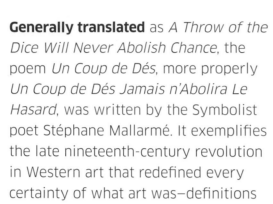

Generally translated as *A Throw of the Dice Will Never Abolish Chance*, the poem *Un Coup de Dés*, more properly *Un Coup de Dés Jamais n'Abolira Le Hasard*, was written by the Symbolist poet Stéphane Mallarmé. It exemplifies the late nineteenth-century revolution in Western art that redefined every certainty of what art was—definitions established 400 years earlier during the Renaissance. The radical shift occurred almost exclusively in France, but its influence soon swept around the world.

No poet was more important in its development than Mallarmé. Rejecting realism and naturalism, he used dreams and symbols to explain the enduring mysteries of human existence, giving rise to a new sense of what poetry might mean. This "Symbolism," as it became known, for Mallarmé meant a new poetic language in which the sounds of spoken words played as key a role as their meanings. In addition, their exact placement around the page encouraged a nonlinear reading that allowed ambiguity and an infinite series of interpretations. Mallarmé's approach would have an enduring influence on numerous twentieth-century poets and thinkers—Eliot, Joyce, and Pound among them. For

STÉPHANE **MALLARMÉ**

1842–1898

Stéphane Mallarmé was a major French Symbolist poet who inspired many artistic movements, such as Surrealism and Cubism. A central figure among intellectuals in Paris, he was a pioneer of the Symbolist movement in poetry.

Born in Paris, Mallarmé knew sadness from an early age: his mother died when he was five, his sister ten years later, and his father shortly afterwards. He learned English in London before becoming a schoolteacher in France. Married in 1863, he had two children (although his son would die of respiratory disease in 1879). Mallarmé moved to Paris in 1871 and became known for hosting intellectual gatherings on Tuesdays, which attracted figures such as WB Yeats, Rainer Maria Rilke, and Paul Verlaine (the group were known as *les Mardistes*). While a schoolmaster Mallarmé also produced his disciplined, yet wholly new style of poetry, impacting hugely on the Symbolist movement.

non-French readers, however, Mallarmé's poetry remains elusive, as its many-layered meanings are almost impossible to translate. It is perhaps as close to the abstraction of music as any poetry has ever been.

Un Coup de Dés was only partially published during Mallarmé's lifetime, but his exact intentions can be seen in the marked-up proofs shown here, which related to the precise layout of the text, its size, and font. Few of these instructions were acted on for the 1914 publication, but today many editions are more faithful to Mallarmé's vision.

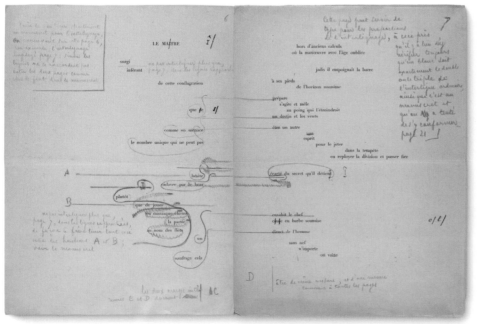

◄ **FORM OVER CONTENT**
The startling, almost shocking novelty of *Un Coup de Dés* stemmed as much from the "indefinite regions" inhabited by its poetry, as from its page layout, over which Mallarmé took great pains, as these corrections in his own hand to an early proof make clear.

▶ **SHAPE AND SIZE** The copy of the poem Mallarmé gave the printers in May 1897 contained precise instructions as to the placement of text on the page, such as these seen here, as well as type styles and sizes. It was Mallarmé's intention that the work resemble a form of musical notation.

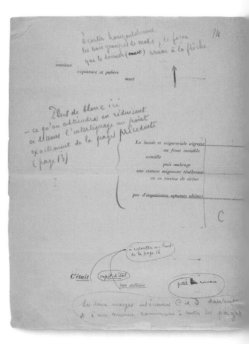

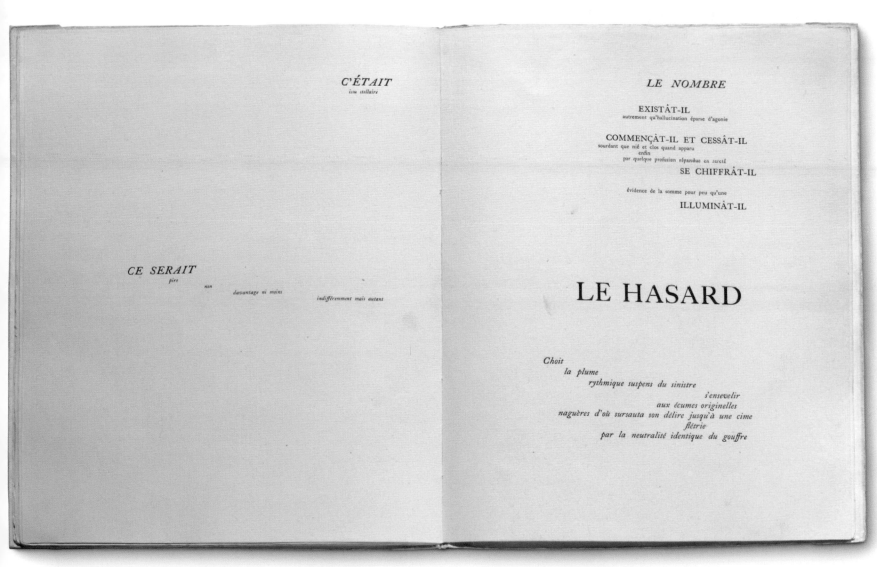

C'ÉTAIT
issu stellaire

LE NOMBRE

EXISTÂT-IL
autrement qu'hallucination éparse d'agonie

COMMENÇÂT-IL ET CESSÂT-IL
sourdant que nié et clos quand apparu
enfin
par quelque profusion répandue en rareté
SE CHIFFRÂT-IL

évidence de la somme pour peu qu'une
ILLUMINÂT-IL

CE SERAIT
pire
non
davantage ni moins
indifféremment mais autant

LE HASARD

Choit
la plume
rythmique suspens du sinistre
s'ensevelir
aux écumes originelles
naguères d'où sursauta son délire jusqu'à une cime
flétrie
par la neutralité identique du gouffre

▲ **FIRST EDITION** *Un Coup de Dés* did not appear in book form until 1914, but Mallarmé's plans had all but been ignored. He had not been happy with the way the poem was laid out in *Cosmopolis* magazine in 1897, and had hoped his next "luxury edition" would include lithographs by his friend Odilon Redon, and his exact typography.

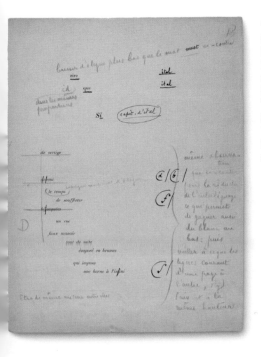

◄ **MUSICAL WORDS** One of Mallarmé's goals was to highlight that words are, in essence, no more than sounds, much like music. He surrounded these "sounds" with large areas of blank space or "surrounding silence" as he called it—much like a musical score.

▲ **NEGATIVE SPACE** Mallarmé wanted the poem's 714 words to be laid out on 22 facing pages, the impact of their apparently artless placing lifted by the white spaces around them. The layout became a form of abstraction in itself—"he unwittingly invented modern space."

Directory: 1650-1899

ETHICA
BENEDICT DE SPINOZA

HOLLAND (1677)

This philosophical treatise is often acknowledged as the greatest work of Benedict de Spinoza (1632–77), one of the most important and radical philosophers of the early modern age. Published shortly after Spinoza's death, *Ethica*, or *Ethics*, was a bold work of metaphysical and ethical philosophy that questioned the traditionally accepted philosophical thought about the relationship between God, nature, and humanity. Rather than writing in ordinary prose, Spinoza presented his text in a "geometrical method" which takes the form of axioms (statements taken to be true as a basis for argument), definitions, propositions, and

demonstrations. Through this complex structure Spinoza's treatise criticized the Catholic Church. As a direct result, all of Spinoza's works were placed on the Vatican's Index of Forbidden Books. The author George Eliot (1819–80)–nom de plume of Mary Anne Evans–published the first English translation in 1856.

TWO TREATISES OF GOVERNMENT
JOHN LOCKE

ENGLAND (1689)

This groundbreaking work by English political philosopher John Locke (1632–1704) was initially published anonymously. Presented in two parts, it is considered to be the foundation of modern political liberalism, and

one of the most influential works in the history of political theory. The *First Treatise* argues against belief in the divine right of kings; the *Second Treatise* outlines a framework for civilized society, placing a moral imperative on government to enforce laws only for the public good. Written between 1679 and 1680, during a period of great political upheaval in England, Locke did not publish *Two Treatises of Government* until after the Glorious Revolution of 1688, when the Dutch Protestant William of Orange had invaded England and overthrown the Catholic James II of England (James VII of Scotland). Locke claimed his work provided justification for England's Glorious Revolution. The *Two Treatises of Government* is also credited with inspiring the European Enlightenment and the U.S. Constitution.

▼ SEFER EVRONOT
ELIEZER BEN YAAKOV BELLIN

GERMANY (1716–1757, SHOWN)

The *Sefer Evronot* (meaning *Book of Intercalations*) was a beautifully illustrated Hebrew manuscript intended as a handbook for the Jewish lunisolar calendar. According to this calendar the months are determined by the moon, while the year is determined by the sun–intervention from an expert in astronomy was therefore needed to ensure that the Jewish community could fulfill their religious duties on the correct days. The *Sefer Evronot* was compiled to aid these intercalations (insertion of days into a calendar), and it proved highly popular. First printed in 1614, with further editions up until the ninteenth century, by the fifth edition–printed in

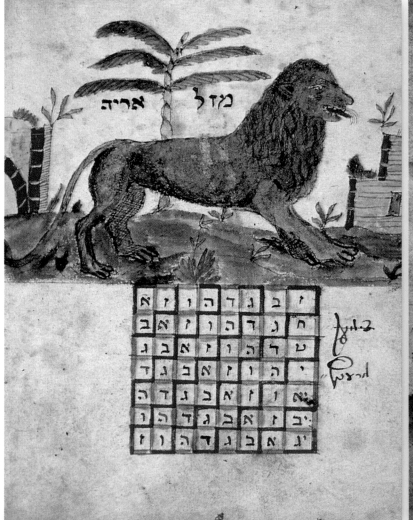

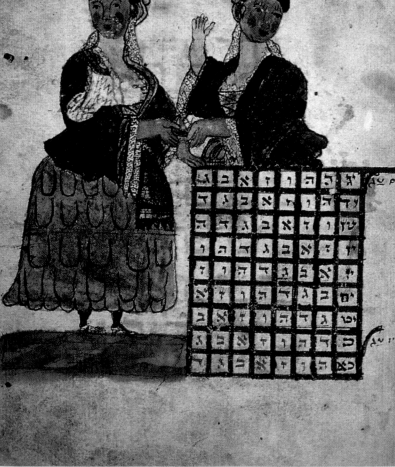

Illustrations representing Zodiac signs Leo, *above left*, and Virgo, *above right*, from a 1716 edition of *Sefer Evronot*.

1722, in Offenbach, Germany—diagrams and intricate multi-layered wheel charts, known as volvelles, with rotating parts were included.

DU CONTRAT SOCIAL; ÉMILE, OU DE L'ÉDUCATION; AND LES CONFESSIONS
JEAN-JACQUES ROUSSEAU

FRANCE (1762, 1782, AND 1789)

These are three of the most important works by the Swiss-born, French philosopher and writer Jean-Jacques Rousseau (1712–78). *Du Contrat Social* and *Émile, ou de l'éducation*, known respectively as *The Social Contract* and *Émile, or On Education*, were published in 1762.

Du Contrat Social was a work of political philosophy seen as influential in the instigation of the French Revolution (1789–99). Rousseau claimed that society was the product of the collective will of its people, and that laws should only be binding if they were supported by that collective will. In saying this, Rousseau challenged the traditional order of society.

Émile, ou de l'éducation was a pioneering treatise that explored the possibility of a system of learning where the pupil is taught in isolation, away from the corrupting influence of society and civilization. Part novel, part instructive and moralistic essay, *Émile* was radical in its call for a reform of teaching and child-rearing, and advocated that religious instruction should not begin until late adolescence. *Émile* was banned in Paris and Geneva, and was even publicly burned when it was first published. Yet it was widely read and greatly influenced the reform of education in France after the French Revolution, as well as in other countries across Europe.

Both of these books outraged the French parliament to such a degree that Rousseau spent much of the latter part of his life in hiding in France and Switzerland. But after the French Revolution he was hailed in France as a national hero.

Les Confessions (or *The Confessions*) is an autobiographical work divided into two parts, each comprising six books, and covers the first 53 years of Rousseau's life. Volumes I-VI were completed by 1767 and published in 1782; volumes VII-XII were complete by 1770, but not published until 1789. A few autobiographical books already existed at this time, but all had a religious agenda. Rousseau's text was an exploration of his own personal experiences and feelings since childhood, exposing his darkest deeds, as well as his finest, to account for the personality of his adult self.

THE HISTORY OF THE DECLINE AND FALL OF THE ROMAN EMPIRE
EDWARD GIBBON

UK (VOLUME I, 1776; VOLUMES II -III, 1781; IV - VI, 1788-89)

This historical work by the British historian and scholar Edward Gibbon (1737–94) traces the trajectory of Western civilization from the height of the Roman Empire to the fall of Byzantium. Gibbon used a dramatic and elegant literary style, and was notable for his extensive referencing of original source material—this technique became a model for subsequent writers of history. The text claimed that there was a moral decline in the people of Rome, which Gibbon felt made the fall of the Empire inevitable—he cited the rise of Christianity as having instilled in the Roman people an apathy that allowed the barbarians to conquer them. Although the work was highly acclaimed, Gibbon was criticized for the scepticism he expressed toward the Christian Church.

COMMON SENSE
THOMAS PAINE

AMERICA (1776)

This incendiary pamphlet, published anonymously by English political activist Thomas Paine (1737–1809), was written as a wake-up call to the people of the 13 colonies of America's Eastern seaboard, who were advocating independence from the British government. It is one of the most influential publications in U.S. history and credited with transforming colonial unrest into the American Revolution (1765-83). Paine's prose was passionate and populist in tone, and his words united

Title page from the first German edition of Kant's *Critique of Pure Reason*.

the people with their political leaders. *Common Sense* was the most widely read publication of the Revolution—around 500,000 copies of the pamphlet are thought to have been sold at the time.

▲ KRITIK DER REINEN VERNUNFT
IMMANUEL KANT

GERMANY (1781)

Written by German philosopher Immanuel Kant (1724–1804) and known in English as *Critique of Pure Reason*, this treatise on metaphysics is considered to be one of the most important in the history of philosophy. A dense and complex text, it was the product of 10 years of work. However, it proved so difficult to understand that Kant was obliged to write a more accessible companion two years later to ensure that it was not misinterpreted. Kant's text radically expands on two schools of thought that were central to the Enlightenment era: rationalism (which states that reason is the basis of knowledge) and empiricism (which states that knowledge can only come from experience). Kant's ground-breaking work on the theory of knowledge and ethics opened up an entirely new branch of philosophical thought. *Critique of Pure Reason* is sometimes referred to as Kant's *First Critique*, as he followed it with *Critique of Practical Reason* in 1788, and *Critique of Judgement* in 1790.

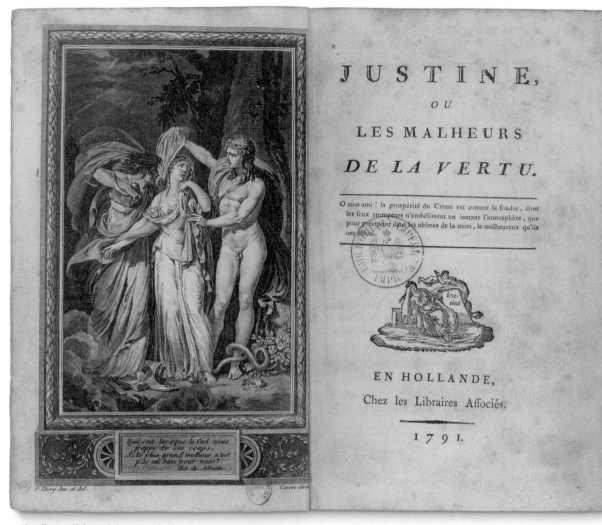

The first edition of the Marquis de Sade's controversial novel *Justine, ou Les Malheurs de la Vertu*.

▲ JUSTINE, OU LES MALHEURS DE LA VERTU
MARQUIS DE SADE

FRANCE (1791)

This disturbing novel (*Justine, or the Misfortunes of Virtue*, in English) is the best-known work by the infamous French aristocrat the Marquis de Sade (1740–1814). *Justine* was written in 1787 as a novella while de Sade was imprisoned in the Bastille. It was reworked as a full novel after he was released and published anonymously. *Justine* encapsulates de Sade's amoral philosophy that goodness is evil and vice should be rewarded—as such, the virtuous heroine suffers deeply for her goodness, and the novel resounds with the depravities, exploitation, and sexual violence for which de Sade is famed ("sadism" originates from de Sade's name). In 1801, Napoleon Bonaparte ordered de Sades's arrest because of the obscene nature of *Justine* and its sequel, *Juliette*, and he spent the rest of his life in prison.

A VINDICATION OF THE RIGHTS OF WOMAN
MARY WOLLSTONECRAFT

UK (1792)

This groundbreaking text by the English writer Mary Wollstonecraft (1759–97) advocated the need for political reform that would enable the formal education of women. One of the earliest expressions of feminist politics, Wollstonecraft's *A Vindication of the Rights of Woman* predated the actual use of the term "feminism." Many of Wollstonecraft's views proved to be prescient—for example, her appeal for co-educational schooling, and her recognition of the importance of enabling women to earn money and be self-supporting. Despite its controversial and radical content Wollstonecraft's book was well-received at the time of publication and two editions were printed in the first year. However, the book fell out of favor when details of her unorthodox lifestyle were revealed after her untimely death at the age of only 38 (she had had several affairs and an illegitimate child, but pretended to be married). Her reputation blighted book sales and it was not reprinted until the mid-nineteenth century.

PHÄNOMENOLOGIE DES GEISTES
G. W. F. HEGEL

GERMANY (1807)

German philosopher Georg Wilhelm Friedrich Hegel's (1770–1831) best-known work *Phenomenology of Mind* (or *Phenomenology of Spirit*) was published just after Napoleon Bonaparte (1769–1821) invaded Hegel's native Prussia. The earliest of his major works, *Phenomenology of Mind* proposed that humans share a collective consciousness that evolves according to a "dialogue." In this dialogue, an initial thesis (or idea) arises and is countered by an antithesis, the two are then reconciled in a synthesis. The pattern is continually repeated, building toward the attainment of "absolute truth." Although Hegel was an idealist like Immanuel Kant, his approach to human progress differed from Kant's philosophy. *Phenomenology of Mind* was a complex philosophical treatise exploring innovative concepts that proved highly influential both within the realm of philosophy, as well as in other fields, such as theology and political science.

BOOK OF MORMON
JOSEPH SMITH

USA (1830)

The *Book of Mormon* is the recognized holy scripture of the Latter Day Saint (LDS) movement, founded in New York in the 1830s by the American preacher Joseph Smith (1805–44). The text from the *Book of Mormon* is said to have derived from a set of golden plates inscribed with a script referred to as "reformed Egyptian." Smith claimed an angel presented him with the plates, and with divine assistance he translated the text into English. Smith's original manuscript was sealed within a stone wall until the 1880s, by which time much of it had been destroyed—the remnants are now in the LDS archives. Smith reportedly returned the golden plates to the angel. Certainly, no trace of them has ever been found, nor has archaeological evidence of Egyptian scripts been discovered in the U.S. However, Mormonism became the name given to the religious tradition of the members of the LDS movement.

THE COMMUNIST MANIFESTO
FRIEDRICH ENGELS AND KARL MARX

UK (1848)

First published anonymously, this 23-page pamphlet was co-authored by the German philosophers and social activists Karl Marx (1818–83) and Friedrich Engels (1820–95), although in reality Marx was the principal writer. Claiming socialism would replace capitalism, the authors aimed to initiate social change across Europe by encouraging the workers (the proletariat) to rise up against the middle classes (the bourgeoisie). *The*

Communist Manifesto became the most influential and widely read political pamphlet in history, and was the foundation of Marxist philosophy. While it had no immediate political impact, the ideas in the manifesto persisted into the twentieth century, and in 1917–23 years after the death of Karl Marx–the world's first successful communist revolution took place in Russia with Marxist theory at its core.

ON LIBERTY
JOHN STUART MILL

ENGLAND (1859)

This short essay written by the British philosopher and economist John Stuart Mill (1806-73) is one of the key texts of political liberalism. Mill believed passionately in the freedom of the individual, and in *On Liberty* he defended individuality against the strictures of society. He also promoted diversity and nonconformity in the book, claiming that it was the challenges presented to society by the nonconformists that prevented it from stagnating. Crucially, he argued for freedom of speech and emphasized that the expression of any individual should be free from state control. Mill's work was not without its critics, but *On Liberty* has been in print since its first publication.

THE INNOCENTS ABROAD
MARK TWAIN

USA (1869)

Also known as *The New Pilgrim's Progress*, this work began as a series of travel letters and developed into what became one of the bestselling travel books of all time. *The Innocents Abroad* chronicles a boat journey across Europe, Egypt, and the Holy Land made by the American author Samuel L. Clemens (1835-1910), writing under his better-known pseudonym, Mark Twain. Through his humorous and satirical narrative, Twain redefined the genre of travel writing by encouraging the reader to find their own experiences, rather than doing only what a guidebook has instructed them to do. *The Innocents Abroad* was sold on a subscription-only basis and was immediately

popular, selling over 70,000 copies in its first year, and it became Twain's bestselling book during his lifetime.

► LE AVVENTURE DI PINOCCHIO
CARLO COLLODI

ITALY (1883)

Written by the Italian author Carlo Collodi (1826-90), *Le Avventure di Pinocchio* (known in English as *The Adventures of Pinocchio*) is a children's novel about an animated wooden puppet, which became one of the best-loved and most iconic stories of all time. *Le Avventure di Pinocchio* was published as an illustrated novel following the huge success of its serialization in a children's magazine between 1881 and 1882. The original tale explored dark themes of morality and the nature of good and evil, and it even resulted in Pinocchio being hanged for his misdeeds. However, Collodi changed the ending for the novel to make it more child-friendly. The novel has been translated into over 240 languages, and is considered an Italian national treasure. The character of Pinocchio became immortalized as a popular icon in Walt Disney's 1940 film.

ALSO SPRACH ZARATHUSTRA
FRIEDRICH NIETZSCHE

GERMANY (1883-92)

Written by the German philosopher who has influenced twentieth-century thought more than any other–Friedrich Nietzsche (1844-1900)–*Also sprach Zarathustra: Ein Buch für Alle und Keinen*, is known in English as *Thus Spoke Zarathustra: A Book for All and None*. A philosophical novel, the book chronicles the travels and speeches of a fictitious character, Zarathustra, using Nietzsche's concepts of "Eternal Recurrence" (that all events will be repeated over and over again for all eternity) and the "Overman" (someone who has overcome himself fully and obeys no laws except the ones he gives himself). Marking the end of Nietzsche's mature period, *Thus Spoke Zarathustra* was written in four parts between 1883

and 1885. He wrote the first three in 10-day bursts while battling serious ill health–they were all published individually from 1883, and only combined in one volume in 1887. Nietzsche originally intended the third book to be the last and gave it a dramatic climax, but subsequently decided to write another three–although in the end he composed only one. Written in 1885, the last section remained private until all four parts were combined in a single volume in 1892. *Thus Spoke Zarathustra* was first translated into English in 1896.

THE INTERPRETATION OF DREAMS
SIGMUND FREUD

AUSTRIA (1899)

Sigmund Freud (1856-1939) was an Austrian neurologist who founded a new branch of scientific theory known

as psychoanalysis. It was in his book *The Interpretation of Dreams* that Freud first outlined his theory of the unconscious mind and the fundamental importance of dreams on the human psyche. Freud believed that all dreams, even nightmares, were a form of wish-fulfillment, and he was one of the first scientists to formally research this field by performing clinical trials, as well analyses of his own dreams. Despite slow initial sales, Freud produced eight revised editions of *The Interpretation of Dreams* in his own lifetime. He also published an abridged version of the book in 1901 called *On Dreams*, which was aimed at readers discouraged by the 800-page original. *The Interpretation of Dreams* is arguably Freud's most significant and influential work. This book has had an enormous impact on the development of scientific research into mental health and is considered to be the foundation of all modern psychotherapy.

Pinocchio as depicted in the first edition, 1883, by the artist Enrico Mazzanti.

1900
ONWARD

- The Wonderful Wizard of Oz
- The Tale of Peter Rabbit
- The Fairy Tales of the Brothers Grimm
- General Theory of Relativity
- Pro Dva Kvadrata
- Penguin's first 10 paperback books
- The Diary of a Young Girl
- Le Petit Prince
- Le Deuxième Sex
- The Feminine Mystique
- Silent Spring
- Quotations from Chairman Mao Tse-tung

CHAPTER 5

The Wonderful Wizard of Oz

1900 ■ PRINTED ■ 9 × 6½ in (22 × 16.5 cm) ■ 259 PAGES ■ USA

SCALE

L. FRANK BAUM

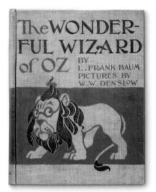

L. Frank Baum's tale of young Dorothy from Kansas, who is carried away by a cyclone to the magical Land of Oz, is considered to be the first American fairy tale. Unusually for fiction of the time *The Wonderful Wizard of Oz* was lavishly illustrated, with 24 color plates as well as intricate color pictures woven into the text. Baum believed the illustrations to be integral to the story and shared full copyright with the illustrator, W. W. Denslow. The publisher, George M. Hill Company, agreed to print all of the pictures in color, provided that Baum and Denslow paid the cost of including full-color plates.

First published in a print run of 10,000 copies in September 1900, the book was produced as three separate component parts—text, color plates, and case—which were then bound together. It was an instant success with press and public alike. The next print run of 15,000 copies, which followed just a month later, met with equal success. Within six months, 90,000 copies had been sold, and the book remained on the bestseller list for two years. To date it has been translated into over 50 languages and seen many adaptations, including a Broadway musical in 1902 (with the involvement of Baum and Denslow), three silent films, and the classic film from 1939, *The Wizard of Oz*, starring Judy Garland. Such was the demand for *Oz* stories that, after Baum's death, 21 sequels were written by children's author, Ruth Plumly Thompson.

In detail

◄ **DENSLOW'S ILLUSTRATIONS**
The title page shows Denslow's instantly recognizable artworks for the Tin Woodman and the Scarecrow. Despite the success of the book, the publisher, George M. Hill, went bankrupt in 1902. The next publisher, Bobbs-Merrill, gradually reduced the number of illustrations in future editions and shortened the title to *The Wizard of Oz.*

► **BACKDROP ARTWORK**
Many pages in the first edition had color illustrations that wove their way in and around the text, creating a backdrop.

, WIZARD OF OZ.

new, and he walked close to
ven bark in return.
the child asked of the Tin
t of the forest?"
answer, "for I have never
ut my father went there once,
said it was a long journey
although nearer to the city
is beautiful. But I am not
il-can, and nothing can hurt
ar upon your forehead the
ss, and that will protect you

l, anxiously; "what will pro-

urselves, if he is in danger,"

me from the forest a terrible
a great Lion bounded into
his paw he sent the Scare-
o the edge of the road, and
odman with his sharp claws.
could make no impression
odman fell over in the road

e had an enemy to face, ran
the great beast had opened

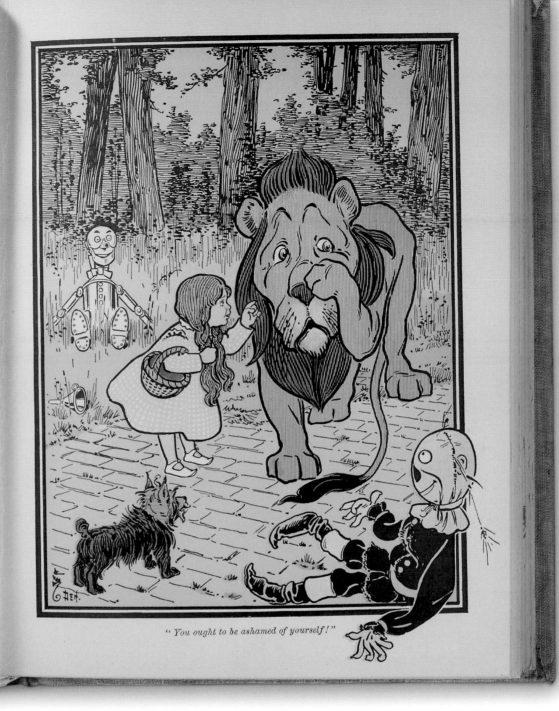

"You ought to be ashamed of yourself!"

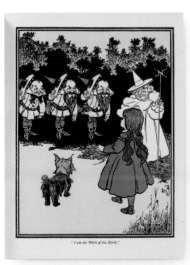

"I am the Witch of the North."

◄ **COLOR CODING** Part of the novelty of the first edition was the importance of color: each chapter was represented by a different color that linked to the text. For example, the illustrations in Chapter 2, "The Council with the Munchkins," are predominantly blue, the Munchkins' favorite color. Other colors used included green (for Chapter 11, "The Emerald City of Oz"), red, yellow, and gray.

LYMAN FRANK **BAUM**

1856-1919

L. Frank Baum pursued a few different careers before settling on writing. *The Wonderful Wizard of Oz*, which was published when he was 44, is one of the most famous works of children's literature.

Baum's lifelong passion was for the theater, but it proved unreliable financially, so he turned to journalism. He married Maud Gage in 1882 and had four sons, for whom he often made up bedtime stories. These stories formed part of his first book, *Mother Goose in Prose*, published in 1897. He first collaborated with the illustrator William Wallace Denslow (1856-1915) on a children's book of nonsense poetry called *Father Goose, His Book*. Published in 1899 it was a bestseller. After *The Wonderful Wizard of Oz* their collaborations were less successful and they parted company in 1902. Baum continued to enjoy success as a children's writer of fantasy novels, with 13 of his later books built around the Land of Oz. In the last nine years of his life, he adapted works for cinema.

The Tale of Peter Rabbit

1901 (PRIVATE EDITION) 1902 (FIRST COMMERCIAL EDITION) ▪ PRINTED ▪ 6 × 5 in (15 × 12 cm) ▪ 98 PAGES ▪ UK

SCALE

BEATRIX POTTER

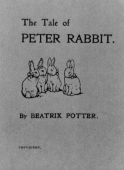

One of the best known of all children's books, Beatrix Potter's *The Tale of Peter Rabbit* is a charming story of a naughty little rabbit called Peter, accompanied by Potter's equally charming artworks. This story has sold over 40 million copies, and the character, Peter Rabbit, appears in five more of Potter's stories.

The first edition of the *Tale* (see left) was self-published. During the 1890s, Potter sent a number of stories to the children of her former governess, Annie Moore, and at Moore's suggestion, she decided to seek a publisher. She chose the story of Peter Rabbit, recounted in an illustrated letter she had written in September 1893 to Moore's five-year-old son, Noel, who was sick. "My dear Noel," she wrote, "I don't know what to write to you, so I shall tell you a story about four little rabbits whose names were—Flopsy, Mopsy, Cottontail, and Peter." The story told of the escapades of Peter Rabbit, who enters the vegetable garden of their neighbor, Mr. McGregor, and wreaks havoc. Potter later expanded the story and created a color illustration and 41 line drawings—one for each page.

Potter believed children wanted a tiny book they could hold, but publishers at the time would only print in large formats. Adamant, she decided to self-publish, producing 250 copies in December 1901, which she presented as

BEATRIX **POTTER**

1866–1943

British writer, illustrator, and naturalist, Beatrix Potter was famous for her children's books featuring little animals such as Peter Rabbit, Mrs. Tiggywinkle the hedgehog, and Jemima Puddleduck.

Beatrix Potter was born in London to a wealthy family. She was largely educated by governesses, but grew up with a love of nature, fostered by summer visits to Scotland and the Lake District. Women were discouraged from higher education in Victorian England, but Potter became an adept scientific illustrator at Kew Gardens, where she wrote a paper on fungi. She also illustrated children's stories and greeting cards, but her big success came with *The Tale of Peter Rabbit*. She fell in love with her editor, Norman Warne, despite her parents' disapproval, and was devastated by his death a month after their engagement. With the royalties from her publications and an inheritance, Potter bought a farm and moved to the Lake District in 1905, where she continued to write successful children's stories and married local solicitor William Heelis in 1913. At her death in 1943, Potter left 16 farms and some 4,000 acres to the National Trust.

Christmas gifts to family and friends. They proved so popular that within two months, she had 200 more printed. Publisher Frederick Warne and Co. reconsidered the book's small format and published the work the following year in an edition with all full-color illustrations. It was so successful that Potter went on to write 22 more children's stories.

▼ **PET SKETCHES** Long before writing her Peter Rabbit story, Beatrix Potter repeatedly sketched her beloved pet rabbit, Peter Piper. Her drawings are scientifically accurate and show both her innate love of animals and her skill as an artist. Her rabbit characters developed naturally from these first studies.

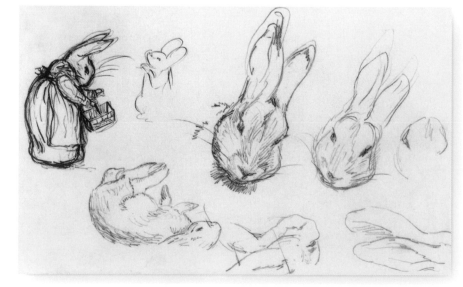

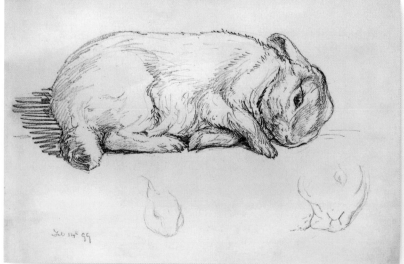

She also had a little field in which she grew herbs and rabbit tobacco. (Uncle ~~Remus says that rabbit tobacco is what we call lavender~~) She hung it up to dry in the kitchen, in bunches, which she **sold** for a penny a piece to her rabbit neighbours in the warren.

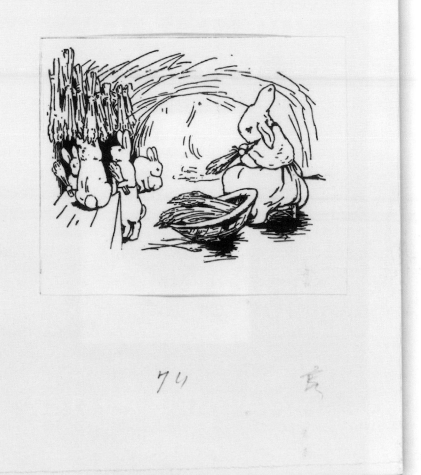

▲ **ORIGINAL MANUSCRIPT** This page from the original manuscript of Potter's *The Tale of Peter Rabbit*, complete with corrections, gives a wonderful insight into how she created the story–crafting the words and illustrations in tandem.

ONCE upon a time there were four little Rabbits, and their names were—
> Flopsy,
> Mopsy,
> Cotton-tail,
> and Peter.

▲ **FIRST EDITION** Beatrix Potter's creativity is evident in the inventive typesetting on the opening page of this self-published edition. Because of the expense, illustrations were limited to pen-and-ink drawings, with the exception of the color title page that was produced with the recently introduced three-color press.

> Thank goodness I was never sent to school; it would have **rubbed off** some of the originality. "

BEATRIX POTTER

In detail

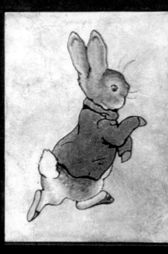

◄ FIRST COMMERCIAL EDITION Seeing the popularity of Potter's own edition, children's publisher Frederick Warne and Co., who had first rejected Potter's proposal, agreed to print the "bunny book" commercially. They wanted color illustrations, so Potter redid all of her drawings in watercolor in just a few months. In October 1902, 8,000 copies with colored prints were published. Of these, 2,000 were bound in deluxe linen covers, with the remainder in paper boards, the latter shown here.

▼ HIGH QUALITY Potter's watercolor illustrations were pale and subtle. To render them accurately in the book, Frederick Warne and Co. had to use the latest "Hentschel three-color" printing technique.

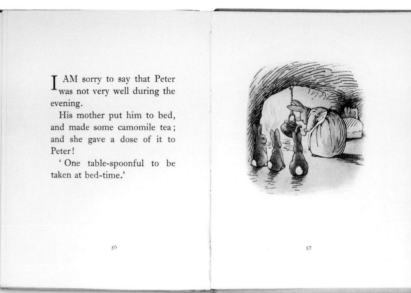

▲ FULL-PAGE IMAGES In order to hold a young child's attention, Potter insisted that each spread have text on the left and a full-page image on the right. She also directed that the commercial editions have rounded edges, which could be held comfortably by children. Potter had initially resisted color prints but was later convinced by the publishers to include them.

▲ MORAL OF THE STORY The combination of simple moral tales and delightful illustrations ensured Potter's popularity with generations of young children. *The Tale of Peter Rabbit* highlights the perils of disobeying one's parents: after his escapades, Peter feels unwell and is put to bed. The books contributed enormously to literacy in Edwardian Britain and were widely read by children of all ages.

'NOW, my dears,' said old Mrs. Rabbit one morning, ' you may go into the fields or down the lane, but don't go into Mr. McGregor's garden: your Father had an accident there; he was put in a pie by Mrs. McGregor.'

10

11

◄ **HUMANLIKE ANIMALS**
Key to Potter's appeal was the way she combined rabbit behavior with human traits. The rabbits eat parsley and get sick from lettuce, but also drink tea from cups. Blending fact and fantasy, all the little rabbits were drawn with the anatomical accuracy of a trained naturalist, yet stand upright like humans and are dressed in clothes.

IN **CONTEXT**

The success of *The Tale of Peter Rabbit* compelled Potter to compose a further 22 short stories for children. These were all published by Warne, earning both the publisher and author considerable royalties and profits through numerous reprints. However, Warne failed to register copyright in the U.S., allowing pirated copies to be printed from 1903 onward, which constituted a considerable loss of earnings. The entrepreneurial Potter learned from the American experience: when she designed a cloth rabbit based on Peter, she was careful to register it at the patent office, making it the first licensed literary character. Seeing the marketing potential of her creation, she also approved the sale of tea sets, children's bowls, slippers, and other novelties based on her animal characters. In 1904 she invented a Peter Rabbit board game, which finally went on sale, redesigned by Warne, in 1917. Potter was always deeply involved in product design and was determined that every bit of merchandise should remain faithful to her book characters. When Walt Disney offered to make an animated film version of Peter Rabbit, Potter turned him down, feeling "To enlarge … will show up all the imperfections." Today, merchandise remains popular, with many large toyshops devoting entire sections to Potter's characters.

► **Beatrix Potter** followed up the huge success of *The Tale of Peter Rabbit* with five more books in which he features, although the other animals he meets are the focus, including *The Tale of the Flopsy Bunnies*, shown here.

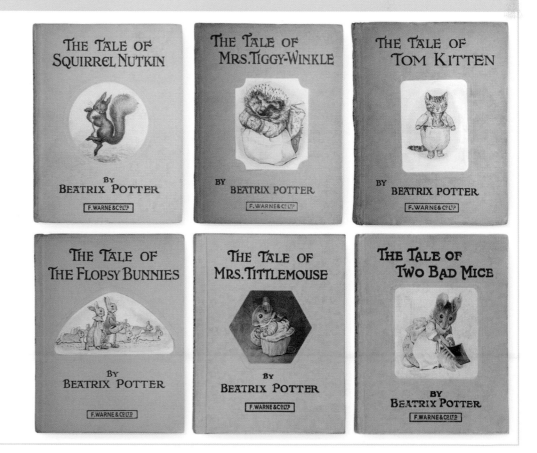

The Fairy Tales of the Brothers Grimm

1909 ▪ PRINTED ▪ 8 × 10 in (20 × 26 cm) ▪ 325 PAGES ▪ UK

SCALE

JACOB AND WILHELM GRIMM

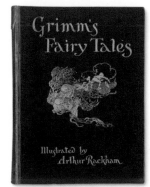

Published in 1909, this collection of Grimm Brothers' fairy tales, featuring exquisite illustrations by Arthur Rackham (1867–1939), was a visual treasure of the Edwardian era. The public's interest in fairy tales had been sparked in the early years of Queen Victoria's reign, and by the late nineteenth century they were entrenched in popular culture. At a time of great social change, brought about by industrialization and the mass migration of people from the countryside to the expanding cities, the tales provided simple escapism.

The market was saturated with fairy tale imagery at the time, yet none quite captured the spirit of the stories, or popular imagination, like the illustrations by Arthur Rackham. Expressive and intricate, 100 of his black-and-white line drawings first appeared in a

1900 edition of the tales, but the work was revised in 1909, with more detailed illustrations and 40 subtly colored new plates. Drawn using pen and India ink, Rackham's artworks were magical and macabre, and depicted the brutality and malevolence behind many of the tales with an innocent, rustic charm and beauty.

The accompanying stories were translated by Mrs. Edgar Lucas from the original German folk tales, compiled in 1812 by Jacob and Wilhelm Grimm, and the book was highly sought after. Rackham would later become one of the most celebrated British artists of the Edwardian era.

BROTHERS **GRIMM**

JACOB GRIMM • 1785–1863
WILHELM GRIMM • 1786–1859

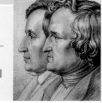

Jacob and Wilhelm Grimm were German academics and folklorists who succeeded in popularizing hundreds of classical fairytales, with which their names are now synonymous.

Although their surname is famously associated with fairy tales, Jacob and Wilhelm Grimm were not children's storybook writers. They were scholars and historians, whose passion for the folklore of the past inspired them to write down the tales that had been part of the oral heritage of Europe for many centuries. Born just a year apart, Jacob and Wilhelm were virtually inseparable as children. Even in adulthood they remained close, studying and working together on shared research projects. After studying law, they both became librarians, devoting their careers to documenting the origins of German language, literature, and culture.

The Grimms recorded European folk tales that had been passed down by word of mouth for centuries, publishing their results in 1812 as a collection of 156 stories entitled *Kinder-und Hausmärchen* (*Children's and Household Tales*). Over the next few years, they added more stories, publishing a second edition in 1815. They gradually edited and reworked the tales to make them suitable for children, since many of the originals were thought to contain too much sex and violence. They also often added moral messages and Christian references, and fleshed out some stories with more detail. The definitive version was published in 1857, two years before Wilhelm's death.

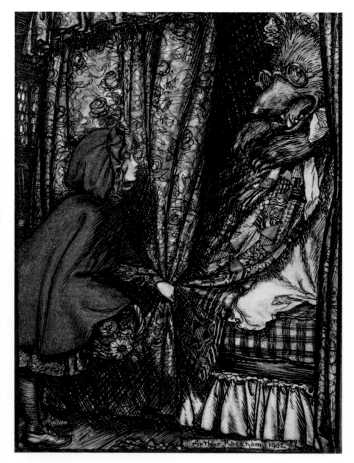

▲ **LITTLE RED CAP** The story of "Little Red Riding Hood" dates back to the tenth century, but one of the best-known versions is Grimm's "Little Red Cap." Rackham's use of color draws the reader's eye toward Red Riding Hood, allowing the wolf's true identity to be partly obscured by the surrounding detail, which adds to the suspense.

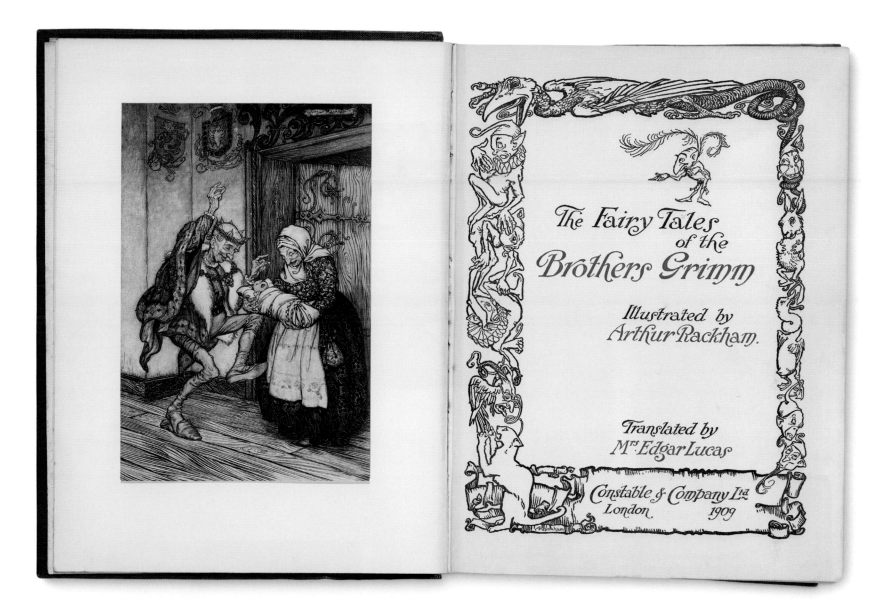

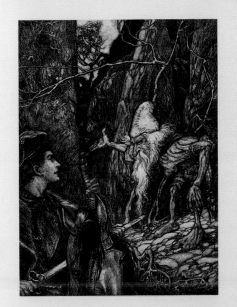

GRIMM'S FAIRY TALES

In the early morning, when she and Conrad went through the gateway, she said in passing—

'Alas! dear Falada, there thou hangest.'

And the Head answered—

'Alas! Queen's daughter, there thou gangest.
If thy mother knew thy fate,
Her heart would break with grief so great.'

Then they passed on out of the town, right into the fields, with the geese. When they reached the meadow, the Princess sat down on the grass and let down her hair. It shone like pure gold, and when little Conrad saw it, he was so delighted that he wanted to pluck some out; but she said—

'Blow, blow, little breeze,
And Conrad's hat seize.
Let him join in the chase
While away it is whirled,
Till my tresses are curled
And I rest in my place.'

Then a strong wind sprang up, which blew away Conrad's hat right over the fields, and he had to run after it. When he came back, she had finished combing her hair, and it was all put up again; so he could not get a single hair. This made him very sulky, and he would not say another word to her. And they tended the geese till evening, when they went home.

Next morning, when they passed under the gateway, the Princess said—

'Alas! dear Falada, there thou hangest.'

Falada answered :—

'Alas! Queen's daughter, there thou gangest.
If thy mother knew thy fate,
Her heart would break with grief so great.'

70

▲ **REVISED EDITION** A special feature of the 1909 edition was the "tipped-in" color illustrations: the images were printed separately from the rest of the book on different paper, then glued into the book before it was bound. Opposite the title page, shown here, is an illustration from "Briar Rose" now "Sleeping Beauty", in which the king jumps for joy on the occasion of the birth of his daughter. The twisting decoration on the wall and door above the characters alludes to the briars that eventually ensnare the castle while Sleeping Beauty sleeps.

◀ **SIGNATURE SCENE** Many of the tales, such as "The Water of Life," shown here, feature perilous forests. To convey a sense of foreboding, Rackham illustrated them using extensive detailing and fine line work so that they appear dark and impenetrable. In the background of this image, the outline of a trapped figure can be mistaken for the branch of a tree.

In detail

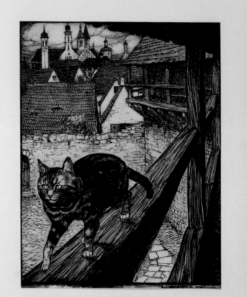

◄ **CONCEALED CHARACTERS** Many of the tales have a theme of deception, where characters are not what they seem. Rackham reflected this in his illustrations, by giving characters a physical appearance that often belied their true nature. In this illustration from "The Cat who Married the Mouse," the handsome-looking cat appears harmless, although the tale reveals the opposite.

▼ **LIGHT AND SHADOW** Rackham's illustrations often feature light and shadow to hint at the opposing forces of good and evil, as in the image below from "The Goose Girl." In this tale, an innocent young girl, raised by a loving single mother, is sent out into the world to marry a stranger in the company of a chambermaid who deceives the girl, but is ultimately punished.

GRIMM'S FAIRY TALES

In the early morning, when she and Conrad went through the gateway, she said in passing—

> 'Alas! dear Falada, there thou hangest.'

And the Head answered—

> 'Alas! Queen's daughter, there thou gangest.
> If thy mother knew thy fate,
> Her heart would break with grief so great.'

Then they passed on out of the town, right into the fields, with the geese. When they reached the meadow, the Princess sat down on the grass and let down her hair. It shone like pure gold, and when little Conrad saw it, he was so delighted that he wanted to pluck some out; but she said—

> 'Blow, blow, little breeze,
> And Conrad's hat seize.
> Let him join in the chase
> While away it is whirled,
> Till my tresses are curled
> And I rest in my place.'

Then a strong wind sprang up, which blew away Conrad's hat right over the fields, and he had to run after it. When he came back, she had finished combing her hair, and it was all put up again; so he could not get a single hair. This made him very sulky, and he would not say another word to her. And they tended the geese till evening, when they went home.

Next morning, when they passed under the gateway, the Princess said—

> 'Alas! dear Falada, there thou hangest.'

Falada answered :—

> 'Alas! Queen's daughter, there thou gangest.
> If thy mother knew thy fate,
> Her heart would break with grief so great.'

70

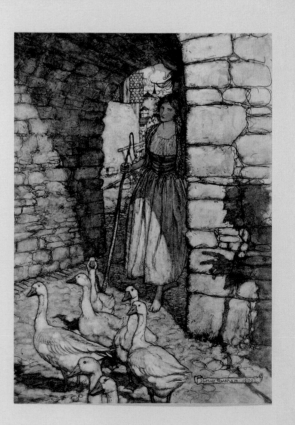

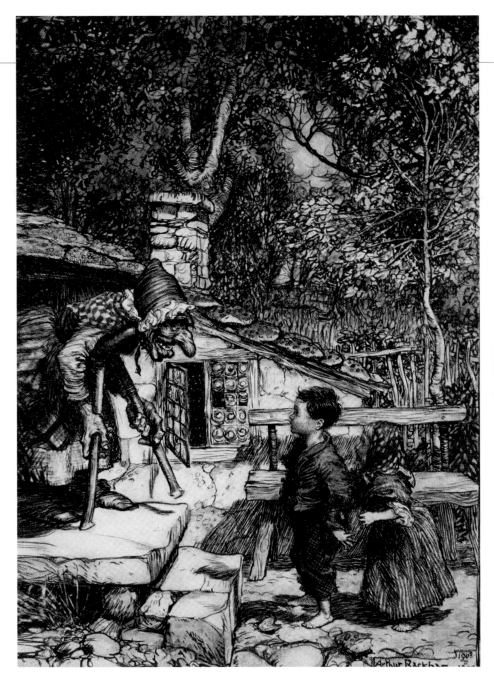

◀ **THREAT OF DANGER** Sex and violence lie at the heart of traditional fairy tales, but the Grimm Brothers edited the stories they had first published to make them more palatable to a young audience. Rackham's illustrations also tempered the frightening elements of the fairy tales, but conveyed just enough potential danger to be exciting. "Hansel and Gretel," shown here, is an example of an edited story: in the original story, the children's own mother sends them away to die, but in the later version it is their stepmother who plots to kill them.

> It is hardly **too much to** say that these **tales rank next** to the Bible in importance ❞

W. H. AUDEN, ON *GRIMM'S FAIRY TALES*

RELATED **TEXTS**

The fairy tales of the Grimm Brothers are predated by Charles Perrault's *Histoires ou contes du temps passé, avec des moralités: Contes de ma mère l'Oye* (*Stories or Tales of The Past with Morals: Tales of Mother Goose*), published in France in 1697. It consisted of eight stories, with titles that are instantly recognizable today, including "The Sleeping Beauty in the Wood," "Little Red Riding Hood," "Cinderella," and "Mother Goose." Perrault, a lawyer by trade, did not invent the tales–they were already well known as part of European folklore–but by writing them down in an engaging way, he established them as literature. He fleshed out the stories, adding complexity and details not in the original versions. Like the Grimm's first publication, the French volume was intended for an adult readership, with violent themes and sexual content, but over the space of several years, the book was edited and repackaged for children. Little Red Riding Hood's wolf morphed from a sexual predator to simply a hungry beast, while Sleeping Beauty changed from a sexually active mother of two to a virgin. Perrault's book remained popular for decades, with several editions published in Paris, Amsterdam, and London between 1697 and 1800.

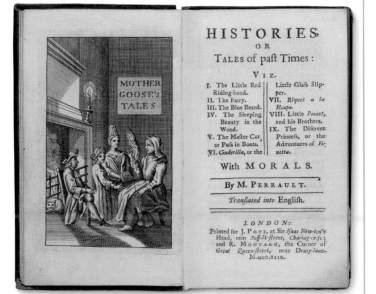

▶ **Robert Samber's** captivating translation for the English edition of 1729 helped to popularize the fairy tales in Britain.

General Theory of Relativity

1916 ▪ PRINTED ▪ 10 × 6 in (24.8 × 16.5 cm) ▪ 69 PAGES ▪ GERMANY

SCALE

ALBERT EINSTEIN

On November 24, 1915, in Berlin, the German-born physicist Albert Einstein presented a revolutionary mathematical physics paper on gravity. Painstakingly formulated over the previous decade, his General Theory of Relativity would have a seismic effect on the scientific world. Its ideas displaced one of the great pillars of physics—the law of universal gravitation put forward by English scientist Isaac Newton (1642–1727) in the seventeenth century— and forced physicists to re-assess their most fundamental beliefs about space, time, matter, and gravity.

Newton's landmark work *Principia* (see pp.142–43) had described the notion that any two objects exert a gravitational force of attraction on each other. Newton believed that gravity affects everything: causing an apple to fall from a tree and keeping the planets orbiting the Sun. Yet he was unable to explain where gravity comes from or the laws of physics that govern it. Einstein saw these theoretical difficulties as puzzles to probe, and he set about solving the mystery of how gravity works.

ALBERT **EINSTEIN**

1879–1955

Albert Einstein was a German theoretical physicist, who through his development of the special and general theories of relativity became the most influential and renowned physicist of the twentieth century. He won the Nobel Prize for Physics in 1921.

Born to Jewish parents in Ulm, Germany, as a child, Einstein's questioning mind led him to challenge existing ideas about science. After school he trained to be a physics and maths teacher, but he was unable to secure a teaching post, and instead worked as a clerk at the Swiss patent office for seven years from 1909. During this time he calculated the speed of light and published his Special Theory of Relativity, which featured the now famous equation $E=mc^2$.

Einstein quickly rose in the academic world, holding senior posts at famous institutions. In 1919 a key prediction of his 1916 General Theory of Relativity— that gravity should bend light—was proven correct, and Einstein became a world-renowned icon. With the rise of Nazism, and a specific threat to Einstein himself, in 1932 he emmigrated to the US where he spent the rest of his life.

In 1905 after conducting research while holding down a job as a clerk, Einstein published three remarkable papers that would alter the course of physics. One of these, the Special Theory of Relativity, showed that the laws of physics for space and time are the same when two objects are moving at a constant speed relative to each other. But there was a hitch—gravity did not fit within this theory because it involved acceleration.

And so Einstein spent the next 10 years working tirelessly on a larger, more explanatory vision that would account for acceleration in space and time. The result was the General Theory of Relativity, which posited that massive objects cause a distortion in space and time that is felt as gravity. It also explained why some things accelerate in reference to each other. Einstein said that gravity does not pull matter, as Newton thought—it pushes. He theorized that there is curved space around the Earth that pushes on the atmosphere and all the objects on the planet.

The consequences of the General Theory of Relativity have been profound. It unleashed new cosmological concepts, including black holes and the Big Bang, and underpins modern technology such as GPS and smartphones.

IN **CONTEXT**

In 1912 Albert Einstein penned a draft manuscript of the General Theory of Relativity. Although he tweaked and modified his calculations many times after this point, the handwritten manuscript remains a historic document that offers a glimpse into the brilliant physicist's mind.

In particular it reveals Einstein's rediscovered passion for mathematics in helping him realize his ideas. While producing the manuscript he wrote to fellow physicist Arnold Sommerfeld, saying, "I have gained great respect for mathematics, whose more subtle parts I considered until now, in my ignorance, as pure luxury." Today the manuscript is held in the Albert Einstein Archives at The Hebrew University of Jerusalem, Israel.

▶ **The 72 pages** of the 1912 manuscript show extensive reworking, revealing Einstein's thought processes more clearly than any other of his handwritten works.

Put your hand on a stove for a minute, and it seems like an hour. Sit with that special girl for an hour, and it seems like a minute. That's relativity.

ALBERT EINSTEIN, EXPLAINING HIS THEORY OF RELATIVITY

— 46 —

von der Größe dS (im Sinne der euklidischen Geometrie) bedeuten. Man erkennt hierin den Ausdruck der Erhaltungssätze in üblicher Fassung. Die Größen $t_\sigma{}^\alpha$ bezeichnen wir als die „Energiekomponenten" des Gravitationsfeldes.

Ich will nun die Gleichungen (47) noch in einer dritten Form angeben, die einer lebendigen Erfassung unseres Gegenstandes besonders dienlich ist. Durch Multiplikation der Feldgleichungen (47) mit $g^{\nu\sigma}$ ergeben sich diese in der „gemischten" Form. Beachtet man, daß

$$g^{\nu\sigma} \frac{\partial \Gamma^\alpha_{\mu\nu}}{\partial x_\alpha} = \frac{\partial}{\partial x_\alpha}\left(g^{\nu\sigma} \Gamma^\alpha_{\mu\nu}\right) - \frac{\partial g^{\nu\sigma}}{\partial x_\alpha} \Gamma^\alpha_{\mu\nu},$$

welche Größe wegen (34) gleich

$$\frac{\partial}{\partial x_\alpha}\left(g^{\nu\sigma} \Gamma^\alpha_{\mu\nu}\right) - g^{\nu\beta} \Gamma^\sigma_{\alpha\beta} \Gamma^\alpha_{\mu\nu} - g^{\sigma\alpha} \Gamma^\nu_{\beta\alpha} \Gamma^\beta_{\mu\nu},$$

oder (nach geänderter Benennung der Summationsindizes) gleich

$$\frac{\partial}{\partial x_\alpha}\left(g^{\sigma\beta} \Gamma^\alpha_{\mu\beta}\right) - g^{mn} \Gamma^\sigma_{m\beta} \Gamma^\beta_{n\mu} - g^{\nu\sigma} \Gamma^\alpha_{\mu\beta} \Gamma^\beta_{\nu\alpha}.$$

Das dritte Glied dieses Ausdrucks hebt sich weg gegen das aus dem zweiten Glied der Feldgleichungen (47) entstehende; an Stelle des zweiten Gliedes dieses Ausdruckes läßt sich nach Beziehung (50)

$$\varkappa(t_\mu{}^\sigma - \tfrac{1}{2}\delta_\mu{}^\sigma t)$$

setzen $(t = t_\alpha{}^\alpha)$. Man erhält also an Stelle der Gleichungen (47)

(51)
$$\begin{cases} \dfrac{\partial}{\partial x_\alpha}\left(g^{\sigma\beta} \Gamma^\alpha_{\mu\beta}\right) = -\varkappa(t_\mu{}^\sigma - \tfrac{1}{2}\delta_\mu{}^\sigma t) \\[2mm] \sqrt{-g} = 1. \end{cases}$$

§ 16. Allgemeine Fassung der Feldgleichungen der Gravitation.

Die im vorigen Paragraphen aufgestellten Feldgleichungen für materiefreie Räume sind mit der Feldgleichung

$$\Delta \varphi = 0$$

der Newtonschen Theorie zu vergleichen. Wir haben die Gleichungen aufzusuchen, welche der Poissonschen Gleichung

$$\Delta \varphi = 4 \pi \varkappa \varrho$$

entspricht, wobei ϱ die Dichte der Materie bedeutet.

— 47 —

Die spezielle Relativitätstheorie hat zu dem Ergebnis geführt, daß die träge Masse nichts anderes ist als Energie, welche ihren vollständigen mathematischen Ausdruck in einem symmetrischen Tensor zweiten Ranges, dem Energietensor, findet. Wir werden daher auch in der allgemeinen Relativitätstheorie einen Energietensor der Materie $T_\sigma{}^\alpha$ einzuführen haben, der wie die Energiekomponenten $t_\sigma{}^\alpha$ [Gleichungen (49) und (50)] des Gravitationsfeldes gemischten Charakter haben wird, aber zu einem symmetrischen kovarianten Tensor gehören wird [1]).

Wie dieser Energietensor (entsprechend der Dichte ϱ in der Poissonschen Gleichung) in die Feldgleichungen der Gravitation einzuführen ist, lehrt das Gleichungssystem (51). Betrachtet man nämlich ein vollständiges System (z. B. das Sonnensystem), so wird die Gesamtmasse des Systems, also auch seine gesamte gravitierende Wirkung, von der Gesamtenergie des Systems, also von der ponderablen und Gravitationsenergie zusammen, abhängen. Dies wird sich dadurch ausdrücken lassen, daß man in (51) an Stelle der Energiekomponenten $t_\mu{}^\sigma$ des Gravitationsfeldes allein die Summen $t_\mu{}^\sigma + T_\mu{}^\sigma$ der Energiekomponenten von Materie und Gravitationsfeld einführt. Man erhält so statt (51) die Tensorgleichung

(52)
$$\begin{cases} \dfrac{\partial}{\partial x_\alpha}\left(g^{\sigma\beta} \Gamma^\alpha_{\mu\beta}\right) = -\varkappa[(t_\mu{}^\sigma + T_\mu{}^\sigma) - \tfrac{1}{2}\delta_\mu{}^\sigma(t + T)] \\[2mm] \sqrt{-g} = 1, \end{cases}$$

wobei $T = T_\mu{}^\mu$ gesetzt ist (Lauescher Skalar). Dies sind die gesuchten allgemeinen Feldgleichungen der Gravitation in gemischter Form. An Stelle von (47) ergibt sich daraus rückwärts das System

(53)
$$\begin{cases} \dfrac{\partial \Gamma^\alpha_{\mu\nu}}{\partial x_\alpha} + \Gamma^\alpha_{\mu\beta} \Gamma^\beta_{\nu\alpha} = -\varkappa(T_{\mu\nu} - \tfrac{1}{2} g_{\mu\nu} T), \\[2mm] \sqrt{-g} = 1. \end{cases}$$

Es muß zugegeben werden, daß diese Einführung des Energietensors der Materie durch das Relativitätspostulat allein nicht gerechtfertigt wird; deshalb haben wir sie im

1) $g_{\sigma\tau} T_\sigma{}^\sigma = T_{\sigma\tau}$ und $g^{\sigma\beta} T_\sigma{}^\alpha = T^{\alpha\beta}$ sollen symmetrische Tensoren sein.

▲ **A TOWERING ACHIEVEMENT** Einstein first announced his General Theory of Relativity late in 1915, as part of a series of lectures before the Prussian Academy of Science. The final paper was published by the scientific journal *Annalen der Physik* in March 1916 and consisted of a set of mathematical equations. The field equations of gravitation displayed here show, among other things, that space and time are part of one continuum—called space-time—and that gravity is not a force, as Newton described it, but the effect of objects bending space-time.

Pro Dva Kvadrata

1922 ▪ NEWSPRINT ▪ 11 × 9 in (29 × 22.5 cm) ▪ 24 PAGES ▪ RUSSIA

EL LISSITZKY

SCALE

Translated as *About Two Squares*, *Pro Dva Kvadrata* is a masterpiece of Suprematist book illustration: the almost stark simplicity of its six main plates encapsulates a revolution in art and typography, an appeal to social revolution, and a simple children's fable. The book's author and designer, El Lissitzky, was working at a time of enormous political upheaval in his home country of Russia, which culminated in the Revolution of 1917 and the first communist government led by Vladimir Lenin (1870–1924). The Revolution also unleashed huge creative energy. Lissitzky, who had been rejected by Russia's conservative art schools, became Professor of Architecture at Vitebsk in 1919. Here the radical artist Kazimir Malevich introduced Lissitzky to the theory of Suprematism, which rejected artistic attempts to imitate naturalistic shapes and favored instead strong, distinct, geometric designs.

Many Russian artists of the era supported the Revolution and turned their talents to promoting the social justice they believed it would bring. Lissitzky drew propaganda posters for the Communist Party and designed their first flag. He also began a series of projects called PROUNS (Projects for the Affirmation of the New) with which he hoped to move Suprematism from a two-dimensional

EL LISSITZKY

1890–1941

Lazar ("El") Lissitzky was a leading proponent of the Suprematist movement, championing the purity of simple artistic forms and integrating them with the revolutionary ideals of the Soviet Union.

Artist, architect, typographer, and designer El Lissitzky grew up in provincial Russia, but studied architecture in Germany, where he was influenced by the clean, uncluttered lines of Walter Gropius's work. Returning to Russia during World War I, Lissitzky found few major architectural commissions and turned to book illustration. In 1919 he became professor of architecture in his home town of Vitebsk. Two years later, he went to Berlin as an artistic emissary for the USSR, where he was exposed to the new avant-garde and Dadaism, before returning to Moscow in 1926. In the late 1920s he experimented with photomontage and continued to illustrate and design books. Crippled by tuberculosis and a political atmosphere in the Soviet Union that became ever more stifling under Joseph Stalin, his later work concentrated on designing exhibition pavilions for the USSR and propaganda posters. He completed the last of these posters, *Make More Tanks*, to help in the war effort against Nazi Germany shortly before his death in Moscow in December 1941.

stage to a three-dimensional one through his architectural expertise. *Pro Dva Kvadrata*, printed by letterpress in red and black, was part of this effort. Outwardly a children's tale, it depicts the adventures of the red square (communist ideals) as it overcomes the black square (convention) to create a better world. The typography, sparse but bold, is closely linked to the illustrations, breaking the bounds of conventional book design and setting new standards for what an illustrated book could be.

In detail

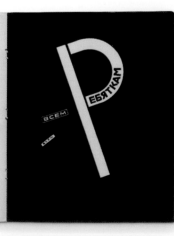

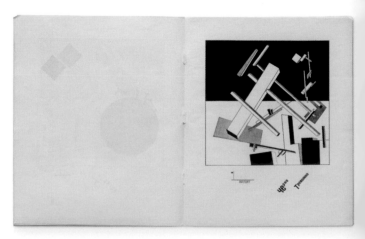

◄ **DEDICATION PAGE** With striking white typography on a black background, Lissitzky dedicates his book "To all, all children." The large, slanting capital Cyrillic "P" forms the first letter of "Children."

► **CHAOS** The distinct words "black" and "alarming," also slanting, contrast with the jumble of blocks and angular objects that float disturbingly in midair, without any sense of perspective or logic.

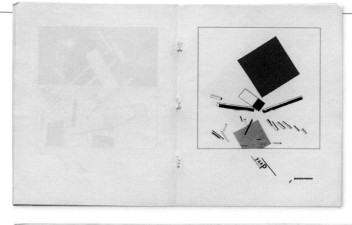

◄ **ORDER** Even though a corner of the red square has crashed down onto the objects below, scattering them, a sense of order seems to have been achieved with the items grouped together by shape and size. Beneath the image sit the words "crash," set slanted, and "scattered," set straight.

▼ **INTRODUCTION** In this plate, Lissitzky shows the red square of communism rising pointedly beneath the black square of convention, as if pushing it aside. The bold, stark graphics, and the simple sans serif type below are typical of the book and the Suprematist movement's disdain for unnecessary ornamentation.

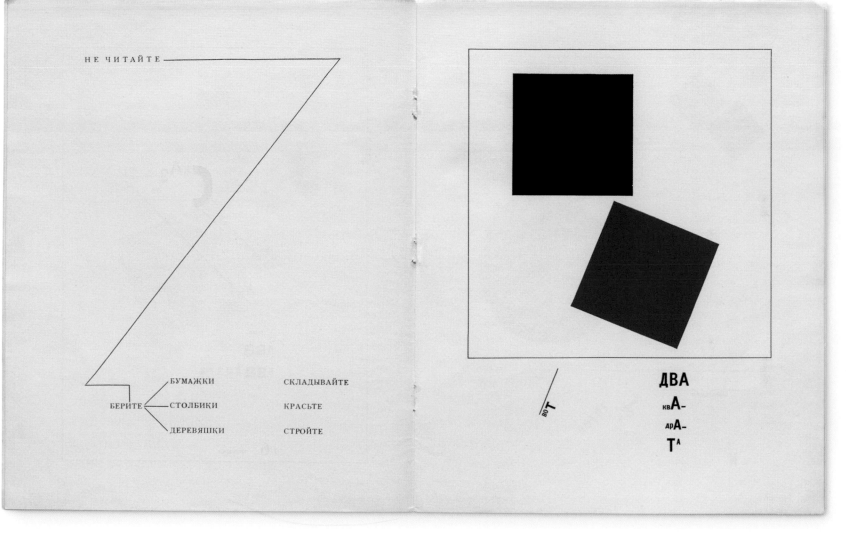

НЕ ЧИТАЙТЕ

БУМАЖКИ СКЛАДЫВАЙТЕ

БЕРИТЕ — СТОЛБИКИ КРАСЬТЕ

ДЕРЕВЯШКИ СТРОЙТЕ

ВОТ

ДВА
КВ**А**–
АР**А**–
Т**А**

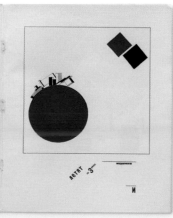

◄ **ON COURSE** One of the tenets of Suprematism was to take a work to the extreme of abstraction, while still being recognized as art. In this plate the image is both abstract and artistic, yet still conveys a political message—the Soviet red square is ahead of the old order black one in the race to Earth.

We are faced with a book form in which representation is primary and the alphabet secondary.

EL LISSITZKY, *OUR BOOK*, 1926

Penguin's first 10 paperback books

1935 ▪ PRINTED ▪ 7 × 4^1/$_2$ in (18 × 11 cm) ▪ VARIOUS EXTENTS ▪ UK

SCALE

VARIOUS AUTHORS

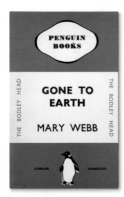

The publication of 10 Penguin books on July 30, 1935, changed the course of publishing across the globe. Paperback versions of 10 popular books (already published as hardbacks) were put on sale for the very low price of 7 cents (6d). Their appeal was instant—they were cheap yet high-quality and had bold, colorful covers. The Penguin list featured writers as celebrated as Ernest Hemingway (1899–1961), Agatha Christie (1890–1976), and Compton Mackenzie (1883–1972). It was precisely because other publishers were certain that the venture was doomed to failure that they allowed the creator of the list, Allen Lane, to pick up the rights for almost nothing.

More significantly, the books were packaged with simple, elegant, clear, obviously modern covers. This was not just serious publishing made accessible to almost anyone: it was the first, and perhaps the most lasting, demonstration of the power of design-led branding in the book world.

Lane's idea for the graphic cover design was not quite as original as it appeared. It was the German publisher, Albatross, which, in 1932, first recognized the potency of

ALLEN LANE

1902–1970

Allen Lane set up Penguin Books in 1936 after leaving Bodley Head. His cheap, boldly colored paperbacks revolutionized publishing and brought high-quality literature to the mass market.

In 1919, Lane joined the London publishing house Bodley Head, founded by his uncle John Lane. He initially fell out with his board of directors over the publication of James Joyce's controversial *Ulysses*, and they were equally sceptical of his launch of the first Penguins as an imprint. Vindication followed when Woolworths placed an order for 63,000 books. In January 1936, he launched Penguin as a separate company. Lane had conceived the idea of cheap, high-quality books that could be sold from vending machines in 1934, after finding himself at Exeter station with nothing to read. By March 1936, over 1 million Penguin paperbacks had been sold. Lane built brilliantly and relentlessly on this initial success. In 1937, he formed the educational list Pelican, with *The Pelican History of Art* becoming one of the great successes of postwar publishing. Puffin, a children's list, was established in 1940, with Penguin Classics following in 1945. Courtesy of Penguin, the likes of Evelyn Waugh, Aldous Huxley, E. M. Forster, and P. G. Wodehouse found new readers as the Penguin paperback became an intrinsic part of British cultural life.

bold colors, simple typefaces, and low prices in creating a new market. But it was Lane who had the crucial insight that quality, in every sense, was the key to mass-market success. The story of Penguin remains an enduring lesson in how culture can be popularized without cheapening it.

IN CONTEXT

In 1935, 21-year-old Edward Young, an office junior at Bodley Head, was commissioned by Lane to create the new logo and a cover design for the fledgling Penguin list. He would later say: "It was time to get rid of the idea that the only people who wanted cheap editions belonged to a lower order of intelligence and that therefore cheap editions must have gaudy and sensational covers." After World War II, Penguin would set higher standards still. The books that followed were in obvious contrast to the dime novel and their UK equivalent, "yellow-backs," expected of popular publishing.

▲ **Mass market fiction** on both sides of the Atlantic had no pretensions to literary merit. Sold as entertaining reading, dime novels and yellow-backs were popular reads.

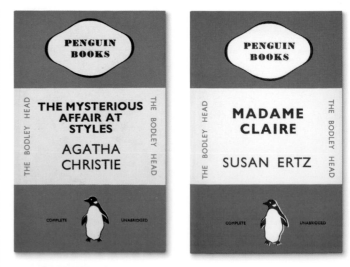

▲ **PURE DESIGN** The early Penguins were almost monastic in their purity: two bands of color at the top and at the bottom, with a white central panel containing the book's title and the author's name.

> [Lane created] an institution of national and international importance, like *The Times* or the BBC.

J. E. MORPURGO, *ALLEN LANE, KING PENGUIN* (1979)

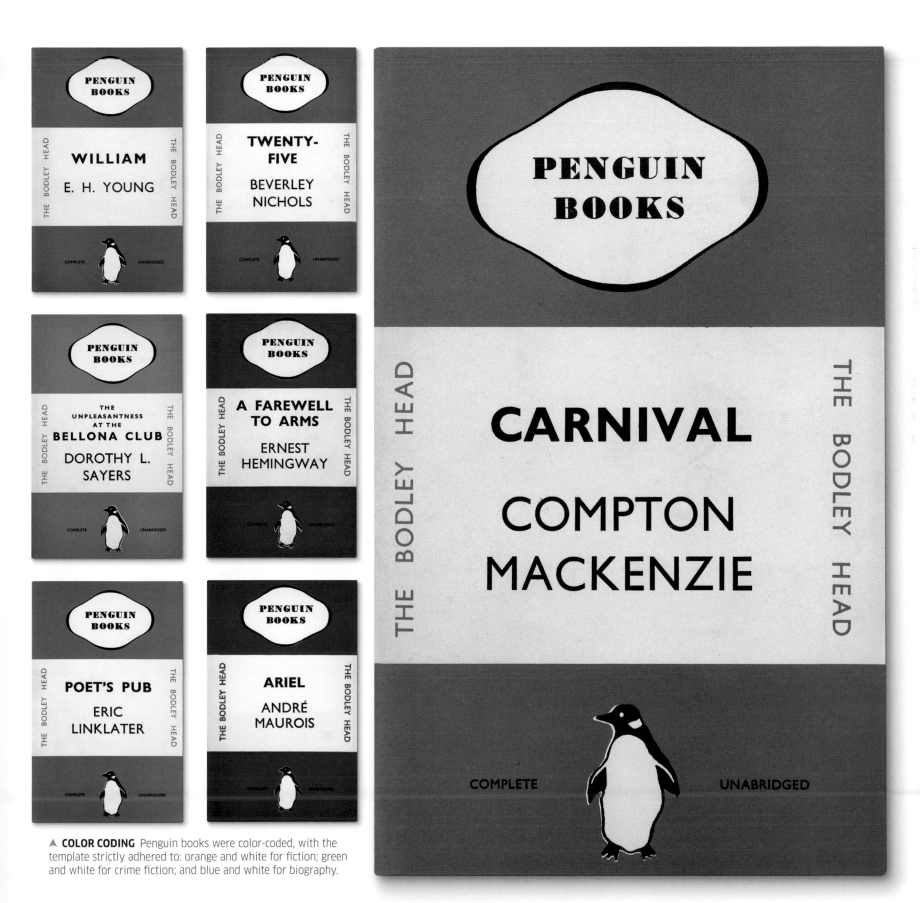

▲ **COLOR CODING** Penguin books were color-coded, with the template strictly adhered to: orange and white for fiction; green and white for crime fiction; and blue and white for biography.

The Diary of a Young Girl

1942–44 ■ AUTOGRAPH BOOK, EXERCISE BOOKS, AND LOOSE-LEAF PAGES ■ THE NETHERLANDS

ANNE FRANK

In 1947 a Jewish man named Otto Frank published the diary of his 13-year-old daughter. Anne had died of typhus two years previously in Bergen-Belsen, a concentration camp in Germany. Her diary records the two-year period that she and her family (along with four others) spent in hiding in a secret annex above her father's office during the Nazi occupation of Amsterdam. Anne's account became one of the most poignant and widely read books about World War II, and Anne became one of the most renowned victims of the Holocaust. Historians also value the work, seeing it as an integral example of Jewish persecution.

Anne Frank's writing filled three books (one autograph book and two school exercise books), as well as 215 loose sheets of paper. She began the diary in July 1942 to record her years in hiding, but decided to revise her work after hearing a radio bulletin in March 1944 calling for diaries and letters to be preserved for posterity. Anne then rewrote her diary on separate pages with a view to publication, adding context and omitting passages of less general interest. She had intended to publish it after the war as *Het Achterhuis* (*The Secret Annex*), but in August 1944 Nazi soldiers raided the annex, and Anne, her family, and the other occupants were deported to Westerbork concentration camp. Anne's diary was found by two of her father's office workers, who secured it until Otto Frank—the only survivor from the annex—returned after the war. He then had the diary published in Anne's memory.

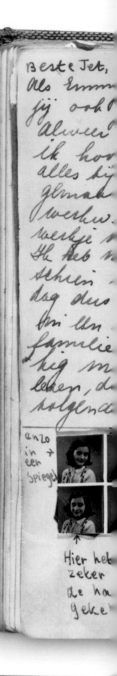

▶ **DEAR KITTY** In a few of her original diary entries Anne wrote her thoughts in the form of letters addressed to various imaginary friends—the letters on the left-hand page of the diary opposite are written to "Jet" and "Marianne." During her rewriting phase, Anne standardized her diary entries, addressing them all to "Dear Kitty." Whether Kitty was a real person or not is unknown.

In detail

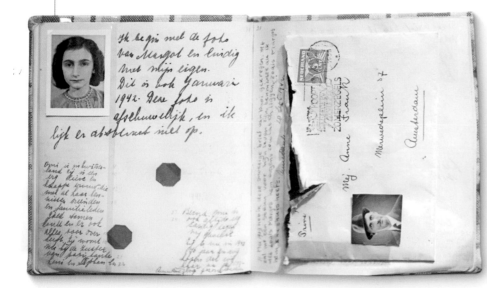

◀ **WISDOM IN YOUTH** Although only 13, Anne showed extraordinary maturity. In addition to keeping a record of daily life in the annex, Anne's entries often revealed deep thoughts and introspection as she contemplated the plight of the Jews and the fate that might await her family. She also expressed her ambition to become a writer and composed several short stories.

◄ **REMEMBERING BRIGHTER DAYS** As she coped with the close confinement in the attic Anne recalled happier times, pasting photos of friends and family vacations in her diary. These snapshots, from 1939 and 1940 show Anne and her family enjoying trips to the seaside. Anne notes that the photo at the top is the only one of her grandmother.

IN **CONTEXT**

On reading the salvaged remains of Anne's diary, Otto Frank discovered a side to his daughter that he had not been aware of. He was impressed and surprised by her depth of feeling and maturity, and decided to honor Anne's repeated wish to publish her diary. In selecting text for publication Otto realized that some sections of the diary were missing, and so he had to combine entries from her original text with those of her subsequent rewrites. He also made his own edits, removing Anne's references to her budding sexuality, as well as unkind comments she had made about her mother.

▶ **Anne's diary** was published on June 25 1947 as *Het Achterhuis*. It has since been translated into 60 languages.

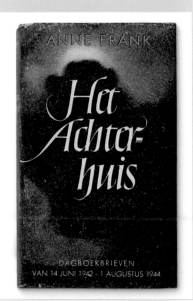

ANNE FRANK

Het Achter-huis

DAGBOEKBRIEVEN
VAN 14 JUNI 1942 - 1 AUGUSTUS 1944

Le Petit Prince

1943 ▪ PRINTED; CLOTH BOUND ▪ 9 × 6 in (23 × 16 cm) ▪ 93 PAGES ▪ USA

SCALE

ANTOINE DE SAINT-EXUPÉRY

A rare example of a children's book that has equally captured the hearts of adults, *Le Petit Prince* remains an international bestseller more than 70 years after its debut. First published in 1943 in both French and English, it has since been translated into over 250 languages and dialects, and is estimated to have been read by 400 million people worldwide. It is the tale of a lonely boy prince who comes to Earth from another planet in search of friendship and understanding. The story is a parable that warns against narrowmindedness and teaches the importance of exploration in order to grow spiritually. It has also been interpreted as a fable about the isolation and bewilderment of war.

Much of the appeal of *Le Petit Prince* lies in Antoine de Saint-Exupéry's watercolour illustrations, which feature throughout the book. They recreate specific scenes, and are also used by the narrator to test characters he meets, and to rediscover his childhood. Saint-Exupéry's original handwritten manuscript includes several watercolors that did not appear in the first edition. This draft manuscript—the only complete handwritten copy known to exist—is held at the Morgan Library & Museum in Manhattan.

ANTOINE **DE SAINT-EXUPÉRY**

1900–1944

Antoine de Saint-Exupéry was a French writer, aviator, and aristocrat. Although best remembered for his novella, *Le Petit Prince*, he also wrote several award-winning novels based on his experiences as a mail pilot and service in the French air force.

Antoine de Saint-Exupéry grew up in a castle in France and enjoyed a carefree childhood. He was privileged to experience his first aeroplane flight at the age of 12, which had a lasting impact on him. In April 1921 he trained as a pilot as part of his compulsory French military service. Later, while working as a mail pilot in North Africa, he wrote his first novel *Courrier Sud* (*Southern Mail*), published in 1929–the first of several books based on his flying exploits. When World War II broke out, Saint-Exupéry flew for the French air force, until the German occupation of France compelled him to flee to the US with his wife Consuelo Gómez Carillo in 1939. He settled in New York City, where he wrote and published *Le Petit Prince*, but thoughts of the war in Europe were on his mind, and in 1943 he enlisted with the Free French forces. He was declared missing in action while on a reconnaissance mission over France in July 1944.

In detail

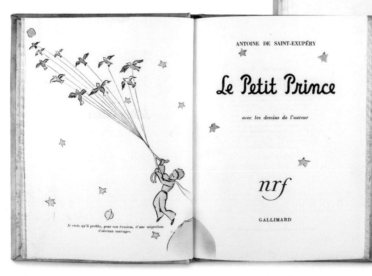

▲ **SKY OF STARS** Images of stars, appearing here on the title page, are repeated throughout the book. The narrator, a pilot, relies on stars for navigation, while the little prince lives among them. Stars symbolize the vastness of the universe, as well as the pilot's loneliness.

▲ **A CHILD'S VIEWPOINT** Saint-Exupéry immediately engages the reader with the illustrations. Here, what grown-ups only recognized as a hat, is shown to be a boa constrictor that has eaten an elephant. The different ways in which adults and children see the world is a recurring theme.

All grown-ups were once children … but only few of them remember it.

ANTOINE DE SAINT-EXUPÉRY, *LE PETIT PRINCE*

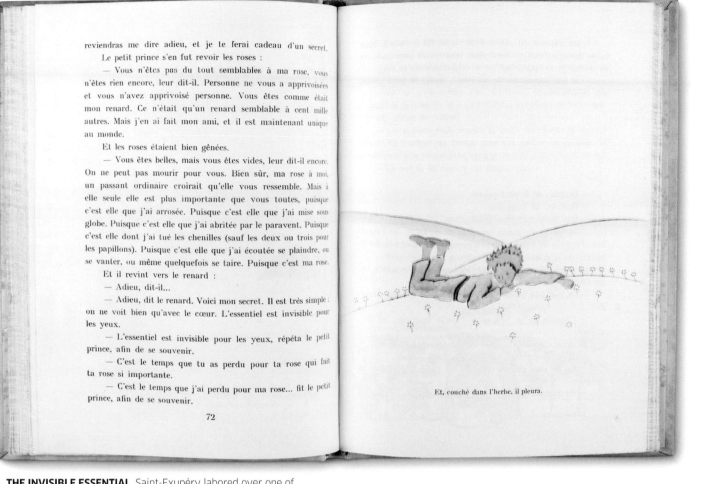

▲ **THE INVISIBLE ESSENTIAL** Saint-Exupéry labored over one of the most important phrases in the book, "*l'essentiel est invisible pour les yeux*" ("what is essential is invisible to the eye"), reworking it up to 15 times. Such reflections on human nature are frequent in the book, here suggesting that what one feels is most important.

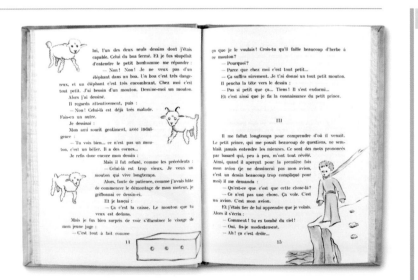

▲ **SHEEP IN A BOX** Black-and-white illustrations, drawn by the narrator, help to establish his relationship with the prince. Here, the prince requests a sheep drawing, but is dissatisfied with the result. The sketch of a box for the animal, however, pleases the prince, as it allows him to imagine the sheep.

IN **CONTEXT**

Le Petit Prince's themes of loss, loneliness, and a longing for home, were close to author's heart, as he wrote it while living in exile in the US during World War II. The narrator's plane crash in the desert was also inspired by real events: Saint-Exupéry's own plane came down in the Sahara desert in 1935, where he and his navigator were stranded for four days, coming close to death. *Le Petit Prince* was published in April 1943, but was initially not available to buy in France (the Vichy government of German-occupied France had banned the works of Sainte-Exupéry after he fled the country). The book was not published in France until the country was liberated in 1944, but went on to be elected the greatest book of the twentieth century in France.

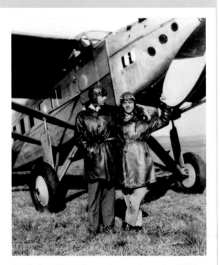

▲ **Saint-Exupéry**, shown here in 1929, used his experiences as a pilot to inform many of his books.

Le Deuxième Sexe

1949 ▪ PRINTED ▪ 8 × 5¹/₂ in (20.5 × 14 cm) ▪ 978 PAGES ▪ FRANCE

SCALE

SIMONE DE BEAUVOIR

The Second Sex (*Le Deuxième Sexe*) is considered one of the founding texts for the feminist movement. It proposes that women are not born with feminine qualities but learn to take them on; furthermore, it outlines how women are conditioned from birth to fit a stereotype, which prevents them from ever being free. De Beauvoir maintained that three steps were necessary for women to challenge the set path laid out for them by society: they must work, develop their intellect, and strive for economic equality. Published in France in 1949, the book did not fully make an impact until the English edition, heavily cut, was published in the U.S. in 1953, causing widespread controversy.

SIMONE DE BEAUVOIR

1908–1986

Born in Paris, Simone de Beauvoir was a philosopher, writer, and committed socialist. She remains best known for her impact on the women's movement and her feminist treatise *Le Deuxième Sexe*.

At the age of 14, de Beauvoir rejected the existence of God and decided never to marry, devoting herself to the idea of life as a philosopher and teacher. She studied philosophy at the Sorbonne, Paris, and taught the subject. With fellow philosopher Jean-Paul Sartre, who would become her partner and lifelong friend, she was one of the leading figures in the French existentialist movement in the mid-twentieth century. She wrote varied works, including the novel *Les Mandarins*. *Le Deuxième Sexe* became essential reading for feminists in the 1960s, inspiring Betty Friedan and Germaine Greer, among others.

◄ **TWO PARTS** Conceived in two parts, *Le Deuxième Sexe* was written as a history of women, in which the author presents men as oppressors and women as the "other," the second sex. The first part, entitled "Facts and Myths," explores the events and cultural forces that forced women to be subordinate to men.

◄ **CREATED HISTORY** The "History" section in Volume 1 covers the historical suppression of women by men. Here, de Beauvoir concludes that men—as the creators of values and ideologies—have composed women's history, but that the majority of women have adapted to their subordinate status rather than acted against it.

◄ **LIFE JOURNEY** "One is not born, but rather becomes, a woman," de Beauvoir famously wrote. The second half of her book, "Lived Experience," attempts to describe in detail how this happens. The author takes a personal view of a woman's journey from birth to old age, to explain how she learns to take on feminine qualities.

The Feminine Mystique

1963 ▪ PRINTED ▪ 8 × 6 in (21 × 15 cm) ▪ 416 PAGES ▪ USA

BETTY FRIEDAN

SCALE

Betty Friedan's book about women's dissatisfaction with their roles in society triggered a chain of events in the U.S. that eventually changed the balance of power between the sexes, both culturally and politically. Friedan wrote that women in the 1950s suffered under the expectation that they should be perfect housewives and mothers, projecting an image of idealized femininity, which the author dubbed "the feminine mystique." With its discussion of women who had gone against this image, the book made a powerful contribution to a new wave of feminism that resulted in legislation for equal pay and the formation of numerous women's groups to champion the rights of women.

BETTY **FRIEDAN**

1921–2006

Acknowledged as one of the most influential women of the twentieth century, Betty Friedan (born Bettye Naomi Goldstein) championed the right of women to break free from stifling traditional roles.

The feminist pioneer Betty Friedan graduated with a degree in psychology from the University of California. In 1947 she moved to New York City, where she worked as a reporter before marrying Carl Friedan and having three children. Frustrated by being a stay-at-home mom, and with the lack of workplace options for mothers, she began to research how other women felt. The book that resulted, *The Feminine Mystique*, raised awareness about women's discontent and is credited with sparking "second-wave feminism," which spanned the 1960s to the late 1980s (the "first wave" being the fight for suffrage in the early 1900s).

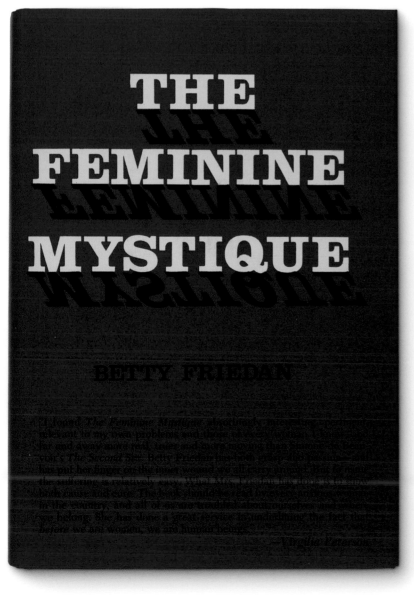

▲ **ALTERNATIVE LIFE** In the final chapter, Friedan proposes an alternative way of life for women, in which they can combine the traditional role of homemaker with meaningful work. She gives examples of women who have successfully managed motherhood and a career, but she also acknowledges the challenges that come with juggling both.

◄ **FEMININE REFLECTIONS** The cover's bold design, with the reflected title, plays with the idea that Friedan believed that women were frustrated because they felt pressured to present an idealized exterior to society. In reality, they were harboring unfulfilled desires, which Friedan called "the problem that has no name."

Silent Spring

1962 ■ PRINTED ■ 9 × 6 in (22 × 15 cm) ■ 368 PAGES ■ USA

RACHEL CARSON

SCALE

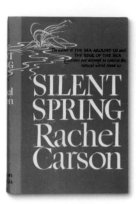

One of the most powerful natural history books ever written, Rachel Carson's *Silent Spring* was the spark that ignited the environmental movement. The book's meticulous exposure of the damage done by agricultural pesticides—in particular DDT, one of the strongest ever developed—was the wake-up call that alerted people to the perils of pollution by chemicals.

In 1958, Carson, a bestselling author of nature books, was prompted to investigate the use of pesticides when a friend wrote to her about how DDT was killing birds in nearby Cape Cod. The pesticide was first employed in World War II to control insects that caused malaria, but, by the 1950s, it was used extensively on farm crops.

As Carson worked on her book, she communicated with many scientists and built up a compelling case against DDT. She showed how it entered the food chain and accumulated in the fatty tissues of animals, including humans, causing genetic damage and diseases such as cancer. Birds were suffering, too—especially the bald eagle, the U.S. national symbol—as DDT thinned the shells of their eggs.

RACHEL **CARSON**

1907-1964

Rachel Carson was an American marine biologist and natural history writer whose seminal book *Silent Spring* brought the dangers of pesticides to public attention.

Born on a farm in Pennsylvania, Carson grew up among animals and wrote stories about them. She trained as a marine biologist, then worked for the U.S. Department of Fisheries. In 1951 she wrote *The Sea Around Us*, a poetic introduction to marine life, which became a bestseller and established her reputation as a writer. In the late 1950s, she turned her attention to conservation and the perils of pesticides, revealed in *Silent Spring* in 1962. She died two years later at her home in Maryland.

Carson's great achievement with *Silent Spring* was to make her findings accessible and compelling to a general readership. She instilled a sense of urgency and fear in the wider public, which forced social and political change. *Silent Spring* led to an eventual ban on the use of DDT, and to the establishment of the Environmental Protection Agency in the U.S.

▶ **RIVERS OF DEATH** In one of the key chapters, Carson explains the effects of DDT on salmon as it leaks into rivers. She describes how poisons can be passed up the food chain to reach human consumers.

In detail

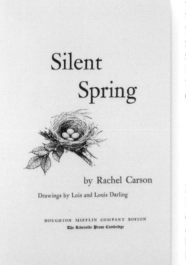

◀ **LOUD AND CLEAR** The title *Silent Spring* originates from the description of a scenario in which all spring songbirds were killed by DDT. It became a metaphor for the way humans could destroy the environment.

▶ **UNIQUE COMBINATION** Making the argument more accessible, Carson's powerful and poetic language was beautifully complemented by the exquisite drawings of American illustrators Lois and Louis Darling.

7. Needless Havoc

AS MAN PROCEEDS toward his announced goal of the conquest of nature, he has written a depressing record of destruction, directed not only against the earth he inhabits but against the life that shares it with him. The history of the recent centuries has its black passages—the slaughter of the buffalo on the western plains, the massacre of the shorebirds by the market gunners, the near-extermination of the egrets for their plumage. Now, to these and others like them, we are adding a new chapter and a new kind of havoc—the direct killing of birds, mammals, fishes, and indeed practically every form of wildlife by chemical insecticides indiscriminately sprayed on the land.

Under the philosophy that now seems to guide our destinies, nothing must get in the way of the man with the spray gun. The incidental victims of his crusade against insects count as nothing; if robins, pheasants, raccoons, cats, or even livestock happen to inhabit the same bit of earth as the target insects and

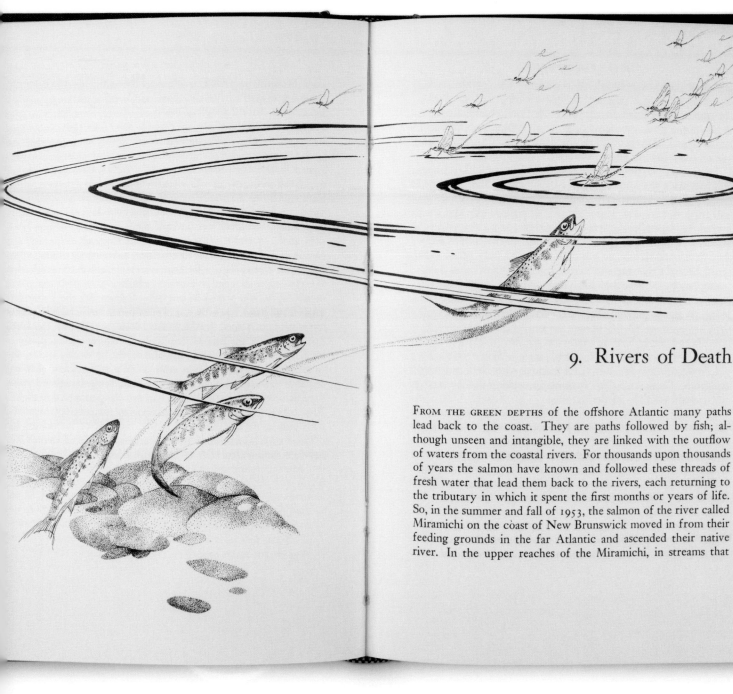

9. Rivers of Death

FROM THE GREEN DEPTHS of the offshore Atlantic many paths lead back to the coast. They are paths followed by fish; although unseen and intangible, they are linked with the outflow of waters from the coastal rivers. For thousands upon thousands of years the salmon have known and followed these threads of fresh water that lead them back to the rivers, each returning to the tributary in which it spent the first months or years of life. So, in the summer and fall of 1953, the salmon of the river called Miramichi on the coast of New Brunswick moved in from their feeding grounds in the far Atlantic and ascended their native river. In the upper reaches of the Miramichi, in streams that

Only [in] the **present century** has one species—man—**acquired significant** power to **alter** the **nature** of the world.

RACHEL CARSON, *SILENT SPRING*

,,

IN **CONTEXT**

After the publication of *Silent Spring*, chemical companies rushed to defend the use of DDT. They argued that many people would die of malaria without it. But Carson's argument swayed President John F. Kennedy to order an investigation, which then vindicated her research. The use of DDT came under close scrutiny by government officials, and in 1972, it was banned in the U.S. as a crop spray; other countries followed, including the UK in 1984. In 2001, the Stockholm Convention introduced a worldwide ban on the agricultural use of DDT; its use has been so drastically curtailed, and today its sole legal use is to control malaria-carrying mosquitoes.

▲ **The widespread spraying** of crops with synthetic chemicals to combat insects that caused disease or attacked crops became commonplace in the 1950s.

Quotations from Chairman Mao Tse-tung

1964 ▪ PRINTED ▪ 6 × 4 in (15 × 10 cm) ▪ 250 PAGES ▪ CHINA

MAO TSE-TUNG

SCALE

Vying with the Bible as the bestselling book of all time, *Quotations from Chairman Mao Tse-tung* is a collection of sayings from the former Chinese Communist leader. It is estimated that more than five billion copies have been printed in 52 languages, with 800–900 million copies sold worldwide. Aside from its status as a publishing phenomenon, the book was a vital political tool, unifying the people of China during the country's transition to a strict form of Communism in the mid to late 1960s.

Running to 88,000 words, the collection of quotations was conceived by Mao and his Defense Minister Lin Biao as an inspirational guide for members of the Red Army. Communist Party officials saw its potential in helping to change popular opinion and vowed to distribute a copy to every citizen—in 1966, new printing houses were built to realize this aim. The book was taught in schools and studied in the workplace, and it was also obligatory to memorize passages to show allegiance to the Party.

IN CONTEXT

In May 1966 the ruling Communist Party in Beijing, led by Mao Tse-tung, launched a program of measures aimed at purging the country of what it saw as capitalist pro-bourgeois elements. This movement became known as the Cultural Revolution. Lasting a decade, it resulted in strict social and political control at every level of society, enforced by a militant student army called the Red Guards.

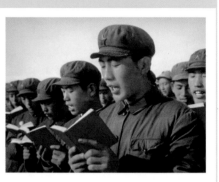

▲ **Every member** of the Red Guard was given their own "Little Red Book." In time, all citizens were expected to carry a copy.

Outside China, Mao's collection of quotations was dubbed the "Little Red Book," an allusion to its red cover. It caught the imagination of diverse political groups, such as the Black Panthers in the 1960s and 1970s, and Peru's Shining Path guerrillas in the 1980s.

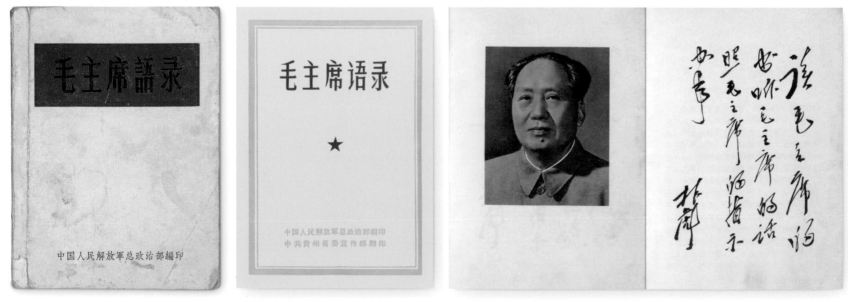

▲ **POCKET SIZE** The book, scaled to fit the breast pocket of an army uniform, was first published with either paper covers, as here, for individual soldiers, or harder-wearing vinyl covers for sharing.

▲ **RED STAR** The five-pointed red star is a well-known symbol of revolutionary communism. Widely used during Mao's time in power, it is shown here centered on the title page of the book, drawing attention to his socialist outlook.

▲ **LINKS WITH HISTORY** "The people, and the people alone, are the motive force in the making of world history," declared Mao in his book, which he modeled on the published sayings of Confucius (see p.50). The inclusion of calligraphy opposite Mao's portrait creates a link between him and the great philosophical traditions of China's past. Mao's aphorisms were gathered from several decades of his political career and embraced varied subjects, such as socialism, communism, youth, and the importance of frugality.

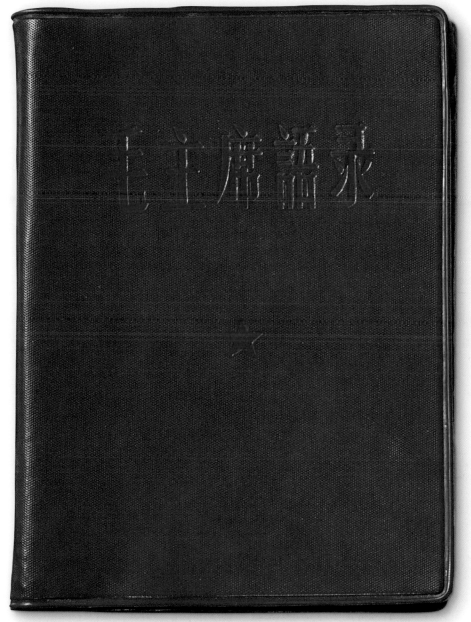

A revolution is not a dinner party, or writing an essay, or painting a picture, or doing embroidery… A revolution is an insurrection, an act of violence by which one class overthrows another.

MAO TSE-TUNG, *QUOTATIONS FROM CHAIRMAN MAO TSE-TUNG*

◀ **COMMUNIST ICON** The book's red cover became an icon of Communist China. Red was not only the color of good luck in China, but also of communism, representing the blood spilled by workers in their revolutionary struggle, and it was associated with China's ethnic Han majority. Until the Chinese Revolution of 1911–12, China had been ruled for over two centuries by the minority Manchu, represented by the color yellow, so the use of red had powerful connotations for the 1.2 billion mainland Han Chinese. After Mao took control of China in 1949, the national flag was changed from yellow to red, and the song "The East is Red" was popularized as part of the effort to cement Mao's image as China's savior.

四、两类不同性质的矛盾

在我们的面前有两类社会矛盾，这就是敌我之间的矛盾和人民内部的矛盾。这是性质完全不同的两类矛盾。

《关于正确处理人民内部矛盾的问题》（一九五七年二月二十七日），人民出版社版第一页

为了正确地认识敌我之间和人民内部这两类不同的矛盾，应该首先弄清楚什么是人民，什么是敌人。……在现阶段，在建设社会主义的时期，一切赞成、拥护和参加社会主义建设事业的阶级、阶层和社会集团，都属于人民的范围；一切反抗社会主义革命和敌视、破坏社会主义建设的社会势力和社会

41

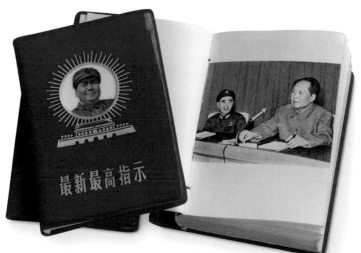

▲ **REVISED EDITIONS** The book was revised a few times before the final volume was published in May 1965. The 1964 original, shown here, had 250 pages, divided into 30 chapters, with 200 quotations on 23 different topics. After feedback from Communist Party officials and members of the People's Liberation Army, it was extended by 20 pages, with 33 chapters and 427 quotations.

▲ **ACCESSIBLE TEXT** The book distilled Mao's dictates on politics, culture, and society into short sayings using everyday language so that it was easily understood.

▲ **COVER STAR** By 1969 the book featured a portrait of Mao on the cover, as well as a photograph of him inside with his second-in-command, Lin Biao. Mao had been in power since 1949, but it was Lin who was instrumental in building the cult of Mao in the 1960s. "Every lesson in political education must use the works of Chairman Mao as an ideological guide," he decreed in 1961.

Directory: 1900 onward

MARRIED LOVE
MARIE STOPES

UK (1918)

Written for married couples by British scientist and activist Marie Stopes (1880-1958), this book, sometimes called *Love in Marriage,* was the first to openly discuss birth control, and promote equality between men and women as sexual partners. *Married Love* revolutionized contemporary views on contraception and marital sex. It was condemned by the Church—in particular the Roman Catholic Church—medical establishments, and the press, and was banned in the U.S. until 1931. Yet the book was instantly popular, and its first print run of 2,000 copies sold out within two weeks; by 1919, it was in its sixth revised, updated, and expanded edition. Marie Stopes became an overnight sensation among young women, and *Married Love* the platform to launch her campaign for women's right to birth control. In 1921, she opened a family planning clinic in London, the first in the country.

WIRTSCHAFT UND GESELLSCHAFT
MAX WEBER

GERMANY (1922)

Known in English as *Economy and Society,* this is the most important work of German sociologist, philosopher, and political economist Max Weber (1864-1920). *Economy and Society* is a collection of theoretical and empirical essays that set out Weber's theories and views on topics such as social philosophy, economics, politics, world religion, and sociology. Weber died before finalizing the texts, so his wife (a feminist and author in her own right) edited and prepared the essays for publication. *Economy and Society* was not translated into English until 1968. It is now widely acknowledged to be one of the most influential sociological texts ever written.

MEIN KAMPF
ADOLF HITLER

GERMANY (VOLUME I, 1925; VOLUME II, 1927)

Translating as "My Struggle," *Mein Kampf* was written by Nazi leader Adolf Hitler (1889-1945) while he was imprisoned following the failed Munich Putsch of 1923. *Mein Kampf* was one of the most contentious and inflammatory books ever written, and came to encapsulate the doctrine of the Nazi Party. Part political manifesto, part autobiography, it outlined Hitler's racist ideology—his glorification of the Aryan "master" race and his vilification of Jews and Communists; as well as his desire for vengeance against France for Germany's defeat in World War I; and his plans for establishing power in a new Germany. Although poorly written and stretching to 1,000 pages, *Mein Kampf* became a bestseller and had sold 5.2 million copies by 1939, rising to 12.5 million by 1945. After World War II, the copyright was awarded to the state of Bavaria, which banned its publication. This copyright ownership expired on January 1, 2016.

▶ LADY CHATTERLEY'S LOVER
D. H. LAWRENCE

ITALY (1928)

Perhaps the twentieth century's most notorious piece of fiction, and certainly the one for which D. H. Lawrence (1885-1930) was best known, *Lady Chatterley's Lover* was a landmark novel that broke the contemporary boundaries of moral and sexual taboos. First published privately in Florence, Italy, this story of an affair between an upper-class, titled woman and her husband's gamekeeper was immediately banned in Britain and the U.S. for its explicit sexual content and its repeated use of offensive four-letter words. In 1960, Penguin Books published an uncensored edition and was prosecuted under

First edition of *Lady Chatterley's Lover,* published by Tipografia Giuntina, Italy.

the Obscene Publications Act 1959. The trial that followed eventually ruled in favor of Penguin Books, citing the literary merit of *Lady Chatterley's Lover.* The book quickly became a bestseller and has since been adapted for film, television, and the theater. The publicity during the trial and the momentous ruling paved the way for increased liberalism in publishing and heralded the start of a sexual revolution in books in the decades that followed.

A SAND COUNTY ALMANAC
ALDO LEOPOLD

USA (1949)

Written by U.S. scientist, ecologist, and environmentalist Aldo Leopold (1887-1948), *A Sand County Almanac*

has been pronounced as one of the most significant environmental works of the twentieth century, along with Rachel Carson's *Silent Spring* (see pp.238-39). Leopold was a champion of biodiversity and ecology, and a founder of the science of wildlife management. *A Sand County Almanac* takes the form of a collection of essays in which Leopold called for preservation of ecosystems, and argued for a responsible, ethical relationship between humans and the land they live in. His writing is notable for its simple directness. Published shortly after his death by his son Luna, *A Sand County Almanac* was Leopold's most important book. It was a landmark publication for the developing U.S. environmental movement and encouraged widespread interest in ecology as a science. This remarkable text has been translated into 12 languages.

THE STORY OF ART
E.H. GOMBRICH

UK (1950)

This illustrated narrative history, which traces the origins of art from ancient to modern times, was the masterwork of Austrian-born art historian and scholar Ernst Gombrich (1909-2001). Since its first publication, *The Story of Art* has maintained its position as the world's bestselling art book. Divided into 27 chapters, each covering a specific period of art history, it is renowned for its clear and accessible narrative and features hundreds of full-color reproductions of pieces of art. The book has been updated regularly and translated into at least 30 languages. The sixteenth edition was published in 2007.

NOTES OF A NATIVE SON
JAMES BALDWIN

USA (1955)

American novelist, playwright, poet, and essayist James Baldwin (1924-87) was in his 20s when he wrote the 10 essays collectively published as *Notes of a Native Son*. The essays had all been published previously in magazines, such as *Harpers*, and together established him as one of the leading and most insightful writers of Black America. Part autobiography and part political commentary on the racial climate in the U.S. and Europe at the early stages of the Civil Rights Movement, *Notes of a Native Son* became a classic text of the black autobiographical genre. In his essays Baldwin attempted to empathize with the white population, while at the same time vilifying the treatment of all black people. As a result *Notes of a Native Son* ignited fierce criticism, as well as critical acclaim.

▶ ON THE ROAD
JACK KEROUAC

USA (1957)

Lauded as one of the most significant novels of the twentieth century, *On the Road* by American writer Jack Kerouac (1922-69) describes a group of friends on road trips across the U.S. set against a heady backdrop of jazz, sex, and drugs. In this iconic blend of fiction and autobiography, Kerouac began the Beat literary movement and captured the spirit of the idealistic youth searching for freedom. Kerouac wrote the first draft of *On the Road* in a three-week, amphetamine and caffeine-fueled stint, in which he fed taped-together sheets of tracing paper into a typewriter and typed using single-spaced text (and no margins or paragraph breaks) until he completed the novel; the resulting "scroll" was 120 ft (37 m) long. Kerouac subjected the text to many rewrites until 1957, when the book was published. It was an overnight sensation; its literary and cultural influence was enormous and *On the Road*—heralded as the bible of the Beat generation—has been the object of critical study ever since.

LA GUERRA DE GUERRILLAS
ERNESTO "CHE" GUEVARA

CUBA (1961)

Written by the Marxist revolutionary Che Guevara (1928-67), *La Guerra de Guerrillas* (or *Guerrilla Warfare*) was intended to inspire revolutionary movements across Latin America. Drawing on his experiences and success in the Cuban Revolution, Guevara's book outlined his tactical philosophy for guerrilla warfare, emphasizing it as a tool against totalitarian regimes where legal and political tactics had failed. In his quest to bring communism to Latin America and alleviate the grinding poverty he had witnessed there as a young man, Che Guevara created a text that became the guidebook for left-wing insurgents around the world.

THE MAKING OF THE ENGLISH WORKING CLASS
EDWARD PALMER THOMPSON

UK (1963)

In his 900-page volume *The Making of the English Working Class*, left-wing historian Edward Palmer Thompson (1924-93) presented a revolutionary new look at British social history. Thompson's book looks at the origins of working class society as it grew following the Industrial Revolution. The book concentrates especially on its formative years from 1780 to 1832, and was the first systematic examination of the working class ever undertaken. Thompson drew on a wide range of source material, but much of it was unorthodox, as official historical documents included very little from working class people themselves, due to widespread illiteracy. Instead Thompson gained much of his information from material enshrined in popular culture, such as songs and ballads, stories, and even sports. Thompson made an effort to re-create the life experience of the working classes, and by doing so he gave a voice to a people who were typically viewed as an anonymous mass. *The Making of the English Working Class* is one of the most significant works of history in the post-World War II period.

PHOENIX
OSAMU TEZUKA

JAPAN (1967-88)

Created by the Japanese artist, cartoonist, animator, and film producer Osamu Tezuka (1928-89), *Phoenix* comprises a series of manga tales. A major part of the Japanese publishing industry, manga are comics that conform to a style first developed in the nineteenth century and are read by people of all ages. *Phoenix* features 12 stories based on reincarnation. Each one is set in a different era, but they are all linked by the appearance of the mythical bird. Tezuka's work was highly visual and experimental, and his subject matter ranged from love to science fiction. After many attempts at publication, *Phoenix* was serialized in the Japanese magazine *COM*. Tezuka considered this to be his most important work, but he died before completing it.

a novel
by Jack Kerouac

ON THE ROAD

Cover of a U.S. first edition of Jack Kerouac's *On the Road.*

THE FEMALE EUNUCH
GERMAINE GREER

AUSTRALIA AND UK (1970)

The publication of *The Female Eunuch* launched the Australian writer and feminist Germaine Greer (b.1939) as one of the leading voices in second-wave feminism. Following writers such as Simone de Beauvoir (see p.236) and Betty Friedan (see p.237), Greer challenged the role of women in society at a time when they could not get a mortgage or even buy a car unless their husband or father countersigned the documents. Greer argued that the accepted repression of women castrated them emotionally, sexually, and intellectually. The book–notable for its iconic and shocking cover featuring a hanging female torso–promoted lively debate around the world and was both acclaimed and criticized by many. *The Female Eunuch* was an immediate bestseller and by early 1971 even the second printing had almost sold out.

WAYS OF SEEING
JOHN BERGER

UK (1972)

This pioneering book by British writer, artist, and art critic John Berger (1926–2017) was written alongside a BBC television series of the same name that featured four 30-minute programs on the nature of art. An introduction to the study of images, *Ways of Seeing* comprises seven essays, four of which have words and images, and three of which use only images. The book aimed to change the way people perceive and respond to art.

SURVEILLER ET PUNIR
MICHEL FOUCAULT

FRANCE (1975)

A history of the prison system in Western Europe, known in English as *Discipline and Punish: The Birth of the Prison*, this book was written by the French historian and philosopher Michel Foucault (1926–84). In it, Foucault examined how the penal system developed from castle dungeons, brutal jails, and the eighteenth-century focus on corporal or capital punishment, to the modern "softer" form of discipline, or correction, through incarceration. Foucault argued that the various reforms implemented over time had been made to enable a more effective means of control, rather than to improve prisoner welfare.

ORIENTALISM
EDWARD SAID

USA (1978)

This ground-breaking book by the Palestinian-American academic Edward Said (1935–2003) is one of the most influential academic texts of the twentieth century. Said argued that the academic field of "Orientalism" (the Western study of the Orient, or societies and peoples who inhabit Asia, North Africa, and the Middle East) is the product of a biased, imperialist ideology that created false cultural stereotypes of the East (in particular of the Islamic world) in order to support and reaffirm Western superiority and colonial policy. *Orientalism*, the work Said was best known for, redefined the way that academics understood colonialism. It has had a lasting influence on the development of literary theory and cultural criticism in the field of Middle Eastern studies, and has become a foundation text in the study of Post-colonialism.

◀ GAIA
JAMES LOVELOCK

UK (1979)

Subtitled "*a New Look at Life on Earth*," this popular science book by the English chemist James Lovelock (b.1919) outlined his "Gaia" hypothesis to a lay readership. First proposed in scientific journals in 1972, Lovelock's theory suggested that living and nonliving organisms on Earth form part of an integrated, self-regulating system that maintains ideal conditions for life to flourish. While it was initially met with scepticism, the Gaia principle is now acknowledged as accepted scientific theory. Lovelock made various predictions on the basis of his proposal, many of which have proved correct, including global warming. *Gaia* was written at the start of the environmentalist movement, and Lovelock has since produced several more texts on his hypothesis, including *The Revenge of Gaia: Why the Earth is Fighting Back and How We Can Still Save Humanity*, which was published in 2007.

MANUFACTURING CONSENT
NOAM CHOMSKY AND EDWARD S. HERMAN

USA (1988)

In this book, the U.S. theoretical linguist Noam Chomsky (b.1928) and U.S. economist Edward S. Herman (b.1925) delivered a searing attack on the mainstream media. In *Manufacturing Consent*, Chomsky and Herman examined evidence suggesting that the mainstream (corporate-owned) media work to support the financial interests and political prejudices of the companies that own them, and of the advertisers who financially support them. Referred to by Chomsky as the "propaganda model of communication," this unprecedented critique of the media undermined the Western concept of a free press.

A BRIEF HISTORY OF TIME
STEPHEN HAWKING

UK (1988)

A landmark work by the British physicist Stephen Hawking (b.1942), *A Brief History of Time: From Big Bang to Black Holes* was targeted at a nonscientific readership. In it, Hawking used nontechnical terms to explain the structure, origin, and development of the universe, and what he proposed as its eventual fate. In doing so he addressed some of the most baffling questions concerning space and time, including the Big bang theory, the expanding universe, quantum theory, and general relativity, as well as his own radical theories on

Cover of the first edition of Lovelock's *Gaia: A new look at life on Earth.*

black holes. Hawking's greatest achievement was to render such complex subject matter so accessible to a lay readership. More than 10 million copies of *A Brief History of Time* were sold within 20 years, and it has been translated into 40 languages. In 2005, a shorter version—*A Briefer History of Time*—was published in collaboration with U.S. popular science writer Leonard Mlodinow (b.1954).

HARRY POTTER AND THE SORCERER'S STONE
J. K. ROWLING

UK (1997)

The first in a series of novels that became a publishing phenomenon, this book launched the writing career of Joanne (J. K.) Rowling (b.1965). The series chronicles the passage from childhood to adulthood of a young wizard and his friends at Hogwarts School of Witchcraft and Wizardry. *The Sorcerer's Stone* was followed by *The Chamber of Secrets* (1998), *The Prisoner of Azkaban* (1999), *The Goblet of Fire* (2000), *The Order of the Phoenix* (2003), *The Half-Blood Prince* (2005), and *The Deathly Hallows* (2007), which became the fastest-selling book in history with 11 million copies sold in the first 24 hours. The Harry Potter books were simultaneously published in children's editions and adult editions (the latter with more sophisticated covers). The series has been translated into more than 65 languages, including Latin and Ancient Greek. Publication dates have even been timed to coincide with school holidays so as not to cause truancy in children desperate to read the books as soon as they appear.

▶ BUILDING STORIES
CHRIS WARE

USA (2012)

This uniquely crafted graphic "novel" was created by the U.S. artist Chris Ware (b.1967). It is presented as a boxed set comprising 14 separate printed elements, including pamphlets, newspapers, comic strips, and posters, which together graphically depict the lives of three groups of inhabitants of a three-story Chicago apartment

Front cover of Chris Ware's *Building Stories* box set.

block (mainly from the women's standpoint), and that of a bee—the only male character in the book. Each of the 14 elements can be read in any order, or even independently, but they combine to create a rich multilayered story of loss and loneliness. Ware is heralded as one of the leading practitioners in this experimental genre, and *Building Stories* has won many prizes.

THE DRINKABLE BOOK
WATERisLIFE IN PARTNERSHIP WITH DR. THERESA DANKOVICH

USA

This 3D-printed water sanitation manual is the brainchild of U.S. scientist Dr. Theresa Dankovich, and is being developed in conjunction with the nonprofit organization

WATERisLIFE. Part information guide, part water filter, this book has the potential to bring clean water to millions. The pages are impregnated with bacteria-killing nanoparticles of silver, and have hygiene and sanitation information printed on them. Each page can filter around 22 gallons (100 liters) of water, so a single book could provide a clean water supply to one person for four years.

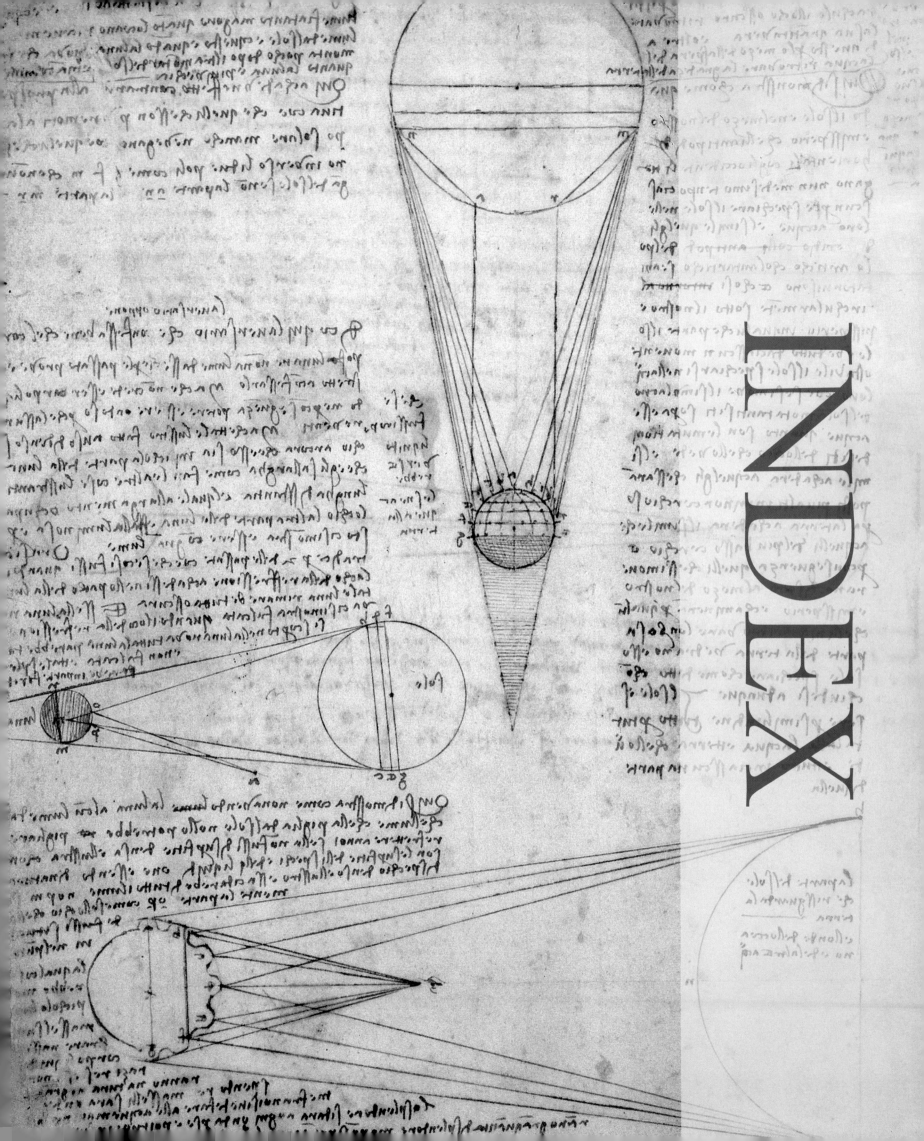

Index

Page numbers in **bold** refer to main entries.

Acknowledgments

Dorling Kindersley would like to thank the following people for their assistance with this book:.

Jay Walker founder of **The Walker Library** for access to his collection

Angela Coppola at Coppola Studios for photography; Ali Collins, Chauney Dunford, Cressida Tuson, Janashree Singha and Sugandha Agrawal for editorial assistance; Ray Bryant and Rohit Bhardwai for design assistance; Tom Morse for creative technical support; Steve Crozier for retouching; Joanna Micklem for proofreading; Helen Peters for compiling the index; Roland Smithies at Luped for picture research; Nishwan Rasool for picture research assistance; Syed Mohammad Farhan, Ashok Kumar, Sachin Singh, Neeraj Bhatia, Satish Gaur and Sachin Gupta for Hires and DTP assistance; Angela Coppola at Coppola Studios for photography.

The publisher would specially like to thank the following people for their help in providing DK with images:
John Warnock (rarebookroom.org); Dr Chris Mullen (for providing images of his first edition volumes of *Tristram Shandy*).

The publisher would like to thank the following for their kind permission to reproduce their photographs:

(Key: a-above; b-below/bottom; c-center; f-far; l-left; r-right; t-top)

1 Library of Congress, Washington, D.C.: Music Division (c). **The Metropolitan Museum of Art, New York:** Purchase, Lila Acheson Wallace Gift, 2004 (cl). **PENGUIN and the Penguin logo are trademarks of Penguin Books Ltd:** (cr). **2 Herzog August Bibliothek Wolfenbüttel::** Cod. Guelf. 105 Noviss. 2°. **3 Herzog August Bibliothek Wolfenbüttel::** Cod. Guelf. 105 Noviss. 2°. **4-5 akg-images. 6-7 Alamy:** The Natural History Museum (b). **The Trustees of the British Museum:** (t). **RMN:** RMN-Grand Palais (domaine de Chantilly) / René-Gabriel Ojéda (c). **8 The Trustees of the British Museum:** (bl). **Harvard Art Museums:** Unknown Artist, Ink, opaque watercolour and gold on paper; 18 x 14.7cm / Arthur M. Sackler Museum, The Stuart Cary Welch Collection, Gift of Edith I. Welch in memory of George Bickford, 2009.202.37 (br). **9 Alamy:** www.BibleLandPictures.com (tr). **The Metropolitan Museum of Art, New York:** Purchase, Lila Acheson Wallace Gift, 2004 (bl). **Courtesy Of The Board Of Trinity College, Dublin:** (br). **10 Bridgeman Images:** British Library, London, UK (bl, br). **11 Library of Congress, Washington, D.C.:** Music Division (br). **Octavo Corp.:** Stanford Library (tr). **12 Octavo Corp.:** Stanford Library (br). **13 Dr Chris Mullen, The Visual Telling of Stories:** (bl). **The Stapleton Collection:** (br). **The Master and Fellows of Trinity College, Cambridge:** (tr). **14 Octavo Corp.:** Warnock Library (br). **15 PENGUIN and the Penguin logo are trademarks of Penguin Books Ltd:** (tr). **Photo Scala, Florence:** The Museum of Modern Art, New York (bl). **16-17 Courtesy Of The Board Of Trinity College, Dublin. 18-19 Getty Images:** DEA / S. Nannini. **18 Bridgeman Images:** Louvre, Paris, France (bl). **20-21 The Trustees of the British Museum. 22-23 The Trustees of the British Museum. 24 Alamy:** Granger Historical Picture Archive (cr). **FOTOE:** Yin Nan (bl). **National Library of China:** (br). **25 Bibliothèque nationale de France, Paris:** (t). **Gottfried Wilhelm Leibniz Bibliothek:** (bl). **26 Special Collection, University of California Riverside:** Vlasta Radan. **27 Alamy:** Universal Art Archive (cr). **AlexHe34:** https://creativecommons.org/licenses/by-sa/3.0/legalcode (cr). **Special Collection, University of California Riverside:** Vlasta Radan (cl, bl, bc). **28-29 Harvard Art Museums:** Unknown Artist, Ink, opaque watercolour and gold on paper; 18 x 14.7cm / Arthur M. Sackler Museum, The Stuart Cary Welch Collection, Gift of Edith I. Welch in memory of George Bickford, 2009.202.37. **29 National Gallery Of Australia, Canberra:** Balinese People, The Adiparwa, first book of the Mahabharata palm-leaf manuscript (lontar) mid-late 19th century, palm leaf, ink, cord, Chinese coin, 4.5 x 53 cm, Purchased 1994 (br). **30 Alamy:** www.BibleLandPictures.com (bl). **Zev Radovan / www.BibleLandPictures.com:** (tl). **30-31 The Israel Museum,** Jerusalem, by Ardon Bar-Hama: Shrine of the Book. **31 The Israel Museum, Jerusalem, by Ardon Bar-Hama:** Shrine of the Book (bl). **32 The Israel Museum, Jerusalem, by Ardon Bar-Hama:** Shrine of the Book (t, b). **33 Alamy:** Uber Bilder (br). **The Israel Museum, Jerusalem, by Ardon Bar-Hama:** Shrine of the Book (t, bl). **34 Alamy:** AF Fotografie. **34-35 akg-images:** Interfoto (b). **35 akg-images:** Interfoto (tl, tc, tr). **36 akg-images:** Interfoto (tc, cl). **Alamy:** Interfoto (tr). **36-37 akg-images:** Interfoto (b). **37 akg-images:** Interfoto / picturedesk.com / ÖNB (tl, tr). **National Library of Sweden:** (br). **38 akg-images:** Pictures From History (bl). **38-39 Courtesy Of The Board Of Trinity College, Dublin:** (b). **39-br Courtesy Of The Board Of Trinity College, Dublin. 40-41 Courtesy Of The Board Of Trinity College, Dublin. 42 Bridgeman Images:** The Board of Trinity College Dublin (tr). **Getty Images:** Print Collector (cr, br). **Courtesy Of The Board Of Trinity College, Dublin:** (l). **43 akg-images:** (bl). **Bridgeman Images:** British Library Board. All Rights Reserved (bc, br). **Courtesy Of The Board Of Trinity College, Dublin:** (tl, tr). **44-45 The Metropolitan Museum of Art, New York:** Purchase, Lila Acheson Wallace Gift, 2004. **46 Bridgeman Images:** British Library, London, UK (l, r). **46-47 Bridgeman Images:** British Library, London, UK (t, b). **48 Exeter Cathedral Library and Archives. 49 Alamy:** Universal Art Archive (br). **Exeter Cathedral Library and Archives:** (t). **50 Bridgeman Images:** Lovers, from the 'Science of Erotics', 'the Kama-Sutra', Himachal Pradesh, Pahari School, Indian School / Victoria & Albert Museum, London, UK (bl). **51 The Metropolitan Museum of Art, New York:** Gift of Richard Ettinghausen, 1975 (tr). **52-53 RMN:** RMN-Grand Palais (domaine de Chantilly) / René-Gabriel Ojéda. **54 Mary Evans Picture Library:** J. Bedmar / Iberfoto (cr). **New York Public Library:** Spencer Collection (bl, br). **55 Alamy:** Uber Bilder (br). **New York Public Library:** Spencer Collection (t, c, bl). **56 Alamy:** AF Fotografie (cr). **McGill University:** Reproduced by permission of the Osler Library of the History of Medicine (cl, fcr, bc, bl). **57 Bridgeman Images:** Bibliotheque Nationale, Paris, France / Archives Charmet (br). **McGill University:** Reproduced by permission of the Osler Library of the History of Medicine (t). **58 The National Archives of the UK:** (cl, bl, bc, br). **59 The National Archives of the UK:** (tl, b). **60 akg-images:** (cb). **Herzog August Bibliothek Wolfenbüttel::** Cod. Guelf. 105 Noviss. 2° (br). **61 Mary Evans Picture Library:** Hubertus Kanus. **62 Herzog August Bibliothek Wolfenbüttel:** Cod. Guelf. 105 Noviss. 2° (tl, tc, bl). **62-63 Herzog August Bibliothek Wolfenbüttel:** Cod. Guelf. 105 Noviss. 2°. **64 RMN:** RMN-Grand Palais (domaine de Chantilly) / René-Gabriel Ojéda (cl, cr, bl). **65 RMN:** RMN-Grand Palais (domaine de Chantilly) / René-Gabriel Ojéda. **66 RMN:** RMN-Grand Palais (domaine de Chantilly) / René-Gabriel Ojéda (tl, tr, bc). **67 RMN:** RMN-Grand Palais (domaine de Chantilly) / René-Gabriel Ojéda. **68 RMN:** RMN-Grand Palais (domaine de Chantilly) / René-Gabriel Ojéda. **69 RMN:** RMN-Grand Palais (domaine de Chantilly) / René-Gabriel Ojéda (l, r). **70 Bridgeman Images:** Bibliotheque Nationale, Paris (b). **71 Bridgeman Images:** British Library, London, UK (br). **74 Bridgeman Images:** British Library, London, UK (bl). **British Library Board:** (bc, br). **Octavo Corp.:** Library of Congress (cl). **75 AF Fotografie:** (br). **Octavo Corp.:** Library of Congress (t, t); Library of Congress (t, t). **Octavo Corp.:** Library of Congress (t, t); Library of Congress (t, t). **76 Alamy:** AF Fotografie (cr). **Octavo Corp.:** The Bancroft Library, University of California, Berkeley (cl, bl, br). **Science Photo Library:** Royal Astronomical Society (bc). **77 AF Fotografie:** Private Collection (br). **Octavo Corp.:** The Bancroft Library, University of California, Berkeley (t, bl). **78 Alamy:** Uber Bilder (bc). **80 AF Fotografie:** Private Collection (tr). **The Trustees of the British Museum:** (bc). **84 Getty Images:** Stock Montage (cr). **Octavo Corp.:** Stanford Library (cl, bl, br). **85 Octavo Corp.:** Stanford Library. **86 AF Fotografie:** (bl). **Octavo Corp.:** Library of Congress, Rare Book and Special Coll. Div. (cl, br). **87 AF Fotografie:** (bl, br). **Octavo Corp.:** Library of Congress, Rare Book and Special Coll. Div. **88 Library of Congress, Washington, D.C.:** Music Division (br, cl, bl). **89 Library of Congress, Washington, D.C.:** Music Division (c, t, cr). **90 Getty Images:** Seth Joel (tl). **90-91 Bridgeman Images:** Boltin Picture Library. **92 Bridgeman Images:** Boltin Picture Library (cl). **Getty Images:** Bettmann (cb). **92-93 Bridgeman Images:** Boltin Picture Library. **93 Getty Images:** Seth Joel (br). **Mary Evans Picture Library:** J. Bedmar / Iberfoto (bl). **94 AF Fotografie:** Private Collection (bl, br). **Octavo Corp.:** The Warnock Library (cl, bc). **95 AF Fotografie:** Private Collection (t). **Alamy:** Universal Art Archive (bl). **96 Bibliothèque Sainte-Geneviève Livres, Paris:** (bl, br). **Getty Images:** De Agostini Picture Library (cr). **97 Alamy:** Universal Art Archive (br). **Bibliothèque Sainte-Geneviève Livres, Paris:** (t). **The State Archives of Florence:** Reproduced with the authorization of the Ministero Beni e Att. Culturali (bl, bc). **98-99 Wellcome Images http://creativecommons.org/licenses/by/4.0/. 98 ETH-Bibliothek Zürich:** BPU Neuchâtel (tl). **U.S. National Library of Medicine, History of Medicine Division:** (cb). **100 Wellcome Images http://creativecommons.org/licenses/by/4.0/:** (tl, tc, tr). **102 Alamy:** Vintage Archives (cb). **ETH-Bibliothek Zürich:** Rar 9162 q, http://dx.doi.org/10.3931/e-rara-14459 (tl). **102-103 Bridgeman Images:** The

University of St. Andrews, Scotland, UK. **104 Alamy:** Universal Art Archive (bc). **Bridgeman Images:** The University of St. Andrews, Scotland, UK (t). **105 Bridgeman Images:** The University of St. Andrews, Scotland, UK (tl, tr, b). **106 Bridgeman Images:** The University of St. Andrews, Scotland, UK (c). **107 Bridgeman Images:** The University of St. Andrews, Scotland, UK (tc, tr, c, bc). **108 Alamy:** Vintage Archives (tr). **Bibliothèque Municipale de Lyon, France:** (bc). **109 Getty Images:** Fototeca Storica Nazionale. (l). **110 The Trustees of the British Museum:** (cl, bl). **110-111 The Trustees of the British Museum. 112 The Trustees of the British Museum:** (cl, tr, bl). **113 The Trustees of the British Museum:** (tl, cr). **SLUB Dresden:** Mscr. Dresd.R.310 (br). **114 AF Fotografie:** Private Collection (tl, bc, br). **North Carolina Museum of Art, Raleigh,:** Gift of Mr. and Mrs. James MacLamroc, GL.67.13.3 (cr). **115 Bridgeman Images:** British Library Board. **116 Biblioteca Nacional de España:** CERV / 118 (bl). **ETH-Bibliothek Zürich:** Rar 7063, http://dx.doi.org/10.3931/e-rara-28464 (cl). **Getty Images:** Bettmann (cr). **117 Alamy:** Penrodas Collection (br). **Biblioteca Nacional de España:** CERV / 118 (bl). **118 The Ohio State University Libraries:** (cl). **Penrodas Collection:** (bl). **119 The Ohio State University Libraries. 120 The Ohio State University Libraries:** (tl, bl, br). **121 The Ohio State University Libraries:** (tl, tr). **125 RBG Kew:** (br). **126 Alamy:** Universal Art Archive (cr). **ETH-Bibliothek Zürich:** Rar 460, http://dx.doi.org/10.3931/e-rara-370 (cl). **© J. Paul Getty Trust. Getty Research Institute, Los Angeles (NA2515):** (bl, br). **127 © J. Paul Getty Trust. Getty Research Institute, Los Angeles (NA2515):** (t, bl). **128 AF Fotografie:** Private Collection (br). **Alamy:** Universal Art Archive (cr). **British Library Board:** (bl). **Octavo Corp.:** Folger Shakespeare Library (cl). **129 Alamy:** The British Library Board / Universal Art Archive (b). **Octavo Corp.:** Folger Shakespeare Library (t). **130 Alamy:** Universal Art Archive (cl, bl, bc). **131 Alamy:** Universal Art Archive. **132 AF Fotografie:** Private Collection (cr). **John Carter Brown Library at Brown University:** (cl, br). **133 Alamy:** North Wind Picture Archives (br). **John Carter Brown Library at Brown University:** (t). **134 Photo Scala, Florence:** The Morgan Library & Museum / Art Resource, NY (bl). **135 Bibliothèque nationale de France, Paris:** (tr). **136-137 Alamy:** The Natural History Museum. **140 AF Fotografie:** Private Collection (r). **142-143 Octavo Corp.:** Stanford Library. **142 National Central Library of Rome. Octavo Corp.:** Stanford Library (cl). **144 Alamy:** The Natural History Museum (cb). **Image from the Bidioversity Heritage Library:** Digitized by Missouri Botanical Garden (cl). **144-145 Image from the Biodiversity Heritage Library:** Digitized by Missouri Botanical Garden. **146 Getty Images:** Heritage Images (bl). **University of Virginia:** Albert and Shirley Small Special Collections Library (cl, bc). **146-147 Getty Images:** Science & Society Picture Library. **148 Alamy:** Universal Art Archive (tl, bl). **Getty Images:** DEA PICTURE LIBRARY (br). **149 Alamy:** Universal Art Archive (l). **150 Getty Images:** Rischgitz (cb). **152 AF Fotografie:** Private Collection (l, r). **153 AF Fotografie:** Private Collection (tl, tr, bl, br). **154 AF Fotografie:** Private Collection (bl, br). **Getty Images:** Design Pics (cr). **Le Scriptorium d'Albi, France:** (cl). **155 AF Fotografie:** Private Collection (t, bl). **156 Alamy:** ILN (cr). **Dr Chris Mullen, The Visual Telling of Stories:** (cl). **Dr Chris Mullen, The Visual Telling of Stories:** (br). **158 Dr Chris Mullen, The Visual Telling of Stories:** (t, br). **159 Dr Chris Mullen, The Visual Telling of Stories:** (tl, tr, cl, br). **160-161 Octavo Corp.:** Bodleian Library, University of Oxford. **160 Octavo Corp.:** Bodleian Library, University of Oxford (cl, bl, br). **161 Octavo Corp.:** Bodleian Library, University of Oxford (c). **162 Boston Public Library:** Rare Books Department (cl, bl, br). **Getty Images:** Hulton Archive (cr). **163 Boston Public Library:** Rare Books Department. **164 Alamy:** Universal Art Archive (cl, cb, br). **165 AF Fotografie:** Private Collection (br). **Alamy:** Universal Art Archive (t). **166 AF Fotografie:** Private Collection (cr). **Octavo Corp.:** Library of Congress, Rare Book and Special Coll. Div. (br, cl). **167 British Library Board. 168 Getty Images:** De Agostini Picture Library (b). **Octavo Corp.:** Library of Congress, Rare Book and Special Coll. Div. (t). **169 Octavo Corp.:** Library of Congress, Rare Book and Special Coll. Div.. **170-171 Alamy:** The Natural History Museum. **170 Bridgeman Images:** Christie's Images (cl). **172 Alamy:** Chronicle (cb); The Natural History Museum (tl, cl). **174 Bridgeman Images:** Musee Valentin Hauy, Paris, France / Archives Charmet (bc, br). **Courtesy of Perkins School for the Blind Archives:** (bl). **Getty Images:** Universal History Archive (cr). **175 Bridgeman Images:** PVDE (br). **Courtesy of Perkins School for the Blind Archives:** (t, bl). **176 Harold B. Lee Library, Brigham Young University:** (br). **The Stapleton Collection:** (cl). **University of California Libraries:** (bl, bc). **177 Penrodas Collection:** (bl). **The Stapleton Collection:** (t). **178 The Stapleton Collection:** (br, bl, cr). **179 AF Fotografie:** Private Collection (br). **The Stapleton Collection:** (t). **180-181 Darnley Fine Art / darnleyfineart.com. 180 Donald A Heald Rare Books:** (cl). **The Stapleton Collection:** (tr). **182 AF Fotografie:** Private Collection (bc). **Alamy:** AF Fotografie (cb). **Andrew Clayton-Payne:** (tc). **Library of Congress, Washington, D.C.:** 3g04054u (c). **183 Getty Images:** De Agostini Picture Library. **184 AF Fotografie:** Private Collection (tc, c, cl). **Darnley Fine Art / darnleyfineart.com:** (bc). **184-185 The Stapleton Collection. 186 Alamy:** Universal Art Archive (cr). **New York Public Library:** Spencer Collection (br, cl). **187 New York Public Library:** Spencer Collection. **188 New York Public Library:** Spencer Collection. **189 Harry Ransom Center, The University of Texas at Austin:** (cr). **New York Public Library:** Spencer Collection (tl, bl, br). **190 AF Fotografie:** Private Collection (bl, br, cl). **Getty Images:** Heritage Images (cr). **191 AF Fotografie:**

Private Collection (t, bl, br). **192 Alamy:** Universal Art Archive (cr). **Special Collections of Drew University Library:** (cl, bl, bc, br). **193 AF Fotografie:** Private Collection (bc, br). **Library of Congress, Washington, D.C.:** 03023679 (cl, t, bl). **194 Image from the Biodiversity Heritage Library:** Digitized by Smithsonian Libraries (br, cl). **The Darwin Archive, Cambridge University Library:** (bl, bc). **195 Image from the Biodiversity Heritage Library:** Digitized by Smithsonian Libraries (t). **Penrodas Collection:** (br). **196 Alamy:** Private Collection (cra); Universal Art Archive (bl, br). **197 Alamy:** Universal Art Archive. **198 Alamy:** Universal Art Archive (tl, tc). **199 AF Fotografie:** Private Collection (tr). **Alamy:** AF Fotografie (bc, br). **200 Alamy:** Everett Collection Historical (bl). **The Stapleton Collection:** (cr). **The Master and Fellows of Trinity College, Cambridge:** (cl, br). **201 AF Fotografie:** Private Collection (br). **The Master and Fellows of Trinity College, Cambridge:** (t). **202 Alamy:** Classic Image (cr). **Octavo Corp.:** Bridwell Library, Southern Methodist University (cl, br). **203 Octavo Corp.:** Bridwell Library, Southern Methodist University (c). **204 Octavo Corp.:** Bridwell Library, Southern Methodist University. **205 Bridgeman Images:** British Library Board (br). **Octavo Corp.:** Bridwell Library, Southern Methodist University (t). **206-207 Octavo Corp.:** Bridwell Library, Southern Methodist University. **208 Alamy:** AF Fotografie (cr). **Bibliothèque nationale de France, Paris:** département Réserve des livres rares, RESFOL-NFY-130 (bl, br). **Getty Images:** Mondadori Portfolio (cl). **209 Bibliothèque nationale de France, Paris:** département Réserve des livres rares, RESFOL-NFY-130 (br). **Getty Images:** Mondadori Portfolio (t). **210 Alamy:** Granger Historical Picture Archive (bl, bc). **211 Bridgeman Images:** De Agostini Picture Library / G. De Vecchi (tr). **212 Bibliothèque nationale de France, Paris:** (tl, tc). **213 Penrodas Collection. 214-215 Roland Smithies / luped.com:** © 2012 BUILDING STORIES by Chris Ware published by Jonathan Cape. All rights reserved.. **217 Library of Congress, Washington, D.C.:** 3c03205u (br). **218 AF Fotografie:** Private Collection (cl). **Courtesy Frederick Warne & Co.:** National Trust (cr); Victoria and Albert Museum (bl, br). **219 AF Fotografie:** Private Collection (bl). **Courtesy Frederick Warne & Co.:** (t). **220 Courtesy Frederick Warne & Co.:** (tl). **222 SLUB / Deutsche Fotothek:** (cb). **The Stapleton Collection:** Private Collection (cl, br). **223 The Stapleton Collection:** Private Collection (t, bl). **224 The Stapleton Collection:** Private Collection (b). **225 President and Fellows of Harvard College:** Houghton Library (br). **The Stapleton Collection:** Private Collection (tl). **226 akg-images:** (bc). **Getty Images:** Culture Club (cr). **Octavo Corp.:** Warnock Library (cl). **227 Octavo Corp.:** Warnock Library (c). **228 Alamy:** Penrodas Collection (cr). **Photo Scala, Florence:** The Museum of Modern Art, New York (bl, br, cl). **229 Photo Scala, Florence:** The Museum of Modern Art, New York (tl, c, bl). **230 AF Fotografie:** (bc). **Getty Images:** Hulton Deutsch (cr). **Science & Society Picture Library:** National Railway Museum (bl). **230-231 PENGUIN and the Penguin logo are trademarks of Penguin Books Ltd. 232-233 Getty Images:** Anne Frank Fonds Basel (b, t). **232 Alamy:** Heritage Image Partnership Ltd (tl). **Rex Shutterstock:** (bl). **233 AF Fotografie:** Private Collection (br). **234 Alamy:** A. T. Willett (cl). **Getty Images:** Keystone-France (cr). **235 Getty Images:** Roger Viollet (br). **236 ©** 1943 LE DEUXIEME SEXE by Simone de Beauvoir published by Éditions Gallimard. All rights reserved. **Getty Images:** Hulton Deutsch (cr). **237** From THE FEMININE MYSTIQUE by Betty Friedan. Copyright © 1983, 1974, 1973, 1963 by Betty Friedan. Used by permission of W.W. Norton & Company, Inc. **237 Alamy:** Universal Art Archive (tr). **238 Getty Images:** Stock Montage (cr). **238-239** Photographs and quotations from SILENT SPRING by Rachel Carson: Copyright © 1962 by Rachel L. Carson, renewed 1990 by Roger Christie. Used by permission of Frances Collin, Trustee and Houghton Mifflin Harcourt Publishing Company. All rights reserved. **239 Science Photo Library:** CDC (br). **240 AF Fotografie:** Private Collection (bc). **Getty Images:** Rolls Press / Popperfoto (cr). **New York Public Library:** General Research Division (br, bl). **241 Alamy:** CharlineX China Collection (br). **Courtesy of the Thomas Fisher Rare Book Library, University of Toronto:** (t). **New York Public Library:** General Research Division (bc, bl, fbl). **242 Bridgeman Images:** Private Collection / Christie's Images (tr). **243 AF Fotografie:** Private Collection (br). **244 AF Fotografie:** © 1979 GAIA: A NEW LOOK AT LIFE ON EARTH by James E. Lovelock. Used by permission of Oxford University Press. (bl). **245 Roland Smithies / luped.com:** © 2012 BUILDING STORIES by Chris Ware. Used by permission of Jonathan Cape.. **246-247 Bridgeman Images:** Boltin Picture Library

All other images © Dorling Kindersley

For further information see:
www.dkimages.com